Eyes of Love

Eyes of Love

The Gaze in English and French Culture 1840 – 1900

Stephen Kern

NYU PRESS
WASHINGTON SQUARE
NEW YORK

Dedicated to my children
Justin and Simone

First published in U.S.A. in 1996 by
NEW YORK UNIVERSITY PRESS
Washington Square
New York, N.Y. 10003

Originally published in Great Britain in 1996
by Reaktion Books Ltd, London, as
*Eyes of Love: The Gaze in English and French
Paintings and Novels 1840–1900*

Library of Congress Cataloging-in-Publication Data

Kern, Stephen
 Eyes of Love: the gaze in English and French culture, 1840–1900 /
Stephen Kern.
 p. cm.
 Includes index.
 ISBN 0–8147–4686–1
 1. Women in art. 2. Gaze—Psychological aspects. 3. Arts,
English. 4. Arts, Modern—19th century—England. 5. Arts, French.
6. Arts, Modern—19th century—France. I. Title
NX652.W6K47 1996
700—dc20
 95-52336
 CIP

Printed in Great Britain

Contents

Acknowledgements 6

Introduction 7

1 Meeting 31

2 Recreation 54

3 Working 81

4 The Nude 99

5 Prostitution 128

6 Seduction 153

7 Rescue 181

8 Marriage 207

Conclusion 228

References 246

Photographic Acknowledgements 276

Index 277

Acknowledgements

The idea for this study occurred to me as I was preparing a lecture on the French Impressionists and discovered, almost at a glance, the compositional pattern that is this book's grounding insight. As I thought about the meaning behind the eyes of men and women in Impressionist art and compared that meaning with what I knew about the interpretation of eyes in nineteenth-century literature, a book began to take shape.

I was encouraged at that time by my long-time friend and critic Sean Shesgreen, who generously shared his enormous learning and sharp editorial skill. I am especially grateful for his impatience with over-interpretation and his insistence on directness. Thanks also to Laurel Bradley for assisting me with her knowledge of Victorian art and to Susan Casteras for help locating hard-to-find images. Rudolph Binion, Robert Brenner, Mary Damer, Michael Gelven, and Walter V. McLaughlin Jr, commented on select chapters. Frank Court read the pages on literature, while Gloria Groom read those on art. Debra N. Mancoff and Levi Smith read the entire manuscript.

Introduction

In the second half of the nineteenth century, French and English artists who depicted a man and a woman in the same composition typically rendered the face and eyes of the woman with greater detail and in more light. Most important, the men are in profile, while the women are frontal. They turn away from the man at their side, who gazes at them intently, and they look down with the required modesty, up for heavenly inspiration, or out into the world with a variety of intriguing expressions – playful or serious, fearful or adventurous, hesitant or resolute.

Artists depicting a man gazing at a woman who looks away might have posed the man frontal and the woman in profile, but they usually posed the pair the other way around in what I call a *proposal composition*. Such a composition highlights the woman's moment of decision after the man has proposed that the relationship move to some higher level of intimacy. At such moments she must respond, whether it be to his searching look or friendly enquiry, or, more significantly, to his seductive offer or proposal of marriage. Her eyes convey an impending answer to the question *Will she or won't she?* And because she is thinking about the many possible consequences of her answer, her expression is especially intriguing. In contrast, the man has done his thinking and said what is on his mind. He wants to hear a *Yes*, so his face bears a more predictable and less interesting expression.

These respective poses of men and women also imply different visual, reflective, and emotional capabilities. The man's single profiled eye implies the limited depth perspective of monocular vision and single-mindedness of purpose; the woman's two frontal eyes imply the greater depth perception of binocular vision as well as a wider horizon of visual interests, a broader range of purposes, and more profound, if not more intense, emotions.

Artists used proposal compositions to capture pivotal moments throughout the scenario of love, including actual proposals of marriage. Numerous examples of such motifs can be found in English courtship art. In Edwin Long's *The Proposal* (illus. 1), the man glances down and fixes

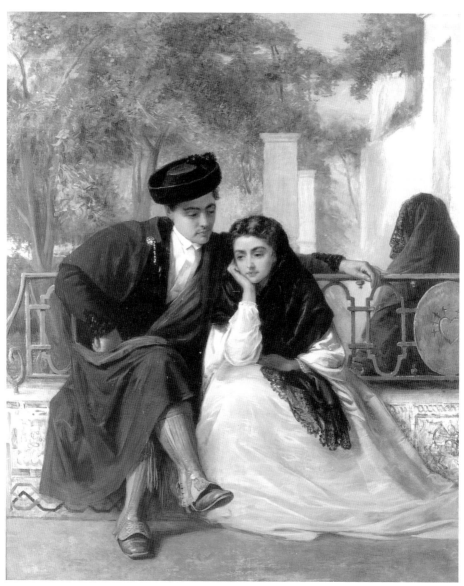

1 Edwin Long, *The Proposal*, 1868, oil on canvas.

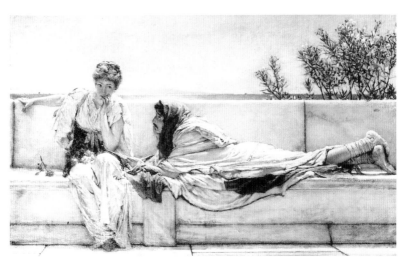

2 Lawrence Alma-Tadema, *Pleading*, 1876, oil on canvas on panel. Guildhall Art Gallery, London.

on the woman patiently as a shadow cuts across his face, while she holds her chin meditatively and looks ahead with magnificent dark eyes under broad, graceful brows. In Lawrence Alma-Tadema's *Pleading* (illus. 2), the couple enact the age-old ritual in an ancient Roman setting. The man stretched out on a marble bench looks at the woman as she leans forward and bites her nails nervously while considering his plea. Other images reveal a woman avoiding the man's determined expression as she looks away from him to consider her crucial decision. In John Everett Millais's *The Proposal* (*c.* 1845) she looks away evasively; in Frank Stone's *The Last Appeal* (1843) she turns away in anguish; in James C. Waite's *A Summer Proposal* (1855) she looks away cautiously; in Frederick G. Stephens's *The Proposal* (*c.* 1850) she looks down sadly; in Edmund Blair-Leighton's *The Question* (1892) she glances down hesitantly; and in William Frith's *A Critical Moment* (1902) she bows her head thoughtfully.[1]

Although the Impressionists avoided such visual narrative, they created images of men and women in a proposal composition with similar expressions of emotion. Renoir's *The Engaged Couple* (illus. 3), for example, suggests a moment out of a courtship scenario and is arranged in just such a composition.[2] The intent man, posed by Alfred Sisley, looks at his fiancée as if she were a treasured possession. Posed by one of Renoir's favourite models, she is more prominent than Sisley in a number of ways. Her red-and-yellow striped dress overwhelms his nondescript trouser-leg, her affectionate hands are more active than his rigid arm prop, and her frontal glance is more nuanced and sees more of the world than his one visible profiled eye pinned on her.

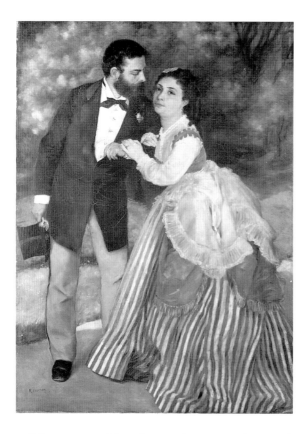

3 Pierre Renoir, *The Engaged Couple*, 1868, oil on canvas. Wallraf-Richartz-Museum, Cologne.

These compositions feature the woman, because her thoughts and feelings are less certain and so the more intriguing. Thus artists focused on women during actual proposals as well as other decisive moments in order to produce the recurrent frontal pose of women's telltale eyes – resolute in Millais's courageous rescuers, haunting in Rossetti's languishing maidens, luminous in Tissot's venturesome socialites, glittering in Renoir's happy dancers, impenetrable in Gauguin's Tahitian Eves, inspired in Hunt's repentant courtesan, and full of longing in Manet's pensive barmaid.

The frequency of the proposal composition calls for reconsideration of a widely held argument about 'the gaze', a term I apply strictly to a way of looking that serves an erotic purpose. This argument, put simply, is that men own the gaze: women are passive erotic objects, while men are active erotic subjects. Over the past 25 years variants of that basic argument have been put to extensive use in studies of art, cinema, and literature.

In the early 1970s these studies began to examine how women were treated as 'sex objects'. In 1972 that concern in art history was announced in a collection of essays provocatively titled *Woman as Sex Object: Studies*

in Erotic Art, 1730–1970.[3] Although the subtitle indicated that the essays would focus on erotic art, the larger argument was that not only nudes in erotic art but clothed women in all sorts of compositions were also objectified by men's gazes, which stripped them of their subjectivity and humanity. That year John Berger concluded his short but influential *Ways of Seeing* with a similar bold claim: 'Men look at women. Women watch themselves being looked at . . . [and become] an object of vision: a sight'.[4]

A theoretical source for subsequent scholarship was *Discipline and Punish* (1975) by Michel Foucault, who argued that the imposition of disciplinary power in an army, a school, or a prison relies on a 'mechanism that coerces by means of observation'. The new 'panoptic mechanism' instituted around the middle of the nineteenth century used the visibility of surveillance instead of the darkness of dungeons to discipline and reform deviants. Those in power remained invisible, while those to be disciplined were subjected to 'compulsory visibility'.[5] His further assessment of the power of vision (along with language and knowledge) to classify, diagnose, and reform other marginal groups such as mental patients and delinquents lent itself to subsequent criticisms of a general male-dominated 'ocular politics' as well as that specific travesty of male surveillance of women in the nineteenth century – compulsory examination of prostitutes for signs of venereal disease.[6]

Film theorists were especially critical of the objectification of women in an art that was predominantly owned, written, directed, and filmed by men. Laura Mulvey provided a manifesto for that concern in 'Visual Pleasure and Narrative Cinema' (1975). She maintained that 'pleasure in looking has been split between active/male and passive/female', with the result that women have been traditionally cast as exhibitionists and 'can be said to connote *to-be-looked-at-ness*'.[7] Mulvey's hyphens are like rivets securing a concept of visual objectification that has become a fixture in subsequent scholarship on the gaze.

In 1982 Mary Ann Doane analyzed 'female spectatorship' as analogous to three modes of deviant sexuality. Because men define and monopolize the desiring gaze, female spectators must renounce desire in masochism, identify with the object of male desire in narcissism, or masquerade as men in transvestism.[8] In 1987 Doane called for 'rethinking the absoluteness of the dichotomy between subject and object which informs much feminist thinking', but then added, in the same sentence, that this can be done by 'analyzing the ways in which the woman is encouraged to actively participate in her own oppression'. Such inability to abandon the idea that the woman is oppressed, no matter how dynamic her role, lies behind Doane's interpretation of *Humoresque* (1947) as a 'denial of the female gaze'. In this film, Joan Crawford, playing a wealthy and unhappily mar-

ried socialite, tries to love John Garfield, who plays a gifted violinist. Her effort is repeatedly signified by the putting on of spectacles in order to see, and even to hear, him better. Between the two lovers, Crawford is the more self-reflective and profound, at least in interpreting love, if not music. And although the film centres on how she strains to understand herself and her beloved (symbolized by her straining to see), Doane interprets her near-sightedness as 'a signifier of the perversity of her scopophiliac relation with the male' and interprets the frames of her spectacles as a cinematic framing device 'designed to contain an aberrant and excessive female sexuality'. In fact, Crawford projects a commanding subjectivity that is dramatized in a magnificent close-up of her shining eyes opening and closing in rapture over the beauty of the music while struggling with the difficulty of loving Garfield, who, with his stubby fingers and boxer's eyes, is ludicrously miscast and thoroughly unconvincing as a virtuoso violinist.[9]

In 1983 E. Ann Kaplan contributed an article with an unforgettable rhetorical question as its title: 'Is the Gaze Male?' The gaze is not necessarily male, she concluded, but contingently so: 'to own and activate the gaze, given our language and the structure of the unconscious, is to be in the "masculine" position'.[10] But convinced of the widespread objectification of women, Kaplan did not ask 'What is the female gaze?' In 1984 Teresa de Lauretis found the patriarchal gaze to be objectifying women everywhere in cinema and society. She challenged its ubiquitous dominion, beginning with her open-ended title *Alice Doesn't*, which, she explained, expresses 'the unqualified opposition of feminism to existing social relations'. Her specific targets included representations of women as an 'object to be looked at' or a 'lure of the gaze'. Whether a woman is objectified in a film as 'spectacle-fetish' or positioned outside of it as 'spectator-subject', she is 'inevitably' defined in relation to a male subject and 'complicit in the production of (her) woman-ness'. For Lauretis, even narrative movement and desire are inherently male. Thus, no matter how dynamic, insightful, powerful, influential, or erotic is a woman's role in a film or in society, she must ultimately be objectified.[11]

In the 1990s a few film scholars began to question such sweeping generalizations. In *Male Subjectivity at the Margins* (1992), Kaja Silverman argued that male subjectivity depends on a 'collective make-believe in the commensurability of penis and phallus', which she called 'the dominant fiction'. Since men's temperamental penises cannot measure up to the ever-ready potency required of the symbolic phallus, the dominant fiction of conventional masculinity is fragile, sustainable only by women co-operating with men to 'deny all knowledge of male castration by believing in the commensurability of penis and phallus' and by sharing in the collective 'misrecognition upon which masculinity is founded'. Men do not

have a monopoly on potency or subjectivity. As Silverman's title implies, male subjectivity is never completely centred and dominant; it is sometimes marginalized and interactive with women, and is always dependent on women helping to 'fortify' it. She also called for greater appreciation of the reciprocity of the gaze and questioned the feminist assumption that 'cinema's scopic regime could be overturned by "giving" woman the gaze, rather than by exposing the impossibility of anyone ever owning that visual agency'.[12]

Art historians have been less willing to forego the subject–object dichotomy between the sexes. In 1985 Rosemary Betterton appeared to be investigating what it was that women depicted in art actually looked at, as suggested by her title 'How Do Women Look?', but her focus was rather on how women look at art or appear as models.[13] In 1988 Linda Nochlin considered the choices open to women as spectators of art, not the choices open to women as they are portrayed seeing the world in art. Similar to Doane on female spectatorship in cinema, Nochlin concluded that female spectators of art have two choices: they can either 'take the place of the male or . . . accept the position of male-created seductive possibility and the questionable pleasure of masochism'.[14] In 1988 Griselda Pollock finally considered what it was that women depicted in nineteenth-century art might actually see. But her account was brief, and her emphasis was on how the male gaze continues to confine women spatially and 'erases' the female look so that 'to look at and enjoy the sites of patriarchal culture we women must become nominal transvestites'.[15]

In 1992 Norma Broude and Mary D. Garrard introduced an anthology of articles by feminist art historians with a survey of scholarship on woman's ocular victimization. 'Much recent writing on the body', they wrote, 'proceeds from the idea that the male in culture and art has been the privileged subject and exclusive possessor of subjectivity, while the female has been primarily object, stripped of access to subjectivity'.[16] The nine articles on nineteenth-century art that they chose to include neglect affectionate relations between men and women. Out of a total of 110 images, only eight show a man and a woman interacting, and these are all images of estrangement, including four by Degas showing a man in a brothel. In a century that abounded with images of lovers, not one is included as an illustration in those articles. Whether by selection or argument, their authors gave far less attention to the vision of women than to the gazes of men.

In 1995 Joseph A. Kestner applied Mulvey's theory to images of masculinity in Victorian art. He argues that the male gaze in front of as well as on the canvas objectifies the 'woman's to-be-looked-at-ness' and that, again quoting Mulvey, 'the "determining male gaze" means that "plea-

sure in looking has been split between active/male and passive/female'".[17]

As I will show, the Mulvey thesis of a dichotomous split between male-as-subject and female-as-object simply cannot be supported by the evidence of art history. Women never were a mere *to-be-looked-at-ness*, and the pleasure men got from looking at women necessitated those women being alive with subjectivity. Men did have privileged licence to enjoy the erotically intended gaze (often it seemed to own them); but women's objectification under that gaze was not even close to being complete, because the eroticism of the gaze encompassed only a limited aspect of women's as well as men's experience, because women's subjectivity was energized by men's failure to recognize their humanity, and because women could always look away and think of something else. Victorian art is full of women looking away from a gazing man, even if it is just to consider his amorous intentions. Arguments about woman's objectification under a determining male gaze are more plausible when applied to the female nude, but even the female nude is not, as Broude and Garrard phrased it, 'primarily object, stripped of access to subjectivity'. Female nudes express a rich subjectivity that most scholars have failed to note.

In the Victorian period men alone were permitted to look at the opposite sex erotically without social stigma. Women were probably less inclined to look at men (we will never know for sure), but undoubtedly were more constrained by social mores from looking provocatively, so that they would not be taken for a prostitute. In 1840 a Scottish surgeon theorized that one could identify prostitutes by the tilt of their head and the 'wild and impertinent glance of their eye'.[18] In France a woman could be hauled up before the Tribunal de Simple Police for a single *œillade* (provocative look).[19] But men's monopoly on gazing does not demonstrate their monopoly on subjectivity. In most images of the sexes together, the man's gaze is more sharply focused than the woman's look, but the woman's look reveals an equal, if not greater, measure of subjectivity. The woman's eyes are just not as intent on looking at a desirable man as the man's eyes are intent on looking at a desirable woman. I will interpret such gendered differences as they were centred in the eyes, which I treat as a metonym for the face and character.

Artists' fascination with women's faces and eyes does not indicate that women in fact saw more of the public world. They could not travel as freely as men, and in the city many neighbourhoods were particularly dangerous for them. Women's lives were centred in the locales of courtship and the home, where they were supposed to care for others and maintain domestic peace, but in that limited sphere they looked more thoughtfully into the meaning of love.

Along with greater depth of feeling and seriousness about the meaning

of love, many of the women so depicted also conveyed a deeper commit-
ment to what I call the morality of love. By way of introduction, I suggest
three explanations for this pattern of highlighting the woman's expression
and for emphasizing her superior commitment to the morality of love:
courtship conventions, the moral character of the sexes, and the relation-
ship between male artists and female models.

The first explanation for the highlighting of women's eyes comes from
the nature of courtship. From the start the man decided whom to court,
when and how to proceed. Only after he proposed marriage did the
woman realize a moment of supreme control. In *A Pair of Blue Eyes* (1873)
Thomas Hardy describes such a moment for his heroine after her suitor
has declared his love and prepared to propose: 'What a proud moment it
was for Elfride then! She was ruling a heart with absolute despotism for
the first time in her life'.[20] However overwhelming her dependency until
then, she finally had an unprecedented moment of power, because her
suitor looked at her in order to learn whether her answer was to be *yes* or
no. A *no* could mean avoiding a bad match, but possibly spinsterhood and
barrenness; a *yes* could mean comfort and security, but also obedience and
dependency. A woman shown contemplating a proposal might be thinking
about family expectations and social pressures to accept or reject, about
the thrill of a wedding or the responsibilities of motherhood, about her
lack of sexual experience or the pain of defloration, about the man's past
sexual experience or her own risk of venereal infection, about the urging
of her love or the uncertainties of its fulfilment, about another man she
prefers or even a man she has not yet met. So this moment was best pro-
longed to give her time to think.

The pathos of her brief moment of power is especially vivid in
compositions that depict a proposal of marriage. In a study of English
courtship imagery, Susan Casteras found five works depicting an actual
proposal that are titled *Yes or No?* Others are titled as variants: *Shall I?*
(1835), '*I Meant to Say Yes, When I Answered Him No*' (1865), *Hesitation:
Yes or No?* (1866), and *Between Yes and No* (1893).[21] In her novel *North and
South* (1855), Elizabeth Gaskell protests women's limited power of mere
consent, when she explains that her heroine Margaret's mouth was 'no
rosebud that could only open just enough to let out a "yes" and "no"'.[22]

After a man proposed, he would look at the woman and wait for a re-
sponse. She had at last a unique moment of freedom in which to speak her
own mind. The speed with which women were required to respond is
parodied in the title of an engraving by George D. Leslie, *Ten Minutes to
Decide* (1867),[23] in which the suitor stands aside and watches intently while
the mother whispers advice into the ear of her daughter, who in response
directs an anxious look toward the viewer.

Writers also recognized the devastating effect of forcing women to hurry their decision. In Anthony Trollope's *He Knew He Was Right* (1869), Miss Rowley is stunned by Mr Glascock's proposal: 'There floated quickly across her brain an idea of the hardness of a woman's lot, in that she should be called upon to decide her future fate for life in half a minute.' Until his actual proposal she had scarcely dared to look at him. Now, 'with a quick turn of an eye she glanced at him, to see what he was like. Up to this moment, though she knew him well, she could have given no details of his personal appearance.'[24] Glascock withdraws his request for a quick answer, but the pattern of Victorian courtship required women to decide almost before they had been able to think about the man, or even, like Miss Rowley, to look at him carefully. Women were featured in art and literature, because at the most decisive moments of a courtship, they were the centre of interest.

A second explanation for the primacy of the woman's eyes has to do with the moral code for love. I use *moral* to refer to a standard of right and wrong that lovers maintained toward one another that required honesty, fidelity, and commitment to make love flourish.

In some paintings the moral issues are muted, especially those I discuss in the first two chapters – Meeting and Recreation. But in pictorial as well as literary interpretations of more involved male–female relationships in subsequent chapters (Working, The Nude, Prostitution, Seduction, Rescue, and Marriage), women show deeper concern about a variety of moral issues. Some of them may be thinking about the unfairness of the various double standards of behaviour for men and women, such as the uniquely harsh consequences for a woman should she model in the nude, engage in prostitution, have sex out of wedlock, seduce a man, or commit adultery. Other women may be worrying about wounding the feelings of a man they do not love or hurting a female rival if they were to consent to the man they do love. Still others may not quite understand what it is they are doing or what its moral consequences might be, and are portrayed trying to figure out what might be the result of giving in to desire. But the question central to a comparison of the morality evident in the expressions of men and women is this: Which sex adhered more rigorously to the fundamental moral code that governed love relationships between the two lovers themselves.

In the Victorian period that code was in accord with the Christian conception of men and women as equally responsible in the eyes of God, and it conformed to the Golden Rule that required one to treat one's beloved in the way one expected to be treated. This private code was shaped by a broader social code and by actual laws that were indeed different for men and women regarding sexual behaviour.[25] But within this hierarchy of

normative imperatives it is possible to identify a single moral standard about how lovers were supposed to treat one another as they stood eye to eye and held one another responsible for the words and deeds that made their hearts throb.

To support this claim, I must challenge the generality of the term 'the double standard' and one specific misapplication of it to this period. The term is too general because there were many double standards. It is misapplied to men and women in love because they judged one another according to a single moral standard.

For examples of double standards I begin with Keith Thomas's classic essay 'The Double Standard', which is packed with evidence that English men and women were regulated by separate standards of behaviour as well as laws that defined the right to hold property in one's own name, the grounds for divorce, the extenuating circumstances for killing an unfaithful spouse, and the punishment for prostitution. But his evidence does not demonstrate a double moral standard about what was right and wrong for a man and a woman who were committed to loving one another. Evidence that prostitution was deemed beneficial to society because it was 'a necessary evil and a buttress for the morals of the rest of society' or that women were obliged to 'tolerate' a rake who made 'illicit' attempts on their chastity does not show that men and women in love held each other to a different standard, only that others did. In fact, Thomas's definition of the double standard explicitly excludes the moral judgement of the lovers themselves. The double standard, he points out, 'is the view [of society] that unchastity, in the sense of sexual relations before marriage or outside marriage, is for a man, if an offence, none the less a mild and pardonable one, but for a woman a matter of utmost gravity.' A double standard maintained by society is not the same as a double standard maintained by lovers toward one another. Thomas's evidence shows only that society punished a man's transgressions less severely.[26]

A woman discovered in adultery no doubt experienced more shame before the reproving eyes of friends, family, and society than did a man, and she was punished more severely. But there is no evidence that she felt more shame before the judgemental eyes of her beloved than an adulterous man felt when discovered by his beloved, or that the adulterous woman was more tormented by private guilt from her own self-evaluation. In Nathaniel Hawthorne's *The Scarlet Letter* (1850), Hester Prynne is punished publicly far more severely than her co-adulterer Arthur Dimmesdale, whose transgression remains unknown to society until the end. But throughout the novel he experiences a similar intensity of guilt, and in the end, as Hester begins to accommodate to her public shame as well as to her private guilt by wearing her scarlet letter – 'A' for adultery – proudly on

her bodice, Dimmesdale's increasing self-torment leads to his death.

A similar double standard governed how French society judged adultery. A man could divorce his wife if he caught her committing adultery anywhere, while a woman could divorce her husband only if she caught him doing it in the marital home. The French Penal Code allowed the man to kill his wife and her lover with impunity if he caught them *in flagrante delicto*, but did not allow the wife to kill her adulterous husband under any circumstance. James F. McMillan documents a double standard that French society imposed on a man and a woman who engaged in pre- or extra-love relations but not a double standard that governed the reciprocal moral judgements of a man and a woman who loved one another. In a discussion of 'The Double Standard of Morality' McMillan cites the court record of one convicted murderer who, in 1880, returned home after serving his sentence and proceeded to bring charges of adultery against his pregnant wife for having taken up with another man. The court sentenced the woman and her lover to a six-day jail term. But such evidence does not demonstrate a double standard of morality for lovers. To document that claim McMillan would have needed to show that the imprisoned woman loved her husband and accepted a less punitive moral code for him. But she did not, as McMillan indicates by quoting her statement before the court that her husband was 'a brute and a drunkard'.[27]

Another historian of French morals, Antony Copley, concluded that in France women were encouraged by the Church to be the 'perpetuators of moral values'.[28] And just as with McMillan, Copley's evidence for a double standard of morality about adultery, prostitution, and divorce does not show that male and female lovers held one another to a different morality. In both France and England, men and women in love held one another to the same moral standard of what is right and wrong with respect to each other, one based on the same requirements for honesty, fidelity, and commitment.

The public code, however, was double. Before marrying, Victorian women were supposed to be chaste, while men were supposed to have had experience. Thomas quotes the conventional wisdom that 'young men may sow their wild oats', but a man's sexual past nevertheless remained something to be concealed from his beloved, while extra-marital affairs were wholly unacceptable. Novels show that men did not freely reveal the sexual relations they had enjoyed before they met their beloved and that the occasional, painful revelation of such a past was accompanied by apologies and excuses. In Hardy's *Tess of the d'Urbervilles* (1891), Angel apologizes to Tess for his 'forty-eight hours of dissipation with a stranger' and promises never to repeat it.[29] The hero of *Jane Eyre* also does not justify his former sexual experiences by a double standard. Rochester con-

fesses those acts to Jane but does so before declaring his love, possibly before admitting it to himself. While intoxicated with wine, he speaks in generalities about his 'road to shame and destruction' and admits his moral lapse, but he projects responsibility for it by complaining that 'fate wronged me' and continues to hide his most important former sexual experience – his marriage to an insane woman.[30]

Just as loving heroes do not dare invoke a double standard, loving heroines do not accept one. In George Eliot's *Middlemarch* (1872), Dorothea is devastated when she mistakenly thinks that Will is making advances to Rosamond. In *La Bête humaine* (1890), Zola's maniacally jealous Flore derails a train, killing and maiming dozens of innocent people as a way of taking revenge on her lover for a perceived infidelity. Even the adulterous heroine of Flaubert's *Madame Bovary* (1857) begs the rakish Rodolphe to say that she is the only one he loves, and he tries to hide his other lovers. Emma eventually gives in to a double standard, but only as her love breaks down, which Flaubert dramatizes in a brutal dialogue. First Emma implores Rodolphe: 'You've never loved anybody else, have you?' When he laughs and replies 'Do you think you deflowered me?' she desperately tries to reassure herself of her privileged role as one of his lovers: 'Tell me it isn't true! Tell me you don't like any of them!' Then she cries out that none of the others loves him the way she does. Defeated, she concedes 'I'm your slave and your concubine!'[31] Emma accepts a double standard, but only after her spirit is broken and love is lost.

Victorian mothers may have advised their daughters to put up with a double standard, and daughters may have given lip service to it, but once a Victorian woman loved a man, she became incapable of genuinely accepting a second moral code for him that sanctioned his loving, or having sex with, someone else. Victorian society was full of examples of men capitalizing on the double standard, but within the frame of a loving relationship the duplicity of the double standard was unacceptable to men and women alike. That frame was what artists used literally (and novelists used figuratively) to *frame out* the world of the double standard and to *frame in* the subjects of their creations, which took place in the private sphere of the courtship scenario and the home.

Publicly enforced gender roles included a distinctly masculine morality that was defined in isolation from women.[32] In mid-Victorian England, masculinity was associated with discipline, independence, chivalry, sexual purity, moral courage, and 'manly Christianity'. Later in the century it was associated with 'stoicism, hardiness, and endurance'.[33] Both sets of traits were cultivated primarily around other men, so their contributions to heterosexual love were marginal, if not counterproductive. The ultimate test of masculine moral strength was that of resisting a woman's

tempting. Masculine moral courage was more a matter of a man's honour among men than doing what is right in loving a woman. And while chivalry was inspired by the idea of protecting a woman, it concerned her only indirectly, because men acted out chivalric virtue by fighting other men in exclusively male locales, such as the boxing-ring, the dueling ground, or the battlefield.[34] In France most duels over a woman were not between rivals for her love but between her protector and the man who challenged her honour, and so they were fought primarily in the service of the protector's *amour-propre*. French masculinity – especially after the military defeat of 1870 – emphasized combative virtues of strength, energy, and courage.[35]

Victorian men monopolized political, military, legislative, economic, medical, religious, and educational authority. They were expected to excel in qualities that enabled them to act in those public spheres in which they also exercised more moral authority than women. But in the private sphere the moral actions of men had less value. Compared with men, women were better at caring for children and the sick. They cultivated a deeper personal moral sense and more interest in the love relationships that dominated the domestic world in which they were confined. Robert A. Nye has documented how in France 'doctors who praised the "feminine" qualities of sensitivity, tenderness, and steadfastness in women, presented the same features in men in the most negative way imaginable'.[36]

In novels and paintings about the private sphere, women evince the stronger moral sense, because they exercised greater moral authority in it. Rochester proposes to Jane Eyre even though he is married. After she finds out and bolts during their wedding, he makes excuses for having married, justifies wanting to commit bigamy, and exhorts her to become his mistress. She is deeply conflicted but refuses in a statement that can be taken as representative of the moral code of Victorian women: 'I will keep the law given by God; sanctioned by man. I will hold to the principles received by me when I was sane, and not mad – as I am now. Laws and principles are not for times when there is no temptation: they are for such moments as this, when body and soul rise in mutiny against their rigour; stringent are they; inviolate they shall be.'[37]

As a foundation of her stronger moral sense, Jane is also more swayed by cultural considerations, while Rochester is more inclined to give in to instinctive urges. The argument that 'female is to male as nature is to culture' does not hold for the love relationship in most Victorian novels.[38] Victorian women were indeed closer to nature because of their reproductive function, which was especially consequent to sexual intercourse in this period due to the infrequent and ineffective use of contraception.

Men were detached from the natural consequences of sex because of their biological uselessness during pregnancy, childbirth, and nursing, and because of conventions that forbade sexual relations during pregnancy, banned men from being present during the birth process, and allowed men to be less involved with feeding and educating children afterwards. These different attachments to nature inherent in sexual biology, however, did not play a major role in novels about love. But another aspect of sexual biology did – sexual desire. In novels women resisted that natural desire far more than did men.[39] That resistance was the grounding act of morality and a foundation for culture – both a matter of not 'doin' what comes naturally'.

In comparing commitments to culture, I do not refer to the production of novels and paintings. Men were more accomplished in art because they had privileged access to studios, galleries, and academies, and they monopolized art journalism.[40] The culture I refer to is the foundation of social life, the denial of the immediate gratification of natural impulse, in particular sexual impulse. High culture comes not from giving in to it, but from controlling or at least sublimating it. Men sublimated quite well, and their impressive cultural accomplishments are the major sources for my study. But although men resisted natural impulse in order to paint or write, they did not resist natural impulse in loving women as well as women resisted it in loving them. My comparison of the respective commitments of the two sexes to nature and culture rests on this limited meaning of 'culture'.

In *Tess of the d'Urbervilles* Hardy refers to Tess's illegitimate child as a 'bastard gift of shameless Nature',[41] meaning that her seducer gave into his own shameful natural impulse, while she resisted. The assumption that bastardy results from indulging natural impulse runs throughout Victorian moralistic discourse. In Elizabeth Gaskell's *Ruth* (1853), the heroine, who is also seduced, impregnated, and abandoned, does not sanction a double standard for the man responsible. Her plight rather fires up the reader's outrage over her struggle to survive the man's immorality. *Tess* also provoked reader outrage by dramatizing the injustice of the double standard. English society treated Ruth and Tess more harshly than it did the men who seduced and abandoned them, and although both women were at first stunned by their misfortunes and acquiesced helplessly to a man's privileges for sexual self-indulgence, both novels exemplify how these women maintained their moral strength and in the end allowed no double moral standard for anyone. Both novels are a sexual–moral *bildungsroman* about how a man wrongs a woman and eventually comes to regret it.[42]

Freud was never more wrong than when he maintained that the women

of his time had a weaker superego and a deficient ethical sense as compared to men.[43] Other male and female theorists throughout the Victorian period rather proclaimed women's superior moral sense. During the formation of English domestic morality between 1780 and 1830, as Catherine Hall has shown, 'Evangelicals expected women to sustain and even to improve the moral qualities of the opposite sex' and act as 'the moral regenerators of the nation'.[44] In 1833, a founder of the science of phrenology affirmed men's superiority in intellect, women's in feeling: J. G. Spurzheim maintained that women have a stronger faculty of 'adhesiveness', which means an 'instinctive tendency to attach one's self to surrounding objects'.[45] In 1839 the British moralist Sarah Ellis urged that society could be improved by the influence of morally superior women. She envisioned some captain of industry returning from the ruthless battle-ground of the market-place and recalling his humble wife at home: 'The remembrance of her character, clothed in moral beauty, has scattered the clouds before his mental vision, and sent him back to that beloved home, a wiser and a better man.'[46] In 1857 the American phrenologist O. S. Fowler wrote that 'women are constituted more moral and religious than men in order both to transmit the most of the moral sentiments to children and then to educate them religiously and supervise their moral conduct as well as that of man'.[47]

The superior qualities of men on Darwin's list – courage, pugnacity, energy, genius, intellect, reason, imagination – develop either when one is in conflict with someone else or in isolation, while the woman's superior qualities are more interpersonal. Women have 'greater tenderness and less selfishness' in comparison with men's 'ambition which passes too easily into selfishness'.[48] In *The Descent of Man* (1871) Darwin also argued that 'from the ardour of the male throughout the animal kingdom he is generally willing to accept any female; and it is the female which usually exerts a choice'.[49] With males displaying and females choosing, the male is the 'to-be-looked-at-ness', while the female is the discriminating observer. Ruskin's list of gender qualities in 'Of Queens' Gardens' (1865) links the man with fighting and reasoning, the woman with sociability and morality: 'She must be enduringly, incorruptibly good; instinctively, infallibly wise – wise, not for self-development, but for self-renunciation: wise, not that she may set herself above her husband, but that she may never fail from his side'.[50] John Stuart Mill assessed the respective contributions of his own thinking and that of Harriet Taylor, his long-time friend and wife from 1851 to her death in 1858. In his writings on political economy, he explained that 'what was abstract and purely scientific was generally mine; the properly human element came from her'. *The Subjection of Women* (1869) would have been far more abstract in its defence of women, he

explained, were it not for her 'rare knowledge of human nature and comprehension of moral and social influences'.[51] In that essay Mill argued that the virtues of 'gentleness, generosity, and self-abnegation', so central to the chivalric ideal, are a product of the unique moral influence of women. Although he believed that society required a new morality based on a public code of justice rather than a personal code of honour, those admirable virtues inherent in the chivalrous ideal itself represent 'the acme of the influence of women's sentiments on the moral cultivation of mankind'.[52] In a recent study of Victorian sexual science, Cynthia Eagle Russett summarized the Victorian gender psychology of George Romanes, for whom 'woman excelled in affection, sympathy, devotion, self-denial, piety, and morality'.[53] This list catalogues the themes of a majority of nineteenth-century paintings and novels about men and women, which tended not to centre on intellect, reason, or genius.

Similar moralizing appeared in France, although its religious source was Catholic rather than, as in England, Evangelical Protestant. Positivists objected to the hold that Catholicism had on the moral instruction of women but agreed that *la femme au foyer* should regulate morality in the home. In 1852 Auguste Comte called on the moral authority of women to facilitate the transition from theological and metaphysical backwardness to a future Positivist society.[54] From reactionaries and monarchists to anti-clericals and republicans, from early in the century to the end, French moralists agreed that woman as nurturing mother was 'the potential redemptress of mankind', the source of children's 'notions of goodness, morality, and religion'.[55] In 1903 a French priest summarized the distinctive qualities of the sexes: man excels in 'reason, reflection, wisdom, majesty, strength, energy, resolution, authority'. Such qualities, however, were cultivated independently of a beloved. Woman's qualities, on the other hand, emphasized her capacity for relatedness: 'delicacy, sensibility, grace, sweetness, goodness, tenderness, discreet attention, devotion, enthusiasm, communicative warmth'.[56] The priest's list of woman's qualities inventories the qualities that made love work.

Some Victorian heroines, of course, were morally compromised. John Kucich documents how 'Victorian fiction thrives on the figure of the woman as deceiver, giving it such monstrous forms as Thackeray's Becky Sharpe, Trollope's Lizzie Eustace, Collins's Lydia Gwilt, Braddon's Lady Audley, and Eliot's Rosamond Vincy'. But the vast majority of Victorian heroines are more honest than men in loving and certainly more faithful, and they evince a stronger commitment to love. Heroines sometimes lie to a man to conceal their love before he makes clear his own. In Trollope's *Framley Parsonage* (1861), Lucy Robarts denies her love for Lord Lufton in order not to seem 'scheming' or 'artful'. But such dishonesty is neces-

sitated by her passive role in courtship and conforms to the ruling gender role that required a woman's modesty not only in expressing her feelings but even in acknowledging them to herself. As Kucich concedes, Lucy's falsehood 'paradoxically defines her moral strength' and in the end inspires her husband's admiration.[57]

Victorian gender theorizing was indeed the product of what Mary Poovey calls the 'ideological work of gender'.[58] In chapters on the medical treatment of women and the Parliamentary debate on the 1857 Matrimonial Causes Act in England, she shows how morality, even as it bore on women's issues, was socially constructed by primarily male thinkers to address current (primarily male) needs, anxieties, and fantasies, and at the same time to prevent women from taking charge of their economic, legal, and political rights. The physiological basis for much of that theorizing about woman's 'innate' moral sense was woman's bearing and nursing of children, which demanded far more intimate physical relatedness, caring, and selflessness than anything biologically destined for man. Such a claim that bases woman's morality on reproductive biology, however, contradicts my challenge to the argument that woman is to man as nature is to culture. Women's natural biological instinct to relate to children was no doubt a foundation for their subsequent treatment of men, but in that latter capacity there are few traces of anything instinctual. Jane's moralizing to Rochester is not based on instinct, on reproductive biology, or on the experience of motherhood, but on reasoned moral arguments. The moral resolve of loving women was interpreted by male and female artists and writers alike as primarily in the service of culture, not nature, because women in love repeatedly made moral decisions in defiance of natural impulse.

For artists looking to express images of love, the private realm of woman's moral action was preferred to the public realm of man's moral action. A man's moral decision in the public sphere was only remotely related to morality in the private sphere of love, and it was not typically the motif for paintings about male–female relations. A male employer pondering whether to agree to the demands of his striking workers (e.g. John Thornton in Gaskell's *North and South*)[59] did not make as compelling a subject as did a woman's eyes straining with moral anguish about whether to continue giving herself to a fancy man, to let a lover risk his life for religious faith, to take a gambling stake from a seducer, or to accept a proposal of marriage from someone she hardly knew.

Victorian art abounds with celebrations of women's moral superiority and with implied moral critiques of the way men gazed at women. The Pre-Raphaelite theoretician F. G. Stephens explicitly identified the PRB's use of phrenology to 'assist the moral purposes of the Arts'.[60] The PRB

painter Holman Hunt was influenced by the physiognomist Sir Charles Bell, who emphasized the importance of capturing mixed emotions evident during moral conflict.[61] Hunt's *The Awakening Conscience* (illus. 85) was an application of Bell's theory to a conflicted woman 'awakening' to the possibility of a moral existence. Ford Madox Brown was influenced by Johann Lavater, the founder of physiognomy, who codified how moving facial muscles signified moral character. In *The Last of England* (1852–5; Birmingham Museum and Art Gallery), Brown rendered the facial structure of the wife with greater 'amativeness' than her husband. These morally inspired artists repeatedly gave women facial indications of 'amativeness', implying their more resolute commitment to love.[62]

Jean-Léon Gérôme critiques gazing men in *Phryne Before the Areopagus* (illus. 4), which shows an ancient tribunal assembled to judge a mythical beauty whose crime was to bathe naked in public. He depicts the moment when her lawyer whisks away her robe to support his defence that no one so beautiful could possibly be guilty of impiety. Some male judges in her tribunal react negatively with paralysis, anxiety, and disbelief, while others react positively with wonder, surprise, and adoration; but collectively they debase her with their judgemental gazing. Like many other Gérôme nudes, the painting indulges the pleasure men take in looking at a naked woman, but it also questions the morality of such crude voyeurism. Gérôme's judgement of naked Phryne, who hides her eyes in shame before a gallery of older men huffing and puffing in their red robes, belongs with his even harder-hitting assaults on men judging women being auctioned as concubines. *A Roman Slave Market* (illus. 5) shows the mean faces of slave traders gazing crudely at and bidding for a humiliated naked woman posed from behind with her bent arm over her eyes, while at her side an auctioneer hawks her value as a concubine. Gérôme's men indeed own the gaze, but one that is devoid of moral worth.

Novelists also critiqued the male gaze. In *Far From the Madding Crowd* (1874) Hardy describes the annoying effect of the male gaze on country girls, such as Bathsheba when she becomes aware that Gabriel has been watching her. 'Rays of male vision seem to have a tickling effect upon virgin faces in rural districts; she brushed hers with her hand, as if Gabriel had been irritating its pink surface by actual touch.'[63] The intrusive male gaze not only irritated the surface of women's skin, it also irritated their feelings and moral sense.

My argument is not, however, that women were in any absolute sense morally superior to men. Women were not empowered to affect directly the morality of slavery, empire, capitalism, religious toleration, or electoral laws, not even the morality of laws regulating marriage and divorce. It is therefore impossible to generalize meaningfully about male versus

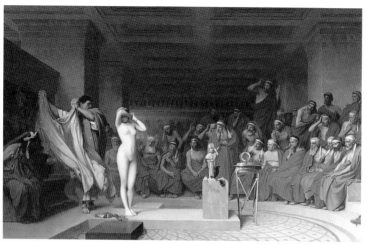

4 Jean-Léon Gérôme, *Phryne Before the Areopagus*, 1868, oil on canvas. Kunsthalle, Hamburg.

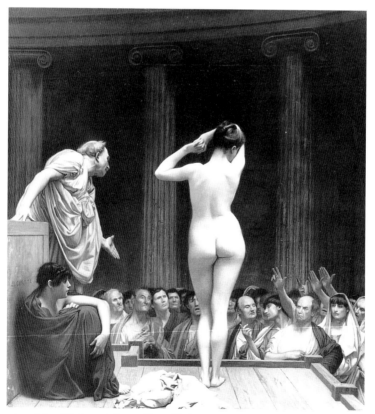

5 Jean-Léon Gérôme, *A Roman Slave Market*, c. 1884, oil on canvas. Walters Art Gallery, Baltimore.

female morality, because many aspects of life cried out for tough moral decisions that only men were privileged to make. But Victorian men and women both made moral decisions in the limited sphere of loving, and there women showed the firmer commitment to making love succeed by doing what was right with respect to others involved and to their beloved. That stronger commitment attracted novelists, and especially artists, who featured women in their compositions because at the most decisive moments of a courtship women were in fact the centre of interest.

The third explanation for the predominance of the proposal composition has to do with the love life of male artists. Among those I discuss, Millais, Rossetti, Hunt, Burne-Jones, Tissot, Renoir, Manet, Gauguin, and Toulouse-Lautrec were in love with, or at least had sex with, models who played crucial roles in their life and art. These artists' fascination with women was intensified by the need to recreate love, or at least desire, in the eyes of models. In 'The Painter of Modern Life' (1863) Baudelaire elaborated on the intensity of artists' desire for women and fascination with their glance:

The being who, for the majority of men, is the source of the liveliest and even – be it said to the shame of philosophic pleasures – of the most lasting delights; the being towards whom, or on behalf of whom, all their efforts are directed; that being as terrible and incommunicable as the Deity . . . that being . . . for whom, and through whom, fortunes are made and unmade; for whom, but above all *through whom*, artists and poets create their most exquisite jewels . . . is far more than just the female of Man. Rather she is a divinity, a star, which presides at all the conceptions of the brain of man; a glittering conglomeration of all the graces of Nature, condensed into a single being; the object of the keenest admiration and curiosity that the picture of life can offer its contemplator. She is a kind of idol, stupid perhaps, but dazzling and bewitching, who holds wills and destinies suspended in her glance.[64]

Baudelaire surveys many of the artists' thoughts and feelings about female models: the Pre-Raphaelites' absorption with their mystery, Degas's respect for their infinite variety, Gauguin's captivation by their incommunicability, Tissot's fascination with their jewelry and clothing, Leighton's deification of their beauty, Burne-Jones's respect for their erotic power, and Manet's preoccupation with their arresting glance. For Baudelaire such women are indeed objectified, but they are also divinities who 'preside' over the artist and are therefore subjects 'through whom' creative processes are generated.

Although male artists looked at female models intently, those looks were fundamentally different from gazes, as I have defined the term, because they were not ultimately sexual. Sexual desire may have originally inspired them, but as artists they could not fulfil that desire with sexual

activity. Controlling and sublimating desire is the challenge of art. Sex comes to a simple pleasurable climax, while artistic creation is an ever more complex and open-ended struggle that the artist has with both his model and his materials. For artists the ultimate goal of art was not to possess a female model but to express her in paint or marble, which explains the abiding appeal as well as the futility of the myth of Pygmalion. The subordinate role of active sexual desire is further documented by the fact that artists not sexually involved with models, such as Degas, Leighton, Watts, Etty, and Waterhouse, also highlighted women's expressions.

Although artists' personal relationships with models help explain why they privileged the faces of women compositionally, my argument is based more on the ubiquity and uniformity of the evidence, not the individuality of personal circumstance. These paintings show what was widely felt by artists who emphasized the faces of women regardless of their own sex, class, nationality, stylistic intention, or personal love life. Thus, the prominence of women is evident whether the artist was a successful academic painter or a rebellious outsider, an adoring husband or a lonely bachelor, an upwardly mobile worker or a *déclassé* aristocrat, a womanizing Parisian or a syphilitic colonial.

Female artists avoided representing emotionally charged relations between the sexes, but when they did show a man and a woman together, their compositions also highlighted the expressions of the woman. Among the 941 works in the *catalogue raisonné* for Mary Cassatt, only four show a man and a woman relating to each other.[65] Berthe Morisot painted hundreds of women, usually shown alone or with another woman or a child. Of the 47 works by women reproduced in Deborah Cherry's study of Victorian women artists, only seven show a significant relationship between a man and a woman, and in only one of these does the woman look directly at a man.[66] Among the 54 images reproduced in Pamela Gerrish Nunn's *Victorian Women Artists*, only four feature an amorously significant relationship between a man and a woman.[67] Female novelists were less reluctant to tackle dynamic love stories, but when they did they suffered anxiety over the self-exposure. Some found comfort in the story of Lady Godiva, who exposed herself naked but was not seen by anyone except Peeping Tom, who, as the story goes, was struck blind in punishment.[68]

My argument is based on images of a man and a woman shown in the same painting, although some of the nudes in chapter Four are an exception. That argument does not apply to individual portraits in which artists captured an equal amount of detail and character in their male and female subjects.[69] But when artists positioned a man and a woman amorously, they consistently gave the eyes of the woman a commanding prominence.

The pattern I am tracing is not, of course, unvarying. In a few paintings men are more frontal. In most of these, however, the man either has feminine features, is projected into what was more typically a woman's role with greater emotional stress and moral conflict, or is weakened as a man and therefore rendered as sick, wounded, mesmerized, seduced, exhausted, evil, or unable to marry. In one, he is disguised as a woman. Artists also produced a few healthy and happy frontal men, but in such images artists did not generally accord to men the same degree of detail as they did to the far more typically frontal women. Artists did depict reciprocal gazes, but these were generally staged portraits of dewy-eyed fusion with both lovers in profile and lacked the tension necessary for a dynamic image. Not all the images I discuss are of fulfilling or mature love, but all reveal some aspect of male–female relations.

To provide the thoughts and words behind the eyes and expressions shown in art, I have drawn on novels. My deference to their narrative structure means that some interpretations of them will extend beyond the precise thematic focus of each chapter. My organizational framework is determined by the paintings, which I discuss primarily one after the other, grouped according to their most apparent theme.

My interpretation rests on the assumption that novels and paintings reveal some aspects of the world of their creators. Of course writers and painters simplified, censored, disguised, embellished, and idealized their experience of a world that included maddening repetition and disappointing banality, but their commitment was ultimately to interpret their own lives. The Realist and Naturalist novelists were formally committed to historical accuracy. Members of the PRB were influenced by phrenology and physiognomy that called for the rejection of classical models that idealized humans in favour of the accurate depiction of real individuals with respect to bodily, gestural, and facial detail. The Impressionists made a point of going out of the studio to capture contemporary life.

My use of art and literature to document historical actuality will be questionable to scholars who focus on the evidentiary unreliability of paintings and novels because of their creators' unexamined presuppositions or even political, class, and gender biases. I note those presuppositions and biases occasionally but do not systematically pursue this line of interrogation. For the more sceptical scholars my sources will reveal little about actual lives beyond the picture frame or the covers of a book. For those who believe that these sources offer insight into past experience, my study will say more. I find it inconceivable that Millais was not showing us the heroism of present-day Victorian women with his images of women rescuing men in danger, that Manet was not showing us the world he loved that was slipping away as he depicted it through the eyes of his barmaid,

that Gauguin was not expressing his vision of the childhood of humanity in Tahitian women whom he thought would enable him to reassess the value of Christian sexual morality, or that Charlotte Brontë was not sharing her intuition of a love that she hoped might be possible in a world with men like her father and brother. However much biased by personal concerns, these artistic works remain invaluable sources solidly fixed at the centre of our understanding of the Victorian domestic ideal, the Parisian demi-monde, primitive society, and gothic romance. They are imaginative recreations of the actual world of artists and writers, crafted with consummate skill at the high point of careers in works of abiding artistic power.

There are many examples of special attention accorded to the eyes of women by earlier painters, in particular Rembrandt, Vermeer, Titian, Fragonard, and Boucher. Numerous examples can also be found in the art of other European countries and America. I concentrate on the art of England and France in the period 1840–1900 because during it narrative painting of courtship themes reached a high point, proposal compositions were especially conspicuous, and much scholarship concerning the gaze is based on this art. Different subjects and styles prevailed in these two countries, but whether the subject was an antique goddess, a medieval maiden, or a contemporary picnicker, and whether the style was neo-classical, Pre-Raphaelite, or Impressionist, the faces and eyes of women as compared with those of men were similarly more prominent.[70] Although English genre art was more explicitly moralistic, the Impressionists, in spite of their de-emphasis on visual narrative and didacticism, did render moments from love stories that, though subtle and ambiguous, implied unmistakable moral valorization.

A final question remains. Can women have maintained moral superiority in a world so tilted in favour of male political governance, military might, economic ownership, social privilege, and cultural hegemony? This study will show that women's moral superiority in the private realm of personal love was not only possible but necessary for the restoration of some balance against male privilege in so many areas. The culture of love produced by men in this period was thus ultimately confessional and celebratory. Male writers and artists poured out their hearts to confess their own failures and disappointments in love and to celebrate their esteem for the women to whom they looked for adventurous courtship, abiding friendship, spiritual enrichment, physical comfort, arousing sex, moral guidance, and occasionally even artistic and intellectual exchange. Those needs were of course extremely difficult for any single woman to satisfy, but they inspired plots for some of the century's most powerful novels and motifs for some of its most unforgettable paintings.

1 Meeting

The Victorian courting ground was cramped and perilous. Inefficient transportation reduced its area, while social conventions restricted the number of places couples could meet. They found secret trysting spots to avoid the eyes of meddlesome chaperones and town gossips, while inwardly they regulated themselves by religious strictures, family obligations, and a restrictive sexual morality. Under such circumstances the first meeting played a decisive role. Whether a sudden thunderbolt or a subtle stirring, it was an especially revealing moment.

In novels these first meetings followed the introduction of characters, which authors usually accomplished with a description of their external appearance, most importantly, their face and eyes. In *Madame Bovary*, as with most accounts from that time, we are told less about the man's eyes than the woman's. Charles Bovary had simply a 'timid look', while Emma's eyes 'were brown, but seemed black under the long eyelashes; and she had an open gaze that met yours with fearless candour'. Flaubert probes the depths of Emma's eyes with their variable colouring: 'Seen from so close, her eyes appeared larger than life, especially when she opened and shut her eyelids several times on awakening: black when looked at in shadow, dark blue in bright light, they seemed to contain layer upon layer of colour, thicker and cloudier beneath, lighter and more transparent toward the lustrous surface.'[1] The depth, variability, and impenetrability of her eyes reflect the mysterious interior of her passion and portend the difficulties that will plague Charles throughout his marriage to a woman who has layers of feeling he will never be able to understand and shifting desires he will never be able to satisfy.

In *Les Misérables* (1863) Victor Hugo gives similar scant description of the man's eyes as compared with the woman's. Marius has 'small but far seeing eyes', while his beloved Cosette has deep azure eyes that become the focus as Hugo's social drama turns into a love story, beginning with Marius's first sighting of her. Unlike artists, novelists could take a reader inside the mind of a lover as feelings arose through sightings. So we learn that when Cosette sat on a bench in the Luxembourg Garden, her eyes

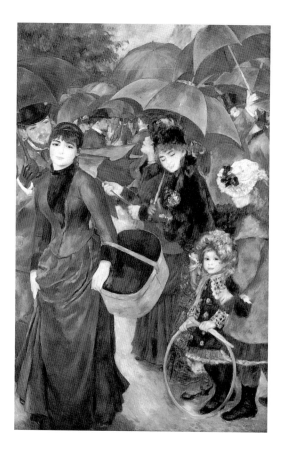

6 Pierre Renoir, *The Umbrellas*, 1883, oil on canvas. National Gallery, London.

troubled Marius by the way they looked about 'with a kind of unheeding assurance'.[2] Six months later he was struck by her more mature beauty, slowly revealed to centre in her eyes. Eventually she initiated an exchange by looking 'steadily at him with a soft pensive glance that caused him to tremble from head to foot'. He was in ecstasy, his head on fire. 'A single look had done it', Hugo summarizes, 'a woman's gaze is like a mechanical contrivance of a kind that seems harmless but in fact is deadly' (604–13).

Novelists could explore the thoughts of a woman whether she looked at her beloved with a potent gaze like Cosette's or looked away to think and choose. Artists showed a predilection to pose such women in proposal compositions, facing front and looking away from the man to reflect on whatever perils or adventures his proposal might bring.

Images of a man about to meet a woman are rare. In *The Umbrellas* (illus. 6) Renoir hints at such an imminent meeting between the man holding an umbrella and the woman holding a basket, although the two might well pass each other without meeting. The woman's modest dress and shopping-basket make clear that she is not a prostitute, so she can walk the

streets unaccompanied and not be the brunt of coarse comments, but she is out there alone and is therefore approachable. Amid the impersonal public commotion is a whisper of possible intimacy suggested by the proximity of the man's face. His position just behind the woman's ear suggests that he may be about to speak to her, or at least that she is available for a first exchange.

The woman's face betrays a subtle tension that is underscored by her clutching at her dress. Her hair is up and not covered by a hat, so there is nothing about her face to block her hearing or vision. Her eyes seem removed from her immediate surroundings: their mysterious searching look contrasts with the carefree, wide-eyed glance of the little girl and the protective downcast glance of her mother. The main woman's vision is paramount: her eyes are painted with greater care and more detail than the man's, they are more open and illuminated, they are closer to the centre and to the picture plane, and they are positioned within the composition more frontally, directed out toward the surrounding activity (illus. 7). Their slight irregularity, which Renoir mentioned as an important feature of his art, makes them especially captivating.[3] Her elegant, dark eyebrows and full lips underscore a strength of character, as she looks toward the viewer with an intriguing mixture of expectation, sadness, vulnerability, and anxiety.

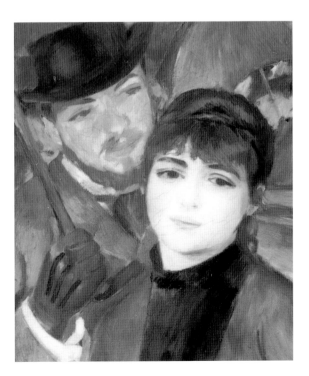

7 Detail of illus. 6.

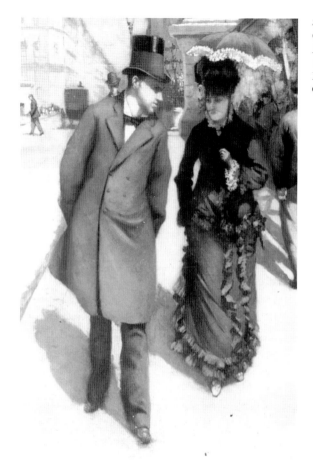

8 A detail from
Gustave Caillebotte,
Pont de l'Europe,
1876, oil on canvas.
Musée du Petit Palais,
Geneva.

Renoir's man represents the *flâneur*, a character type who appeared on the streets of Paris in the 1830s and quickly became a model for artists.[4] In Gustave Caillebotte's *Pont de l'Europe* (illus. 8) the strolling man just passing a woman and turning toward her as if he is about to introduce himself is one example of the intrusive *flâneur* who is able to go wherever he wants, gaze at whomever he wants, even a strange woman on the street. His eyes focus ambiguously away from the woman he seems to be preparing to address. Her mouth is set, and her eyes seem slightly alarmed, as if she were preparing for the uncertainties of being accosted on the street. She averts her glance behind his back, perhaps to avoid engaging his look with a compromising *œillade*. In this proposal composition, for all the assertiveness of the man's posture and gaze, Caillebotte features the woman's intriguing face with the more frontal view. The man's gesture, made without interrupting his passing stride, suggests that whatever becomes of this relationship, it will be for him a passing fancy.[5]

In an essay of 1863, Baudelaire celebrated the *flâneur*'s 'ecstatic gaze'. The author of *The Flowers of Evil* (1857), who shocked readers with poems mixing beneficence and crime, did not trouble over the morality of male–female relations. His *flâneur* is a well-travelled man of the world, who 'lives very little, if at all, in the world of morals and politics'. He is a passionate spectator with a deep and joyful curiosity, but he cannot love a single woman. 'To be away from home and yet to feel oneself everywhere at home, to see the world, to be at the centre of the world, and yet to remain hidden from the world – such are a few of the slightest pleasures of those independent, passionate, impartial natures. . . . The spectator is a prince who everywhere rejoices in his incognito.'[6]

While Baudelaire emphasizes the *flâneur*'s aesthetic significance, recent critics emphasize his political and moral significance. Walter Benjamin takes Baudelaire's sketch of the *flâneur* as a summary of the evils of 'high capitalism' and so focuses on his restless movement, intoxication with commodities, eye for crime, lack of roots, and incognito life on the outside.[7] In 'Modernity and the Spaces of Femininity', Griselda Pollock gives that reading a feminist twist in her widely cited essay that deplores the limited spaces allotted to women in nineteenth-century life and art. She contends that women are confined spatially and visually in contrast to the expansive realm of men, which she elaborates after Baudelaire's idealization of the *flâneur* who 'symbolizes the privilege or freedom to move about public arenas of the city observing but never interacting'.[8] She cites further Janet Wolff's article that protests the 'invisibility' of the female *flâneuse* in modern life and literature.[9] Wolff tags another distinctly modern type – the stranger: 'These heroes of modernity [the *flâneur* and the stranger] thus share the possibility and the prospect of lone travel, of voluntary up-rooting, of anonymous arrival at a new place. They are, of course, all men.'[10] The implication of this description of male privilege is that women ought to have been able to do the same. But lone travel, uprooting, and anonymity are failures in human relatedness, deficient characteristics for men or women.

Many of the places to which these *flâneurs* and strangers go to gaze, as described by Baudelaire and as depicted by the Impressionists, are public places of money, power, anonymity, or commercial sex – streets, bars, race-tracks, cafés, music-halls, and brothels. The men who frequent such places are typically lonely, unsettled, anonymous strangers. Pollock concedes as much: 'The public domain became also a realm of freedom and irresponsibility if not immorality'.[11] Freedom *from* constraints may be irresponsible, but the more humanizing freedom *to* achieve or accomplish is incompatible with irresponsibility and especially with immorality. The men Pollock tracks strolling about Paris may have been free from the con-

straints or demands of human interaction, but they were not free to interact, especially not free to love.

Pollock argues further that the *flâneur*'s incognito spared him from being seen in contrast to the more visible and hence more vulnerable woman. But hiding and concealment evade what it means to be in a world with others, especially with a beloved. Willingness to be open and be seen as vulnerable is a distinctly human characteristic. Jean-Paul Sartre, who centred his philosophy of human relations on 'the look', argued that a human being is also a *being-for-others*, and that seeing the other involves being seen by the other.[12] In a Sartrean sense, women who love visibly and openly, without the *flâneur*'s incognito, are more truthful. Pollock's claim that women 'did not have the right to look, to stare, scrutinize or watch' would have been correct if she had added another word – *men*.[13] But there was more to look at than men, as the women in nineteenth-century art show. Their field of vision was indeed limited by gender roles, but their looking was not so exclusively focused on what stimulates sexual desire as it was for men.

A number of feminist scholars, many of them French, critique vision itself as masculine.[14] They are determined to avoid a stultifying 'ocularcentrism' that they believe has diminished the fullness of human experience by privileging vision at the expense of the other senses, and they link seeing itself with masculine domination. Pollock begins her essay with an epigraph from the most outspoken of these French feminists, Luce Irigaray: 'Investment in the look is not as privileged in women as in men. More than other senses, the eye objectifies and masters. It sets at a distance, and maintains a distance. In our culture the predominance of the look over smell, taste, touch and hearing has brought about an impoverishment of bodily relations'.[15] For Irigaray and Pollock the modifier in 'masculine gaze' is redundant.

This association of vision and masculinity has fueled widespread criticism of patriarchal domination in the studio, in art-history scholarship, and in paintings. Irigaray elaborates this sexual dichotomy: 'The predominance of the visual, and of the discrimination and individualization of form, is particularly foreign to female eroticism. Woman takes pleasure more from touching than from looking, and her entry into a dominant scopic economy signifies . . . her consignment to passivity: she is to be the beautiful object of contemplation'.[16] Criticism of the dominion of the patriarchal gaze derives from such sexually dichotomous, reductive theorizing.

Men may become more sexually aroused by looking at women than women do by looking at men, but such erotic gazing does not encompass all vision. Women get more pleasure from visual attention to other things.

Irigaray grounds her argument on the Freudian theory that sexual difference is first discovered and then verified by the sight of the genitals of the opposite sex, which reveals to a female that 'her sexual organ represents *the horror of nothing to see*'.[17] Belief in the objectification of women in art, and especially in the female nude, is thus supported by the following tenets of radical French feminism: the conflation of gazing and sexual investigation, the grounding of female character in the non-appearance of external genitalia, the identification of vision with masculinity, and the critique of vision itself. Such theorizing leads to the paradox that enhancing the role of woman in art depends on looking at less of her.

Irigaray's argument that the invisibility of women's genitalia signifies the horror of their deficiency and weakness conflicts with other feminist arguments that the invisibility of men – their privileged incognito status as *flâneur* – is a source of power. Anthea Callen applies that argument to art: 'Although in Degas's work woman may appear to be the painter's obsession, and man marginal, in fact he is the subject. . . . Man's very invisibility . . . testifies to the overwhelming importance of his presence in it.'[18] Such an argument is irrefutable by counter-evidence and hence empty. By its logic, men dominate whether present or absent, and invisibility signifies both women's weakness and men's power. To cut through such equivocation, I argue simply that presence means abundance and strength, while absence means deficiency and weakness. Being visible and seeing realize human potential, while being invisible or blind diminish it. Women models viewed in the studio as well as women viewed in the finished work create a subjective presence that shapes the gazing men's sense of themselves.

Women's presence in nineteenth-century life, however, was indeed limited in terms of the locales into which they were allowed to venture, as Pollock argues and as Judith R. Walkowitz has confirmed.[19] But such exclusion obscured seeing only in those specific places. Men who travelled more freely in those urban places and about the wider world did not cultivate intimate relationships as easily or perceive their subtleties as clearly as did the women who stayed closer to home. In George Eliot's *The Mill on the Floss* (1860), after Maggie separates from Stephen, he writes to her about the uselessness of travel away from her: 'Perhaps they tell you I have been "travelling". My body has been dragged about somewhere; but *I* have never travelled from the hideous place where you left me'.[20] Although women were not as free to gaze at men as men were free to gaze at them and not as free to go about the wider world, they looked over a broader and more complex terrain of human relationships.

Nineteenth-century artists showed first meetings and subsequent trysts in ways that decentred and devalued the male gaze in proposal composi-

9 A detail from William Midwood, *At the Crafter's Wheel*, 1876, oil on canvas.

tions, whether the man was first meeting a woman on the street, visiting her in a cottage, chatting with her at a dance, looking at her on a swing, accosting her at a spa, introducing himself during a tennis break, trying to meet her after a concert, or appealing to her in a garden. The assertiveness of the male gaze can be tracked from the possible meeting between Renoir's man and woman in *The Umbrellas* through a series of ever more actively 'proposing' men.

William Midwood used a proposal composition to capture the meeting of a couple in *At the Crafter's Wheel* (illus. 9). The man in profile gestures with a finger that accents the intentions he no doubt worked out carefully before his visit. He also leans forward to press his point, while the woman leans back, cocks her head sceptically, and looks away thoughtfully. He wants to hear a *yes*, while she is not sure. Her meditation is the heart of the implied narrative, which centres on her frontal expression. His offer will save her from spinsterhood, hinted at by her proximity to the spinning-wheel.[21] But she remains undecided. In looking across the man's line of vision and his pointing finger, she suggests that her thinking may be at cross-purposes to his pointed intentions. Her emotional reserve indicates that she knows that if she consents she will miss out on the possibilities for the future that lie behind her intriguing eyes.

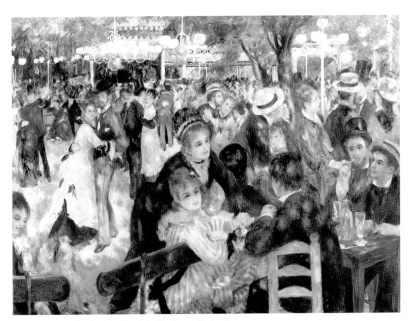

10 Pierre Renoir, *Le Moulin de la Galette*, 1876, oil on canvas.
Musée d'Orsay, Paris.

Renoir depicted several young men meeting women in *Le Moulin de la Galette* (illus. 10). He worked on this pictorial anthology of urban socializing for a year and a half, much of it at the site, an outdoor dance-hall in Montmartre. In this carefully composed image of Parisian merrymaking, the eyes of the two women in the foreground have a commanding presence. The man with his back to the viewer leans on a chair while conversing with these women, one of whom leans toward him intently, while the other looks away in the direction of the viewer. The swirl of activity funnels into her glance, which moves away from the dancers and creates a fleeting interruption, as it engages the viewer directly during her moment of hesitation. The men know what they want. Most likely the young women will be accommodating to some extent, but they are not yet certain. That difference is registered in the eyes. In an article that accompanied the painting's exhibition, a close friend of Renoir explained its purpose, which included showing the eyes of the young women who dominate the foreground. One of them 'is chatting, emphasizing her words with a subtle smile, and her curious glance tries to read the face of the young man speaking with her'.[22] Viewers of this painting are drawn into sharing her flirtatious curiosity.

Compared with what women see, what the men in Impressionist art see is less interesting, because they typically look at women with more consis-

tently erotic intentions. In *The Swing* (illus. 11) Renoir does not show the eyes of the man at all – just his back as he looks at a woman who looks away. Robert Rosenblum notes its debt to Rococo art, 'where attractive young women enjoy the childlike pleasures of swinging while their potential suitors watch'.[23] But unlike the women in the Watteaus and Fragonards to which this comment refers, this young woman does not swing high and kick up her dress and is not enthusiastically given over to her suitor's romantic interests. Her minimal activity is full of subtle resistance. She leans against the swing's rope and away from the determined gesture of the man's right hand. Her left thigh and backside gently stretch the rope away from him, suggesting a mixture of her own self-stimulation, inner tension, and instinct to pull away. She seems lost in reverie, and her partly opened mouth indicates a distracting thought, a hint of evasion. The touch of sadness in her eyes is similar to that of the woman in *The Umbrellas*. She is not looking at the man and is scarcely listening to him.

Considerably more intrusive, if not downright offensive, are the two men standing over a seated woman at the seaside in F. Sydney Muschamp's *Scarborough Spa at Night* (illus. 12). Neither has removed his top-hat, thus

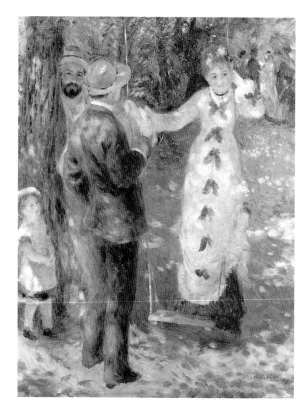

11 Pierre Renoir, *The Swing*, 1876, oil on canvas. Musée d'Orsay, Paris.

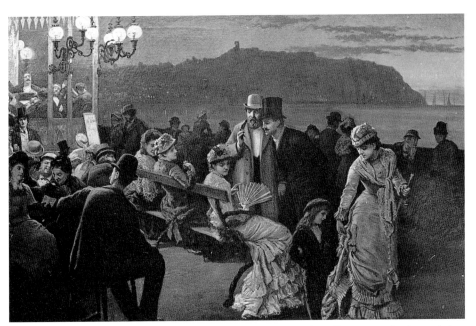

12 F. Sydney Muschamp, *Scarborough Spa at Night*, 1879, oil on canvas. Scarborough Art Gallery.

violating etiquette and indicating their vulgar intentions. They have openly forced her to twist away from their rude gazing. The more aggressive man in profile bends forward and crowds the woman whose fan is spread out like a claw to keep him away. As a reminder of the pervasiveness of unsolicited male gazing, in the right mid-ground another aggressive man in profile leans on his chin and stares at a woman who looks away from him with a forlorn expression, suggesting that she is also annoyed by the pestering.

A single man could trouble two women with a similarly assertive move. The profiled sailor holding the arm of two women on a path through a wheatfield in John Horsley's *Showing a Preference* (illus. 13) has made an impulsive choice of the blue-eyed blonde to his right. He twists around awkwardly to catch her eye while rudely pulling away from his other companion. His face is in shadow from a parasol held by the woman who is determined not to be interrupted by the man's intrusive gaze. The image creates little doubt about his intentions but considerable intrigue about both women's turbulent thoughts, which Horsley dramatizes with their frontal positioning.

The preferred woman is gathering wheat tops and wild flowers in a basket, which she manages to prevent from falling in spite of the man's jarring move. Wheat is a nutritive staple, and in this painting it is unusually

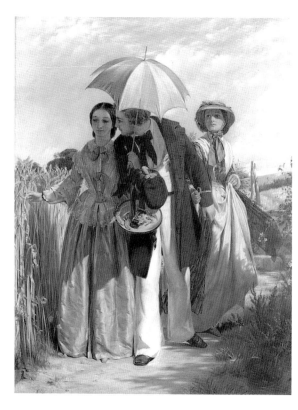

13 John Horsley, *Showing a Preference*, 1860, oil on canvas. Private collection.

14 Detail of illus. 13.

high. The woman stands proud and continues harvesting it, although with little energy. The red poppies growing at her feet, the same colour as the bows on her dress, suggest another aspect of her experience. As a commentator observed in 1860 – 'the very poppies hang their head in shame'.[24] The woman does not return the man's insulting leer but stares wistfully down the path, indignant and ashamed that her presence could create such an insult to another woman and cheapen her own reputation (illus. 14). She stands tall and is outwardly undeterred, but inwardly she is ashamed and slumped like the poppies.

The dark-eyed woman has caught her shawl in a bramble. The sailor abandoned her in her time of need and used her difficulty as an opportunity to snag someone else. She is unsuccessful in trying to pull free, because she is stunned by the man's flirting and cannot bend down to free herself and because her other hand instinctively holds onto his sleeve. She is caught not only by the thorn but by her surprise and conflicted feelings. Horsley renders her wide-eyed innocence before she has been able to react. Her expression and posture express a complexity of feelings equal to those of the other woman and in striking contrast to the mind set of the man with his morally dubious but erotically obvious aim.

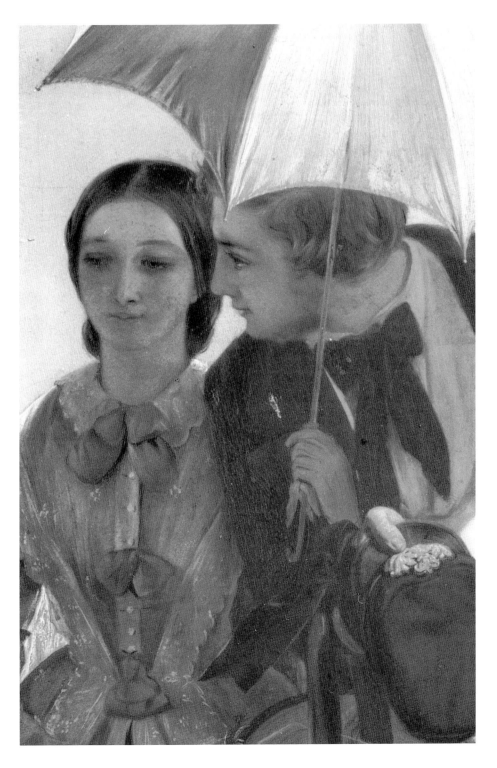

15 James Tissot, *The Captain's Daughter*, 1873, oil on canvas. City Art Gallery, Southampton.

A far different sort of sailor is shown trying to summon the courage to make an advance in Tissot's *The Captain's Daughter* (illus. 15). He is also profiled and looks at the standing woman, who seems beyond his reach. He needs bolstering from the woman's father and from the whiskey, although in actuality he may be reluctant to drink, as indicated by his full glass next to the captain's empty one. The prominently positioned magnifying instruments hint at the different visual as well as emotional capacities of the man and woman. On the table in front of the man is an enormously long telescope, a symbol not only of vision but of a man's wider travel opportunities and perhaps also of this particular man's currently idle phallic capability. The flags of the world displayed in a band around it suggest that the rosy-cheeked young man may have sailed around the world but has not learned his way around the world of love. A telescope makes far away objects appear close-up, but does so within a limited depth of field and in a narrow visual context. Binoculars, in contrast, reveal a broader field of vision and more depth. The man's instrument implies monocular vision, while hers implies binocular vision, with greater depth of field and wider range of vision. His big telescope lies inertly on the table, and he glances at her desirously but cannot act. The woman actively holds her binoculars, although her immediate intentions

are uncertain: she may be about to look through them into the distance or put them down and turn around, even though her eyes show independence and irritation. The man's gaze centres intently on the woman's back, while her look is more open and expresses more determination to search a broader horizon.

A country estate is the setting for a meeting in Edith Hayllar's *A Summer Shower* (illus. 16), where a mixed-pairs tennis foursome has just come inside during a rainstorm. The pair in the foreground make a proposal composition, even though no high romance appears to be at stake during this chance respite. Still, the man is shown with his eyes in shadow and in profile, posed with his face almost out of view, while the woman treats the viewer to a revealing frontal glance. The title is perhaps a comment on the momentary cooling of a budding relationship, although the two seem to be intending to resume play, as indicated by their hold on the rackets. Whatever happens when the shower is over, the choice is hers to make, as Hayllar indicates by choosing to highlight the woman's commanding look.

Two Renoir proposal compositions show men in profile with frontal women. One of the top-hatted men in *Leaving the Conservatoire* (illus. 17) has his one visible eye in shadow, while the other man is blocked from view. The painting focuses on the women's animated responses, which are made visible with a revealing profile of one and a frontal view of the other. The

16 Edith Hayllar, *A Summer Shower*, 1883, oil on board. The Forbes Magazine Collection, New York.

17 Pierre Renoir, *Leaving the Conservatoire*, 1877, oil on canvas. The Barnes Foundation, Merion Station, PA.

frontal woman's expression is a mixture of excitement over the men's attention but also caution, as she looks to her friend to take charge of this potentially threatening solicitation, even though her friend seems scarcely less uncertain how to handle these socially more experienced men. The excitement of the two is accented by their hands: one interlaces her fingers anxiously, while the other rolls up her concert programme.

The most intriguing Renoir proposal composition is *In the Garden* (illus. 18). I include it with other images of first meetings because the man's rapt attention and appealing stare align it with them. It is, as Barbara Ehrlich White explains, 'the last painting in which [Renoir] depicts the love of a modern man for a modern woman in a rural setting'.[25] Renoir may have abandoned such images because they stirred up conflicts about women that were too troubling for him to express in art.

Renoir was deeply conflicted about models. He was fond of them and indebted to them, but insulted them directly. His son recorded that Renoir once said 'My models don't think at all', and later in life 'called them

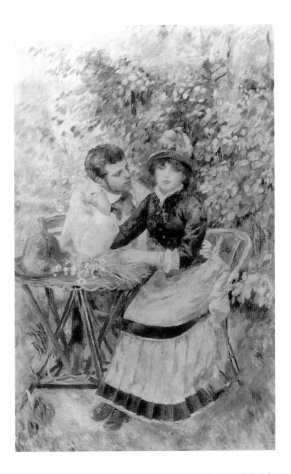

nitwits, fatheads, and geese and would pretend to threaten them with his cane'. Then they would shriek with laughter and joke about the aging artist's weak rheumatic legs.[26] Women professionals and artists also provoked his ire. In a letter of 1888 he insisted that 'I consider that women are monsters who are authors, lawyers and politicians, like George Sand, Madame Adam, and the other bores who are nothing more than five-legged beasts. The woman who is an artist is merely ridiculous.'[27] But he was a close friend of Berthe Morisot, admired her art, and valued her opinion. For all the patriarch's outrages, he was fascinated by women, especially his models, and developed an unforgettable way of expressing it with affection in art.

In the Garden hints at Renoir's ambivalent feelings about women. The peasant woman who posed for it and whose dazzling bright eyes captivate the viewer's attention was his mistress, Aline Charigot, who was pregnant by him when he painted it (illus. 19). He married her in 1890. Although the man is not Renoir, I would speculate that Renoir projected into the

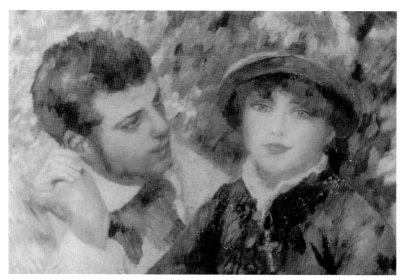

19 Detail of illus. 18.

man's rapt expression his own feelings about Aline and the child she is carrying. Her commanding presence and seeming intelligence belie Renoir's critical private remarks about formally educated and artistically accomplished women. The man gazes intently at Aline and holds her hand imploringly, while she nonchalantly leaves her hand in his and ignores his eyes riveted on her. In other paintings Renoir rendered Aline's eyes dark. In this one her eyes are bright, as if illuminated from within, and accented by a dark ring around the iris that sharpens their piercing look. Aline was not an educated woman, but in this image her penetrating eyes seem to have the power to see through things.

The title of Hardy's novel *A Pair of Blue Eyes* could also serve as a title for Renoir's painting. Hardy's heroine, Elfride Swancourt, is a country girl with moral and intellectual qualities that are also not readily apparent. 'One point in her, however, you did notice: that was her eyes. In them was seen a sublimation of all of her.' They were 'a misty and shady blue, that had no beginning or surface and was looked *into* rather than *at*'.[28] Like her eyes, her mind was difficult to trace to a beginning, because her education was so unorthodox. Men who looked at her eyes found it difficult to focus on their surface and rather were drawn into their mysterious depth, although these men did not want to see the humanity that enriched their brilliance.

Similar to the art of this time, the novel reveals less about the eyes of the man. Elfride's suitor, Stephen Smith, had 'bright sparkling blue-gray eyes'. Hardy scarcely mentions them again. Elfride shows surprising

48

artistic talent when first singing for Stephen and then demonstrates unexpected reasoning skill when they play chess and she lets him win. His emotional immaturity becomes evident when he tries to explain why he loves her, and says 'Perhaps for your eyes'. She presses him. 'What of them? – now, don't vex me by a light answer. What of my eyes?' When she demands a more satisfactory explanation, he responds that her eyes are 'indifferently good'. She cannot believe that he is serious and continues to question him. 'Come, Stephen, I won't have that. What did you love me for?' She wants something less superficial. 'Now – what – did – you – love – me – for?' Baffled by what she wants to hear, he clumsily lists her other features – 'your neck and hair', 'your hands and arms', even 'your feet that . . . played about under your dress like little mice'. Offended, she replies, 'I don't care for your love, if it made a mere flat picture of me in that way'. When he continues to resist, she gives in. 'I'll not ask you ever . . . to say out of the deep reality of your heart what you loved me for'. But his reality is not so deep. In frustration Stephen sums up his superficiality: 'It comes to this sole simple thing: that at one time I had never seen you, and I didn't love you; that then I saw you, and I did love you. Is that enough?' She replies finally that she will have to 'make it do' (111–12). By the end of their romance we understand that Elfride is more creative than Stephen, has better understanding of classical languages, is a more gifted writer as well as a better chess-player, and loves more courageously and profoundly. He is dazzled by her blue eyes, while she looks through them to see more meaning in love and life.

Their responses to one another's dark secrets highlight her greater maturity. Their disclosures of those secrets occur in a cemetery, where she is reluctant to sit on the tomb that Stephen picks but agrees because she is ashamed to explain why. There he confesses that his father is a lowly mason, and his mother a dairy-woman. Elfride is undeterred by this confession and reassures him that she loves him all the same. But when she tells him her secret – that another man, whom she did not love, once kissed her on the very tomb on which they are sitting – Stephen becomes inconsolably depressed. In addition to being more forgiving, she also has more courage to love, because she risks her reputation by choosing to run off and marry him, but when there is trouble getting a marriage licence his courage fails and he makes her return home alone.

Her superior moral courage to that of a more formally educated, but less accomplished, man is even more evident in her next love. Once again Hardy introduces the man with a brief account of his eyes. Harry Knight's eyes, 'though keen, permeated rather than penetrated'. They had lost their 'boy-time brightness by a dozen years of hard reading' (182). Keen, permeating eyes obsess rather than perceive clearly, and Knight will

indeed become obsessed while trying to dig out the truth about Elfride's first kiss. Knight has learned to see the world through books that have drained him of boyish brightness more than they have filled him with adult insight. His knowledge of men and women, he confesses, 'is a mass of generalities. I plod along, and occasionally lift my eyes and skim the weltering surface of mankind' (185).

Knight first reacts to Elfride's intelligence in a review of a novelette she published under a male pseudonym. He guesses the author's correct sex and condescendingly admits that on 'matters of domestic experience' and 'the natural touches which make people real . . . she is occasionally felicitous' (202). When they meet, he reveals that he is unable to write a novel because he is capable only of short reviews. With Knight as with Stephen, Elfride is more productive and more perceptive, as Hardy explains, 'Her eyes seemed to look at you, and past you, as you were then, into your future; and past your future into your eternity' (215).

Knight is a more honest lover than Stephen. He prefers dark hair to blond, and hazel eyes to blue, which he tells her candidly. Compared with Stephen, he is less superficial, as Hardy explains: 'Stephen fell in love with Elfride by looking at her: Knight by ceasing to do so.' But Knight's lack of experience and uncontrollable jealousy drive him into relentless interrogations about her experience with men. At one point, to relieve himself from the anguish triggered by her account of a sexless and relatively innocent former love, he playfully lies to her and says that he prefers blue eyes to hazel. His conciliatory white lie contrasts with the ever more serious real lies that Elfride is forced to tell in order to fend off his obsessive curiosity. He confesses that he wanted an innocent woman, which means a woman with no experience, one who has not seen anything, ideally one who has not even been seen. He wanted, he confesses, 'an unseen flower' (355). Elfride has seen too much for this Victorian literatus, and their love ends tragically with separation and her early death.

While some novels painted pictures with words, some paintings depicted moments from literary sources. As the subject for *King Cophetua and the Beggar Maid* (illus. 20) Edward Burne-Jones took a scene from a Tennyson poem in which a medieval king searches for a virginal maiden to be his wife. This thirteen-foot-high proposal composition shows Burne-Jones himself as the King in profile, humbly holding his crown in his lap, looking up idolatrously at his beloved maiden, while she does not look down at him but stares frontally with wide-open hypnotic eyes that are unresponsive even to his royal courtship. Burne-Jones intended to moralize about love's triumph over royal power, but he also suggested that a woman's eyes have an ocular power of their own that can overcome even the most immense differences in social status. The painting analogizes the

20 Edward Burne-Jones, *King Cophetua and the Beggar Maid*, 1884, oil on canvas. Tate Gallery, London.

power of the artist over a model with the power of a king over a beggar maid, and implies that in both situations, which typically accord greater power to the male, the female is capable of garnering considerable power, as is evident in this model's piercing eyes.

Henry Holiday's *Dante and Beatrice* (illus. 21) shows a second meeting in a story that began with the most written about love-at-first-sight in history. In *La vita nuova* (*c.* 1293) Dante recorded the beginning of his love for Beatrice, when they were both eight years old. On first seeing her, he recalled, 'the vital spirit, which dwells in the inmost depths of the heart, began to tremble so violently that I felt the vibration alarmingly in all my pulses'. That passion ultimately inspired *The Divine Comedy*, in which he journeys through Hell and Purgatory until he again meets Beatrice, who leads him through Paradise.

21 Henry Holiday, *Dante and Beatrice*, 1884, oil on canvas. Walker Art Gallery, Liverpool.

The moment depicted in Holiday's painting is nine years after Dante's first sighting, when he sees Beatrice on the street 'dressed in purest white, walking between two other women of distinguished bearing, both older than herself. As they walked down the street she turned her eyes towards me where I stood in fear and trembling, and with her ineffable courtesy . . . greeted me. . . . As this was the first time she had even spoken to me, I was filled with such joy that, my senses reeling, I had to withdraw.'[29] Two features of Holiday's composition, the moment in the story and its point of view, provide more evidence of the way artists of this time highlighted the expression and vision of women.

The moment shown is not when Beatrice looks at Dante, but before, just after her two companions have seen him. Dante is shown in fear and trembling, standing with hand on heart before he is filled with joy after she returns his gaze.[30] Beatrice's look is self-absorbed, unmindful of the impassioned admirer at her side. Holiday's choice of this moment cannot have been based on its emotional importance, because compared with what is immediately to follow, when she speaks to Dante and his senses reel, it is trivial.

The point of view gave Holiday a way to narrate pictorially an extended moment of three women looking at the poet. The woman to Beatrice's left was the first to see him. Her interest has settled into a concerted stare, as she has had time to interpret what the imminent meeting might bring. The other companion has just seen Dante and must lean back to continue

viewing him as they pass, because Beatrice's head is in her way. Her strain-ing posture indicates that she understands Dante's interest and senses what might happen next. That they notice Dante before Beatrice sees him accents Beatrice's anticipated sighting and its effect on the great poet, which viewers are left to imagine. Together the women's eyes create a dra-matic sequence of visual force-lines to balance the intensely focused gaze of Dante in profile.

These two compositional features that stress the female look are all the more remarkable when considered in light of the historical consequences of this imminent visual exchange, which inspired Dante to embark on his great poetic celebration of love. Holiday chose to show frontally not one of the most important and inspired male gazes in the history of literature but the three women just before Beatrice's uninspired and (for her) in-consequential glance at an admirer. She never loved Dante. She died at the age of 24 without ever having read a single line of his poetry. Holiday accents the pointedness of the male gaze by showing it in profile, and he marginalizes its value by centring the painting on its object, which, given the historical context, was highly unworthy of it.

This image was one of the most frequently reproduced of its time, in part because of the quasi-visibility of two of the women's bodies under-neath clothing. Holiday centred his composition on the lively frontal expressions of three tantalizing women sashaying past the chaste poet, who is posed at the side and in profile.

For all the privileges of the male gaze, writers and artists were pre-dominantly interested in the eyes and expressions of women who were not entitled to gaze at men with evident erotic interest. The men's motives were more uniform, and their goals more obvious. Hardy's Stephen Smith summed up that pattern of superficiality when he told Elfride 'It comes to this sole simple thing: that at one time I had never seen you, and I didn't love you; that then I saw you, and I did love you.' After such a man made his approach and managed a first meeting, the woman had to decide whether or not to respond. That decision was not only about her desire and his appeal but about right and wrong with respect to her beloved or to a third party. The woman's higher level of vulnerability, ambivalence, and moral conflict supplied the richer interpretive possibilities. Artists were more intrigued with the way the woman's thoughts about those issues reg-istered in her more searching expressions and multi-coloured eyes, and so they focused on her frontal pose as she looked away from the profiled gaze of a man in order to consider the possibilities of courtship beyond a first meeting.

2 Recreation

Images of couples picnicking, boating, touring, dancing, drinking, and theatre-going also feature the eyes of frontal women. Next to them profiled men assume supportive, if not subordinate, roles and are often posed in shadow, sometimes pursuing shady objectives.

Manet's *Le Déjeuner sur l'herbe* (illus. 22) explicitly depicted the uncontroversial recreations of eating, drinking, bathing, and boating, but it implied another morally questionable recreation and created a scandal. The presence of dressed men and the location of the woman's removed clothing indicated that she had undressed right in front of the men. In addition, the three foreground figures were well known to the art world. The man gesturing with his hand is Manet's brother Gustave; the other man is his friend and future brother-in-law, the sculptor Ferdinand Leenhoff. The woman is Manet's well-known model Victorine Meurent. The sexuality of a real woman in the company of real men could not be distanced, as it could if she had been a nameless classical nymph. The painting did not apologize for female sin or praise female chastity, and Victorine exhibited no conventional gesture of modesty, such as a downcast glance or hands covering her breasts or pubis. Indeed, the painting shocked critics precisely because she was staring unabashedly back at them.[1] Thus the most controversial features of the painting had to do with Victorine's vision and visibility.

Victorine was herself a painter, a scandalous model, and mistress of artists. In *Mme Victorine as an Espada* (1862), which in 1863 was hung beside *Déjeuner*, Manet depicted her as a female bull-fighter, wielding a sword and cape. In both paintings her body is posed to the side but with her face turned to look at the viewer. Later, in the *Gare Saint-Lazare* (1873), Manet captured another interruption of Victorine's concentration as she looks up from her book to engage the viewer with a searching glance. The fingers of both her hands are still marking pages of her book, as if she had been studying the text, perhaps comparing passages.[2] In *Déjeuner* she is also interrupted, this time from her interest in two men. She seems to have just undressed, rested her chin in her hand, and turned to

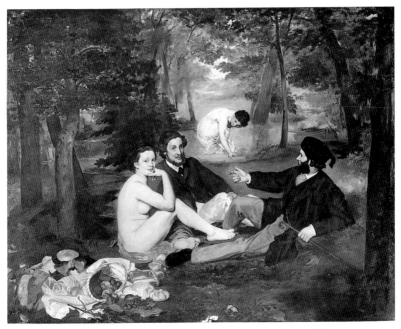

22 Edouard Manet, *Le Déjeuner sur l'herbe*, 1863, oil on canvas. Musée d'Orsay, Paris.

look at the viewer. Her pile of clothing hints at hurried undressing, accented by the overturned basket of fruit nearby (tipped over in the rush). Thus her quick disrobing, tumbled fruit, and spontaneous glance express the free activity of a naked woman in the presence of relatively more passive male observers.

Viewers of the painting most likely felt the shock of first seeing an undressed woman rather than the customary pleasure of viewing a nude. Her nakedness leaves her unprepared for the activities suggested by the presence of food, the flask, and the boat, nor is it a preparation for bathing, since the bather in the background is not herself naked, and Victorine does not seem about to join her. Women sometimes take off their clothes in the presence of men to have sex, but that seems unlikely here. She looks away from the men with composure and is remarkably secure. Her head is supported by a squared formation of hand, wrist, and bent elbow, stead-ied against the strong pyramid of her right leg. She presents that impos-ing edifice to the viewer in the same plane and in the same bright light as her face. She does not invite viewers to satisfy any demeaning sexual fan-tasy but does open up a novel context for eroticism in her time. As Beat-rice Farwell noted, 'The clear gaze and unself-conscious smile of Victorine offer the spectator the freedom of a simple image of vitality and satisfaction engaged in relaxed conversation'.[3]

Her direct look and self-exposure contrast with the visual evasiveness of the men and their physical concealment under drab clothing. Both men not only fail to look directly at her but seem to deny her nakedness. Ferdinand's glance is unfocused and away from her, while Gustave, although he looks in her direction does not quite look at her. The two men do not carry on the long tradition of their voyeuristic predecessors – the satyrs, lechers, fancy men, and elders shown gaping at naked women and bathers in the traditional nude that Manet was so intent on updating and revising. These seated men are rather points of reference for the two women, who also embody the allegorical meaning of the painting, an interpretation of sacred and profane love.[4]

The men play lesser symbolic roles, although Gustave's perplexing gesture with his hand animates the centre of the painting. Manet adapted that gesture from Marcantonio Raimondi's engraving, in which the seated man holds an oar. In the *Déjeuner*, the man's ambiguous gesture (half pointing, half summoning) does not seem an appropriate response to Victorine's nakedness; it confuses the meaning of his view of her.[5] Her male companions thus seem unfocused and slightly off-balance in comparison with her confident frontal look and secure seated position.

While Manet accented a woman's vision and visibility by means of her bold frontal stare and nonchalant nakedness, in *The Picnic* (illus. 23) Auguste-Barthélemy Glaize accented the vision and visibility of several picnicking women by means of composition, lighting, and contrasting activity. At the centre of the painting, the only fully illuminated man (the art patron Alfred Bruyas) toasts the woman at his side with champagne; she leans toward him as if pretending to listen, although she is looking away. The other men are relegated to margins and shadows. One man's face is crossed by Bruyas's glass as he looks intently toward a woman and sits with a third man in a shadowy trio. At the base of the central tree a profiled man in deep shadow smokes a cigarette while leaning back toward the shoulder of a seated woman; she ignores his presence and looks away as she holds her chin reflectively. At the far left a profiled man in shadow is ignored by two conversing women. Behind him is the top-hatted artist himself in deep shadow, sketching the scene while conversing with another man holding a champagne glass. Behind them a barely visible man in the background speaks to two women. Another profiled man in shadow lies sprawled out in the foreground, peering up adoringly at the animated face of a woman who looks over his upturned forehead at the play of light on her basket rather than into his searching eyes.

Thus the six most illuminated areas of the painting feature women who relate primarily to other women and appear as if spotlighted in a shadowy

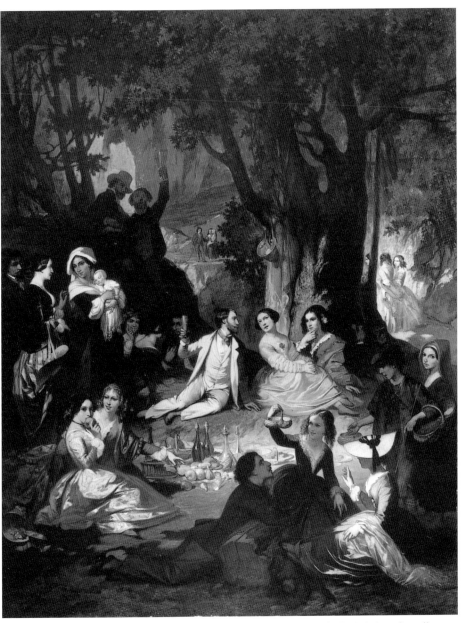

23 Auguste-Barthélemy Glaize, *The Picnic (Olim, souvenir des Pyrénées)*, *c.* 1850, oil on canvas. Musée Fabre, Montpellier.

world of men. Two women at the middle left are preoccupied with mothering. The sunny pair of women under the tree are focused away from Bruyas. At the right the profiled face of a standing boy is in shadow, while just behind him the face of a girl catches the light as she eyes the viewer. In the right background another brightly lit woman looks frontally as she walks away. In the right foreground the seated woman facing a man has her eyes hidden by a hat-brim and is most likely looking at and gesturing toward her animated female companion holding up the basket, while in the left foreground two women sit in a final spot of sunlight.

Glaize's women are primarily involved in preparing and sharing food. One woman in the left foreground reaches toward a spread of apples and figs as her companion bites into an apple and looks directly at the viewer with an inviting glance. A mother, no doubt still nursing, holds her infant while her companion looks on sympathetically. With the exception of the artist, the adult men gaze at women, smoke, or propose toasts. The women, in addition to being more illuminated, are also more useful and productive. Glaize has created a pictorial anthology of women who are not objectified by the male gaze. Compared with the men, they reflect on a wider range of human possibilities, engage in more meaningful social exchanges, and cultivate deeper levels of their own subjectivity.

In Renoir's most fully realized eating scene, *Luncheon of the Boating Party* (illus. 24), the artist once again celebrates women pictorially (in contrast to his demeaning personal view of them).[6] Although the composition is dominated by men in sheer numbers (as the society it depicts was dominated by men in consideration of their professions), its emotional centre is dominated by women. To achieve this complex composition, Renoir sacrificed the eyes of men left and right. Among the nine men there is scarcely a single open and fully visible eye except those of the man at the rear, and he is the most recessed. The top-hatted banker (also an amateur art historian) who is speaking to him is shown from the back, as is the seated man wearing a bowler – a former cavalry officer and close friend of Maupassant. In the right foreground a journalist stands in a striped jacket and looks down in profile at a seated woman. The profiled man in front of him is Caillebotte. Among the two friends of Renoir shown at the rear, trying to attract the attention of a woman, one is in profile and the other has an eye covered by the woman's hat-brim. At the left, the standing man in profile (the restaurant owner's son) wears a white shirt that is positioned to highlight the face of the seated Aline Charigot. Her animated profile combines with frontal views of the three other central women to establish the dominant sight-lines and heart of this scene.

The woman shown drinking is, like Aline, a model. The other women are probably models or actresses. They are not as educated, as prosperous,

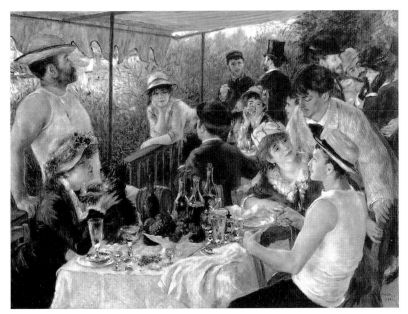

24 Pierre Renoir, *Luncheon of the Boating Party*, 1881, oil on canvas. The Phillips Collection, Washington, DC.

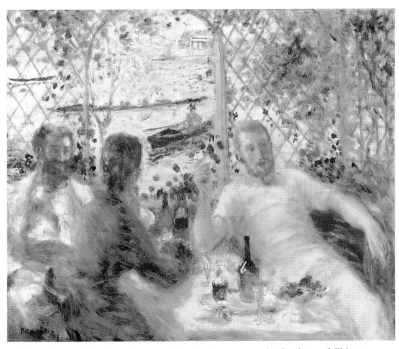

25 Pierre Renoir, *The Rowers' Lunch*, 1875–6, oil on canvas. Art Institute of Chicago.

as artistically accomplished, or as socially respected as the men, but their expressions are the painting's focus. The woman leaning on the rail is alert and looks squarely at the ex-cavalry officer with soft and inviting eyes. The other women avoid the men's gazes. At the far right a woman adjusting her hat accidentally also appears to be covering her ears and seems to avoid the attention of the two men who press their attentions on her. The seated model looks over the top of her raised glass, blithely ignoring the attentive man shown in profile, partly visible at her side. The look of the seated woman in the right foreground is somewhat incredulous: her attention wanders between the journalist and Caillebotte. And Aline, as a comment on the men's captivating conversation, remains preoccupied with her dog. In this major painting Renoir de-emphasized the intelligent faces of his literary and artistic friends to concentrate on the lively expressions of some female models and actresses.[7]

Renoir featured the faces of men in *The Rowers' Lunch* (illus. 25), but gave them less clarity and intensity of expression than the faces of frontal women in other works with similar themes. It captures a moment of relaxation after boating and eating, but rather than the more detailed faces of the women as in *Luncheon of the Boating Party*, in *The Rowers' Lunch* the men's faces are sketchy. The canoeist holding a cigarette is so relaxed that his left hand seems about to dissolve into brisk brushstrokes, and his large blue eyes look off dreamily into the distance. The other man looks at the woman with a pleasant wide-open glance, although his eyes, like those of his companion, are rendered with a cottony brushwork that makes it difficult to read in them any expressive detail.[8]

Nineteenth-century images of sailing comment on the relative values of staying at home and going away, roles sharply divided between women and men. Throughout the history of art, women's connection with water had been to be born out of it, to sleep by it, to sleep on it, to bathe in it, to be raped over it, to drown in it, or to drown men in it.[9] But navigating over it was for men. Although in this period there were female boaters, a few of whom Renoir and other Impressionists depicted, piloting a vessel was a man's sport or work.

Artists typically depicted the woman in a dependent role when shown with a sailor or near a harbour. She waved goodbye, waited anxiously for the man to return, mourned his loss at sea, gathered up her dress to step precariously into a canoe, sat stiffly in the bow of a sailboat as a man held the tiller, sat at his feet and held his hand affectionately, or listened to sea tales back in port.[10] In most of these scenes, however, the expressions of the women are more prominent, their thoughts the primary centre of interest. An underlying implication of these images is that men squander their opportunity to travel over water only to return home with inflated

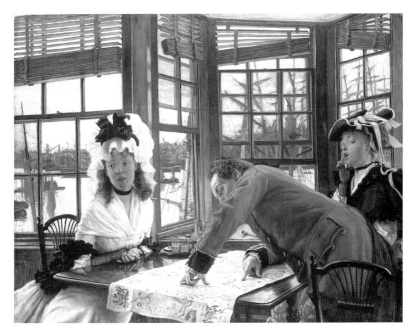

26 James Tissot, *An Interesting Story*, 1872, oil on wood panel. National Gallery of Victoria, Melbourne.

27 James Tissot, *The Tedious Story*, c. 1872, oil on canvas. Private collection.

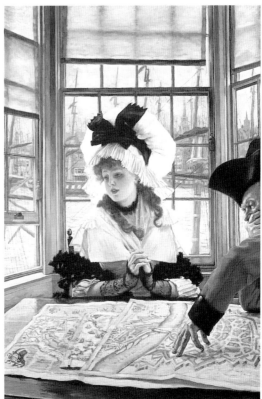

stories about adventures that do not prepare them even to hold a woman's attention let alone understand her needs in love.

Tissot captured that squandering in his ironically titled *An Interesting Story* (illus. 26). It shows a desperately bored woman looking away to think of something other than the tedious yarn she is forced to endure from the officer in profile, bending over a map.[11] She stares wistfully into the foreground space; her thoughts are emphatically elsewhere. The promise of travel that was open to men is suggested by the complex rigging and busy docks of the Thames visible through the window. Her thoughts have clearly wandered, perhaps to the way men waste their opportunity to travel, thinking only of booty, conquest, or escape. The other woman, pressing a finger to her lip, casts an indignant glance at the man's backside that looms into her view as he bends over the map. Tissot repeated the theme of a foggy-eyed sea dog boring a clear-eyed woman in the more accurately titled *The Tedious Story* (illus. 27). Its frontal woman appears even more distracted, no doubt immersed in thoughts of other persons and places. Her clasped hands suggest polite listening but also self-control, enabling her to endure this old sailor who grabs his mouth as a sign that he is self-absorbed and perhaps half aware that he ought to stop talking. Tissot's *The Return From the Boating Trip* (1873; private collection) shows a flashy oarsman with droopy whiskers who has just returned to shore. He looks away from the woman out of weak eyes, which suggests that something went amiss on the trip. The centred woman is closer to the front and looks straight at the viewer with crystal-clear and intelligent, if slightly exasperated, eyes.

While Tissot mocked masculine fantasies about the amorous value of seafaring, Millais indulged in them. But his well-known *The Boyhood of Raleigh* (illus. 28) must have generated as many masculine anxieties as fantasies of amorous conquest. It shows the delicate boy holding his knees defensively and looking down in bewilderment, almost cowering, as a huge, mustachioed Genoese sailor with a muscular forearm stares down at him while pointing out across the sea toward the distant lands where the grown Sir Walter would one day serve England's imperial destiny. In a country that idealized Admiral, Lord Nelson, this image was supposed to inspire boys to dreams of greatness by valorizing masculine heroics of conquest. But conquering distant lands and 'lower' races does not create the genuine authority necessary for reciprocal love. And even if Victorian males were not overwhelmed but rather inspired by identifying with young Raleigh while mindful of his subsequent imperial conquests, the projects they envisioned would not prepare them for handling the real love relationships that would await them at home, relationships that would be compromised by their lack of experience in loving a real woman.

28 John Everett Millais, *The Boyhood of Raleigh*, 1870, oil on canvas. Tate Gallery, London.

29 John Everett Millais, *The North-West Passage*, 1874, oil on canvas. Tate Gallery, London.

Millais celebrated the heroics of sea travel at the other end of the life cycle with *The North-West Passage* (illus. 29), a prime example of what Kaja Silverman calls 'the dominant fiction'.[12] In 1909 Millais's son revealed some of the painting's fiction when explaining that it was popular because it expressed 'the manly enterprise of the nation and the common desire that to England should fall the honour of laying bare the hidden mystery of the North'. He also speculated that the woman was the captain's daughter and that she was reading some record of previous efforts to reach 'the Pole'.[13] The dominant fiction of this image is that the 'manly enterprise' of England might be carried out by an old sea dog lost in distant thoughts who would be comforted by a young, beautiful, devoted, subservient, and affectionate daughter or wife. But young women tended to prefer to love young men who did not slump in chairs or comb their wispy curls forward, men who were virile and lost in thoughts of love. The dominant fiction also glossed over the fact that sailors were poor at relating to women. This young woman holds the captain's determined fist affectionately, so as not to make any sexual demands, and with the other hand points to a line in a book similar to the two tomes labelled 'LOGBOOK' that lean against the table. But young wives or even daughters did not typically dress up in white and sit on the floor at a man's feet while holding his hand and learning about his travels, past or future. Millais exhibited the painting with a caption that expressed the captain's private thoughts – 'It might be done, and England should do it'. But the private thoughts of young Victorian women were usually of other realms and discoveries. If they dreamed of a man 'laying bare the hidden mystery' of a watery passage or finding a way to 'do it', they would not likely have in mind his discovering the North-West Passage.

The woman in Manet's *Argenteuil* (illus. 30) does not even pretend to be at home in the world of sailing. She sits stiffly beside a sailor on a dock in front of some sailboats. Manet's contemporaries judged her to have low morals, and their views, as Robert L. Herbert speculates, 'may well reflect male assumptions that a woman shown as the object of a man's attention was necessarily a *cocotte*'.[14] Such assumptions also presumed women's lack of intelligence along with morality, although the painters who subscribed to such views repeatedly depicted prostitutes with at least more savvy, if not more education, than the men in their company. But this woman is not a prostitute. Unflirtatious, she is self-possessed, and modestly posed. Her eyes are hard to read not only for viewers but for her companion. He has made little headway with his right hand behind her back, his left hand holding her parasol, his left leg crossed in front of her dress, and his eyes staring with little effect at her fixed frontal glance.

Manet featured the woman's eyes not only by posing her with the man

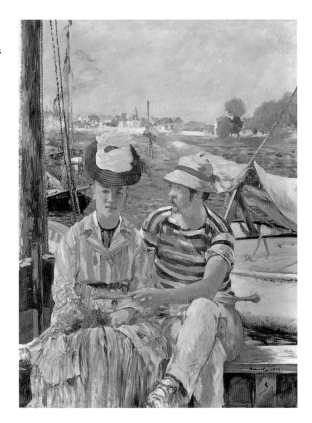

30 Edouard Manet,
Argenteuil, 1874, oil
on canvas. Musée des
Beaux-Arts,
Tournai.

in a proposal composition but also by the greater detail of her eyes. Critics were troubled by the man's relatively unfinished eyes, which, compared with the woman's, are weak and unclear. Manet took far greater care with her entire face. Her frontal glance is accented by the brightly coloured verticals of her dress and by the solid mast and strong vertical riggings on her side in contrast to the smudgy horizontals of the man's shirt and the casually covered and windless sail at rest behind him. Even her clearly defined lips suggest an ability to speak more precisely than does the man's droopy lower lip visible below his floppy moustache.

The expression of another woman being courted by a sailor is the focus of John Horsley's *Blossom Time* (illus. 31). The painting is based on an engraving Horsley did for the 1857 Moxon edition of Tennyson's *Poems*, which includes a poem with the line to which the painting refers: 'Two lovers whispering by an orchard wall.' The poem also mentions 'two graves' beside a church (not shown) as well as 'two children . . . playing mad pranks', who are shown in the background of the painting.[15] Horsley tried to capture in the background the poem's larger message of love ripening throughout life as well as the lovers' 'blossom time', when the woman's

feelings are pivotal. The sailor's intent stare seems to be energized by spring blossoming all around, while the woman's expression is more uncertain, because she cannot allow herself to give in so easily to natural desire. Her uncertainty is indicated by her looking away as she absent-mindedly plucks a blossom from the branch that he makes more accessible by bending it toward her hand. His urging eyes are more in shadow and intently focused on her, while her pensive eyes, although no more frontal than his, are in brighter light and look out toward the viewer. His hat has been knocked off his head in the course of his spirited courting and lies upside down on the ground, covered with a feminine piece of clothing, as a hint of where the couple might themselves wind up should she give in to desire.

Such a conflict between a man urging a woman to give in to impulse and a woman hesitating while harkening to the demands of morality is the focus for a masterful love tragedy. *The Mill on the Floss* (1860) opens with a lyrical evocation of the river Floss, embodying the force of nature that Maggie Tulliver will fight against figuratively in her forbidden love for Stephen Guest and then fight against literally at the end of the novel when she drowns in the flooding river itself. For 500 pages George Eliot sets the stage for these conflicts: how Maggie struggles with the restrictions that prevent a woman from being formally educated as well as a man, with the suffocating love of the humpbacked Philip Wakem who finagles her pity

into a promise of eternal love, and with the Christian asceticism of Thomas à Kempis that taints her love of pleasure. These challenges instil a strong moral sense that will sustain her against giving in to her passionate love for Stephen when it threatens to violate the commitments they both have to others.

Their struggle is reflected in their eyes. The initial description of Stephen's are minimal; they appear as 'a half-ardent, half-sarcastic glance from under his well-marked horizontal eyebrows'.[16] Maggie's more complex and profound eyes play a decisive role. Stephen scarcely knows what he is saying when he is the object of her look, but quickly realizes its meaning: 'She doesn't look at me when I talk of myself'. While his first glances evaluate her beauty, hers assess his character. When he speaks less self-centredly, she rewards him with a 'large, clear gaze' (489).

One afternoon Maggie is alone and Stephen appears: 'He only wished he dared look at Maggie, and that she would look at him, – let him have one long look into those deep strange eyes of hers and then he would be satisfied. . . . It was becoming a sort of monomania with him, to want that long look from Maggie' (519). He is aware of the danger of this passion and cannot resist pursuing it through her eyes into her mind. He searches her 'unwilling, half-fascinated eyes' with his own 'vexed complaining look'. That evening, as he reflects on the risk of his loving Maggie while engaged to Lucy, he considers ending his love with a quarrel, but then wonders helplessly 'Was it possible to quarrel with a creature who had such eyes – defying and deprecating, contradicting and clinging, imperious and beseeching – full of delicious opposites' (523–4). Eliot also registers the progress of Maggie's love in her eyes, with their 'childish expression of wondering delight', their 'traitorous tenderness' (553, 535).

As in the art of the period, the woman's eyes, as compared with the man's, create more dramatic interest and express a stronger commitment to the morality of love. After Maggie and Stephen confess their passion, she leads in the struggle against it because of what she believes to be right. He defends their feelings as natural and characterizes her resistance to them as 'unnatural'. In this novel 'female is [not] to male as nature is to culture'. My modified quotation negates the implied argument in the title of Sherry Ortner's frequently cited essay 'Is Female to Male as Nature Is to Culture?' Ortner defines culture as 'the specifically human ability to act upon and regulate, rather than passively move with and be moved by, the givens of natural existence'. She then argues for a 'universal' connection between women and nature and between men and culture as one explanation for women's secondary status in all societies.[17] But in *The Mill on the Floss* the man tries to make the woman go with the flow of the river (a symbol of natural passion), while the woman resists.

Morality is based on the ability to say *no* to nature, and in nineteenth-century love relationships, women constrained their natural impulses more rigorously than did men. Against Stephen's and her own instincts, Maggie takes a more cultured stand, one based on a demanding moral code. That struggle is expressed in their eyes. He glowers at her with a look of wilful determination as he tries to wear down her 'unnatural' scruples. She looks back with 'her eyes fuller and fuller of appealing love', while insisting on responsibility to others even if it means renouncing her natural, passionate love (569–71).

While responding to his urging her to go boating, her eyes are again the more revealing. 'He was looking into her deep, deep eyes – far off and mysterious as the starlit blackness, and yet very near, and timidly loving' (588). He gazes at her ever more urgently, but with a single, all too evident purpose, while the consciousness behind her eyes remains inaccessible to his comprehension and influence. As they drift with the current beyond where they were supposed to disembark, Stephen repeats his argument that the force of nature ought to define what is right: 'See how the tide is carrying us out – away from all those unnatural bonds that we have been trying to make faster round us – and trying in vain.' He wants to give in to nature; she struggles to resist on behalf of what she believes is right. Outraged that he knowingly allowed them to drift past their destination without telling, she protests, 'You have wanted to deprive me of any choice' (590–91). Although it is too late to turn back that evening, she resolves to leave him the next day.

Their final confrontation is a tortuous exchange registered vividly in her face and eyes. Once again Stephen argues from natural impulse: 'We have proved that the feeling which draws us towards each other is too strong to be overcome. That natural law surmounts every other.' But she resists. 'If we judged in that way, there would be a warrant for all treachery and cruelty – we should justify breaking the most sacred ties that can ever be formed on earth. If the past is not to bind us, where can duty lie? We should have no law but the inclination of the moment' (601–02). She urges him to think of Lucy, as she is thinking of Philip, but he cannot and pleads that this is the first time that either of them has loved heart and soul. She directs at him an anguished glance and replies 'No – not with my whole heart and soul' (603). She cannot love at the expense of another's suffering. Maggie's stronger commitment is not only to a private morality that requires honesty in relating to her beloved but to a public morality that bears on her treatment of others.

Realizing that no appeal to principle will work, Stephen reminds her that their transgression is already an accomplished fact, that if she returns home unmarried she will be condemned and ostracized. Still she does not

yield, and her eyes open wide 'in one terrified look'. Stephen realizes that she is lost to him. 'He was silent for a few moments, not looking at her – while her eyes were turned towards him yearningly, in alarm at this sudden change. At last he said, still without looking at her, "go, then – leave me – don't torture me any longer – I can't bear it"' (606). Maggie is more able to act in accord with a moral sense while looking her disappointed lover straight in the eye, and the manly glance under Stephen's 'well-marked horizontal brow' cannot bear to look at his beloved at the moment of her supreme sacrifice. She must leave alone.

For George Eliot love was not simply the gratification of natural impulse. Neither was it simply the extirpation of that impulse or capitulation to convention, but a reasoned restraint of beautiful, passionate feelings in accord with the values of her culture, grounded in a moral code about how to treat a beloved and everyone else concerned. Maggie's rejection of Stephen's love – and he did love only her – was an autonomous moral act made on behalf of what she thought was right. Her highest love, more than Stephen's, had to be reconciled with a sense of responsibility to everyone immediately concerned, including Philip and Lucy whom she and Stephen did not love. That moral sense was not dictated by conventionality, because she sought not to win widespread public approval but to do what she believed in her own conscience to be morally correct. George Eliot's own love for George Henry Lewes was by no means sanctioned by conventional morality. She showed great courage in defying convention in order to gratify her passion – cohabiting with him – while reconciling that difficult lifestyle with a strong personal sense about what was right.

Eliot's novel elaborates the pre- and post-history of the experiences that lay behind images of boating and other seemingly playful recreations depicted in art. Each of the tourists, dancers, drinkers, and theatre-goers I consider in the remainder of this chapter are captured in a single moment out of what may well have been an equally convoluted, if not so tragic, story.

In Tissot's *London Visitors* (illus. 32) a bearded man reads from a guidebook to a distracted woman who seems bored and slightly impatient. This violation of decorum is accented by the model of acceptable behaviour shown in the background, where a schoolboy points and a responsive young woman bends forward to look intently where directed. In contrast, the woman in the mid-ground listlessly points her umbrella in the direction of interest toward which the foreground boy is looking and perhaps also about which her companion is researching, but she turns her face away and looks down at the viewer from a commanding position that is strengthened by the massive columns of the portico of the National Gallery in Trafalgar Square and the towering spire of St Martin-in-the-

Fields behind her. With the monuments of art and religion behind her, and the authority of a male companion at her side, she is still daring enough to look for a fleeting moment at whatever or whomever she pleases, creating a parenthesis of visual autonomy amid the other directions of attention that preoccupy everyone else.

In *Woman and Child Driving* (illus. 33) Mary Cassatt created an image of touring that suggests a bold, gender role-reversal. The man is seated at the rear and faces backwards in the coach with his undistinguished pro-filed face barely visible, while in front the woman literally takes the reins and looks ahead with a focused, determined expression. On the seat next to her is a girl with large and open dark eyes that also look ahead, down the road and symbolically into the next generation.

Renoir was fascinated by the play of light on dancing couples moving in different lights, but he accorded special attention to the eyes of the dancing women. In *Le Moulin de la Galette* (illus. 10) the three women dancing in the centre have the only clear frontal faces among the entire dancing throng, and they stand out against their partners. One of those

33 Mary Cassatt, *Woman and Child Driving*, 1881, oil on canvas.
Philadelphia Museum of Art.

men turns away, another is in profile, and a third, shown frontally, is a
sketchy blur. In Renoir's three large panels of dancers, the eyes of the
dancing women are also the centre of interest. In *Dance in the City*
(1882–3; Musée d'Orsay) only the left eyebrow of the man is visible; the
remainder of his face is covered by his partner's profile. In *Dance at Bou-
gival* (1882–3; Museum of Fine Arts, Boston) the concealment of the
man's eyes by his hat sharpens the focus on his partner's downcast but
frontally posed eyes that look away from his eager glance. The seventeen-
year-old who posed for both of these dancers and who later exhibited her
own paintings under the name Suzanne Valadon, gave birth in December
1883 to Maurice Utrillo, an accomplished painter, who may have been
fathered by Renoir around the time when he was painting these life-size
dancers. In *A Dance in the Country* (illus. 34) the woman, posed by Aline
Charigot, shares her pleasure directly with the viewer in a candid frontal
glance, while the man sneaks a peek at her out of the corner of his eye. Her
friendly smile invites viewers to share the pleasure which inspired her to
interrupt her meal spontaneously, as is evident from the spoon sticking up
out of a bowl on the table. The movement of her head may have knocked
off the man's hat that lies conspicuously in the foreground. In this picture
of uncomplicated happiness, her open eyes are accented by the fan that
picks up the colour of her bonnet and rises up like a crown she holds on
high, supported by the man's hand as if in celebration of her triumphant
openness to the world.

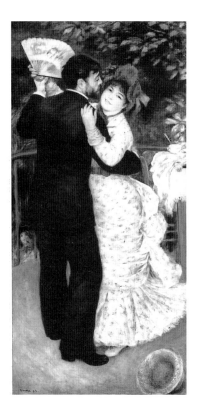

34 Pierre Renoir, *A Dance in the Country*, 1882–3, oil on canvas. Musée d'Orsay, Paris.

Manet's *A Masked Ball at the Opéra* (illus. 35) uses black to show a darker and more formal world than that of Renoir's merrymakers. Despite the painting's title, there is no dancing but rather flirtation and possibly money talk about sexual favours. The men appear like stands for about two dozen gazes, almost as uniform in their purpose as their top-hats are arrayed in a row. Aside from one puffy, dark-eyed man staring toward the masked woman at the left, the men most attentive to women are in profile or posed out of view, and their eyes are sketchy and blurred. Although the identity of a few of them was determinable, Manet suggested a mass of men with a common sexual purpose.

The women's purposes are not quite so evident. The unmasked woman left of centre looks boldly into the face of the man she pets, initiating her erotic business with a bold gaze and fingers that spider up the front of his shirt. A barely visible masked woman at the far right sucks her middle finger while staring through her mask at a man. Another masked woman with her little finger scratches the cheek of the man standing third from the right, while her thumb points suggestively toward her lips. Most of the men's hands are gloved, while most of the women's are bare, and their active fingers complement their active glances to generate the scene's

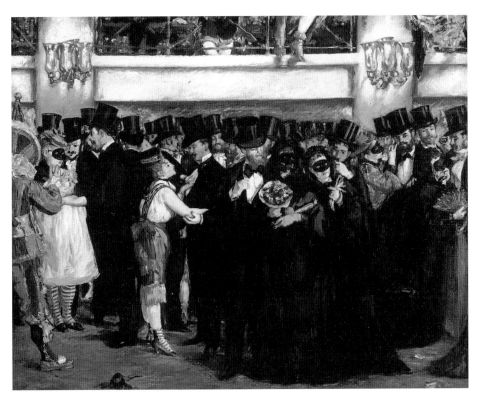

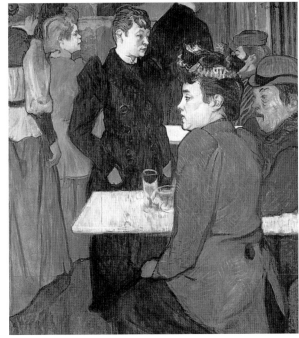

35 Edouard Manet,
*A Masked Ball at
the Opéra*, 1873–4,
oil on canvas.
National Gallery of
Art, Washington,
DC.

36 Henri de
Toulouse-Lautrec,
*A Corner of the
Moulin de la
Galette*, 1892, oil
on cardboard.
National Gallery of
Art, Washington,
DC.

dynamism. The masks on the five women hide their identities but accentuate their eyes by raising questions about their looks and their availability as well as their identity.[18] These women peer out without being found out; they can cruise this crowd incognito like the *flâneurs* who cruised the boulevards. The drama in the painting centres around their willingness and perhaps their price, both of which are as mysterious as their eyes.

The world of Toulouse-Lautrec is populated by men even more obviously in pursuit of similar adventures, who more often watch women dance than actually dance themselves. And while Manet placed his gazing men in the centre of his composition, Toulouse-Lautrec relegated his men and their bloated, baggy eyes to the margins, as in *A Corner of the Moulin de la Galette* (illus. 36). The eyes of Toulouse-Lautrec's men and women seem drugged and fatigued – the women by alcohol and overwork, the men by alcohol and sexual desire or sexual failure. The dance-halls and brothels are hazy from smoke and darkness, clouding a clear view of anyone. In these commercial places for the amusement of men, the performing women must cater to the lecherous glances of intoxicated clients. The eyes of Toulouse-Lautrec's women may not be more educated than those of their customers, but they are more street-wise.

Manet showed more detail in the faces of men as well as women in commercial establishments that mixed drinking and entertainment. These compositions came from his wanting to paint a waitress he admired, who would only agree to pose if he allowed her boyfriend to accompany her to the studio.[19] In *Corner in a Café-Concert* (1878–9; National Gallery, London) Manet included the boyfriend but painted his face rotated out of view; he showed the waitress frontally, clutching two beers in one hand and directing a strong sidelong glance toward an impatient customer. Manet cropped this composition in on the same two heads in *The Waitress* (1878–9; Musée d'Orsay), again with the man posed from behind. In this view Manet showed the waitress staring toward the viewer with a softer yet still confident expression.

In *Café-Concert* (illus. 37) the waitress is shown in profile as she pauses for a drink, while the man and woman in the foreground are the main subjects.[20] He is more central, but he is also in profile and with eyes a painterly blur in contrast to the big dark eyes and thick arching brows of the pensive woman to his right. The man's gaze is fixed on a female performer whose comical profile appears in a mirror at the rear. While his eyes are taken up with the light entertainment of this café-concert, the eyes of the woman next to him are downcast in serious if meandering thoughts. Her cigarette, tall glass of beer, and unescorted presence in such a place suggest that by current codes of behaviour she is the more vulnerable and the more adventurous. Her carefully rendered and detailed eyes allow viewers

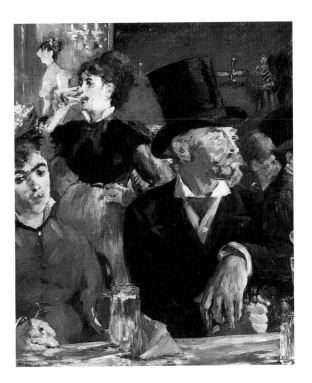

37 Edouard Manet, *Café-Concert*, 1879, oil on canvas. Walters Art Gallery, Baltimore.

to see more of her face, empathize with her more evident feelings, and wonder more about her fate.

Images of women looking through opera-glasses clarify differences between the visual opportunities of the two sexes in public. Three questions about these images are most germane to this study: what do these images tell us about artistic attention given to the eyes of men and women; what do women as opposed to men actually see; and what is the value attached to those respective visions?

Renoir's *The Loge* (illus. 38) highlights the eyes and vision of women in all three respects. First, the eyes of the man are obscured by the opera-glasses. Their seeing power is magnified by the lenses, but that magnification is something viewers have to infer. The way the man looks is socially indelicate, if not inconsiderate.[21] He arches back to look way up and scan the crowd, possibly for another woman. He is emphatically not interested in the elegant woman in his box. She, by contrast, appears to have dazzling visual power to see, as well as to attract looks. The model for her was known as Nini or 'Guele-de-Raie' (literally 'fish-face').[22] Whatever her actual appearance, Renoir saw her as a radiant beauty. Her bodice is low-cut and bejewelled, indicating her interest in being seen, but she can also see and does so out of magnificent eyes that are slightly irregular, although hardly 'unfocused'.[23] They focus confidently on the viewer, with flashes of

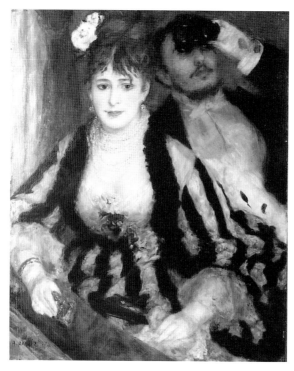

38 Pierre Renoir, *The Loge*, 1874, oil on canvas. Courtauld Institute Galleries, London.

highlight to sharpen their intriguing luminosity. Renoir loaded her eyes with as much meaning and penetrating power as he was able to achieve, hinting perhaps that a woman with such eyes had no need for the gold opera-glasses she holds.

Mary Cassatt interpreted a similar subject in *Woman in Black at the Opéra* (illus. 39). While the eyes of the gazing man in the Renoir are covered by opera-glasses, in the Cassatt the eyes of the relatively small man with opera-glasses who leans out of his box to get a better view are similarly covered but also more distant. The object of his gaze is clearly the woman, who is profiled to him and oblivious of his ogling. In the Renoir, the man eases back gently and is subtly indelicate; in the Cassatt, the man bends forward unabashedly and is positively crude. The eyes of Cassatt's woman are not visible, but they are actively looking and magnified by the opera-glasses. Cassatt presents a woman looking out into the world, ignoring the magnified gaze of a visual predator.

Griselda Pollock argues that this picture 'juxtaposes two looks, giving priority to that of the woman who is, remarkably, pictured actively looking'.[24] There is nothing remarkable about a depiction of a woman actively looking, because in nineteenth-century art women are often depicted actively looking at all sorts of things, more intriguingly and more imaginatively, if not more intently, than men whose gazes are repeatedly pinned

39 Mary Cassatt, *Woman in Black at the Opéra*, c. 1879, oil on canvas. Museum of Fine Arts, Boston.

40 Eva Gonzalès, *A Loge at the Théâtre des Italiens*, c. 1874, oil on canvas. Musée d'Orsay, Paris.

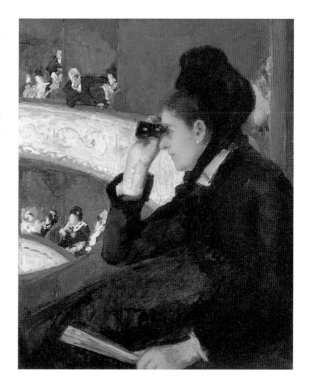

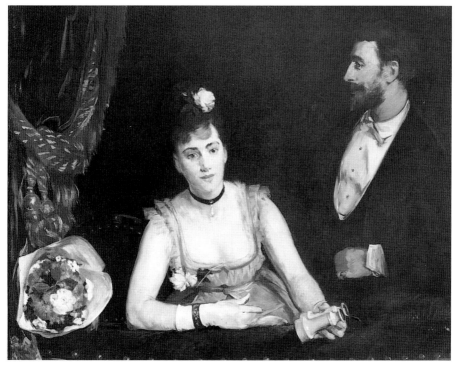

on women. Women are just not shown actively looking at men with clear erotic purposes. It is remarkable, however, to show a woman so blatantly disregarding a man's gaze. In Cassatt's entire corpus nothing else comes close to this explicit comment on male–female relations, which amounts to an indictment of the impoverished visual predilections of men and a call to arms on behalf of the visual capacities of women.

In *A Loge at the Théâtre des Italiens* (illus. 40) another female Impressionist, Eva Gonzalès, shows a woman with opera-glasses looking away from a man, although the woman is not looking through the glasses. The man's profiled eye is subordinate to the woman's frontal eyes not only in number, in centrality, in illumination, and in detail, but in its function as a visual lead into her more engaging glance. He sees only her, while she looks out into the theatre and towards the viewer. She ignores his gaze as she has just set aside his bouquet, which itself looks like an enormous eye. She is in the light, almost the source of light, and her viewing is both more extensive and more intensive. In comparison to this cipher of a man, the woman expresses more humanity and presence. In addition to the penetrating vision implied by her carefully rendered eyes, she holds opera-glasses that can extend her vision away from her immediate surroundings, including the man at her side.

She is indeed someone to be viewed. Her black choker, dangling jewel, and open *décolletage* make her even more explicitly sexual than Renoir's woman in *The Loge*. But in spite of both women's sexual objectification, they also evince greater subjective vision than their male companions. They have more important and more impressive eyes, they look out into a broader world of more varied experiences, and they have more positive value attributed to their vision. Cassatt's woman is not dressed to attract attention, and her one profiled eye is obscured by the opera-glasses, but she shares the same visual priorities as the opera-goers by Renoir and Gonzalès.

Tissot's *Women of Paris: The Circus Lover* (illus. 41) shows a crowd of men at a circus, some too self-involved to bother watching the performers.[25] Tissot ridicules the pomposity of a male acrobat on a swing by giving him an absurd monocle that catches the light and obscures one eye from view. The serious top-hatted men in the lower rows appear uninterested in what is before them. They look down and away with eyes that are obscured by their poses and hats. At the far left, the bloaty, uniformed men standing in a group appear to be contemptuous of the performance. Most of the men in the upper rows, fidgety and uncomfortable in their black suits, are distracted from the performance and obscured by composition and shadow. In contrast, the women in the middle rows make a panorama of varied colours and visual animation. While none of the men in the crowd are smiling, many of the women appear to be excited about the per-

41 James Tissot, *Women of Paris: The Circus Lover*, 1883–5, oil on canvas.
Museum of Fine Arts, Boston.

formance, which they are eager to watch. The woman in the front section who turns away from the performance seems to cut off the gaze of the man at the right foreground as she looks toward the viewer. When artists, male or female, depicted men and women at a theatrical performance, they showed women looking the more appreciatively at it.

Artists who depicted men and women amusing themselves together in public typically gave more prominence to the eyes and vision of women. When men had no sexual interest, as in Tissot's *The Circus Lover*, their eyes were less interesting because they seemed to have no focus. When men had such an interest and they gazed directly at a woman, as in Cassatt's *Woman in Black*, their eyes were less interesting because they were so obvious. When men had a sexual interest and did not gaze in the way they were supposed to, as in Manet's *Déjeuner*, their eyes were less interesting because they lacked conviction. When men were posed out of view or in shadow, as in Glaize's *Picnic*, their eyes were less interesting because they could not be seen. The visual centres of these images were one or more women, and the paintings' thematic centres were the wide range of possibilities surrounding women's responses to men.

In these images the commitment to a personal moral code was not so markedly different between men and women. Some with more insistent men, as in *Argenteuil* or *Blossom Time*, hint that the man may be pressing the woman beyond what she thinks morally respectable. But in most recreation scenes artists did not make as clear a moral distinction between the sexes as was evident in Eliot's novel about a woman resisting a man's appeal to the forces of nature. The different commitments of men and women to the morality of love will become more evident in the chapters that follow on more involved relationships.

3 Working

Art-historical and literary sources about men and women meeting and amusing themselves generally concern the middle classes. Sources on working provide the richest vein of evidence about the lower classes. Whether the man worked for the woman, the woman worked for the man, or both worked side by side, artists and novelists consistently featured the eyes of women.

Some couples are shown so overwhelmed by the strain of physical labour that they scarcely relate to one another visually.[1] Even when resting, their eyes appear glazed with exhaustion, as if they might never think about love relations. In *The Hay-Makers* (illus. 42) Jules Bastien-Lepage features a frontal view of the resting woman with big dark eyes that are open and forthright, although dazed. The attitudes of the couple are further accented by their shoes. The man's dirty and battered shoes are flopped to one side as if he were dead. The woman's cleaner shoes imply that she has been doing less dirty work, and their upright, splayed-out position suggests that she is more alert, though somewhat bewildered. The distance between the two is registered in the woman's fatigued but open and searching eyes.

Artists were especially intrigued by images of women working for men, especially barmaids, clerks, governesses, laundresses, dancers, and performers, whose faces, as compared with men's, they rendered more frontal, illuminated, detailed, and expressive. The mixture of servility and independence of a woman waiting on a customer, protected by her position but vulnerable because of its duties, is the subject of a number of paintings. The most celebrated is Manet's *A Bar at the Folies-Bergère* (illus. 43). His model was a barmaid at the Folies-Bergère named Suzon, whom he posed wearing a choker and a dress with a plunging neckline decorated with flowers. At the right side of the mirror behind her is the image of a man standing in front of her, probably ordering a drink. His half-profiled face is not as well lit or as detailed as hers, and his stony gaze, large head, and imposing location hint at a threat to her security. Something else about him is also disturbing – in front of the mirror, where he ought to be blocking our view of her, he is missing.

42 Jules Bastien-Lepage, *The Hay-Makers*, 1877, oil on canvas. Musée d'Orsay, Paris.

The barmaid's glance is also unnerving because we expect her to be looking, if not at the man, then at least at us standing in for him in front of the bar. But her eyes are focused slightly to her right, behind the spot immediately in front of the bar and farther away. Art historians have hotly debated the meaning of her glance. It may be illuminated with some background information about Manet's life and art.

When Manet began the painting he was a member of a circle of leading artists and writers who loved the glamour and sexual adventure of Paris. This world was the subject of his art, and he occasionally put himself in it. Twenty years earlier he had painted himself near the left margin of another animated crowd in *Music in the Tuileries* (1862; National Gallery, London).[2] In 1873 he appeared near the right margin in the pleasure-minded crowd of *A Masked Ball at the Opéra* (illus. 35). Although he did not depict himself in *A Bar at the Folies-Bergère*, he established his presence by including portraits of his friends (illus. 44). The painter Gaston La Touche modelled for the mustachioed man at the far left of the balcony and the man at the bar. The woman nearest to the left edge, leaning on the

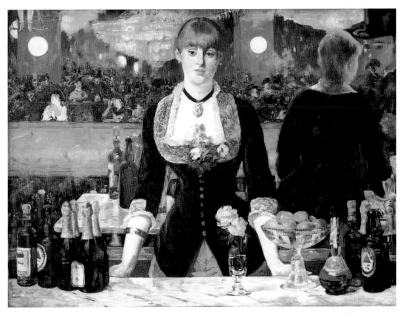

43 Edouard Manet, *A Bar at the Folies-Bergère*, 1882, oil on canvas. Courtauld Institute Galleries, London.

44 Detail of illus. 43.

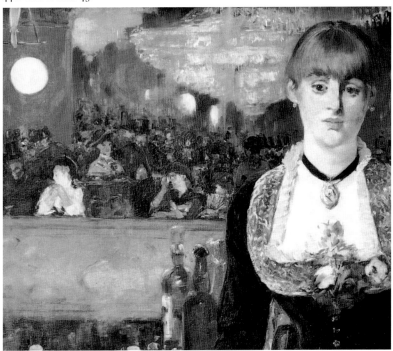

loge rail and wearing long yellow gloves, is Méry Laurent, who had been Mallarmé's mistress before she became Manet's. He painted her nine times, and she remained one of his closest friends during the last years of his life. She was an illegitimate peasant who parlayed her great beauty and modest singing talent to become an expensive courtesan. To her left and behind an empty seat is the actress Jeanne Demarsy wearing a yellow dress and a tilted black hat. On the other side of the empty seat to Méry's left and also leaning on the loge rail is a woman holding opera-glasses, possibly a token of admiration for the painting by Mary Cassatt, *Woman in Black at the Opéra* (illus. 39).[3] On that woman's left is a woman hidden by a fan, possibly Nina de Callias, the subject for Manet's *Woman with Fans* (1873; Musée d'Orsay).[4] A beautiful model who had personal wealth and a taste for the exotic, she ran a distinguished salon for the Parisian avant-garde. The fan may also refer to Berthe Morisot, whom Manet depicted holding a fan in four images.[5] Thus the most prominent figures in the loge are women who represent a world of beauty, talent, luxury, sex, culture, and art. Suzon is looking toward these women with longing for that world but also with a sense of hopelessness regarding its accessibility.[6]

That mixture of emotions is similar to Manet's, although he had very different reasons for them. At the time he began this painting he was ill with what his doctor diagnosed as ataxia (an inability to coordinate bodily movements), but which Manet himself believed to be syphilis.[7] His father also had been diagnosed as ataxic and died after a number of years as a paralytic. Manet believed that a similar fate awaited himself. His disease attacked the central nervous system, causing terrible pain and making it difficult to walk. By 1879, when he began sketching at the Folies-Bergère, the pain was interfering with his work. By April 1880 he had been forbidden to climb stairs and could not reach the second floor of the Folies-Bergère without great pain, if at all. The following summer he could scarcely get out of a chair, and his friend Antonin Proust recorded how physical suffering impeded his work.[8] In early 1882 the artist Georges Jeanniot noticed 'how illness had ravaged him; he walked with a stick and seemed to tremble'.[9]

Manet's illness also cut short a series of paintings of his favourite models symbolizing the Seasons. He was only able to finish *Spring* (1881; private collection), posed by Demarsy, and *Autumn* (1882; Musée des Beaux-Arts, Nancy), posed by Laurent. He thus used his two good female friends to represent intervals of the time that was running out so quickly that he was unable to complete all four Seasons. Gangrene set in, his left leg was amputated on 20 April 1883, and he died ten days later at the age of 51.[10]

Thus Suzon and Manet were both separated from what they could see in the loges of the Folies-Bergère. Suzon was separated because of her

lower-class status, poor education, and work duties. Manet was separated because of ill-health and because he knew he was dying and would not be around to see his exciting world much longer. About that time he was offered a chair at a hat shop and replied angrily 'I don't need a chair. . . . I'm not a cripple' (*impotent*). Referring to that insult, he commented to Proust: 'How could she be so tactless? Trying to make me look like a help-less cripple in front of all those women. Talking of women, I saw a really beautiful one on the Pont de l'Europe yesterday.'[11] Manet was about to lose what Suzon was hoping to discover, and he expressed through her eyes his own envy, longing, hopelessness, and frustrated desire.[12]

Interpretations of her expression conflict. In 1882 critics were still jarred by Impressionist technique, and their opinions were divided. One referred to 'the brightness (*miroitement*) of her gaze', and another saw it as 'altogether full of character'. A pupil of Zola saw her as 'truly alive, truly modern'. Others found her look to be 'bored' or 'flat and plastered'.[13] More recently, art historians have followed specific interpretive agendas. T. J. Clark reads the 'inconsistencies' of the composition as a reflection of the inconsistencies of bourgeois-capitalist society. But the compositional inconsistencies were rather to get the man in the corner out of the way and to introduce a mirror so that viewers could observe Suzon's face as well as what she was looking at and longed to experience. Clark reads her expres-sion as 'not quite focused on anything'. Her eyes do appear unfocused, in part because Manet, like Renoir, intentionally avoided facial symmetry.[14] A more significant reason is that she is looking not at the viewer but vague-ly into the distance, slightly down and to her right, the way a somewhat preoccupied standing person might look at seated people across the the-atre space and to the right. Clark's emphatic conclusion, that 'she is *detached*', misses the conspicuous object of her longing, which Manet depicted prominently in view by means of the mirror.[15] Suzon was an employee paid to serve customers at a bar. She was indeed detached from the man she was obliged to serve, but she was emotionally attached to the people she envied across the open space.[16] She was securely positioned against a solid marble bar, looking at what she wanted, but she was imped-ed from getting it by her meagre education, menial job, and limited talent.

Hollis Clayson interprets the image as one of 'covert prostitution', and describes Suzon's expression as 'cool, detached, aloof'.[17] Those expres-sions may describe Suzon's look toward the *flâneur* in the corner (a look we do not see), but they do not describe her frontal look, which, although dreamy and distracted, is nevertheless warm and full of longing to be somehow part of the world across the way. Suzon's confrontation with the man at the bar is behind her as viewed in the space of the painting and pos-sibly also behind her in time, if indeed it occurred at all. The man could

be from an earlier moment or merely a passing reflection (represented by a mirror reflection) about whatever keeps her from becoming what she wants to be.[18] Manet exhibits deep sympathy for women imposed on by men such as the one in the corner, whom he removed from the 'real' part of the painting. His painting of Suzon is of a moment he shares with her in longing for a life that increasingly was becoming less accessible.

Several recent studies emphasize Manet's identification with his barmaid. As Werner Hoffman observes, 'The barmaid alludes to the detached observer who painted her and who at that very moment was physically and definitely cut off from the showcase world – no actor, not even an eyewitness, but the man, fatally ill, who had to recall life from memory.'[19] Jack Flam views her not as a victim of the male gaze, stripped of subjectivity, but as 'a kind of surrogate for the artist – observer and observed – the person who unifies and mediates everything that we see before us'.[20] For Bradford R. Collins, Manet 'may well have seen the barmaid's somewhat downcast emptiness as the very mirror of his own'.[21]

Manet did not intend this final work to be a critique of the world around Suzon. He identified with her and modelled her face to reflect his own troubled emotions in the final months of his life. In January 1882, Jeanniot had observed Manet painting Suzon's face and later recalled the artist's technique: 'Manet did not copy nature at all; I became aware of his magisterial simplifications; the head of this woman had a sense of depth, but this modelling was not obtained with the means that nature offered him. Everything was abridged; the tones were clearer, the colours more vivid, the values closer, the tones more varied. The result was a completely tender and limpid harmony.'[22] Manet modified the depth of her expression to project into it his own view of the fading world of the Folies-Bergère. Following Flaubert's exclamation – 'Madame Bovary, c'est moi' – Manet might well have proclaimed his identification with Suzon in this, his final major painting. As James H. Rubin concludes with respect to the artist's entire oeuvre: 'Manet's way of seeing, increasingly rooted in his private life, *is* his world; and for his art to express the world through his way of seeing is to express the position of his eye within it – diffident, of course, but embedded (immersed) at its very centre'.[23]

Manet was well aware of the vast social gap that separated the way he and Suzon experienced the world of the Folies-Bergère, but he sought a shared vision of it through her young and healthy eyes that look toward what he loved and was losing.[24] Her eyes seem slightly unfocused to show that she does not know precisely what to look for. But he did. His own experience supplied that ingredient in achieving her tender and limpid glance. He gave his barmaid slightly averted eyes that literally annihilate the male customer's insistent gaze and its predictable erotic goal, so that

45 James Tissot, *The Sales Clerk*, 1883–5, oil on canvas. Art Gallery of Ontario, Toronto.

she may be seen reflecting on her own life while longing for a more glamorous one that was temptingly near but in fact out of reach. Her eyes look at but do not quite comprehend the world that Manet loved, one which appears to be shifting out of her focus just as its sensuous reality was slipping out of his grasp.

Tissot's *The Sales Clerk* (illus. 45) captures a different mix of emotions on the face of a working woman, who overlays her private feelings with the artificiality required by her duty to customers. The London exhibition catalogue entry for the painting noted in 1886: 'She knows her business and has learned the first lesson of all, that her duty is to be polite, winning, and pleasant. Whether she means what she says, or much of what her looks express, is not the question; enough if she has a smile and an appropriate answer for everybody.'[25] She is confined by the open door, her encumbered right hand, her corset and high collar, and her work responsibility; but in response to the unseen exiting customer she appears nevertheless direct and respectful, although a bit artificial. Her insincerity is

indicated by the required gesture of opening the door for the customer, while her private thoughts remain concealed behind a professional smile.

Two other women in the painting are shown avoiding intrusive male gazes. Outside the window is a female pedestrian who, even though she is passing a window full of enticing goods, casts her glance sharply down to avoid the determined gaze of an approaching young man who touches the brim of his hat. On the inside a shop-girl is caught at a vulnerable moment and in a revealing position, struggling with a box above her head, when she notices a middle-aged bespectacled man looking at her through the window. Clouded by reflections off the two layers of glass and rendered with a quick horizontal dash of paint, his right eye seems to leer at her with a near-sighted squint. She is no doubt startled by his gazing at her instead of at the goods in the window, which even include a curvaceous bust modelling a fancy waistcoat. This painting shows three women in the commercial world withholding genuine visual responsiveness from gazing shoppers.

While Tissot generated pathos by showing a captive female employee in public, Rebecca Solomon, painting 30 years earlier, portrayed another captive employee in private, envious of the freedom and privileges of an amorous couple at her side. In *The Governess* (illus. 46) the man is shown in profile, propping his head with his hand while adoring the standing blonde in a pink dress who is delighted over his attentions. Their mutual adoration accents the isolation of the governess in black. The refinement of her face implies that she is as well educated as the other woman and from the same class, but misfortune (possibly the death of her father, as suggested by her mourning outfit) has compelled her to go into service.

The governess's pose and face express multiple sources of conflict. She appears competent to teach but is momentarily neglectful, because she points to a line in the book but does not look at it. She lays an affectionate hand on her pupil, but it is a mechanical gesture. Her look is halfway between an inner reflection and an outward glance, between nowhere in particular and the couple at her side, perhaps also halfway between the life she has been forced to leave and the uncertainty ahead. The man is most likely a suitor of the daughter of the house, and therefore ineligible. The governess's mournful expression suggests the unlikelihood of her inspiring or responding to such a man's idolatrous smile, but he is the man in the painting and therefore generates expectation about her feelings toward him. That expectation might have been especially strong when the painting appeared, seven years after the publication of *Jane Eyre*, which traced a romance between the head of a house and his governess and sustained the reader's expection of the fulfilment of that love until the very end.

Throughout *A Pair of Blue Eyes* and *The Mill on the Floss* the men re-

46 Rebecca Solomon, *The Governess*, 1854, oil on canvas. Edmund J. and Suzanne McCormick Collection.

main morally less responsible than the women they love. *Jane Eyre* is about a man who rises toward a woman's higher moral standard but only after a tragedy causes his loss of sight and leads to a spiritual conversion with her help.[26] Before Jane met Rochester, he had married Bertha Mason (who went insane), had some affairs, wounded a man in a duel, and returned to England with the child of an ex-mistress (possibly his own) whom he hires Jane to educate. When she first meets him, she observes how 'his eyes and gathered eyebrows looked ireful and thwarted'.[27] Typically for Victorian descriptions, the man's eyes are associated with his brow – a hairy patch of skin over a bone that protects the eye and partly conceals it.

In his mansion Rochester summons her for a fireside chat, and she observes 'his great dark eyes'. If they did not reveal softness directly, she narrates, they 'reminded you, at least, of that feeling'. That physiognomical reading foreshadows his emotional future: an underlying softness pushing through a hard exterior.[28] Rochester remarks that her eyes fix on the carpet except 'when they are directed piercingly to my face'. Her vision continues to pierce his moral rationalizing until he learns to see the

good. When Rochester pushes up his hair to expose his forehead, Jane observes a solid mass of 'intellectual organs, but an abrupt deficiency where the suave sign of benevolence should have risen'. He is relieved by her puzzled expression because, he confesses to her, 'it keeps those searching eyes of yours away from my physiognomy'. That searching continues as Rochester defends his murky past. At the age of eighteen he was 'a good man', but now, he tells her, 'you see I am not so'. He spots a concurring glance in her eye and warns, 'beware . . . what you express with that organ; I am quick at interpreting its language' (162–7). Jane's organ of sight repeatedly puts the physically, socially, and financially more powerful Rochester on the defensive.

Jane is a formidable *eye*-er.[29] When Rochester reappears after a journey, she realizes she loves him because of what happens to her eyes in his presence: 'My eyes were drawn involuntarily to his face; I could not keep their lids under control: they would rise, and the irids would fix on him. I looked, and had an acute pleasure in looking – a precious yet poignant pleasure; pure gold, with a steely point of agony.' Brontë is attentive to the eyes of both, although she interprets Rochester's through Jane's view of them, as when she inventories his face to discover his power: the 'square, massive brow, broad and jetty eyebrows, deep eyes, strong features, firm, grim mouth – all energy, decision, will'. But in matters of love he questions his own strength, and so returns to his mansion with beautiful Blanche Ingram to increase his power over Jane by making her jealous.

Rochester sees how good Jane is, but cannot see as well as her. At this moment he is not eligible to love her openly, because he has a dark secret and cannot bear honest scrutiny. When he fails to break down her moral fibre by making her jealous, he tries disguising himself as a gypsy to influence her by fortune-telling. Now he can look into her eyes, deviously incognito, and tell her what he sees: 'The flame flickers in the eye; the eye shines like dew; it looks soft and full of feeling. . . . It turns from me; it will not suffer further scrutiny: it seems to deny, by a mocking glance, the truth of the discoveries I have already made' (229–30). That truth may include Jane's love, but more importantly at this moment it also includes her determination not to have a morally tainted love, which she manages to foresee and express through her eyes even before she understands why Rochester is tainted.

Finally Rochester reveals his strong love and proposes marriage. Before answering she must – what else? – read his countenance. She reacts quickly to the 'strange gleams' in his eyes and accepts. When, during the ceremony, she discovers that he is already married and rushes from the church, he tries to justify what he has done by explaining that his wife is insane and that he has cared for her and will continue to do so, but cannot divorce her.

Whereas previously he had urged an unenlightened Jane to commit bigamy, he now urges an enlightened Jane to become his mistress. On the heels of this offer, he threatens Jane to her face while speaking of her in the third person: 'I could bend her with my finger and thumb: and what good would it do if I bent, if I uptore, if I crushed her? Consider that eye: consider the resolute, wild, free thing looking out of it, defying me, with more than courage – with a stern triumph. Whatever I do with its cage, I cannot get at it – the savage, beautiful creature!' (344).[30] But the muscular patriarch with a stern brow is humbled by the resolute, wild, free gaze of his governess. For all the emotional turbulence in Rochester's gaze, he is powerless against Jane's intelligent and morally superior look.

She leaves the next day and within a few weeks learns that she has inherited £20,000. Before she returns to him, fire destroys his mansion and costs him his wealth and his eyesight. These misfortunes ultimately restore his faith in God and bring about his moral transformation; marriage becomes feasible across class lines after the new heiress acquires the financial means to rescue her impoverished patriarch. Jane returns to Rochester but remains momentarily incognito (recalling his gypsy ruse) in order to enjoy for a moment her visual advantage over the stumbling invalid who pathetically laments his blindness to her.

Love becomes possible with the restoration of Rochester's sight and moral integrity, assisted by Jane. She discloses her identity to him and observes a tear slide down his cheek. First she soothes away the tears, and after they are married she substitutes for his eyes. As she narrates: 'He saw nature – he saw books through me; and never did I weary of gazing for his behalf.' Restored to health and happiness thanks to her moral powers, he recovers sight in one eye. Then he recovers his sight in both eyes, in a sense, by means of her reproductive powers, because their son inherits his eyes, 'as they once were – large, brilliant, and black' (476).

In this story the woman's vision is spiritually, morally, and physically superior to the man's. The coincidences of the novel are unique to Charlotte Brontë's story, but the woman's possession of a more commanding vision of what matters most in love between the sexes is typical of the literature and art of its time.

In many other nineteenth-century love stories a woman with superior vision leads her myopic if not actually blind man by the hand toward love.[31] Emily Brontë was not as attentive to the eyes of her lovers in *Wuthering Heights* (1847) as was her sister, but her romantic lover, Heathcliff, is blinded by jealousy and cannot see Cathy's love and sacrifice for him. In the climactic scene when he rushes into her bedroom to embrace at last his pregnant beloved on her deathbed, he is afraid to look into her eyes or have her look back into his, and so he commands her, 'Kiss me

47 Pascal-Adolphe-Jean Dagnan-Bouveret, *A Rest by the Seine*, 1880, oil on canvas.
Private collection.

48 Emily Osborn, *Nameless and Friendless, c.* 1857, oil on canvas. Private collection.

again, and don't let me see your eyes!'

Men shown around working women take advantage of their servile position. Artists frequently depicted men-about-town gazing suggestively at low-paid and vulnerable milliners, flower-girls, and laundresses. Pascal-Adolphe-Jean Dagnan-Bouveret's *A Rest by the Seine* (illus. 47) shows one such overworked laundress resting with her enormous load. The painting indeed captures her economic and social disadvantages, but it does not warrant Clayson's emphasis on them: 'As in most pictures that sexualize a chance encounter between a working woman and men-about-town, [the laundress's] attractiveness coupled with her profession appear to justify and naturalize the men's impertinence. . . . The most powerful persons (the men) are the active (walking) subjects, while the least powerful person (the working woman) is the passive (seated) object of their gaze.'[32] The painting does not justify or naturalize the men's impertinence, because the viewer's sympathies align with the woman. The economically, socially, and physically more powerful men are actively walking, but that activity is predictable. We know what they are about, and their superior physical strength only accentuates their moral weakness. Their hands hold thin walking-sticks, emblematic of manual uselessness, while the woman's hands are lost in the basket and bundle of laundry, emblematic of her manual usefulness. The cigarette stub in the mouth of the man on the left adds a hint of arrogance and menace to his shadowy profile, which contrasts with the frank and sympathetic frontal expression of the weary woman. The woman's consciousness is more important and pictorially more visible. She is more intriguing, because the drama centres on her labour and isolation, her weariness and vulnerability. Her moral superiority in comparison with the men is suggested by her more frontal pose and location in a composition that features her more illuminated and detailed face.

Whether the artist was male or female, predatory male gazes were similarly devalued. Emily Osborn centred *Nameless and Friendless* (illus. 48) on another working woman under the direct gaze of two men and the indirect scrutiny of several more. It shows a pensive woman artist dressed in mourning and posed frontally with downcast eyes. Two men at the left are distracted by her entrance and look up from a print of a ballet dancer that they have been examining. The standing man looks at her out of eyes that in the shadow of his hat-brim catch a glare from the surface of the print, which intensifies the lewdness of his gaze. His seated companion also turns from the print to look at her. Together the two men seem to be plotting a crime. Other men are in full or three-quarters profile, and serve to frame the woman's brightly lit frontal face. The critical shop-owner does not look directly at her but sees her vision of the world through her art.[33]

Deborah Cherry argues that in this art world men alone have the right to look, women are 'encoded for their *to-be-looked-at-ness*', and the male gaze transforms women 'from desiring subject to desired object'. But Osborn's purpose is rather to show how a creative woman cannot be 'encoded' by gazing men. This female artist is indeed vulnerable as she nervously fingers a string while the dealer appraises her work, but she is no mere looked-at object of desire. Her pose is more active than that of the seated men. She has been outside in the rain, where the woman in the background is headed, and is about to return, possibly for more artistic subjects. She has looked at that world with creative vision to produce her art, and she retains her own capacity for sensuous desire and subjective looking. She is not, as Cherry adds, 'dispossessed of her gaze', because she never had a use for a gaze such as is caricatured in these men, and she certainly has no use for one at this moment, when her survival may be at stake.[34] She has not lost any vision, but is conserving it. She projects an unforgettable look that is indeed her own: it is thoughtful and beautiful, cautiously hopeful of a sale, anxious about rejection, protective of her younger brother, and dismissive of the ogling men.

Artists and writers were also fascinated by women preparing to perform under the watchful eyes of ballet instructors, theatre prompters, and concert impressarios. Our conception of the nineteenth-century ballet dancer as a worker is associated with over 600 artworks by Degas. No doubt his dancers were, like all dancers, preoccupied with watching themselves in mirrors to follow the progress of their strength, flexibility, and artistry. Their eyes did not engage a viewer or flash a seductive glance, but pointed as the choreographer directed: how to position the head, where to look, sometimes even when to blink. To avoid dizziness while twirling, they learned to find a spot on a wall, snap their head around to focus on it during each turn, and exclude the spinning world. Any male gaze was lost in the blur.

Degas did not render the dancer as a playful nymph or a flirtatious aristocrat but as a disciplined professional, training and performing under the experienced eyes of male dance instructors. Located in the real world, the dancer also took it in. She was, as Degas wrote in a sonnet, a 'new little being, with her bold look'.[35] She also had to contend with a special class of oglers: wealthy subscribers to the theatre called *abonnés* who could go behind stage, watch from the wings, and proposition dancers when they were not performing.[36] Degas interpreted these top-hatted intruders as comical but sinister figures: in shadows and at the margins, cut off from view by curtains and scenery, waiting in the wings and outside dressing-rooms, sometimes even inside. Degas did not exploit this privileged male gazing: he indicted it. The *abonné* shown in *Dancers Backstage* (illus. 49) is

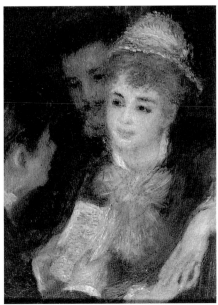

49 Edgar Degas, *Dancers Backstage*, 1876–83, oil on canvas. National Gallery of Art, Washington, DC.

50 Pierre Renoir, *Reading the Role*, c. 1876-77, oil on wood. Musée des Beaux-Arts, Reims.

triply sinister; wearing black, standing in shadow, and cut off by the margin, he is a forerunner of the even more debased men in Degas's later brothel scenes.

The two men attending to the dazzling face of the woman actress in Renoir's *Reading the Role* (illus. 50) are obscured by shadow, composition, and painterly blur. The man at the back in deep shadow looks on innocuously. The quarter-profiled man in front who cues the actress from a script is a prop to set up the alert dark eyes that shine out of her bright face, illuminated in the surrounding shadows as if she were already on stage.

The ultimate powerlessness of the male gaze to see and understand a woman, let alone to control her talent or win her love, is the subject of George Du Maurier's novel *Trilby* (1894). It is the story of the most demonic male gaze in English literature, that of Svengali, a German-Jewish musician some 40 years old, who has 'brilliant black eyes, with long heavy lids, a thin, sallow face, and a beard of burnt-up black, which grew almost from under his eyelids'.[37] The object of his desire is an eighteen-year-old milk peddler and artist's model named Trilby. She is tall and fully-developed with eyes too far apart and 'a very fine brow, broad and low, with thick level eyebrows much darker than her hair' (13).

Svengali mesmerizes Trilby to cure her bad headache and uses the

occasion to examine her mouth. He suggests that the next time she has a headache, she should come to him for treatment. After he removes the pain, he says 'you shall see nothing, hear nothing, think of nothing but Svengali, Svengali, Svengali!' (57). When she would refuse his cure, as Du Maurier narrates, 'he would playfully try to mesmerize her with his glance, and sidle up nearer and nearer to her, making passes and counter-passes, with stern command in his eyes, till she would shake and shiver and almost sicken with fear' (83). The central drama of this novel is the struggle between Svengali's gaze and Trilby's soul.

While he tries to control her soul through her eyes, three artists enchanted by her try to capture on canvas the depth of character and capacity for love in her eyes. During one sitting, Little Billee, the most enamoured, looks for his own self in their reflection: 'Her grey eyes fixed on him with an all-enfolding gaze, so piercingly, penetratingly, unutter-ably sweet and kind and tender, such a brooding, dovelike look of soft and warm solicitude, that he would feel a flutter at his heart' (75). He wants to capture on canvas what her piercing eyes see, but after he bungles a marriage proposal, she disappears.

Five years later he and his two friends discover the awesome potency of Svengali's gaze when they find out that the great creative potential they had seen in Trilby's eyes is now realized in concert singing which she per-forms while in a trance: 'Her voice was so immense in its softness, rich-ness, freshness, that it seemed to be pouring itself out from all round; its intonation absolutely mathematically pure' (248). Trilby is *the* great artist of this story. The highest achievement of her talent is activated by a man's gaze, but the trance he induces also isolates her from access by normal communicative means and turns her consciousness back toward her inner self, the source of her creative genius.

Du Maurier also illustrated the novel. His drawing for the first perfor-mance that the artists attend, titled *Au clair de la lune* (illus. 51), shows a moment when Trilby began singing 'and her dove-like eyes looked straight over Svengali's head, straight in [Billee's] direction – nay, *at* him – [and] something melted in his brain, and all his long-lost power of lov-ing came back with a rush' (251). Trilby's inspiring look thus restores life and love to the artist. The drawing also shows another aspect of this same moment, as the mesmerized Trilby towers over Svengali and looks away from his powerful gaze even while under its spell.[38]

The dramatic climax involves a sequence of looks. On the evening of Trilby's London debut, her artist admirers are in the audience and spy Svengali in a box. He leers back in jealousy and anger with 'the whites of his eyes showing at the top, and his teeth bared in a spasmodic grin of hate'. Trilby anxiously eyes Svengali's box but hesitates to sing. Unknown

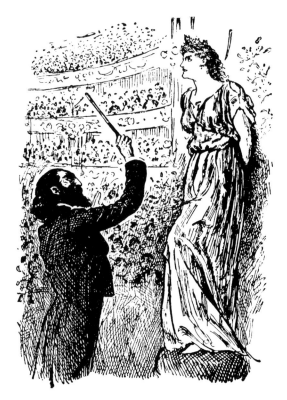

51 George Du Maurier, 'Au clair de la lune', illustration for *Trilby*, New York, 1894.

"AU CLAIR DE LA LUNE"

to everyone in the theatre, Svengali has just died of a heart attack but remains sitting with his mesmerizing eyes still visible above a 'ghastly, sardonic smile . . . of hate and triumphant revenge'. His death releases Trilby from a five-year trance, and she suddenly does not understand why this conductor is asking her to sing. She sings an old ditty off-key, and the conductor looks accusingly at Svengali, not realizing that he is already dead. As Trilby leaves the stage, Svengali remains propped up in his chair 'watching his wife's retreat – still smiling his ghastly smile' (292–96).

The next day Trilby explains to the artists how she came under his spell, and she revitalizes their capacity to love. Billee says, 'a mere look from your eyes, a mere note of your heavenly voice, has turned a poor miserable, callous brute back into a man again!' (311). Trilby's eyes possess a restorative strength, which she augments on her deathbed by giving all three artists a ring to be worn by their brides if ever they marry.

Years later one of the artists meets the violinist who was present during the years when Svengali kept Trilby in a trance and trained her voice. The violinist explains the ultimate failure of the master's malevolent gaze:

'With one look of his eye – with a word – Svengali could turn her into the other Trilby, *his* Trilby – and make her do whatever he liked . . . and think his thoughts and wish his wishes – and love him at his bidding with a strange, unreal, factitious love . . . just his own love for himself turned inside out. . . . It was not worth having!' (357). The quintessential patriarchal gaze failed to control or possess anything of value.

In many respects Trilby was indeed the object of men's visual powers: she was conceived and created by a male author; her readers saw her through the adoring eyes of three male artists plus Svengali's evil eye; her original appeal to all four had to do with showing herself, posing for their creative purposes; the artists worshipped her physical charms; and Svengali coveted her magnificent mouth. But in trying to possess her, all four became themselves possessed. In the end she restored to the painters their ability to love. The loss she suffered in Svengali's power proved to be superficial, because he could not take her soul. What Svengali got from his predatory gaze was indeed 'not worth having'.

Du Maurier belongs with a number of male and female writers and artists who depicted working women with greater capacity to love and do good, even to understand and create, than the men they worked for. These artists and writers may not have explicitly acknowledged that moral superiority, but they nevertheless consistently made those traits visible in women's eyes. Manet put his longing for the world of art and adventure into the eyes of his barmaid Suzon and half effaced the male patron gazing at her, who is visible only in the mirror's reflection. Solomon captured a bitter longing for emotional and cultural riches in the mournful eyes of her impoverished governess that contrast with the gushy eyes of a romancing man. Charlotte Brontë traced a triumph of goodness in the eyes of Jane Eyre battling a man with eyes that were initially 'ireful and thwarted' and subsequently blinded before his partial vision and moral integrity returned with her help. Degas depicted hundreds of ballet dancers whose eyes ignored the ogling of the *abonnés* and moved artfully under the direction of a choreographer. Du Maurier crafted Trilby's Faustian struggle for her own soul that was threatened by a man whose name made its way into the dictionary as 'a malevolent hypnotist'. Her demonic enemy was a cartoon character, and her final triumphant look across the stage killed his evil eye and restored to three artists their capacity to love. The last thoughts of Svengali might well have echoed those of Rochester when he realized his own incapacity to control a woman whom he desperately needed: 'Consider that eye: consider the resolute, wild, free thing looking out of it, defying me, with more than courage – with a stern triumph. Whatever I do with its cage, I cannot get at it – the savage, beautiful creature!'

4 The Nude

Evidence for the representation of women as sex objects is most compelling in the countless female nudes with allegorical meanings that were so popular in nineteenth-century art: alert Muses holding up the mirror of Truth, predatory Dianas grasping a bow and arrow, voluptuous Venuses stepping out of the sea, modest Susannas seated by a bath, lounging concubines imprisoned in a harem, sultry nymphs sleeping beside a pond. Spectacularly naked, flawlessly endowed, they are posed to reveal appealing contours of flesh to men as viewers, or sometimes to men within the painting itself. But these models are not simply sex objects, because they retain their subjectivity even as they pose for gazing men.

Two famous Salon nudes reveal often overlooked sources of the nude's own subjectivity. In Ingres's *The Turkish Bath* (illus. 52) none of the concubines looks at the viewer and only a few look at one another. They show their bodies but withhold visual responsiveness; one concubine in the very lowest right section actually holds her eyes. Together they create the expectation of an explosive counter-look. Far from documenting the woman as a mere sex object for the male gaze, this painting proclaims the limitations of male sexuality and visual control.[1]

These concubines epitomize availability, but no man could make his way past them without sensing the potential subjectivity of all these women, because above every pair of breasts would be an enigmatic pair of eyes, and behind each of them would be the endless possibilities of a human consciousness. The three women in the right foreground, detailed on the dust-jacket of Hess and Nochlin's book *Woman as Sex Object*, are a vortex of erotic capability – self-contained and remote from male gazing, not objectified by it.[2] The frontal eyes of the large foreground nude with raised arms are not objectified by an intrusive male gaze but locked to the side, prominently disengaged from any visual solicitation. The nude behind her looks attentively at the nude playing an instrument, while squeezing her companion's breast. More than a mere sex object, she is sensuously active in touching, seeing, and hearing, while the censer being used nearby also stimulates her sense of smell. None of the nudes looks

52 J.-A.-D. Ingres, *The Turkish Bath*, 1862, oil on canvas on wood.
Musée du Louvre, Paris.

down modestly, some look about with desire, and all seem impervious to
the male gaze and quite capable of looking wherever they please, even if
they are not free to *go* wherever they please.

Perhaps some mythical Turkish potentate might be able to walk coolly
through such a harem to survey and choose, but for a nineteenth-century
West European such a feat would violate every precept of liberal, human-
itarian, or Christian morality, and its emotional effect would be anxiety
mixed with desire. He would be distracted from looking pleasurably at the
concubines' naked flesh by their potent eyes filled with pent-up sexuality
as well as resentment and hostility. Collectively the harem is a formidable
network of visual capability. Sleepy or drugged, overfed or overstimulat-
ed, these nudes announce the impossibility of their sexual satisfaction in
the midst of sexual plenty. The scene depicted in *The Turkish Bath* may
be a visual feast for the male gaze, but it is also a visual gauntlet for the
male ego.

Rozsika Parker and Griselda Pollock argue that in such images the man's absence secures his dominance: 'Woman . . . is passive, available, possessable, powerless. Man is absent from the image but it is his speech, his view, his position of dominance which the images signify.'[3] Absence does protect, but in this painting women dominate the viewing. As with the supposedly privileged position of the incognito *flâneur*, hiding and concealment evade responsibility and show not strength, but weakness. Men looking at naked women through keyholes (as the tondo form suggests) are morally suspect. The eyes of the women in *The Turkish Bath* are, like all human eyes, active, possessive, and powerful even if they are not looking desirously at a man.

Males are not as completely absent from Alexandre Cabanel's *The Birth of Venus* (illus. 53). Robert Rosenblum interprets the painting's objectification of woman as 'a dream of carnal abandon and easy accessibility that corresponded to a fantasy shared by many male spectators of the period. Served up on a shell, cushioned by cascades of unbound russet hair, tilted backward from toes to bedroom eyes in supine acquiescence, this Venus hovers somewhere between an ancient deity and a modern dream.'[4] Rosenblum includes many compelling reasons for the appeal of this striking body, but he omits the visual ambiguity that must have given pause to male spectators. That ambiguity is in Venus's eyes. At first glance they seem closed in sleep and covered by her arm, but a close look reveals that she is awake and that her forearm shades rather than covers her eyes. The whites of her eyes are visible between slit lids, and her dark pupils are turned to her right, perhaps directed toward the putti. Her ambiguous

53 Alexandre Cabanel, *The Birth of Venus*, 1863, oil on canvas. Musée d'Orsay, Paris.

glance is unnerving. A sleeping nude derives visual potency from the pos-
sibility of her waking, and an awake nude has the power to see, but a nude
who could be asleep or awake is especially formidable for a male viewer,
because he does not know if he can be seen. However he reacts, his motives
are confused and his actions suspect.[5]

Male spectators of a sort appear in this painting, but the five putti con-
spicuously fail to measure up to the woman in body size, sexual capability,
or visual potency. Two of them fly off tooting on conch shells. Another
hovers above her and looks away. A fourth just above her elbow reacts as
though she were too sacred, or too sensuous, for him to dare touch with
his tiny hands. The animated fifth putto above her abdomen is over-
whelmed, and his glowing boyish eyes express overweening desire. Like a
child trying to romance an adult woman, he is ill-suited physically and
sexually. His eyes are too big and his penis too small.

Parker, Pollock, and Rosenblum are not alone in viewing such paintings
as evidence of female objectification under the triumphant male gaze.
That sexual dichotomy is treated by many scholars as historical fact.
'Sometime beyond the middle of the eighteenth century', writes Peter
Brooks, 'the female nude is well established as the erotic object of specifi-
cally gendered spectatorship'.[6] Charles Berheimer also uses the passive
voice to confirm the universality of this sexual difference: 'Traditional
representations of the nude put woman on display for the pleasure of a
spectator presumed to be male. Her naked body becomes nude insofar as
it is seen as an erotic object offered to the male gaze.'[7] Anthea Callen's
interpretation of the objectification of Degas's nudes goes against com-
mon sense: 'Degas assigns to his own sex the power to see, to know and
give meaning to woman, as she is incapable of knowing herself – incapable
of consciousness.'[8]

In 'The Female Body and the Male Gaze' Norma Broude and Mary D.
Garrard sum up recent scholarship: 'A central critical principle of feminist
and other postmodern theory of the past decade has been the concept of
the "male gaze". In a gender-imbalanced world, as Laura Mulvey ex-
plained in her influential 1973 article, males assert their power through the
privileged and, in linguistic terms, the "subject" position of looking, while
females are the passive, powerless objects of their controlling gaze'.[9] These
generalizations about a gendered spectatorship are partially correct in that
nude art does reveal primarily women painted by male artists for male
viewers, but they are incorrect for two reasons: they fail to consider ade-
quately the vision and awareness of female nude models, and they make
bogus dichotomies out of the relational philosophy on which they are
based.[10] Before returning to the artistic and literary evidence for the female
nude's subjectivity, I must sketch the origins of that relational philosophy.

The subject–object distinction has long been used to understand the difficult philosophical problem of how a subject that is interior to itself can have knowledge of an object exterior to itself. To express that relatedness philosophers needed to refer to the subject*ive* and object*ive* aspects of knowing, but they did not need to separate those interrelated aspects into discrete entities as *the* subject and *the* object. Such dichotomization clouds understanding of the way a human being can relate to anything that is outside of itself. That understanding is even more problematical when what is outside is another person.

In his *Phenomenology of Spirit* (1807) Hegel explored the interaction of the subjective and the objective in human relations. An individual needs the Other to realize its individuality in a process of 'recognition', which implies not only a recognizing of the other but also a re-cognition of the self by interacting with the Other. 'The first does not have the object before it merely as it exists primarily for desire, but as something that has an independent existence of its own, which, therefore, it cannot utilize for its own purposes.' Communication between these two is a double movement of two self-aware individuals. As a result 'they *recognize* themselves as *mutually recognizing* one another'.[11]

In *The Second Sex* (1949) Simone de Beauvoir elaborated the concepts that subsequent theorists used to tag women as 'sex objects'. She based her philosophy of female objectification on Sartre's philosophy of human relations, which is itself derived from Hegel. Sartre viewed human relations as a struggle between equal consciousnesses that are expressed in 'the look' (*le regard*), the major twentieth-century source for subsequent theorizing about 'the gaze'. For Sartre, men do not own the look, because no one can. An individual cannot even own his own look, because its autonomy is always compromised in freely looking anywhere it wants by the counter-look of others. Sartre's social world is a combat zone of peering eyes.

Beauvoir's analysis is divided between an essentialist philosophy that regards humans as inherently subjective and a historical reconstruction of how 'man put himself forward as the Subject and considered the woman as an object, as the Other'. 'The drama of woman lies in this conflict between the fundamental aspirations of every subject (ego) – who always regards the self as the essential – and the compulsions of a situation in which she is the inessential.'[12] Beauvoir does not resolve this conflict between the necessary aspiration of every subject and the accidental compulsions of each situation, but offers abundant evidence on either side. Her compelling arguments for the essential and hence inalienable subjectivity of women are omitted by many theorists who maintain that men own the gaze.

I do not question those historical events whereby men succeeded in making woman the Other. My Introduction lists many of them. But I do question neglecting the essential consciousness manifest in the eyes of all human beings: man and woman, artist and model. I also question the dichotomous nature of scholarship about 'the female body and the male gaze', because it fails to appreciate the relational nature of the philosophies (from Hegel to Sartre to Beauvoir) from which its own gender theorizing is ultimately derived.

Such a relational interpretation of the artist and model is taken by the Belgian art historian France Borel. She begins a chapter on 'The Two-Way Seduction of the Gaze' with the 'eyebeams of the creator [that] strike his subject, enveloping, penetrating, caressing and assaulting it'. The artist seduces the model but is also is seduced by her. 'Desire condenses in her contours [and is] transformed beyond its anatomical destiny, its naked truth, by the eyes of the artist'. 'The artist tries to reassure himself through her, but she keeps him off balance . . . disguises herself . . . hides herself behind the varied poses . . . to be reborn elsewhere, in another form, in the immortality of the work of art'. 'Though occasionally a dictator, he is nonetheless dominated by his subject and the mental images to which he tries to give form'. 'The artist tries to capture the nudity of the woman. But the woman posing is also an ogress; she attracts the artist, magnetizes his gaze, directs it to the edge of her own self'. 'The artist's and model's eyes cross and clash in a voluptuous duel'. 'The woman who poses, the seductress, is never exactly where the artist wants her to be'. 'Seduction oscillates between two poles: between a strategy, the artist's willful, determined obstinate application to his work . . . and an animality, the nude model's brutal, physical suggestivity, flung into the face of the dissecting gaze, the visual embrace'. Borel's interpretation of the visual exchange between artist and model is closer to studio practice than a one-way visual domination of one sex by the other.[13]

Such a reciprocal seduction of artist and model is also the dramatic focus of several literary works that provide words for the mute nude model in art. The heroine of *Trilby* was an artist's model, who maintained a potent subjectivity whether posing clothed or in the nude. Her beloved artist Billee became insanely jealous when she posed nude for someone else. He burst into the studio, stared at her in disgust, and 'stood as one petrified', that is, objectified. Trilby's eyes had the power to inspire or defeat the artist from the earlier days of her comforting look while modelling clothed to her later astonished look when caught modelling nude.

While Trilby is degraded by an artist's outrage at her posing in the nude, the heroine of Ibsen's *When We Dead Awaken* (1899) is degraded by an artist's lack of passion while she posed nude for him. After many years

separation, the great sculptor Rubek meets his former model Irene, who tells him her secret truth – that he 'wronged [her] innermost being'. As she tells him, 'I stripped myself naked for you to gaze at me . . . and you never once touched me'. She gave her young soul, and he took it and left her empty. Rubek explains that he had longed to create a great work in the likeness of a young woman who symbolized everything that is 'sacred and untouchable, fit only to be adored'.[14] When she modelled in the nude, he looked at her body but refused to see her love, because his desire was killing his passion for art. If he had touched her, he would have been profaned.

Irene reveals what he had refused to see in her eyes. 'When I stripped myself naked and stood there before you, I hated you . . . because you could stand there so unmoved . . . so intolerably in control of yourself . . . and because you were an artist, only an artist, not a man!' (353). The supreme insult was what he said when he finished – 'This has been an inspiring episode in my life' (357). Irene could not bear having the sacrifice of her love referred to as an 'episode'. She reminds him that years before he had offered to show her something wonderful: 'High, high up on a dizzy mountain top. You enticed me up there and promised you would show me all the glory of the world, if . . . I did as you told me' (359). Her modelling and his painting were to have been a shared vision of the glory of the world, but he was dead to her love, and the promised vision remained unfulfilled at the end. They could not look directly at one another years before and were denied a fulfilling vision in the end. As they at last hike to a spot where they can see everything together, they are killed by an avalanche.

Trilby could not express what she saw in her artist admirer, because she did not understand his limited vision of her. Irene remained silent for many years out of indignation over her sculptor's blindness. Another model from literature, the heroine of Zola's *L'Oeuvre* (1886), tried repeatedly and also without success to express her feelings to an artist who sacrificed love for art.[15]

Claude Lantier, the hero of Zola's novel, is an imaginative mix of Cézanne, Manet, and Degas.[16] One night Claude offers shelter to young Christine Hallegrain whom he meets by his door, rain-soaked and lost. She is sexually innocent and reluctant to undress. In the morning he discovers that her chemise has slipped down while she slept and bared her breast. She is precisely the sort of model he had been trying to find, and he begins sketching her. She awakens disturbed to see him 'devouring her with his eyes'.

When she appeared, Claude had been working on a landscape with female nudes and was having trouble with the central figure. As he paints

Christine's face to go with the nude's body, his feelings for her grow. She leaves and turns up six weeks later only to be shocked at the 'uncouth' way he had put her head on a nude body, so she disappears for two more months. As model after model fails to inspire, Claude sinks into impotence and doubt. Christine reappears, now an artist herself, and they grow closer. He comments on her sketches, and she warms to his passion for art. She agrees to model, but only for the head. Claude realizes the folly of putting her head over another woman's body and begs her to pose for the entire nude. Eventually she realizes that she does not want someone else to model the body. 'She wanted it to be *her* picture, hers entirely', so she undresses to pose. Her eyes conceal her humiliation and resolutely maintain 'the fixed, mysterious smile that was part of the pose'. Her eyes become the refuge of an identity that she must work to maintain, as he continues to devour her with his eyes.

His exhibition of her as a nude humiliates them both: he from public ridicule, she from public exposure. But back in the studio she swallows the shame, courageously reassuring him that she is proud to be of help. He remains inconsolable until she kisses him. Sex thus restores his confidence in his art and her confidence in their love. Next day they lie together in a climactic moment of re-cognition, 'gazing ecstatically at the flecks of gold each saw sparkling in the depths of the other's brown eyes' (143).

Christine conforms to the nineteenth-century male's (and Zola's) fantasy about passion erupting in a virgin. Once released, she allows her sensuality to gush forth without bounds in order to please Claude's every desire, guided miraculously by nature rather than past experience or his direction. Desiring her body inspires his art, but fulfilling that desire brings it to a stop. After they marry he loses interest in her sexually and lives only for art. In desperation she agrees to model. During the sessions he looks at her 'with eyes that slashed her across like knives', and she is 'reduced to being nothing more nor less than a kind of human lay figure which he set in position and copied' (243). His maniacal gazing burns up her identity. 'He had been looking at her ever since morning, but she knew it was not her image she would find in his eyes, she was a stranger to him now, an outcast' (245). One day he forgets the customary kiss after a long session and she is further degraded. He tries (and fails) to strip away her subjectivity and leave nothing but an objectified naked body: 'He wanted all women, but he wanted them created according to his dreams: bosoms of satin, amber-coloured hips, and downy virgin loins' (246). No mention of eyes.

After two years of struggling he is still unable to make his nude real, because, he complains, it 'didn't *say* anything' (248). It could not speak because of what he worked to remove – the voice of her humanity. Unable

to speak to her, he tries to shut her up; unable to feel his passion for her, he tries to destroy it. After an especially frustrating session, he thrusts his fist through the canvas, doing to his art what he repeatedly does to Christine emotionally in a destructive cycle that lasts several more years: he begs her to pose in the nude, she reluctantly agrees, he becomes inspired and then quickly discouraged, he debases her with some new humiliation, she refuses to pose, he becomes despondent, she mothers him back to health, and once again he begs her to pose.

Late one night, years later, she discovers him working like a madman on the nude and realizes that he is a failure and that the painting will never be finished. She makes a final attempt to help him see what he had fought so hard to remove from their love and efface from his art – the love in her eyes. Out of a crazy notion that genius must be chaste, he had spurned her sexually for over eight years, but the result had been artistic impotence, not success. Frantic, she points at the nude and lashes out: 'Now look at . . . the woman you love and see what a monster you've made of her in your madness! . . . Did any woman have bright gold thighs and flowers growing out of her loins? Wake up! Open your eyes and come down to earth again! You're lost!' (351). Claude looks at the nude and realizes that he has been blind to Christine's beauty and dead to her love. She rips off her nightgown, poses seductively, and begs him to compare her in the flesh with the monstrosity he has made of her on the canvas. 'I'm still as I was at eighteen, and the reason is: *I* love you'. She offers the oblivion of sexual fusion. 'I'll kiss you on your eyes and your lips and on every part of your body. I'll warm you at my breast; I'll twine my legs round yours and clasp my arms around you and I'll be you.' One evening she makes him spit on the nude and promise never to paint again. After his enforced desecration they make love savagely, as if to force through the narrow conduit of sexual connection all the love they are unable to express to one other.

Claude awakens alone and in despair. Having spat into the eye of his nude, he hangs himself in front of it. Christine finds him in the morning. 'His face was turned towards the picture and quite close to the woman whose sex blossomed as a mystic rose, as if his soul had passed into her with his last dying breath, and he was still gazing on her with his fixed and lifeless eyes' (356). Years earlier Claude had first laid eyes on Christine's exposed body as she lay asleep. In the end she finds his dead eyes still fixed on the muddled image of her body that he had been unable to capture, because he was unable to see her as a human being and allow her to have a vision of her own.

Zola's novel addresses one of the major developments in art during the second half of the nineteenth century – the shift in subject-matter from the nude to the naked woman. The difference between these two kinds of

figures is not about dress, because both are without clothing; it is about the way they are revealed. Classical nudes are veiled or metaphorically 'clothed' by conventions that make them remote in time, place, and identity in contrast to real naked women with real names and identifiable professions, performing everyday activities in the present moment. Throughout this study I use *nude* to describe paintings of undressed women that violate the conventions of the Salon nude, because the term *naked woman*, though more accurate, still seems remote from the subject of serious art.

In the studio Christine fought for her actuality and her subjectivity, while in the bedroom she fought against the imaginary pictorial nude to which Claude had become fixated. She failed to sustain her subjectivity with love and understanding in the face of his knife-like artistic gazing and so resorted to seduction and vindictiveness in a futile effort to rescue him. Her struggle to maintain her subjectivity under Claude's objectifying artistic gaze typifies a more general struggle at the heart of the dynamic history of the nineteenth-century nude.

Claude's desire to render a real nude who could 'say something' was also the desire of the Impressionists who disregarded convention and depicted the nude female as she is found in everyday life, able to see for herself. One marker of that history was the scandal over Manet's nude in *Olympia* (illus. 66) which was fueled by her reality and actuality, by her stunning frontal look, which gave the impression that she might just be about to say something. During the remainder of the century nudes seemed to develop more capacity to express their actuality and their subjectivity by looking back at the male gaze, by remaining impenetrable to it, or by ignoring it.

The most explicit literary source for a gazing male artist as subject and a sightless naked woman as object is the myth of Pygmalion, which attracted considerable interest among nineteenth-century artists. As Linda Nochlin concludes, it 'admirably embodies the notion of the artist as sexually dominant creator: man – the artist – fashioning from inert matter an ideal erotic object for himself, a woman cut to the very pattern of his desires'.[17] In Ovid's *Metamorphoses* the artist's story is told by Orpheus, who was himself punished for looking at a woman. Pygmalion was a legendary king who turned away from women because he found too many prostitutes among them. He carved a beautiful nude figure, Galatea, to fulfil his longing for love. His fantasies about her coming to life involved touch more than sight. After adorning her body with robes, necklaces, and earrings, he 'kissed the statue . . . and thought he felt his fingers sink into the limbs he touched'. Galatea did acquire vision, but not from the artist's

powers. Venus brought her to life in response to Pygmalion's prayers, and he discovered that she was alive not by gazing into her eyes, but by touch. 'She seemed warm: he laid his lips on hers again, and touched her breast with his hands . . . and stroked the object of his prayers. It was indeed a human body! The veins throbbed as he pressed them with his thumb.'[18] Then Galatea opened her eyes and became his wife.

Galatea acquired consciousness and vision passively, and Pygmalion certainly used his eyes while creating her form. But for several reasons the myth cannot be characterized simply as the story of a 'sexually dominant creator: man – the artist – fashioning from inert matter an ideal erotic subject for himself'. Pygmalion is not sexually dominant, because his dominant creative role is a function of his artistic, not his sexual, powers. Second, his creation is not an alive erotic object, because when his creative efforts are finished, that object is still inert material – marble. Third, he does not endow Galatea with vision, consciousness, subjectivity, or life: those crucial creative functions are accomplished not by 'man – the artist' but by a goddess. And finally, after Galatea comes to life, Pygmalion seems uninterested in, if not intimidated by, an essential element of male as well as female eroticism – vision – and so responds to Galatea primarily with touch.

The most famous Victorian paintings about this myth also avoid a simple subject–object dichotomy between artist and model. In 1868 Burne-Jones began a series of four paintings illustrating the story of Pygmalion. The model for Galatea was Maria Zambaco, a married woman with whom he was having a tempestuous affair. She was wealthy, artistic, and emotionally volatile, and like him she was married and unwilling to leave a spouse and children. He projected his frustration into this myth in which an artist's even more hopeless love for a model was fulfilled. But Burne-Jones's paintings, like the myth itself, are not those of the male artist in command over his nude creation, but a mixture of suffering and uncertainty, a groping for reciprocal love and visual recognition.

The third image in Burne-Jones's series, *Pygmalion and the Image: The Godhead Fires* (1879; City Art Gallery, Birmingham), shows Venus entwining one arm with those of the already animated Galatea while looking into her eyes. Venus creates consciousness in Galatea with a touch, but especially with a look, and Galatea's look in return is the most intense of the series. In the fourth image, *Pygmalion and the Image: The Soul Attains* (illus. 54), Galatea, with eyes that can finally see, looks not at Pygmalion but over his head. His one visible eye is rotated up, creating an eerie mixture of blindness and fixation. Far from representing 'the artist as sexually dominant creator . . . fashioning . . . woman cut to the very pattern of his desires', the painting shows the artist kneeling humbly, as if proposing

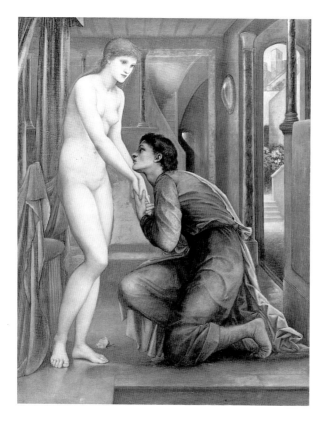

54 Edward Burne-Jones, *Pygmalion and the Image: The Soul Attains*, 1869–78, oil on canvas. Birmingham Museums and Art Gallery.

to his long-awaited fantasy love, but not knowing precisely what to do with her now that she is alive.[19]

In turning Pygmalion's eye away from Galatea, Burne-Jones avoided suggesting that he could actually see her nakedness, which, given the composition, would mean looking straight at her abdomen. Burne-Jones also buffered such a shocking male vision of actual female flesh by identifying his figures with mythological characters and by universalizing their features so as to make them unrecognizable. He did not portray his own frustrations with a naked Maria Zambaco (as 50 years later Egon Schiele would do with his tempestuous mistress-model Wally Neuzil), but rather he portrayed the frustrations of a mythical artist from classical antiquity updated to a medieval setting and in that way distanced his stand-in artist in time and space from being a real male with real eyes seeing actual female flesh.

The Impressionists and Post-Impressionists had little use for those conventions and shocked the viewing public with visually alive nudes. Among the most sensuous of these is the one in Caillebotte's *Nude on a Couch* (illus. 55), an imposing life-size figure who is hardly objectified by

the male gaze. Even though her body is revealingly open to view, she is visually self-involved and emotionally self-sufficient. Her eyes may be closed or slightly open, but either way their direction is down toward her hand as it rests on her breast, with the index finger touching her nipple as she calmly indulges her own need for rest or stimulation. The notion that female sexual arousal is acutely intentional is undermined because she is touching herself almost inadvertently. Gloria Groom observes how this nude 'challenges our experience of spectatorship and activates our own anxieties about sexuality and looking'.[20]

The nude's clothing and pose as well as the play of light on her body also indicate self-sufficiency and sensuousness. The boots are for her to walk in, not props for arousing a man. Her bare feet look real: their soles are still red from a recent walk; her toes are crushed-in; the nails are mis-shapen. A slight mark around her waist signals that she may have just come in and undressed. This woman seems to be resting after a long walk more than she is posing in the nude. Her red hair is still coiffed high (she takes trouble over her appearance), while her luxuriant pubic hair hints at an abundant sexual capacity and sensuous private side. Light falls on her tilted right leg, which guides the eye in a curving line to her pubis and from there to her right hand.

55 Gustave Caillebotte, *Nude on a Couch*, 1882, oil on canvas. The Minneapolis Institute of Arts.

Although this portrayal of a nude may have stimulated nineteenth-century male voyeurs, the woman depicted in it is – in and for herself – an embodiment of subjectivity. She has walked where she wished to and undressed when and where it pleased her, not for a man in a top-hat or an artist at an easel but for her own convenience, tossing onto a pillow her black skirt and chemise. While falling into a restful slumber, she casually fondles herself. One of her arms lies across her breast, while the other shades her eyes from the sunlight that seems to warm her body for comfort as well as illuminate it for a male gaze.

Two other painters actualized the nude in other directions – Gauguin toward the primitive and Degas toward the modern.

Gauguin's later life marks a high point of male victimization of women. At the age of 53 this white, male, European artist infected with syphilis[21] left his wife and children and travelled to Tahiti to find new erotic and artistic opportunities. There he made a thirteen-year-old Polynesian girl named Tehamana his mistress and model. When she became pregnant and could no longer pose, he took another model. When Tehamana left him, he replaced her with two other teenage mistress-models whom he most likely also infected with syphilis.

While in actuality Gauguin dehumanized several Tahitian mistresses, his art celebrated the island's women as the quintessence of beauty, goodness, and vision. Shortly after arriving he wrote 'I understand why these individuals can remain seated for hours, or for days, without saying a word, and look at the sky with melancholy'.[22] Of course, he had no idea why they sat and looked at the sky. He pursued his wonder right into their enigmatic eyes, which he repeatedly depicted as diverted from him and out into the world. When their eyes directly engaged his own, they were disarming, as he noted in a description of the journey he took with Tehamana back to his house: 'We did not cease studying each other, but she remained impenetrable to me, and I was soon vanquished in this struggle.'[23]

Gauguin tried to read Tehamana's eyes late one night when he returned home and found her in bed naked. That scene was the inspiration for *Manao tupapau (The Spirit of the Dead Watching)* (illus. 56). As he recalled, her 'eyes [were] inordinately large with fear. She looked at me and seemed not to recognize me. . . . I had the illusion that a phosphorescent light was streaming from her staring eyes. Never had I seen her so beautiful.'[24] Her potent eyes were themselves filled with terror. He supposed that she may have thought he was one of the spirits of the dead with glowing eyes that cause nightmares. This painting captures a scenario of fear that originated in some distant ancestor, haunted the nights of intervening generations, and took on a hallucinatory presence for Tehamana in the

56 Paul Gauguin, *Manao tupapau (The Spirit of the Dead Watching)*, 1892, oil on burlap mounted on canvas. Albright-Knox Art Gallery, Buffalo, NY.

luminous flowers and in the glowing profiled eye of the Spirit of the Dead, which she may have imagined as Gauguin's own. Tehamana's impenetrable eyes are especially evident, because even though they are wide open with fear, they are difficult to read. She is typical of those Tahitian women painted by Gauguin who do not betray strong emotions and who are shown casually naked performing everyday activities. They are monumental and stoic, with bronzed skin and broad calm eyes that seem incapable of being lowered in shame.

Gauguin searched their eyes for a lost paradise that was more his own fantasy than a lost reality. In 1895 he explained why he went to Tahiti: 'In order to produce something new, you have to return to the original source, to the childhood of mankind. Eve, as I see her, is almost an animal; and this is why she is chaste, though naked.'[25] He hoped that naked primitive women would reveal the childhood of humanity, which he would embody in naked Tahitian Eves to reinterpret the beginning of Christian sexual morality. Gauguin recast Eve's responsibility for the origin of sin by emphasizing her role as the first active moral agent.

Eve was tempted to eat the fruit of the Tree of Knowledge by the serpent, who appealed to her desire to know and to see:

'For God knows that when you eat of it your eyes will be opened, and you will be

like God, knowing good and evil'. So when the woman saw that the tree was good for food, and that it was a delight to the eyes, and that the tree was to be desired to make one wise, she took of its fruit and ate; and she also gave some to her husband, and he ate. Then the eyes of both were opened, and they knew that they were naked.

The primordial couple's new sense that they were naked was their first experience of the Fall. Although they both became aware of their nakedness at the same time, they did not bear equal responsibility for their shame, because it followed from Eve's action: she alone conversed with the serpent; she alone first saw that the Tree of Knowledge was a delight to the eye; she alone had the courage to defy God's prohibition, however misrepresented by the serpent; and she first acquired the knowledge of good and evil that God forbade to Adam. Only after she gave the fruit to Adam did he acquire the capacity to know good and evil, and only then were the eyes of both opened.

Thus Eve's first historically significant acts were to take the initiative in seeing what the Tree was good for, to be delighted by what she saw, to defy God's prohibition in order to become wise (i.e., to see), to lead her husband out of ignorance, and to transform herself and him into morally responsible beings capable of shame. The Fall was about daring to see and to know, and the woman was the more daring.

Eve and her female descendants were punished by having child-bearing made into a painful process and by being always subservient to men. Later orthodox Christian commentators emphasized the role of women's sexual temptation in the moral corruption of men.[26] But these commentators misinterpreted Eve's actual responsibility in what was the first moral transgression. They blamed her because she was responsible, but her responsibility located the origin of moral action in her. The subservience to man with which God punished Eve and all her female descendants remains a consequence of her path-breaking moral action, and man's moral authority over woman is compromised insofar as it is based on an event in which he showed moral cowardice. Adam proclaimed both Eve's greater moral responsibility as well as his own moral cowardice when, in response to God's anger at their disobedience, he replied, 'The woman whom you gavest to be with me, she gave me the fruit of the tree, and I ate.' Eve, at least, blamed the serpent.

Gauguin's *Te nave nave fenua (The Delightful Land)* (illus. 57) reinterprets Eve's role in the grounding moral act of Christendom. It shows a virginal Eve standing in a Tahitian Garden of Eden. Gauguin replaced the serpent with a red-winged flying lizard just above her right shoulder that suggests various evil males: the serpent, the devil, a dragon, and a tempter of women. Eve takes on this primordial seducer, a seducer with whom

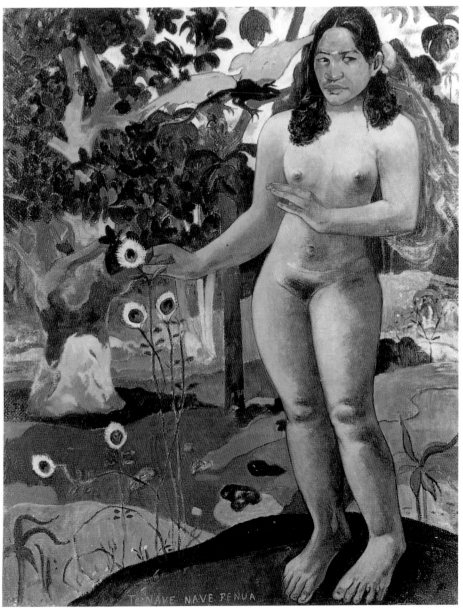

57 Paul Gauguin, *Te nave nave fenua (The Delightful Land)*, 1892, oil on canvas. Ohara Museum of Art, Kurashiki.

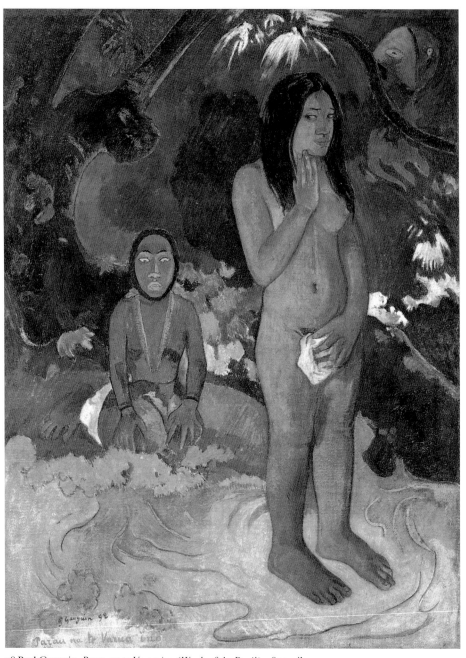

58 Paul Gauguin, *Parau na te Varua ino (Words of the Devil)*, 1892, oil on canvas.
National Gallery of Art, Washington, DC.

Gauguin no doubt identified. In place of the apple, he substituted an imaginary flower that resembles a male peacock's eye-like tail-feather, which also has several meanings: the eternally-open eyes of immortality; the mother's watchful eye of protection; the ubiquitous evil eye of death.[27] His Eve is powerful and inaccessible. An original version shows her with the face of his mother, although in the final painting she has the face and body of Tehamana along with the identity of Eve – a formidable mix for any male gazer.[28] To violate her would desecrate the Christian symbol of innocence, set off instinctive fears about the primitive and the strange, and, for Gauguin personally, transgress the incest taboo. Her body is as forbidding as her identity. The large splayed toes, thick ankles, puffy knees, pubic hair, powerful shoulders, and elongated fingers violated nineteenth-century aesthetics and necessitated a new way of looking at the female nude.[29]

The plucking of the eye-flower clarifies the most important aspects of Eve's biblical role. In offering her the fruit, the serpent appealed to Eve's desire to know and to see. In this painting by Gauguin her conflict is symbolized by her looking away from the lizard's eyes but reaching out to take his eye-flower. Gauguin shows the decisive moment described in Genesis: 'So when the woman saw that the tree was good for food, and that it was a delight to the eyes, and that the tree was to be desired to make one wise, she took of its fruit and ate.' Not shown, but anticipated, is Eve's giving this primordial capability of seeing to man. 'She also gave some to her husband, and he ate. Then the eyes of both were opened, and they knew that they were naked.' This painting celebrates woman's greater responsibility in the biblical account of the origin of Western sexual morality. As Wayne Anderson has argued, 'Gauguin's Tahitian Eve appears alone, with no Adam to counsel her or share her fate. She is in a position of complete responsibility and complete vulnerability: the decision and the doom are hers alone. Adam is no fit adversary for her; if he exists at all it is as some vague, hovering spirit – a presence and a motivation but no participant.'[30]

Gauguin remained preoccupied with this image for several years and painted a number of variants, one of which included the inscription 'Don't listen to the liar'. The speaker is Eve warning all viewers, but the identity of the liar is uncertain. The serpent lied to Eve, but for Gauguin the most pernicious lie was the Christian view of sin. He speaks through his Tahitian Eve in rejecting the lies of the serpent and those of Christian sexual morality.

Parau na te Varua ino (Words of the Devil) (illus. 58) is Gauguin's portrait of Eve after the Fall. It also shows her as bearing a greater moral responsibility than her co-sinner, who is not present. The original flying lizard has been moved behind Tehamana and reduced to a greyish-blue

shadow of a lizard-serpent behind her left shoulder, almost lost in the dark foliage. His devilish exhortative function has been replaced by a seated Spirit of the Dead, who in an earlier drawing for this painting was a seated Gauguin holding a mask to one side. In the final painting the mask has been moved to the upper-right corner, and Gauguin has been replaced by the seated female Spirit.[31] That Spirit's eyes are aglow with frightful intensity, as her mouth opens to utter 'words of the Devil'. Radiographic studies of this painting show that Eve originally had a second pair of eyes before Gauguin painted them out in the final version. She may well have needed an extra pair to ward off the evil Spirit's (formerly male) evil eye. Her left hand protects against entry into her body (by the Devil, by evil spirits, or by diseased men), and she shifts her eyes dramatically to the side in an expression of alertness and alarm. What remains of the artist's own evil eyes is relegated to the mask. Just below the mask is a brown hand. Its thumb touches the lower tip of the mask in a meditative gesture that Gauguin used in other self-portraits to express his unhappiness in love.[32] Although Adam and Eve both have lots to think about after the Fall, in this painting Eve's alert face is the only one visible and singularly expresses the founding moment of Christian moral consciousness.

Gauguin's fascination with how women appear and how they see was matched by a neglect of both aspects in men. When he painted, his own male vision controlled what was created, but *in* his paintings male bodies and male vision are consistently missing or disguised. In the three paintings I have discussed, the man's eyes are either embodied in a female form, symbolized by an animal, removed from the final composition, or represented by a mask and marginalized. In *Primitive Tales* (illus. 59) he employed three of these strategies. The male figure is Meyer de Haan, a Belgian painter who supported Gauguin financially, instructed him in philosophy, and worked along with him in Brittany before the Tahitian voyage. De Haan is feminized by being attired in a missionary dress typically worn by women, and he is animalized by his pawlike hand, clawed foot, and fox-like eyes, which associate him with the devilish spirits that haunted Tahitian women. He is not removed from the composition, but his face is mask-like and at the side, behind the nudes. He grabs his mouth in a self-abnegating gesture, and his glazed green eyes are far more uncivilized than those of the primitive nudes. He does not participate in the meditation of the two females but watches from a position out of their view, like a number of other 'unsympathetic observers' in Gauguin's art.[33]

This devilish caricature is a disguised self-portrait of Gauguin himself, unable to understand the women he found so beguiling. In 1889 he and De Haan loved the same woman, Marie Henry, and Gauguin was the jealous loser.[34] The face and hand of De Haan are taken directly from a portrait of

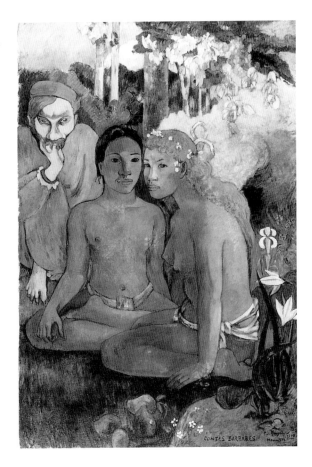

59 Paul Gauguin, *Primitive Tales*, 1902, oil on canvas. Museum Folkwang, Essen.

him that Gauguin painted on a cabinet door-panel next to another panel of himself in 1889, *Self-portrait with Halo* (National Gallery of Art, Washington, DC). Gauguin used the same colours in both portraits, which were hinged to the same piece of furniture. In his self-portrait he is under a halo, next to some apples, holding a serpent. He thus presents himself as redeemer and martyr, genius and tempter, creator and sinner, and pairs himself with another similarly tormented artist. Thirteen years later Gauguin repeated the image of De Haan in *Primitive Tales* as a disguised portrait of himself cowering, almost hiding, beside two nudes whose beauty his morbidly drugged eyes cannot see.

Those nudes recall two others in Gauguin's *Where Do We Come From? What Are We? Where Are We Going?* (1897; Museum of Fine Arts, Boston), an enormous panorama of his philosophy of life composed mostly with female figures and a female idol. At the right, two of the women eye the viewer while holding their chins and pondering the questions announced in the title. The two women in *Primitive Tales* form a similar pair as they

sit in thought and look toward the viewer. One of them adopts a calm Buddhist pose of self-containment and wisdom. Her frontal glance is fixed, as if she has found truth and need not look elsewhere. She is impenetrable and undistracted by everyday concerns, especially those involving male tempters. Her red-haired companion is less monumentally posed but equally secure in avoiding the wild eyes of the crouching man behind her.[35]

Unable to speak French and patronized by the older artist, subject to vastly different sexual mores and conventions about returning a man's look, Gauguin's models express themselves most effectively with their eyes. Whether contemplating the action that initiated moral sense, looking to the side in alarm, focusing at the horizon with a vision of truth, or engaging the viewer with controlled affection, their eyes are strong and intriguing.

While Gauguin's primitive nudes suggest visual potency by their stony silence and immobility, Degas's modernist nudes achieve visual power by self-absorption and mobility. They are the product of his abiding fascination with the female body, portrayed over and again and ever more intimately, from his earlier ballet dancers to his later prostitutes and bathers.

Throughout his career Degas opposed the deadening objectification of the traditional male gaze. In 1856 he sketched King Candaules's wife at the moment she discovers she is being watched by Gyges, but he never sketched the mythical voyeur and ultimately abandoned the composition. Then he drew Susanna at her bath, but never added the peeping Elders and abandoned that composition. He recognized his own historical role in rejecting voyeuristic themes when he remarked to a friend that 'in another age I would have been painting Susanna and the Elders'.[36] Although artists in his own age continued to depict male voyeurism, he could never indulge the Elders' voyeurism or exploit Susanna's shame. In his *Interior* (illus. 128), the woman remains visually self-absorbed and offers only an exposed shoulder to the man's menacing stare. In later years Degas expressed outrage over Gérôme's exploitation of the male gaze: 'What can one say about a painter who has made a poor shame-filled woman who covers herself up out of *Phryne Before the Areopagus*? Phryne didn't cover herself, she couldn't, because her beauty was precisely the reason for her fame. Gérôme did not understand and duly made this subject into a pornographic painting.'[37] Even though Gérôme ridiculed the ogling judges, he still degraded one of the glories of ancient beauty. Degas avoided the voyeurism and the shame implied in the typical nude by depicting naked women who believed that they were unobserved and had no reason to cover their eyes.

In 1886, at the final Impressionist exhibition, Degas exhibited ten pastels depicting bathers, described in the catalogue as a 'Suite of female

nudes bathing themselves, washing themselves, drying themselves, wiping themselves, combing themselves or being combed', all titled with reflexive verbs that accented the bathers' self-absorption.[38] In a conversation with the Irish writer George Moore, Degas explained the meaning of their actions. They are images, he said, of 'the human animal taking care of herself, a female cat licking herself. . . . Hitherto the nude has always been represented in poses which presuppose an audience, but these women of mine are honest, simple folk, unconcerned by any other interests than those involved in their physical condition. Here is another; she is washing her feet. It is as if you looked through a key-hole.'[39] This remark touched on the historically distinctive features of his nudes – their simple humanity, their natural poses, and their self-involvement, all of which confounded traditional male viewing.

Degas might have been showing Moore his own *Woman Bathing in a Shallow Tub* (illus. 60), a pastel that I will interpret along with *Woman in a Tub* (illus. 61) and *The Tub* (illus. 62) as representative of the entire suite. Each shows a bather in a zinc tub. One bends to wash her feet, another kneels to sponge her neck, and the third sits drying her arm – everyday actions alive with unpretentious humanity. They gently touch their bodies with a clear purpose, echoing the artist's rhythmic pastel strokes.

60 Edgar Degas, *Woman Bathing in a Shallow Tub*, 1885, pastel on paper. National Gallery of Art, Washington, DC.

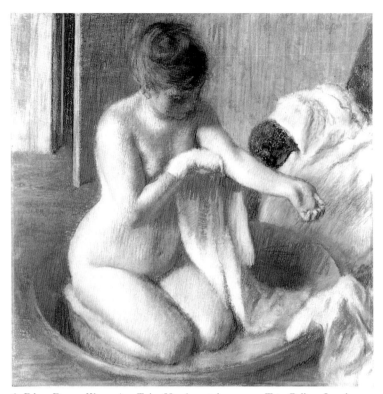

61 Edgar Degas, *Woman in a Tub*, 1885–6, pastel on paper. Tate Gallery, London.

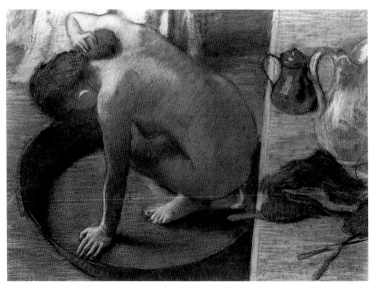

62 Edgar Degas, *The Tub*, 1886, pastel on cardboard. Musée d'Orsay, Paris.

Their simple activities make for untraditional poses. In French and English, *pose* means a position assumed by a model, or an affectation. Degas eliminated the affectation of the classical pose. His nudes are not being judged at a tribunal, auctioned into slavery, or watched by old men. He directed them to assume unusual positions in a shared search with his models for new but still universal human attitudes. That search is not expressed through their eyes, but directly through their bodies – along the musculature of their twisting backs, out of the play of light on their rounded limbs.

Their self-absorption with everyday functions monopolizes their eyes, as they follow the sponges and towels over the surface of their bodies, oblivious of the dimming male gaze.[40] That combination of tactile and visual self-absorption challenged the restrictive sexual morality for women and unsettled male viewers.[41] Their secure sense of privacy also disconcerted men accustomed to seeing women who posed to be seen, as is evident in the twenty-or-so reviews of these pastels that provide an extensive record of the male gaze in the late 1880s. The reviews were, as Richard Thomson concluded, 'contradictory, uncertain, or ambivalent'.[42] Most appreciated what Degas was trying to do, but not the women he depicted. Even laudatory reviewers were anxious. A few noted the bathers' animality, but rather than seeing feline grace and cleanliness, they saw the clumsiness of cows, the sliminess of frogs, the animal instinctuality of women.[43] Others viewed the bathers as crippled, battered, ugly, hateful. To some, the dirty water indicated dirty bodies that no amount of soaping could clean. Several reviewers projected their anxiety onto Degas, whom they tagged a misogynist.[44]

One reviewer was certain that Degas had shown 'the swollen, pasty, modern meat of the streetwalker'.[45] Degas's models may well have been prostitutes skilled at taking charge of sexually aggressive men and further stimulating their gazing.[46] Prostitutes would have been least likely to be ashamed before a male gaze and most likely to return it, and Degas needed models who were willing to show themselves without shame in positions that regular models would find demeaning. His bathers as depicted, however, give no evidence of being prostitutes, and they bathe parts of their bodies that would not particularly interest a prostitute's client. Degas used these models to subvert the male gaze, not stimulate it.[47]

His male reviewers also reveal a sense of dislocation. They felt uncomfortable when so close to the model and were unable to gain pleasure from viewing images of real women in ordinary tubs, who touched their bodies only to clean themselves. One complained about the bathers' 'excessive intimacy'. The reviewers' sight was also narrowed. One of them wrote that Degas 'wanted to paint a woman who did not know she was being

watched, as one would see her hidden by a curtain or through a keyhole'.[48] This interpretation reduced the potency of the male gaze on both sides of the keyhole: on the model's side it suggested a woman free to move without concern about being seen, and on the other side it suggested a voyeur's ineptitude and timidity. Male gazing is not always an act of possession; it can also be a frustrating reminder of what a man cannot have. These reviewers' anxieties were evidence of a growing awareness that their way of looking at the bathers might be deficient.

In response to the scandalized critics, I quote from Edward Snow's sensitive essay on the bathers. He emphasizes

the tenderness with which [Degas] creates for these women their own bodies, their own privacies, their own solicitous spaces. . . . What these canvases witness is not misogyny but its poignant, complex inverse: the artist's need to absent himself from the scene constituted by his gaze, his attempt to redeem sexual desire by transforming it, through art, into a reparative impulse. It is as if these images are offered to the women themselves rather than to the audience that beholds them. They are rendered as incarnate selves rather than as projected, complicit objects of masculine desire, delivered not only from the male gaze but from any introjected awareness of it.[49]

When Degas made those male watchers visible in the picture area, as he had done earlier in the brothel monotypes, they look silly and uncomfortable, not like womanizers enjoying the pleasures of the gaze.[50]

Another of Degas's bathers, in *The Toilette after the Bath* (illus. 63), interrogates the classical nude as well as the male gaze. The bather is half out of the picture and bends awkwardly in a position that can hardly be called a pose. The composition cuts off her head and part of her left breast and belly, as if they were those parts of her body that a view through a keyhole might exclude. At the same time she looms close to the left foreground and reflects light off her flank to emphasize that what remains in view is to be looked at. That viewing is represented within the picture by the maid. In many images of bathers painted since the Renaissance, artists had included a servant who looked at her mistress's body but whose own non-committal expression enabled male viewers to exercise freely their own erotic fantasies. With this pastel Degas invaded that fantasy world. He employed an actress named Réjane to use her expressive talents and create an explicitly judgemental look directed at the bather.[51] Her slightly curling lips hint at a sneer, her arching eyebrows imply scepticism, and her heavy eyelids indicate the tedium of a daily routine. She looks at the bather's backside, which will be visible for only a moment before she covers it with the towel.

Although Réjane appears mildly disdainful of what she sees, Degas was fascinated by the idea of the bather, as he was by most anyone in most any

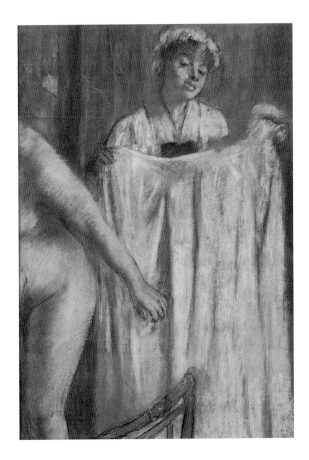

63 Edgar Degas, *The Toilette after the Bath*, *c.* 1888–9, pastel on paper. Ny Carlsberg Glyptotek, Copenhagen.

position. 'Degas's lifelong quest', wrote Paul Valéry, 'was to discover in the nude, studied from every angle, in an incredible variety of poses, and even in rapid movement, the one and only linear pattern which, while defining a momentary pose of the body with the greatest precision, gives it the greatest possible generalization'.[52] Degas's quest for generalization necessitated bringing to an end the crude particularity of male gazing. Réjane's towel was a final curtain.

My Introduction included an explanation that my method of comparing images of a man and a woman in the same painting would have to be abandoned in order to consider nudes in which the male gaze is usually outside the picture, either in the artist contemplating his model or in the viewer looking at the finished painting. After considering art by and for those archetypal gazers, my argument about male versus female looking remains in place. Neither the male artist nor the male viewer monopolizes active looking, and the nude model herself remains in possession of a formidable visual activity and subjective presence.

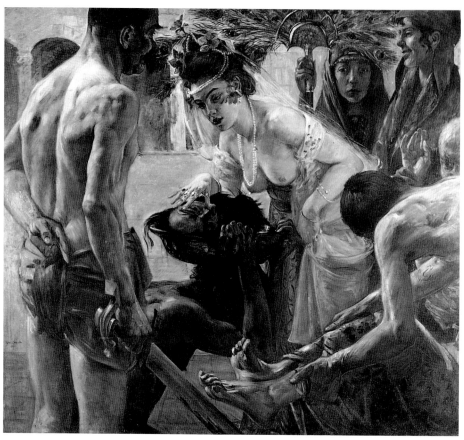

64 Lovis Corinth, *Salome*, 1900, oil on canvas. Museum der bildenden Künste, Leipzig.

The male artist chooses his female model and directs her pose, but once the contract between the two is struck, they collaborate for the most effective artistic forms. His vision and skill create the image, but that vision must transcend mere gazing and sexual interests. And whether she remains mute and anonymous, like so many nude models, or talkative and demanding, like Zola's Christine, whether she is the artist's wife or a local prostitute, in the finished art work her eyes are present while the man's are absent. That presence valorizes her vision and consciousness whether the artist glamourizes her body for erotic enjoyment, reinvents her body for aesthetic appreciation, or naturalizes her body with moral intent. In nudes of this period the abiding images of seeing human beings are not those of male artists or viewers, but the ubiquitous eyes of Ingres's concubines, the mysteriously shaded eyes of Cabanel's Venus and Caillebotte's nude, the

covered eyes of Gérôme's Phryne, the ethereal eyes of Burne-Jones's Galatea, the impenetrable eyes of Gauguin's Tahitian women, and the self-absorbed eyes of Degas's solitary bathers. The woman's look remains superior to the male gaze that is often outside the picture, sometimes ignominiously glued to a keyhole.

Other nudes or partial nudes reveal aggressive gazes directed at male viewers or at vulnerable, if not already dead, men in the picture. Moreau's partly nude Salome looks on the closed, and dramatically objectified, dead eyes of John the Baptist's severed head. Von Stuck's partly nude Eve coddles a python around her shoulders and aggressively returns the gaze of male viewers whom she tempts to a new round of sin. No doubt the French critic Octave Uzanne had such nudes in mind when in 1894 he noted:

The modern nude no longer just inspires the artist, she dominates him. She is no longer the Muse; she is the Succubus. She no longer poses with a halo of splendor and perfection; she leads her visionary to a riot of the senses; she lives, palpitates, convulses like a luxurious demon, and her nudity expresses a pernicious and sincere beauty, a perverse voluptuousness, a sadistic and sensuous sadism. Everywhere one smells her, discovers her, breathes her in, becomes imbued with her gaze.[53]

A few years later, Lovis Corinth depicted one of the most visually aggressive women in the history of art. In *Salome* (illus. 64), while John the Baptist's bloody torso is being hauled away in the foreground, a half-naked Salome, bending forward with her full breasts dangling in front of his decapitated head, pries open his eyelid with a bejeweled forefinger for a final predatory gaze into his dead eye. Behind her a servant holds up a fan of peacock tail-feathers, like a sunburst of potent female eyes.

5 Prostitution

During the nineteenth century the sharp rise in the number of prostitutes, the places in which they could be found, and the services they provided caused increasing public concern about their effect on health and morality, which in turn led to more official surveillance.[1] At a time when a woman's morality was primarily her sexual morality, the prostitute personified immorality. Although some were thought to have 'hearts of gold', all were 'fallen women' whose moral character defined the boundary between right and wrong.[2] Guardians of public morality blamed them for tempting adolescents, corrupting husbands, betraying wives, spreading disease, demoralizing soldiers, and, especially in France, lowering the birth rate and weakening the state. With all that dangerous power went a large measure of moral leverage, if not moral authority.

T. J. Clark argues that by the 1860s the sharpness of the simple moral distinction between good and bad women in France began to blur as prostitutes moved into new urban areas and serviced a larger range of social classes. He presents much compelling evidence for the blurring, although his final quotation from a character in Joris-Karl Huysmans's novel about a prostitute, *Marthe* (1876), is based on the old dichotomy: 'Women like her have this much good about them, that they make us love those they do not resemble; they serve as a foil to respectability.'[3] In the art and literature I have considered, prostitutes remained powerful, if increasingly ambiguous, symbols of immorality throughout the century.

Novelists showed the sordid lives of down-and-out streetwalkers and bordello prostitutes as well as the high dramas of self-sacrificing consumptive *grisettes* and man-eating grand courtesans. Artists preferred courtesans surrounded by the visually evocative imagery of top-hatted clients, enticing undergarments, and dazzling jewelry. Lounging in sumptuous furnishings, these courtesans appealed to voyeuristic needs and cultivated exhibitionistic skills.[4] They were allowed to show and see what was forbidden to 'decent' women in order to captivate or even paralyse a man's gaze. Paintings depict them as persons to be looked at, but that objectification did not allow male gazers free range. Men looking at prostitutes are

shown as highly aroused, but nowhere is their gazing more brutally mocked. They are stiffly posed in profile or in shadow, and often cut off by the picture frame. When in view, they are weak, sometimes comical figures, absurdly gawking, patiently sitting or tentatively approaching, too old, too fat, too gullible, too aroused, or too drunk to take charge.

Writers were also drawn to the prostitute's painted eyes.[5] In 'The Promises of a Face', Baudelaire praised the allure of those dark eyes that inspired his art and revealed a 'truth from navel to thigh'.[6] Flaubert, who boasted about his brothel experiences and ultimately contracted syphilis, was candid about his obsession, as he disclosed in a letter of 1853 to his mistress Louise Colet:

It may be a perverse taste, but I love prostitution, for itself, independently of what is beneath. I've never been able to see one of those women in décolleté pass by under the gaslights, in the rain, without feeling palpitations. . . . There is, in this idea of prostitution, a point of intersection so complex – lust, bitterness, the void of human relations, the frenzy of muscles and the sound of gold – that looking deeply into makes you dizzy, and you learn so many things![7]

While writing *Madame Bovary*, Flaubert acknowledged being uncontrollably excited by prostitutes. They were lovable, complex, and endlessly intriguing, able to fill his dreams and inspire his art, trigger bitter sadness and heart-throbbing joy. His *Sentimental Education* (1869) included an episode of dizzy gazing at prostitutes during his own sexual education. Reconstructing that moment as an episode in the life of his hero Frédéric Moreau, Flaubert recalled the heat of the day, the fear of the unknown, the thrill of what he might see. 'The pleasure of seeing at a single glance so many women at his disposal affected [Frédéric] so powerfully that he turned deathly pale, and stood still, without saying a word.'[8] The prostitutes burst out laughing and he fled. Whatever the reason for the pleasure of that moment, which Frédéric recalled as the 'happiest time' he had ever had, it centred on seeing and being seen by a roomful of prostitutes.

The magnetism of Flaubert's attraction to their gazes was intensified by the suppressed sexuality of his middle-class life. Nineteenth-century sex education was largely *mis*education. Physicians and moralists taught that masturbation was a sin, that frequent nocturnal emissions could cause spermatorrhoea (an imaginary disease that supposedly caused involuntary leaking of sperm), and that a man could contract gonorrhoea by having sex with a woman during menstruation. There was no test for syphilis and no cure for it, and so intercourse was dangerous and scary, more so for women because of the added perils of pregnancy, childbirth, and motherhood. Many brides had little understanding of their sexual responsibilities, consummated their wedding with a crude sexual initiation, and never established a trusting marital sex life. Men used prostitutes

to begin their sexual apprenticeship and supplement their sex-starved marriages. Their experiences with prostitutes were full of the sadness, bitterness, greed, and empty muscular frenzy that so excited Flaubert. His fascination and frustration came out in writing as it did for many contemporaries.[9] Two writers who explored the symbolism of a prostitute's eyes are Zola, in *Nana* (1880), and Dickens in *Oliver Twist* (1838).

The opening chapter of *Nana* surveys the men who in the course of the novel will be destroyed after viewing the courtesan's magnificent body. When she appears naked on stage during a play, the men in the audience go wild: their 'faces were tense and serious, their nostrils narrowed, their mouths prickly and parched'. Soon every man was under her spell, as backs arched and hair bristled. A truant schoolboy was lifted out of his seat by passion. A count grew pale and pursed his lips. A banker became apoplectic. Another man was 'ogling away with the astonished air of a horse-dealer admiring a perfectly proportioned mare'. Another's ears became blood-red and twitched with pleasure. The Count de Muffat sat 'bolt upright, his mouth agape and his face mottled with red, while beside him, in the shadows, the misty eyes of the Marquis de Chouard had become cat-like, phosphorescent, speckled with gold'.[10]

Nana's main conquest is Muffat, who starts his decline during a visit backstage, amid the arousing sights and overripe smells of her dressing-room. He had grown up in ignorance of a woman's body and was disgusted by the mechanical way his wife carried out her conjugal duties. Nana lets him see everything, and he cannot take in enough to satisfy his hungry eyes. 'Now, all of a sudden, he was thrown into this actress's dressing-room, into the presence of this naked courtesan. He, who had never seen the Comtesse Muffat putting on her garters, was witnessing the intimate details of a woman's toilet' (155).

Nana takes possession of him with her devilish laughter, her full breasts and buttocks, and her sensuous face. While watching her applying make-up he becomes captivated: 'He could not turn away his eyes from that dimpled face, which seemed fraught with desire, and which the closed eye made so seductive. When she shut her right eye and passed the brush along it, he realized that he belonged to her' (156). Zola caricatures the gazing obsession of the Second Empire in the eyes of this Count with privileged access to the Emperor, as he bends over to look through a backstage peep-hole at the back of a courtesan while she displays her frontal nudity to a full house of gaping theatre-goers.

One evening Muffat sits reading in Nana's bedroom while she undresses before a large mirror, caressing herself, absorbed in ecstatic self-adoration. She twists her body for a side-view of her breasts, then sways right to left with her knees apart. Muffat is fixated. She raises her arms, tosses back

her head, and thrusts her hips toward him. His eyes follow the solid line of her firm breasts, the rolling muscles under her satiny skin, the vanishing of her fair flesh into a golden pubis. 'Muffat gazed in fascination, like a man possessed, so intently that when he shut his eyes to see no more, the beast reappeared in darkness, larger, more awe-inspiring, more suggestive in its posture. Henceforth it would remain before his eyes, in his very flesh, for ever' (223). Nana is exquisite and able to show proudly what other women hid in shame. Therein lies her power. With steadily diminishing self-restraint Muffat follows his own captivated gaze.

Nana is vain, self-indulgent, lazy, and dishonest, but in contrast to other women shackled by a strict conventional morality she is sexually open and experimental. She shows off her body proudly and speaks of sex candidly. She is not the 'origin of all evil'.[11] As Zola explains, she is 'a force of nature, a ferment of destruction, unwittingly corrupting and disorganizing Paris between her snow-white thighs' (221). Evil suggests an intentional act of will and an awareness of the consequences of one's actions. Nana corrupts men 'unwittingly'. Men are also more responsible for their corruption, because, Zola implies, Nana is 'a force of nature' fated to her prostitution by poverty and a hereditary taint, while the men have more choice in deciding to pursue her than she has in pursuing them. The men are also more responsible for the corruption of love from sexual desire. Their corrupting desire for her comes from a wilful pursuit of faked love, while her desire for money is irrelevent to love and requires sexual faking only as a means.

Nana loses no moral points to Muffat in particular, and she revitalizes that part of his visual sensuousness that had been deadened by a restrictive moral code. So he puts up with her ever more degrading insults as he discovers her successive sexual conquests – an adolescent who stabs himself in anguish, a youth who steals for Nana and goes to prison, some 'sluts' she picks up on the street and enjoys hurriedly in her carriage, a groom who wants a last fling on his wedding night, a retired sailor whom she cheats out of his pension, a banker whom she drives to ruinous speculation. The more Muffat tries to restrict what she can do, the more forbidden fruits she seeks. Sometimes disguised as a man, she goes to infamous houses and watches scenes of debauchery to relieve her boredom. To control Muffat's outrage over each debasing discovery, she taps into ever more debasing elements of his desire. An ultimate degradation involves temporarily blocking his gaze altogether: she makes him crawl about blindfolded, sniffing out a perfumed handkerchief.

A final vision of her debauchery finishes him. He walks unexpectedly into her bedroom to discover her lying next to the lamentable Marquis de Chouard in his nightshirt, with 'the omnipotence of her sex' open to view.

Muffat is devastated by the sight of an even more decrepit roué than himself, stammering and shivering with his nightshirt pushed up over his bony legs. Muffat falls to his knees, calls to God, and renounces his own sight and the world of flesh that has driven him to ruin. This final eyeful brings him full circle from that first night at the theatre, sitting next to Chouard, when both were dazzled and could not see enough of Nana.

At the end of the novel none of the men in her life want to look at her. She is lying in a hotel room, dying of a disease that Zola identifies as smallpox (*petite vérole*), but that carries the symbolic meaning of syphilis (*grande vérole* or *vérole*).[12] About a dozen courtesans who knew her are up in her room for a last visit, willing to risk infection, while an equal number of men, who are afraid to get near, remain downstairs. This final scene contrasts the humanity of the courtesans with the cowardice of Nana's clients.[13] Zola describes what the men do not see. Disease had turned her face into a mass of pus and blood: 'The left eye had completely foundered in the bubbling purulence, and the other, which remained half open, looked like a dark, decaying hole.' In Zola's description, her sick eye looks like a diseased vagina, a final moribund image of a once healthy organ of pleasure that dared to satisfy so many desires.

The exact nature of her illness is unclear. Zola explains that she caught smallpox from her son but adds that 'the poison she had picked up in the gutters . . . the ferment with which she had poisoned a whole people, had now risen to her face and rotted it' (470). Poison from the gutter could refer to smallpox or, metaphorically, to Nana's hereditary background, childhood poverty, or chosen adult trade. The child may have been tainted in some confused Zolaesque manner by inheriting from Nana what she herself had inherited, by a venereal disease she had contracted during pregnancy or childbirth. But the ferment with which she had poisoned people clearly refers to a venereal disease, not smallpox. A disease that destroys the source of its infection implies that the disease is sexually transmitted. Such a disease comes not from inheritance or from the gutter but from men who have had sex with her. The possibility of her disease being syphilis would add another reason for the men's fear. If they infected her and did that to her eyes, then it is only a matter of time before they succumb to the same disease and come to look the same as her. Her pus-filled eyes are thus a portent of their own fate. Zola concludes his novel with this horrific image of a woman's erotically charged eyes morbidly corrupted by men.

A mixture of sex, immorality, degeneration, and death was also evident in numerous images of courtesans in the art of this period. The most influential of these in France was Thomas Couture's *Romans of the Decadence* (illus. 65). The centre of this panorama of sexual indulgence and

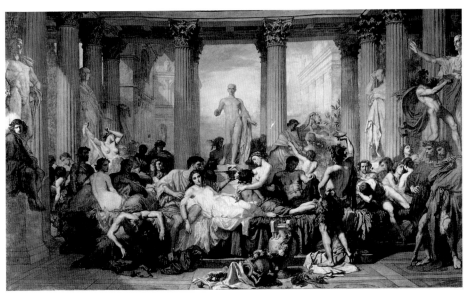

65 Thomas Couture, *Romans of the Decadence*, 1847, oil on canvas.
Musée d'Orsay, Paris.

moral decay is shared by a statue of the Roman general Germanicus and a
reclining courtesan. While the General's dead, stony eyes remain blind to
the moral corruption, the courtesan's living sensual eyes are at the centre
of it.[14] Like the eyes of the central woman in Renoir's *Le Moulin de la
Galette* (illus. 10), the courtesan's eyes unify the surrounding activity and
direct it toward the viewer. They are larger, clearer, more central, more
frontal, and more detailed than those of anyone else. They have seen the
orgy as a participant and are satiated and exhausted. Like a Roman Eve,
the courtesan looks toward viewers as if to make certain that they under-
stand the difficulty of reconciling the requirements of moral law with the
powerful passions all around. In addition to herself, four other women are
sexually assertive and well lit. One sits at the left in bright light, exposing
to the viewer a full and sensuous back. Behind her another dances into a
delirium of ecstasy. A third tears off a man's tunic, while another woman
just to the left of the central statue pours wine for one man while gazing
intently at another and flaunting her full breasts in front of his eyes. She
illustrates the power of a sexually adventurous courtesan to captivate a
man's eyes in order to control the rest of him.

The men are less frontal, less illuminated, less sexually assertive, and
less in control of their actions and desires. One at the far right offers wine
not to a responsive woman but to a statue, while another in the foreground
collapses in exhaustion with outstretched arms and downcast head. Five

others remain apart. In the foreground one stands with his back to the viewer. Another at the right peers out at the viewer, but his engaging glance is lost in the flurry of activity. A sad poet at the far left and two judgemental philosophers at the right seem removed from the action. Couture may have intended to align the viewers' judgement of the immorality with the critical expressions of these two abstemious philosophers, but their disengaged moralizing is peripheral and shadowy in contrast to the brightly lit central action that surrounds the courtesan.

She is positioned to tell this moral tale, and her eyes are those of a pictorial narrator. She does not distance herself from the action or condemn it. She accepts her responsibility and looks frankly at the viewer. Any forthcoming moral understanding or recovery must be made by someone like herself who has broken the moral code. Her body is the focus of the decadent men's desires and the source of her own, although from the position of her limp right arm she appears to be momentarily undesirous. Her eyes are the most informed witness to the orgy and the starting-point for any viewer's understanding of this moment in the history of sexual indulgence.

Couture's painting became a model for generalizing the particular identity of a courtesan. Other artists used a variety of generalizing techniques – a classical precedent, a mythical setting, an oriental prop, an averted glance. In 1863 Manet satirized the classical precedent with *Olympia* (illus. 66). This image particularized the convention of the anonymous, generalized nude because it was posed by Victorine Meurent, who had a well-known face and eyes that actually see. Posed as a short, angular courtesan, she looks at the viewer as if she has just been interrupted and is turning to see who is there. Aside from the hint of classicism suggested by the name 'Olympia',[15] she is otherwise contemporary and real. She has penetrating dark eyes that provide no easy access for the conventional male gaze.

Although no men are shown directly in *Olympia*, two are implied – Olympia's client and the viewer, who might be one and the same. The eyes of the client are suggested by the eyes of the servant and the cat, and perhaps also by the bouquet. As a stand-in for the client, the servant looks at Olympia through two eyes that are soft and deferential as well as shadowy and dim. She also serves the client by delivering his bouquet, an enormous cyclopean eye that Olympia disregards with a lofty detachment that justifies her name. The male black cat is another stand-in for the client.[16] Like many men shown with courtesans, he is near the margin and in shadows. He is also subservient – literally at her feet. She appears uninterested in his arousal (raised tail) and unruffled by his anger (arched back and glowing eyes).

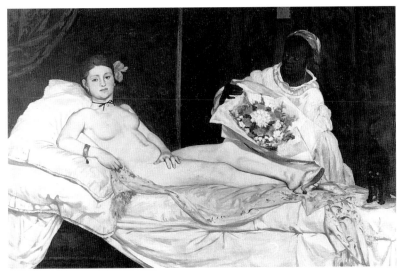

66 Edouard Manet, *Olympia*, 1863, oil on canvas. Musée d'Orsay, Paris.

Even though no man is directly represented, *Olympia* is another pro-
posal composition, with the absent client proposing that Olympia at least
look at his offering of flowers, which she ignores. While in many of the
other proposal compositions that I have discussed the visual focus of the
woman is unclear, in *Olympia* it is directed unmistakably at a male viewer.
It is also confident, if not sovereign.[17]

One possible influence on Manet in creating that look is the prolifera-
tion of pornographic photographs about which Baudelaire complained
in his 'Salon of 1859'. Around that time, 'thousands with greedy eyes
bent over to peer through the stereoscope as if they were windows to
the infinite'.[18] Olympia's pose does resemble that of nudes in porno-
graphic photographs of that time, as Gerald Needham has demonstrat-
ed,[19] but Manet refused to give Olympia their sexually inviting looks.
Baudelaire's poems and essays were another likely inspiration for her
provocative controlling glance. In 'Jewels' Baudelaire wrote of a naked
and jeweled prostitute 'with a charm as powerful as an evil angel', whom
he loved to madness as she sat 'smiling in triumph from the heights of her
couch' with 'her eyes fixed as a tiger's in the tamer's trance'.[20] In 'The
Dancing Serpent' Baudelaire addressed another prostitute directly: 'Your
two eyes that neither sweetness / Nor bitterness hold / Are two chilly
gems mingled of / Iron and Gold'.[21] The year Manet painted *Olympia*,
Baudelaire described woman as a dazzling and enchanting idol 'who holds
destinies and wills suspended in her glance'.[22] While Manet may have been
influenced by the poet's vivid rendering of the enchanting eyes of prosti-

tutes, he avoided Baudelaire's preoccupation with the forbidden and the malevolent.

At the Salon of 1865, Manet chose for *Olympia*'s catalogue entry a stanza from a contemporary poem by Zacharie Astruc with the final line, 'The august woman who keeps a steady eye on passion'.[23] Male critics found Olympia's steady eye to be brutal: she looked like 'a female gorilla', 'a being prematurely aged', 'a cadaver displayed in the morgue'.[24] During the exhibition, the painting was moved from eye level to a spot high above the huge door of the last room, where it was difficult to see.[25]

The critics' interpretive excess and the relocation of the painting indicate how effectively Olympia seemed to challenge the male gaze. Their reactions are especially revealing since her glance is in fact calm, unaggressive, and desexualized. Unlike the eyes of the typical courtesan, hers show no sign of sexual provocation, sexual challenge, or sexual fatigue. She ignores the implied male gazes in the painting as well as the desires they embody, but she is no prude. Her left hand, firm and with spread fingers, seems to be a confident, protective gesture in contrast to the coy, attention-guiding hand gestures of traditional modest Venuses who seem to be inviting and seductive. She looks straight at the beholder(s), without a hint of salaciousness, as though someone had asked a simple question of a clothed woman involved in an acceptable profession and was interested in what she had to say. In short she addresses the viewer with her basic humanity. For men expecting the naked courtesan to be ever-ready to arouse and satisfy their desires, her apparent lack of interest in sex must have been disconcerting. Some may have found her, as Kenneth Clark wrote, with too much character.[26] Close to the gift symbolism of the black choker and hair ribbon – both tied in a bow – her confident eyes contradict the imagery of gift-giving or sacrifice. They retain her humanity in striking contrast to other details of the painting that suggest her commodity status and loss of humanity. With *Olympia* Manet ingeniously challenged the conventional expectations of the male gaze with a naked courtesan whose own look stops it short.

Her glance inspired the extraordinary personal odyssey of the art historian Eunice Lipton. In 1970 she sensed 'that the naked woman was staring quite alarmingly out of the picture . . . [and] her eyes demanded attention'. For over 20 years Lipton gave them that attention, culminating in a book that records her search for official records, salon catalogues, former residences, published accounts of Victorine's life and work, a mysteriously missing unpublished essay on her by Adolphe Tabarant, paintings of her, paintings by her, surviving relatives, a death certificate, a gravestone – anything that might bring to life the person behind the look. Lipton found little. At one point, she wrote, 'I say to myself, "Look, there

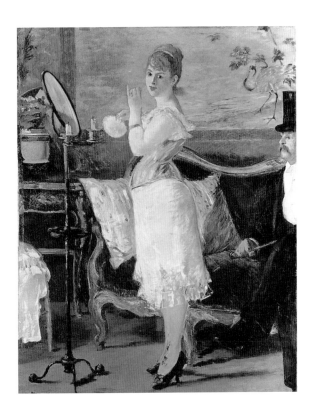

67 Edouard Manet, *Nana*, 1877, oil on canvas. Kunsthalle, Hamburg.

was no life, just an interesting face. Eyes. A big maybe that went nowhere. Forget it. Go home."' To fill in for the lack of new evidence, she imagined Victorine's thoughts and wove them into the story of her search. One of Lipton's monologues includes a comment she imagines that Manet might have made to Victorine about her expression: 'I can't quite put my finger on it, Victorine, but there's something about the way you look, your face. You never look at the world as if you need anything from it.'[27]

Manet created an equally self-sufficient courtesan's look in *Nana* (illus. 67), where the man's ineffectual gaze is represented by several effacing aspects. His eyes are puffy, inexpressive, sketchy, in shadow, in profile, and near the edge of the canvas with part of his head beyond it. Painted between the time of Zola's introduction of Nana as a young girl in *L'Assommoir* (1876–7) and the story of her adult life in *Nana* (1880), Manet's painting was influenced by and in turn had an influence on the creation of her literary counterpart. The painting combines two of Zola's scenes – one in Nana's dressing-room, where Muffat watches her apply eye makeup, and another in her bedroom, where he watches her pose in front of a large mirror. The image has in common with those scenes a male client gazing ineffectually at a self-involved courtesan.

Manet mocks the privileged male gaze with this respectful client, who is not the sexual, visual, or physical equal of the powerful courtesan who captivates him with her smooth skin, strong neck, solid arms, massive hips, and alert dark eyes. The model for her was the well-known courtesan Henriette Hauser, mistress of the Prince of Orange. Muffat is a complement to the standing mirror, a seated reflector for the other side of her visual self-involvement. With a stunning frontal look she stands at the centre, mastering the three gazes that converge on her. She masters the seated man by ignoring him and offering to his view only her imposing backside. She owns the gaze in the mirror because it is hers. Without a trace of embarrassment she confidently engages the viewer, who is privileged to join in this visual celebration of her self-adornment. Her furnishings, clothing, make-up, pose, and glance are testimony to her penchant for self-admiration and self-display. She looks at whom she wants, whenever she wants, although her favourite viewing object is herself, and it apparently takes something special to wrest her gaze from herself. Viewed along with a number of paintings by Manet that show assertive women turning from their activities to look at the viewer, she gives the impression of having been interrupted from more important concerns rather than returning an inquisitive look. Unlike the marginalized and timid male gaze, Nana's is centred, in control, and sexually competent, but without being sexually obsessed.

Cézanne parodied Manet's *Olympia* with *A Modern Olympia* (illus. 68). It includes the enchanted client posed with his back to the viewer and with a balding head that looks like Cézanne's. He sits in shadow beneath an enormous bouquet several times larger than the one that failed to make

68 Paul Cézanne, *A Modern Olympia*, 1872–3, oil on canvas. Musée d'Orsay, Paris.

69 Paul Cézanne, *The Eternal Feminine*, *c.* 1877, oil on canvas. J. Paul Getty Museum, Malibu.

Manet's Olympia turn her eyes. Cézanne depicts the male gaze as more present and more insistent than it was in Manet's version. His Olympia is less alert than Manet's and less formidable, but also less accessible. She reclines at the centre, on a cloud of white sheets, at the moment of her dramatic unveiling by the servant.

With *The Eternal Feminine* (illus. 69) Cézanne parodied himself in the act of painting a sexually available woman. It multiplies the spellbound male gaze into a gallery of neck-stretching and head-turning gawkers at a naked woman who is seated in a temple of light under an awning that looks like an enormous vaginal opening. The men represent different professions for buying, protecting, prosecuting, blessing, condemning, serving, celebrating, and recording the eternal object of the male gaze. Among the identifiable professions, at the upper left a banker holds up a moneybag, a military officer wears a helmet, and a lawyer holds a portfolio. Toward the centre a bishop holds his crosier, and a bald man, identifiable from an earlier watercolour as Cézanne himself, stands back from the crowd but

remains captive to this temptation. To his right, a waiter eager to serve holds a tray with golden apples and a bottle. Behind him two trumpeters blast a fanfare, while above them an odd twisting figure with a striking ribbed robe, possibly an actor, holds what may be a skull. Just above him, a deathly head renounces the gaze and looks away out of skeletal eye-holes. At the upper right another artist, possibly Cézanne at his easel, paints a pyramidal shape similar to the vagina–awning that represents the ultimate sexual object of the male gaze. About six men have turned away in shame or disgust.

The men who do look are objectified by their own gaze. They are like male concubines in front of the vaginal tent of their ocular obsession. The men's bodies remain hidden, but their desires are exposed and obvious; and while the woman's body is open to view, her desires remain hidden and mysterious. The men strain to see and compete for attention, while she can scan and choose among them. They look at one thing, while she can survey them all and look for more. She is faceless except for blood-red blots for eyes that ignore men's gazing but are aglow to what may lie beyond. *The Eternal Feminine* is a multiple proposal composition in which men seek in vain for what eternally attracts them and thereby become captives of their own idolatry.

Cézanne's circus of ogling men suggests a broader and deeper preoccupation with a prostitute's sexuality than was typical in earlier art: broader because of the wide cast of characters, and deeper because it shows a symbol of the sexual opening itself. His imagery inadvertently reflected institutional and medical changes in the viewing of prostitutes' sex organs that began in the 1830s. As prostitution increased, authorities became concerned about the spread of venereal disease as well as moral pollution and so began to be more aggressive in policing the problem.[28] The founding text for that surveillance was A.J.B. Parent-Duchâtelet's *De la Prostitution dans la ville de Paris* (1836), which investigated the lives of 12,000 women, analyzed why they became prostitutes, charted their expanding business, and warned about the harm they did to themselves and others. It ultimately led to many other studies and to the institution of more rigorous surveillance in France as well as in England.

Foucault interpreted that surveillance as a source of pleasure for men that 'comes of exercising a power that questions, monitors, watches, spies, searches out, palpates, brings to light'. The other side of that cruel pleasure is evident in Toulouse-Lautrec's *Rue des Moulins, 1894* (illus. 70), which depicts two highly *dis*pleased prostitutes with raised shifts waiting to submit to a periodic medical examination. They show no evidence of the reciprocal pleasure that Foucault believed was felt by those under surveillance, which he identified as 'the pleasure that kindles at having to

70 Henri de Toulouse-Lautrec, *Rue des Moulins, 1894*, 1894, oil on cardboard. National Gallery of Art, Washington, DC.

evade this power, flee from it, fool it, or travesty it'. For Foucault police and prostitutes were players in a 'game' of seeing and being seen that was played throughout the nineteenth century, creating 'circular incitements' or 'perpetual spirals of power and pleasure'.[29] Police examinations were part of an expanding set of surveillances that controlled the body through categorization and classification, diagnosing and treating. Similar to the diagnostic and punitive function of surveillance in the 'panoptic mechanism' that was supposed to reform the prison system, these vaginal examinations were supposed to discipline and regulate prostitutes.[30] The medical examination and the confession were two technologies for regulating sexuality that came together, according to Foucault, in psychoanalysis. But examining prostitutes separated these 'technologies'. There was no self-examination and no confession, only a singularly objectifying experience of being peered into by a medical inspector in order to protect other men from contamination. Legally enforced vaginal examinations were no pleasure for women, and they travestied the eroticism of the gaze.[31]

Although Toulouse-Lautrec's prostitutes are being dehumanized, they retain a powerful subjectivity that is still evident in their expressions at the prospect of this indignity. The one in front looks down in resignation; her thoughts remain especially impenetrable as her vagina is about to be probed and scoped. The other prostitute glances toward the viewer out of slits in her puffy eyes, as if warning off any peeks not required by law. The two prostitutes are unlikely to return the male gaze with anything other than fake passion or genuine contempt.

In England the lewdness of men's legal-medical peering into the vaginas of prostitutes was even more blatant. The Contagious Diseases Acts of 1864, 1866, and 1869 were introduced to control venereal disease among soldiers, and they permitted special plainclothes policemen to identify any woman as a 'common prostitute' and oblige her to submit to fortnightly examinations. If found to be infected with gonorrhoea or syphilis, she could be locked in a hospital for as long as nine months. No men or, of course, women inspected the soldiers' penises. All punishment fell on the prostitutes, along with the humiliation and danger of the examinations, which were usually conducted without proper sanitary precautions and led to further contamination of the prostitutes. The Acts were another example of the legal enforcement of a double sexual standard for those loveless unions, because they punished only women for engaging in the same vice as men. Although the surveillance was not as punitive in France, vaginal examinations were required for all registered prostitutes.

To make this extensive surveillance effective, a new intensive surveillance was introduced at mid-century with the help of the speculum invented by the French physician Joseph Récamier. It was an instrument for separating the walls of the vagina to permit the introduction of a mirror, enabling a gynaecologist to examine and diagnose malformations, injuries, and diseases. The American gynaecologist Marion Sims tried it in 1845 and boasted 'I saw everything as no man had ever seen before. . . . I felt like an explorer in medicine who first views a new and important territory.'[32] In the syphilis wards of French hospitals in the 1830s the speculum began to be used to examine prostitutes and apply useless caustic lotions to treat those infected. When gynaecologists tried to introduce the speculum for general practice there was resistance from doctors and moralists. Medical journals reported on women who had felt violated or were poisoned by specular examinations.[33] In 1888 Elizabeth Blackwell, the first woman doctor in America, campaigned against its use because it threatened women's purity.[34] More recently, Luce Irigaray assailed the 'hysteroscopy' made possible by the speculum: 'Yes, man's eye – understood as substitute for the penis – will be able to prospect woman's sexual parts, seek there new sources of profit.'[35] Most feminist thinkers, gynae-

cologists, and anyone with common sense must recognize, however, that the speculum is an indispensable instrument for diagnosing and treating disorders of the female sex organs and saving female lives.

Artists devalued the male gaze up and down the social scale. Tissot depicted the upper classes in which rich older men could not hold on to the look of fascinating young women. In *The Woman of Fashion* (*La Mondaine*; illus. 71) the old man's eyes gaze weakly at the back of the head of an evasive young woman as he fumbles with her cape. She needs neither his hands nor his gaze and looks candidly at the viewer to underscore her availability and her desire to see everything. But she does need his money and social contacts to provide her with the sumptuous clothing and introductions necessary to gain entry to the world of the rich. The man's wrinkled eyes are confined to his hopeless task and strained as if tempted to look around the woman's face, while she treats the viewer to a flirtatious glance. In Tissot's *The Reception* (illus. 72), a grey-haired man posed out of view is losing possession of his beautiful young courtesan, who surveys the

71 James Tissot, *The Woman of Fashion (La Mondaine)*, 1883–5, oil on canvas. Private collection.

72 James Tissot, *The Reception*, c. 1883–5, oil on canvas. Albright-Knox Art Gallery, Buffalo, NY.

animated crowd and looks away from him in the direction of the viewer. Her eyes appear like the centre of a brilliant flower created by the cascading ruffles of her train and the feathery spread of her fan. Tissot accented the strength of her composed but ambitious expression by making her porcelain smile and large eager eyes the stable centre of an animated scene. The vision of men is secondary; it is as marginal and as sneaky as the comments whispered by two men at the far right, gossiping about the passing couple. The most prominent male face has the look of a cartoon character. Sitting at the left and facing toward the passing woman, he holds his jowls and stares crudely across the *décolletage* of his companion and through a monocle that catches the light, emphasizing his nearsighted and puffy-eyed admiration for this woman of fortune.

Jean-Louis Forain painted backstage and brothel scenes in which portly, top-hatted, shadowy, and mostly profiled old men size up partially naked, more frontally posed, and better illuminated prostitutes and actresses. In *The Actress's Dressing-room* (1880; private collection) the profiled eyes of

the lecherous old man standing in the shadowy background are almost closed by scrofulous swelling, while the two open, healthy, and sparkling frontal eyes of the actress are accented by her exposed and equally illuminated nipples.[36]

The eyes of streetwalkers or brothel prostitutes are rarely full of lively allure, but, along with a seductive display of their bodies, they are still able to captivate the male gaze or at least deny its dominion. In John Singer Sargent's *Street in Venice* (illus. 73) the streetwalker with a forthright frontal look strides past two prospective clients huddling in shadows at the side. One of them gazes at her from barely visible eyes, while the eyes of the other are buried in darkness. Toulouse-Lautrec depicted numerous scenes at theatres, dance-halls, and brothels with men and their groggy eyes in shadows or near the margins, as in *A Corner of the Moulin de la Galette* (illus. 36).

Prostitutes could even exercise considerable visual power when asleep.[37] The closed eyes of the prostitute in Henri Gervex's *Rolla* (illus. 74) captivate the down-on-his-luck man at the window. From the Musset poem on which it is based, we learn that this woman was forced into prostitution by family poverty, while the man was driven to despair after squandering the family fortune. Before committing suicide he spent his last coins on a final night of pleasure. Gervex shows him the next morning, looking in the direction of the naked prostitute lying asleep. Her undergarments hurriedly piled with his hat and cane indicate eagerness to remove the corset at the front without unlacing it, even before the man had taken off his hat.[38] In spite of her profession, she is a vision of health, beauty, and emotional calm. Her eyes are peacefully absorbed in sleep and take on renewed beauty under the lamp, whose light combines with the sun's. As if by a miraculous photosynthesis, she appears to take sensual nourishment from under the two sources of light. Her eyes under pink lids follow the endless possibilities of her dreaming, while the man's eyes in dark sockets glare into the doom of a suicide. A last gaze drains his living energy and does not revive with the rising sun that glances off his body and casts his eyes into darkness. He is triply marginalized: at the window of the room, at the edge of light and dark, on the brink of death. She is centred like a goddess, both radiating and absorbing the light.

The painting was rejected by the Salon of 1878 primarily because of the piled underclothing that Gervex introduced at Degas's suggestion in order to make her look like an actual prostitute. Such dedication to accuracy accords with Degas's artistic interest around that time. In 1879–80 he made about 50 monotypes of brothel scenes. Small in size (they average six by eight inches) and never exhibited publicly, they have nevertheless attracted much scholarly interest because they represent a transition

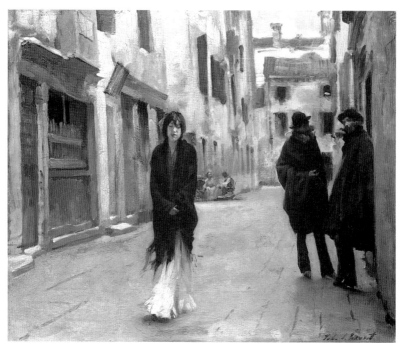

73 John Singer Sargent, *Street in Venice*, 1882, oil on wood. National Gallery of Art, Washington, DC.

74 Henri Gervex, *Rolla*, 1878, oil on canvas. Musée des Beaux-Arts, Bordeaux.

between his popular dancers and his later bathers, many of whom are posed like the prostitutes and in rooms that might well be those of prostitutes. The monotypes provide a candid look at brothel life: how clients enter, hesitate while choosing, get pulled in, and sit while watching a prostitute bathe. The clients are pictorially marginal and tentative in their demeanour.[39] In *Repose* (1879–80; Musée Picasso, Paris), only parts of the client's hat, face, hand, and leg are visible beyond the door through which he is entering. The title refers not to the client, but to the prostitutes. One lounges while the other looks toward the viewer; both are securely reposed and unconcerned about the client. In *Waiting for the Client* (1879–80), the client is cut off by the picture frame. He is a black smudge. He is observed by three prostitutes, one of whom sits casually with her legs open, while another leans forward to examine him. Presumably there to survey the women, he is made to be the one under examination. In *The Customer* (1879–80; Musée Picasso) the entering man is also partly cut off by the margin, as if he were reluctant to move into the room where he might be fully visible. He looks at two bloated prostitutes, who stare back with cold eyes that size up his cash value. *In the Salon* (1879–80; Musée Picasso) reveals yet another man at the margin, apparently unable to decide where to look first among the nine lounging prostitutes who scrutinize him nine times over, blatantly unobjectified by his gaze. The man in *The Serious*

75 Edgar Degas, *The Serious Client*, c. 1879, monotype on paper. National Gallery of Canada, Ottawa.

76 Edgar Degas,
Admiration, 1877–80,
monotype on paper.
Bibliothèque d'Art et
d'Archéologie, Paris.

Client (illus. 75) is drawn into the room by an aggressive prostitute who grabs his hand. He looks toward the four prostitutes, all eager for his business. Their painted eyes are artificially seductive, and the two who smile are obviously faking. This 'serious' client's look indicates not deeper thoughtfulness but merely his venturing to make physical contact, however tentatively. The admiring client in *Admiration* (illus. 76) has no hesitation about being in a brothel and knows where to sit in order to see everything. He rests his chin on the edge of the tub and positions his eyes as low as possible in order to see as much as possible from below. While the naked prostitute prepares for his voyeuristic delight, he looks up with a gleeful leer. Degas comments on his look by embedding it in such a silly face. When this male gaze finally sees all it wants, the expression is not one of patriarchal dominion but of besotted adoration. The woman flexes her muscles and reveals the graceful and powerful contours of her twisting back as she washes her neck. The juxtaposition of this man and woman suggests a redistribution of power between the sexes and a scepticism about the humanistic worth of the male gaze.[40]

Earlier in this chapter I interpreted a novel in which a glamorous courtesan captivates the gazes of male clients who infect her body and who

after her death cannot bear to look at the morbid result in her eyes. I conclude this chapter with a novel in which the eyes of a street-walker carry out another post-mortem act of poetic justice in defence of the Victorian moral code.

In *Oliver Twist* (1838) Nancy is a prostitute with a heart of gold. She loves the brutal criminal Bill Sikes, who has 'two scowling eyes', one of them discoloured from a blow. His dog, named Bull's-eye, also has 'ill-looking eyes' and a face scarred by fighting. Sikes's associate in crime is Fagin, whose dark eyes are described throughout the novel as 'furious', 'menacing', 'greedy', 'crafty', 'hawk-eyed', or 'blood-shot'. Nancy is pitted against these evil eyes as well as the spying eyes of Fagin's henchmen. Dickens does not describe the colour of her eyes, but their moral force and avenging power loom large.

Sikes scarcely needs to see. He lives in a dark and gloomy den, where a gaslight flares all day in winter, and no sun shines in summer. He is often blind drunk; he issues forth from the fog on pitch-black nights to rob. Nancy also works in the dark, selling her body to the dirtiest men in the dingiest dens of London. In helping Oliver to escape from Fagin and Sikes she is motivated by her basic humanity and by a longing for a life in the sunlight. When Sikes learns that Nancy has met Oliver's rescuer, Rose, he assumes it means a betrayal. He bursts into Nancy's room and smashes her in the face with his pistol, causing her to fall back 'nearly blinded with the blood'. He then staggers over to her and 'shutting out the sight with his hand' grabs a club and strikes her dead.[41] His reluctance to look at his victim during the crime portends his sorry fate thereafter.

In the morning, a bright sun bursts on the city in radiant glory, penetrating the room in which Nancy lies. Sikes throws a rug over her body, but her eyes still menace him: 'It was worse to fancy the eyes and imagine them moving towards him, than to see them glaring upward, as if watching the reflection of the pool of gore that quivered and danced in the sunlight on the ceiling.' Like the ubiquitous vision of her dead eyes, blood was everywhere, even on the feet of Bull's-eye, who thus soaks up the seeing power of Nancy's dead eyes. Sikes drags this one witness of his crime out of the room and heads into the country. There, like the dog that is with him, a vision of Nancy continues to haunt him as 'that morning's ghastly figure following at his heels. . . . If he stopped it did the same. If he ran, it followed.' In panic Sikes tries to outrun the vision but is overtaken by the even more terrifying image of Nancy's eyes. He seeks refuge in the darkness of a shed where the eyes' accusatory power hits full force.

Those widely staring eyes, so lustreless and so glassy . . . appeared in the midst of the darkness; light in themselves, but giving light to nothing. There were but two, but they were everywhere. If he shut out the sight, [he envisioned] the room with

every well-known object. . . . The body was in its place, and its eyes were as he saw them when he stole away. He got up, and rushed into the field without. The figure was behind him. He re-entered the shed, and shrunk down once more. The eyes were there. (423–9)

Next morning before returning to London, Sikes contemplates killing Bull's-eye for fear that he will give him away, but the dog senses danger and runs off. Sikes returns to the filthiest part of London. There Nancy's judgemental eyes have multiplied into the eyes of a crowd seeking retribution for his crime. The people shout and tear apart the neighbourhood so as to get a look at him. Trying to escape, Sikes climbs out on a roof where he sees 'tiers of faces in every window' (451).

Why are the poor masses so enraged about the murder of a prostitute? Dickens's moralizing offers a clue. 'Of all the horrors that rose with an ill scene upon the morning air, that was the foulest and most cruel' (423). The foulest crime must be one that had deep emotional significance for everyone. The killing of a lowly prostitute could not inspire such outrage and horror, but it could if she symbolized motherhood.

The novel provides abundant evidence of Nancy's mothering role. She protects the orphan Oliver against brutal beatings by Fagin and Sikes, she tries to prevent his involvement in their crack-brained crimes, and she takes enormous risks to save his life. Dickens's own life further suggests the personal significance of Nancy's mothering role. When he was twelve his father was confined in a debtors' prison, and his mother, like Nancy, joined his father along with the other criminals in the prison, where she cared for Dickens's four younger siblings, as was possible under prison rules at that time. Before Dickens's father entered prison, his last words to his son were that the sun had set upon him forever.[42] In the novel, when Nancy tells Rose of Oliver's whereabouts, Nancy remarks mournfully, 'Look before you, lady. Look at that dark water. How many times do you read of such as I who spring into the tide. . . . I shall come to that at last' (415). Thus the misdeeds of Dickens's father forced his mother to live in a sunless world of crime, a biographical source for Nancy's longing for sunlight as well as her sense of her own dark destiny in a den of male criminals.

Even after Nancy is dead, like an avenging mother she continues to protect Oliver by hounding Sikes and ultimately causing his and Fagin's deaths. To get away from the angry mob, Sikes climbs onto the roof, intending to escape over the top and lower himself with a rope down the other side. But just as he puts the loop of the rope over his head before putting it under his armpits, he looks up, sees a pair of eyes in the dark, takes them for Nancy's, and shouts in terror – 'The eyes again!' Startled, he loses his footing, falls from the roof, and hangs himself. The eyes were

in fact those of Bull's-eye, who had followed Sikes onto the roof. Sikes had mistaken the eyes of the one living witness to his murder for those of his victim, and their collective judgemental force was multiplied by the eyes of the London crowd clamouring for justice.

Dickens could not have bestowed such emotional power on the eyes of a street-walker had they not represented the judgement of a person who typically carried greater moral force. Nancy represented fundamentally not the corruption of a prostitute but the self-sacrifice and protection of a mother, a figure whom Dickens himself spent a lifetime trying to recover. As he remarks in his Preface, 'the very dregs of life' may 'serve the purpose of a moral'. The night Nancy arranged Oliver's escape, Rose offered her money as a reward. Nancy refused, but did accept Rose's white handkerchief, a symbol of the purity she lost and the light she longed to see. Just before Sikes delivered the fatal blow, Nancy held up that handkerchief to her own bloodied eyes and begged for mercy. At the end she symbolized goodness, light, and hope. The eyes that caused Sikes to fall belonged ultimately to the author's mother, the people of London, and Victorian moral authority.

Sikes's 'foulest and most cruel' murder carries the moral force of the murder of a mother trying to protect her child. When Dickens moves the judgment of that crime to a court of law with Fagin's trial as an accessory to murder, once again the eyes of London are on the evildoer: 'The court was paved, from floor to roof, with human faces. Inquisitive and eager eyes peered from every inch of space.' Like a host of avenging angels they peered down on Fagin, who 'seemed to stand surrounded by a firmament, all bright with gleaming eyes'. Fagin's 'bewildered glance' finds nothing but looks of angry condemnation in the gallery and pitiless scorn in the eyes of the judge pronouncing sentence of death. In his cell Fagin envisions 'the cap, the noose, the pinioned arms, the faces that he knew, even beneath that hideous veil. – Light, light!' (469). Fagin's fantasy of execution and his futile plea for light mark the fulfilment of poetic justice: they echo Nancy's final plea for mercy just before Sikes, in carrying out Fagin's evil intentions, delivers the final killing blow on Nancy's already blinded eyes. The brutal murder of a motherly prostitute is avenged by a 'firmament' of gleaming eyes in a court of law, by a crowd of retributive eyes in a London slum, and by the eyes of a fatally faithful dog – eyes that derive their ultimate moral energy from the haunting eyes of the murdered woman herself.

Although this murder occurs in an early Dickens novel, its emotional force stayed with the author to the end of his life, especially during his last eighteen years, when he gave public readings from his novels. In 1868 he added one based on Nancy's murder, in which he assumed the moral

responsibility of Sikes himself, as indicated by the way he referred to the reading in conversation with a friend: 'I do not commit the murder again . . . until Tuesday.'[43] The readings caused women in the audience to become rigid, requiring them to be carried out, and they caused Dickens's own pulse to climb to 124. Afterwards he was unable to stand or speak for fifteen minutes. His physician and friends urged him not to read the episode, and his close friend Wilkie Collins believed that his death in 1870, a few months after he collapsed during his final tour, was hastened by the strain of reading 'Sikes and Nancy'.[44] The avenging eyes of the murdered prostitute had the power to make women listeners collapse and Dickens ill. Clearly their haunting vision tapped into deep sources of Victorian sensibility.

The popularity of prostitutes in the arts shows their importance in nineteenth-century life. In symbolizing what women were not supposed to be, they helped define what women were as well as what they were in danger of becoming. Prostitutes' eyes were supposed to entice male desire, not open a window into the soul of a human being. Manet disturbed male critics because Olympia's eyes seemed to belong to a real woman and glowed with subjective power capable of returning the gaze and resisting the authority of every client. They expressed a seditious message about what courtesans thought of male gazes and their all too predictable 'subjectivity'. Degas gave a withering visual critique of that message in monotypes with timid clients in shadows, almost clinging to the doors and walls of rooms, positioned at the margins of the image. Dickens's maternal and morally courageous prostitute articulated that message in the pathetic dialogues between herself and her brutal lover. Her final futile plea moved Dickens and his audience so much because it offered both a pardon for the man's crimes and a plea for his salvation, even as he prepared to kill her: 'Let us both leave this dreadful place', she cried, 'and far apart lead better lives, and forget how we have lived, except in prayers, and never see each other more' (422). Sikes was, of course, not a typical Victorian gentleman, but no doubt his blind and blinding reply struck a nerve in readers who feared that his brutality merely caricatured the more pervasive inability of men to see straight when they were sexually aroused or to act rationally when they were bent on vengeance.

6 Seduction

In a world where women had to make their way to marriage and mother-hood by being sexually appealing, the line between seductress and victim was often unclear. Even the most innocent victim of seduction bore some responsibility for her predicament, and the most culpable male seducer could find some grounds for excuse. In the novels, sometimes only the outcome of events distinguished a seduction from a courtship. In Gaskell's *Ruth*, for example, the man who romanced and impregnated Ruth may have intended to marry her or perhaps just did not clearly think through the consequences of his actions before his mother took charge, whisked him away, and left Ruth to fend for herself.

In art the separation between seducer and victim was also not entirely clear. I have arranged interpretations of that art from more active male seducers to more active female seductresses, although this ordering is an approximation. Artists were especially fascinated by women all across that gradation from innocent virgin to experienced seductress, because while the eyes of male seducers were focused on what they wanted and were rel-atively lacking in mystery, the eyes of seductresses as well as women being seduced expressed more intriguing varieties of human experience – power and helplessness, triumph and defeat.

I begin with the most innocent seduced woman in Christendom. Ros-setti's *Ecce Ancilla Domini!* (illus. 77) can be interpreted as a seduction, because it depicts the solicitation of a virgin by a male for procreative pur-poses. The ultimate aim, however, is not satisfaction of one man's moment of pleasure but redemption of all mankind for its primordial lust. The man shown is the angel Gabriel announcing to the Virgin Mary that she will bear the son of God. The painting is arranged as a proposal composi-tion with Gabriel's profiled face in shadow and Mary's frontal face in bright light. His nimbus and flamed feet signal his divine mission, but he nevertheless stands before her as a physical man thrusting in front of her withdrawn body and impassive face a white lily, symbol of purity. Although the Annunciation is synchronous with the Incarnation, Mary reacts as though she is pondering a sequence of events, or at least thinking

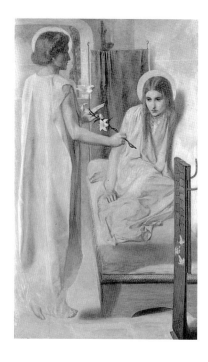

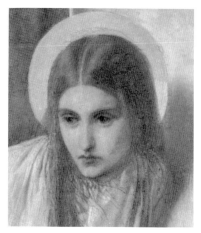

77 (*left*) Dante Gabriel Rossetti, *Ecce Ancilla Domini! (The Annunciation)*, 1849–50, oil on canvas. Tate Gallery, London.

78 Detail of illus. 77.

through the consequence of this divine 'seduction' over which she has a lack of control unprecedented in human history. Gabriel knows precisely what he is doing, while she is perplexed. He steps toward her assertively, while she leans back in resignation as if cornered. Rossetti captures the moment when Mary is 'greatly troubled' (Luke 1:29) at the Annunciation, perhaps before she learns that her impregnation is miraculous and untainted. He daringly renders her eyes brooding over her fate without a trace of satisfaction or honour about her godly role (illus. 78).

The woman shown in E. C. Barnes's *The Seducer* (illus. 79) is far less innocent than Mary, but standing next to this Lothario she seems relatively innocent. The painting provides a visual anthology of the clichés of seduction from nineteenth-century melodrama.[1] By approaching her without removing his towering top-hat he shows disrespect and looks down at her from a menacing shadow that cuts across his gaze. He has a hawk-like nose, dark drooping moustache, and predatory eyes. For good measure, Barnes added a coiled snake around the handle of the cane and a skull on the cravat pin. The man's weak-willed victim knows that what he wants is bad but lacks the strength to resist, as the painting narrates. The brick wall blocks her escape, and on it is a notice for *La Traviata*, an opera about a courtesan who eventually dies of consumption. Below that is a notice printed with the word 'conscience', and below that a notice with the word 'Lost' that has slipped loose and is itself about to fall. The woman is

an image of impending moral collapse because of her own vanity and acquisitiveness that are clearly indicated by her prominent hat-box.

The man indeed owns the gaze which has just about overpowered the woman, but her intriguing, resistant eyes are the key to the moral struggle over the question *Will she or won't she?* We see clearly what the seducer reaches for (a hat in a box is also a symbol for sexual intercourse), but we do not know whether she will cross the line suggested by the mysterious dark strip on the wall, which still separates her from the fateful notices. Will she cross it, and if she does, how will she react when abandoned? She does look away and hold up her hand as if to resist, but her turned-away expression and resisting gesture are feeble. Can she save herself, or, failing that, will she exact some revenge, which Barnes perhaps hints at with the hat-box that casts a shadow over the seducer's genital area and across the thrust of his knee? The title refers to the man and suggests the fulfilment of his titular role, but would-be seducers can fail, and the mystery in this painting centres on the woman's moral choice as she ruminates behind an averted glance.

Such images of male seducers and female victims were consistently arranged as proposal compositions.[2] The eyes of the women were more

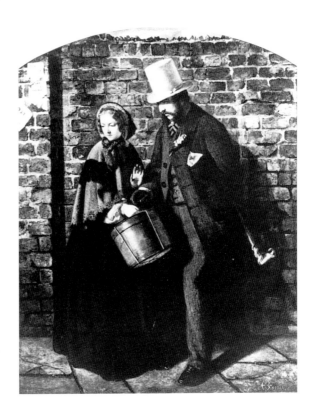

79 E. C. Barnes, *The Seducer, c.* 1860, oil on canvas. Private collection.

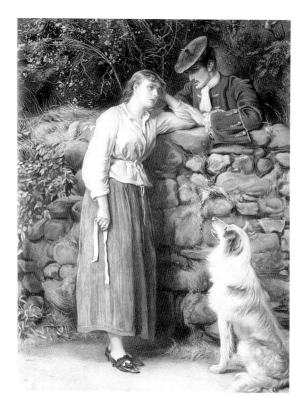

80 T. O. Barlow after John Everett Millais, *Effie Deans*, mixed mezzotint of 1878 after an 1877 oil painting.

81 Detail of illus. 80.

frontal, better lit, and the centre of interest in didactic narratives about right and wrong. On the verge of moral collapse, these women offered powerful images of moral crisis in which artists showed the dangers of saying *yes* in order to demonstrate the need for saying *no*. The Impressionists intentionally avoided such explicit didacticism and so avoided the theme.

Somewhat more responsible for her impending seduction is the heroine of Sir Walter Scott's novel *The Heart of Midlothian* (1818), whom Millais depicted in *Effie Deans* (illus. 80). It illustrates the scene in which Effie resists a gentleman's seductive caressing, but only tentatively and for the moment. She passively accepts his touch with her inert arm, while her other hand has already begun to respond positively by letting down her hair, which Millais indicates with the untied snood that dangles conspicuously in her hand. Later she will give in to desire, become pregnant, and be sentenced to death for allegedly killing her baby. Like Barnes's seducer, this one also wears a hat with a brim that casts his determined gaze into shadow. He is driven by natural desire, while Effie hesitates as she thinks about reasons to resist. Her faithful dog looks up at her helplessly with a patient stare that counterposes the man's impatient gaze. Millais com-

pressed the unfolding of the story into Effie's eyes, which, compared with the man's, are better illuminated and open to view (illus. 81). The man has decided to break the governing sexual morality, while she struggles to follow it. Her eyes are wide open to show their exceptional beauty and moral turmoil, and they glisten with emotion in anticipation of her fate.

The more frontal male suitor in William Frith's *The Lovers' Seat* (illus. 82) is Percy Bysshe Shelley, who looks imploringly at Mary Godwin as they sit on a bench in Old St Pancras churchyard, the burial place of her mother, Mary Wollstonecraft, the Enlightenment feminist philosopher. Shelley is more visibly active, as is indicated by his hat and gloves, which have been tipped over in his rush, but the outcome of this exchange rests with Mary, who is being pressed to go further with their love. She looks down pensively.

Frith reconstructs a moment around the time when, at the age of sixteen, Mary pledged her love to the already married Shelley, as the two knelt at her mother's grave. Shelley had been insistent, even threatening suicide. Although he is the more frontal, Mary is the more intriguing as she ponders giving in to her forbidden love near the grave of her philosophically daring mother and prepares to challenge the reigning sexual

82 William Frith, *The Lovers' Seat: Shelley and Mary Godwin in Old St Pancras Churchyard*, 1877, oil on canvas. Private collection.

morality. By the time of the painting's composition, Frith, and perhaps many viewers of the painting, knew how much Mary was to pay for her 'beautiful and calm and free' moral courage in bursting the 'chain of custom'.[3] Against the curses of even her enlightened father William Godwin, she eloped into an unmarried cohabitation with Shelley in 1814. Her first child died just after its birth in 1815, and later she saw three more of her children die, while Shelley took mistresses. In this proposal composition with the couple rotated from their more typical positions with respect to the viewer, Frith shows more of the famous Romantic poet's face but celebrates the woman's greater moral courage in the pursuit of love.

Like Mary Godwin, the tempted woman in Alfred Elmore's *On the Brink* (illus. 83) bears a measure of responsibility for her predicament, although the stakes are far more mundane. She is tempted by money and faces an urgent moral crisis outside a German gambling den. She is not on the brink of losing, because she has already lost, as is shown by her dangling purse and by the worthless pieces of paper that lie torn in the foreground. Moments before she was full of gaming passion, like the sporting women still at the table in the background with a weakness for the exciting *yes* or *no* decisions of which bet to make. Now she has to make a moral decision, because the man behind her is no doubt offering money in

83 Alfred Elmore, *On the Brink*, 1865, oil on canvas. Fitzwilliam Museum, Cambridge.

84 Detail of illus. 83.

exchange for sexual favours. She is on the brink of being seduced. She is located in a scenario that mid-Victorians assumed would lead from gambling to seduction to prostitution and to suicide or early death, but she is nevertheless contemplating a fateful moral decision that is centred in her large and troubled eyes.

The devilish man belongs to the world illuminated with a hellish red glow, and he tempts her like the serpent in the Garden of Eden. His purpose is as evident as his shadowed eyes are secretive, while the woman's uncertain thoughts lie behind intriguing eyes that are frontally directed and strikingly illuminated, especially as they are cut by harsh cross-shadows (illus. 84). Elmore draws on contemporary familiarity with the symbolic Language of Flowers to indicate the woman's choice. At her left the lily (innocence) droops, and is located beneath the passion-flower (sexual arousal) that itself surges toward her like a menacing gaze flourishing in the moonlight. Her moral conflict is symbolically overdetermined by her being poised between outdoors and indoors, moonlight and gaslight, lily and passion-flower, virtue and vice, and perhaps also life and death.

Lynda Nead has documented the Victorians' conviction about the inevitability of the scenario from gambling to death at the hands, and presumably under the eyes, of men.[4] But however routinely such women were pressed by circumstances and tempted by charmers, they bore some responsibility for enticing men, because at some moment the moral decision was theirs to make. Male seducers in Victorian art remain watching from the margins, whispering out of the shadows, posed in profile, doting on the eyes and hoping for the *im*moral decisions of women. The focus of the art in which they are represented is not so much on their predatory gazes, however, as on the more inwardly as well as outwardly searching eyes of their female victims.

Seduction led to prostitution because many fallen women became outcasts and had no other way to survive, but among the causes of prostitution, vanity and the accompanying love of finery were conspicuous. In Victorian literature, and in art especially, seduced women generally had beautiful eyes. The woman in *On the Brink* with magnificent, tortured dark eyes conjures up George Eliot's attractive heroine in *Daniel Deronda* (1876), which opens at a German gaming-room, where Gwendolen Harleth is being observed by Daniel. The first words of the novel are his interior monologue, a series of questions about Gwendolen's face and eyes that portend the story that unfolds for 900 pages:

Was she beautiful or not beautiful? And what was the secret of form or expression which gave the dynamic quality to her glance? Was the good or the evil genius dominant in those beams? Probably the evil; else why was the effect that of unrest

rather than of undisturbed charm? Why was the wish to look again felt as coercion and not as longing in which the whole being consents?

Although these questions objectify Gwendolen, they also attribute to her a potent subjectivity, the 'coercion' of her glance. The novel explores the secret dynamism of her eyes, the emergence of her compassion, and her moral development from 'The Spoiled Child' (the title of part One) into a woman who in the end writes to Daniel the hope that she 'may live to be one of the best of women, who make others glad that they were born'.[5]

Daniel's opening interrogation was important to Eliot herself, who devoted the remainder of the first chapter to an essay on Gwendolen's glance. In an earlier novel, *Adam Bede* (1859), Eliot confessed her fascination with the way a beautiful woman's eyes can mislead. As she narrated, 'I find it impossible not to expect some depth of soul behind a deep grey eye with a long dark eyelash, in spite of an experience which has shown me that they may go along with deceit, peculation, and stupidity.'[6] Eliot explored the disappointment of those expectations in her novel about vain Hetty Sorrel with exquisite eyes, who is seduced by a young aristocrat, becomes pregnant, kills her baby, and is sentenced to be hanged.

Other Victorian heroines, like Hetty, belong in that morally ambiguous area between victim and seductress. Many of them also had exceptionally beautiful eyes that were dangerous for the men they tempted as well as for themselves. At the beginning of *Daniel Deronda*, Gwendolen's eyes beamed with an 'evil genius'. While out boating with her cruel husband, she was beset by a 'fierce-eyed temptation with murdering fingers'. When he accidentally falls into the water she is paralyzed and watches him drown without trying to save him (35, 738, 763). Emma Bovary's beautiful dark eyes captivated even her experienced seducer Rodolphe, who on the first meeting noted how her 'eyes really bore into you'.[7] After failures in adultery, Emma kills herself. In Zola's *La Bête humaine* (1890), beautiful blue-eyed Séverine Aubry, who is both a victim of seduction and a seductress, helps her maniacally jealous husband murder her seducer. The dangerous seductress in Mary Elizabeth Braddon's *Lady Audley's Secret* (1862) possessed a 'magic power of fascination' that was centred in her irresistibly 'soft and melting blue eyes'. After Lady Audley murders her first husband and plots arson, the narrator explains her wickedness as 'an assertion of the right divine invested in blue eyes'.[8] The heroine of Giovanni Verga's 'The She-Wolf' (1880) had 'devilish eyes' that drew men 'behind her skirt with a single glance' and bewitched her son-in-law into a tortuous affair. In the final scene as the young man approaches her with an axe, she walks toward him with 'her black eyes devouring him'.[9] Even

the deep azure eyes of innocent Cosette in Hugo's *Les Misérables* had a 'power to implant in another heart the ominous flower, so loaded with fragrance and with poison'.[10] Hardy's heroine, whose exquisite eyes inspired the title *A Pair of Blue Eyes*, destroyed the loves of the possessive men in her life, albeit unwittingly, before she died from a broken heart. Bathsheba, the heroine of *Far From the Madding Crowd* (1874), was named after a biblical character whose beauty seduced her lover into an immoral act that cost her husband his life. In the novel Bathsheba sends to a neighbour a whimsical valentine that ultimately leads to disaster: 'His bachelor's gaze was continually fastening itself [on the valentine], till the large red seal became as a blot of blood on the retina of his eye.'[11] By the time her inadvertent seduction of him has run its course, he has murdered the man she first married and become insane.

I list these heroines with strong and dangerous eyes, not to establish their commitments to the morality of love, but as examples of women who are not objectified by the male gaze and who have powerful, objectifying eyes of their own. Victorian literature also abounds with heroines who have strong eyes as well as a superior commitment to the morality of love.

Nathaniel Hawthorne's *The Scarlet Letter* (1850) is an American novel set in seventeenth-century Boston, a town infused with British moral values. Its heroine is Hester Prynne, who has 'a face which, besides being beautiful from regularity of feature and richness of complexion, had the impressiveness belonging to a marked brow and deep black eyes'.[12] Years earlier Hester had an adulterous affair, which Hawthorne does not detail, but which carries the moral significance of a seduction. She is punished for this sin by having to wear the ignominious scarlet *A* on her bosom. She first exhibits it at the town pillory, where she bears the pain of 'a thousand unrelenting eyes, all fastened upon her, and concentrated at her bosom'. Hawthorne explains that 'those who had before known her and had expected to behold her dimmed and obscured by a disastrous cloud, were astonished, and even startled, to perceive how her beauty shone out, and made a halo of the misfortune and ignominy in which she was enveloped' (81). Her eyes are clear and bright, while the eyes of her co-adulterer, the cleric Arthur Dimmesdale, are dim.

After seven years of hiding behind hypocritical sermons against sins of the flesh, he is relieved, he tells her, 'to look into an eye that recognizes me for what I am!' (183). But as becomes evident during their talk in the forest, she alone sees a way out of their unhappiness, and he lacks the courage to accompany her to safety, let alone rescue her. She urges him to flee with her to Europe, but he is paralyzed by fear. 'She had wandered, without rule or guidance, in a moral wilderness' on a journey that had set her free (189). Dimmesdale has never gone beyond the law except for his one

moment of passion which brought no liberation and became rather a defining moment of guilt. She elegantly embroidered and proudly exposed the *A* on her bodice, while he concealed his sin and developed a mysterious symbol of adultery on the skin over his heart, which he unconsciously strokes whenever he feels guilty.

Dimmesdale's final dimming is fatal. He fears that the resemblance of his illegitimate daughter, Pearl, to him will be detected: she is the living hieroglyphic that can expose his secret. Her name itself conjures up a gem that grows slowly in the dark, like his own unacknowledged sense of sin. Dimmesdale fears her look, and so Hester asks Pearl to meet Dimmesdale face to face. With 'her bright, wild eyes' the girl looks him over and sees the deception of the moment when she notices that her mother has removed the Scarlet Letter. Pearl insists that it be replaced. She will not sanction her mother's love until Dimmesdale publicly acknowledges his paternity, which he refuses to do. Later, just before dying, he finally summons the courage to confess his past sin. He cannot bear to let the world see the truth about himself until his vision is about to fade for the last time. He allows his own sin to be seen only when he is about to disappear. To the end Hester has brighter eyes, clearer vision, and greater moral courage.

In Hardy's *Tess of the d'Urbervilles* Angel Clare first views Tess as a vision of purity, with her 'large innocent eyes'.[13] But he walks away. Her parents, to serve their financial and social ambitions, push her into the company of her cousin Alec, a consummate seducer with a 'bold rolling eye' (79). She tenaciously resists but then reluctantly agrees to live at his estate and care for his mother's poultry farm. Tess shows her disgust by repeatedly rejecting Alec's seductive efforts, but her lack of money, status, and experience with men make her vulnerable. She succumbs late at night in a fog-shrouded wood. Hardy does not describe the actual seduction, but he vouches for her surviving purity by questioning 'why it was that upon this beautiful feminine tissue, sensitive as gossamer, and practically blank as snow as yet, there should have been traced such a coarse pattern as it was doomed to receive' (119). Even though Tess becomes pregnant, she remains morally untainted.[14]

Although she is socially ostracized for bearing an illegitimate child, her growing maturity and complexity are registered in her eyes. One day she stops working in the fields to nurse her baby and appears with 'large tender eyes, neither black nor blue nor gray nor violet; rather all those shades together, and a hundred others, which could be seen if one looked into their irises – shade behind shade – tint beyond tint – around pupils that had no bottom' (140–41). Her eyes reflect a depth of feeling and richness of character that Alec and later Angel find irresistible.[15] The eyes of no

man in Victorian literature are described with such depth as an indication of a profound soul. I do not mean that men were not as deep, but that their depth was not indicated by multi-coloured eyes. Flaubert described the eyes of Emma Bovary similarly, and the eyes of Hardy's Elfride Swancourt were 'a misty and shady blue, that had no beginning or surface'. Men's eyes are generally described as black, indicating a depth of character that no one can plumb at all, in contrast to the more brightly coloured, if not multi-coloured, eyes of women that indicate a somewhat more accessible and visible depth.[16]

After her baby dies, Tess finds work at a dairy farm, where she again meets Angel, who this time falls in love. His subsequent rejection of her is devastating, because he is intelligent, considerate, and morally responsible. The son of a poor parson, he declines a university education even though he is intellectually promising; he refuses to become a minister on a matter of principle and despises distinctions based on wealth or lineage, and he is an impassioned defender of the abstract rights of man, although blind to the current subjugation of women.

Tess's way of getting up in the early morning indicates her superior self-discipline and strong moral fibre. Among the dairy workers she alone can be depended on not to sleep through the alarm. As she and Angel emerge one morning at dawn, they appear, Hardy writes, like Adam and Eve at the dawn of civilization. Tess's refined beauty is evident in her expression, which seems 'to exhibit a dignified largeness both of disposition and physique, an almost regnant power'. Emerging into the sunlight she looks like a visionary with diamonds of moisture hanging on her eyelashes (186–8).

Angel's proposal begins with the couple in a proposal composition, because when preparing to put the question, he gazes intently at Tess, while she looks away. After her eyes lifted, 'his plumbed the deepness of [her] ever-varying pupils, with their radiating fibrils of blue, and black, and gray, and violet, while she regarded him as Eve at her second waking might have regarded Adam' (232). Tess's multi-coloured eyes symbolize the complex colouring of her character, which Angel will be unable to comprehend.

She refuses his proposal because she has not told him about Alec and fears that Angel will blame her when he finds out. She does not want to agree to anything that will cause bitterness, and the struggle in her conscience registers in her deepening glance. Angel 'would sometimes catch her large, worshipful eyes, that had no bottom to them, looking at him from their depths, as if she saw something immortal before her' (257). Even after accepting, she tries to sabotage the wedding, but the confessional letter that she slips under his door also slips under his carpet, and

when she finally retrieves it, she loses her nerve.

On their wedding night Angel confesses to having indulged in 'forty-eight hours of dissipation with a stranger'. Encouraged by his candour in confessing a sin that he chose to commit, Tess hopes that he will forgive her sin with Alec that she struggled to resist. Hardy describes the pathetic composition of the couple as Tess begins to murmur her confession while 'pressing her forehead against his temple . . . and with her eyelids drooping down' (293). When love troubles have to be discussed, Victorian women cannot look their man in the eye.

Angel's response is a classic instance of the double standard, as Hardy announces with the title of the next section – 'The Woman Pays'. Angel won't pay until later. Hardy's highlighting the destructive effect of the double standard sets up the emotional force of the story which derives from the injustice of the double standard. Angel is frantic with a sense of being betrayed. When she protests that she forgave him and asks why he cannot forgive her, he replies, 'the woman I have been loving is not you' (299).

Angel's jealousy may have been aggravated by his knowledge of erroneous theories about sex and reproduction. Victorians had no knowledge of the placental barrier. They believed that a pregnant woman shares fetal blood and that therefore after delivery retains in her own bloodstream permanent traces of the father's character. Victorian men worried that their own essence, as one moralist warned, would have to 'enter into conflict' with traces of their 'predecessor's organism' in any child of theirs conceived by a woman who has had a child sired by another man.[17] In Angel's mind, Tess cannot be his wife, because she is contaminated by her seduction and especially by her pregnancy. Hardy does not spell out this theorizing, but it is implied by Angel's remark – 'You were one person; now you are another' (298). Angel returns to this obsession when he ends any possibility of their remaining together with the bitter question 'How can we live together while that man lives? He being your husband in Nature, and not I.' If he married her, he warns, their children would become 'wretches of our flesh and blood growing up under a taunt [taint?]'(313).

Whatever the reason for Angel's reaction, his explanation is based on a double standard, which Hardy exposes as terribly wrong. Tess is indeed not the person Angel thought she was, but neither is he the person she had taken him to be. Learning to love is a process of discovering things about one's beloved that were once concealed. By having Tess be the more accepting of those disclosures and having Angel act so brutally during the breakdown of their marriage, Hardy establishes Tess's stronger commitment to a single and more humane morality of love.

Their respective responses to separation also show her superior com-

mitment to that morality. Angel condemns and abandons her, while she reaffirms her love and determines to remain faithful to him. In an impulsive moment before leaving England, Angel even asks Tess's friend Izz to accompany him as his mistress. When Izz reminds him that he already has a loving wife, he thanks her for saving him with such honesty about Tess and adds, 'Women may be bad, but they are not so bad as men in these things!' (345). In contrast to Angel's unfaithful impulse, Tess waits faithfully for Angel to change his mind and return to her. She wants to avoid any possibility that in the meantime she will again be the victim of a seduction and so tries to eliminate her own sex appeal at the place of visual access to her soul by cutting off her eyebrows.

She is nevertheless seduced again by Alec, whose religious conversion in the interim has barely sublimated his earlier lust. Hardy again centres Alec's predatory character in his eyes, which bore into Tess's body: 'Her back seemed to be endowed with a sensitiveness to ocular beams – even her clothing – so alive was she to a fancied gaze' (385). Her own resisting eyes unintentionally seduce the distraught Alec, who protests in vain – 'Tess – don't look at me so – I cannot stand your looks! There never were such eyes, surely, before Christianity or since!' (396). Alec extols the pagan beauty of her eyes but also blames them for his own succumbing to temptation.

Condemned and rejected by a self-righteous husband on her wedding night, deserted by her family, impoverished by misfortune, weighted with guilt, and weak from overwork, Tess relents and becomes Alec's mistress. After Angel returns, she murders Alec. Then the reunited couple escape for a brief honeymoon on the run before she is captured, tried, and hanged. Hardy concludes with a glimmer of hope in anticipation of the marriage of Angel to Tess's sister Liza-Lu, 'a spiritualized image of Tess . . . with the same beautiful eyes' (488).

The moral assessment of Tess is in the novel's subtitle: 'A Pure Woman Faithfully Presented by Thomas Hardy'. That judgement, he wrote in the 1912 preface, 'nobody would be likely to dispute', although, as he added, it was 'disputed more than anything else'. That public protest was energized by the double standard. The novel could not have stirred up such powerful reactions if readers, in spite of their public posturings, had not really believed that the double standard was wrong. The novel drew its message from the single moral code for lovers that guided Tess from beginning to end, one that Angel learned to embrace and that Hardy obliged his readers to consider as preferable to the double standard that ruined Tess's life.

Other Victorian literary heroines exhibit their tempting beauty far more intentionally than do Hester or Tess. By way of transition to more

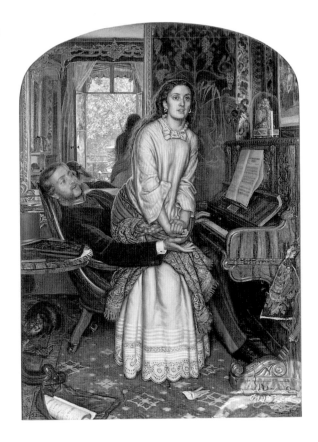

85 William Holman Hunt, *The Awakening Conscience*, 1853–4, oil on canvas. Tate Gallery, London.

aggressive seductresses, consider one former partner in seduction who is rethinking the value of her sexual power – the courtesan who has just resolved on an inspired *no* in Hunt's *The Awakening Conscience* (illus. 85). She rises from her seducer's lap in yet another proposal composition. He is in three-quarters profile and looks at her, while she is frontal and looks away. His upturned eyes with curling eyebrows have a feline look, similar to that of the predatory cat on the floor behind his chair.[18] The cat is playing a deadly game with the bird, just as the man has been toying with the woman. The man's eyes are full of fatuous desire as he sings the song displayed on the piano, 'Oft in the Stilly Night'. The song tells of an earlier time of innocence and includes the lines 'The words of love then spoken:/ The eyes that shone,/ Now dimmed and gone'. He is unaware of the effect this song has on the woman, as Hunt explained 50 years later: 'These words, expressing the unintended stirring up of the deeps of pure affection by the idle sing-song of an empty mind, led me to see how the companion of the girl's fall might himself be the unconscious utterer of a divine message'.[19]

The emotion in the woman's eyes is further indicated by the title of another song lying on the floor – 'Tears, Idle Tears'. Its first stanza also describes the eyes of lost innocence:

> Tears, idle tears, I know not what they mean,
> Tears from the depth of some divine despair
> Rise in the heart, and gather to the eyes,
> In looking on the happy autumn-fields,
> And thinking of the days that are no more.

Eyes dimmed with regret and filled with tears of divine despair are not the eyes shown, a discrepancy explained by the fact that the purchaser of the painting was so disturbed by the woman's anguished face that he made Hunt change it (illus. 86). One reviewer in *The Athenaeum* was troubled enough by her original expression to write that 'the author of the "Bridge of Sighs" could not have conceived a more painful-looking face'.[20] John Ruskin described the original look as 'sudden horror' and the original eyes as 'filled with the fearful light of futurity'.[21] The original portrait was modelled by Hunt's sexually adventurous 'fiancée', Annie Miller. As he explained, his intention in the painting had been to show this woman 'breaking away from her gilded cage with a startled holy resolve'.[22] Another contemporary reviewer explained that the religious significance of her

87 William Holman Hunt, *The Light of the World*, 1851–3, oil on canvas. Keble College, Oxford.

resolve was most evident in her eyes: 'The points of reflection are placed so low on the eyes as to give a supernatural, or even a death-like, appearance to them'.[23] While Hunt painted over the original face's despair and horror, in the final image he retained the heavenly regard with radiant eyes that look up to see the divine light and express a hope for salvation.

The woman looks away from her vacuous companion's heavy-lidded eyes of desire toward the redeeming eyes of God, which Hunt depicted in a pendant to this painting, *The Light of the World* (illus. 87). It shows Christ bringing light to a closed soul, symbolized by a rusty-hinged, wooden door overgrown with weeds. Hunt inscribed on the frame a quotation from Revelations 3:20: 'Behold I stand at the door, and knock; if any man hear my voice, and open the door, I will come in to him, and will sup with him.' Although the biblical language refers to generic man, the painting refers to the compromised woman in *The Awakening Conscience*. 'When "The Light of the World" was on my easel at Chelsea in 1851', Hunt wrote, 'it occurred to me that my spiritual subject called for a material counterpart in a picture representing in actual life the manner in which the appeal of the spirit of heavenly love calls to a soul to abandon a lower life'.[24] A biblical passage suggested to Hunt the man singing a song that recalled a lost innocence. 'In scribbles I arranged the two figures to pre-

sent the woman recalling the memory of her childish home and breaking away from her gilded cage with a startled holy resolve, while her shallow companion still sings on, ignorantly intensifying her repentant purpose.'[25] The cause of the woman's closed soul is sin, symbolized by the apples at Christ's feet. Thus the soul Christ approaches and the sin he redeems are a woman's. When the paintings are viewed together (as Hunt intended), it is evident that, as Susan Casteras concludes, Christ is 'knocking on the door of the woman's soul'.[26] Christ's saving light is also feminine. He wears a white gown similar to that of the fallen woman, and the two most important models for Christ's head and face were the two most creative female Pre-Raphaelite artists, Elizabeth Siddall and Christina Rossetti.[27] As a result, Christ's facial features and compassionate eyes are feminine. In Revelations, near the passage that Hunt inscribed on his frame, Christ is also recorded as saying 'I counsel thee to . . . anoint thine eyes with eye-salve, that thou mayest see'. Hunt shows the fallen woman's anointed eyes looking for a light that emanates from Christ, 'the light of the world', which also creeps into the lower-right corner of *The Awakening Conscience* as it lights up the leg of the piano.

This morally awakening courtesan plays a morally provocative role in a society that viewed women who fornicate as beneath contempt rather than worthy of Christ's personal salvation. As Helene Roberts concluded, Hunt took 'the fallen woman, the symbol for the Victorians of what was physically and morally monstrous, a creature unworthy to be represented in art, and elevated her into a religious, an almost saintly symbol – the woman taken in adultery, the Magdalene. She is the sinner whom Christ did not forget, the damned soul whom He helps to redemption'.[28] Hunt accorded to woman a higher level of moral strength than her seducer, as is evident in her God-seeking eyes.

The roles of seducer and victim are impossible to separate distinctly in Hunt's *The Hireling Shepherd* (illus. 88). The shepherd's moral transgression is clearly indicated in the background, where the sheep have strayed into the ripe field of grain under his unwatchful eye, and his objective is clearly indicated in the foreground with his keen focus on a sexual conquest, the moral value of which is implied by the death's-head moth that he is using to impress and unsettle the shepherdess. Although her sexual interests are slightly ambiguous, her immorality is equally in evidence. She is no courtesan, but she is on the brink of committing an immoral act, as is indicated by her already evident lapse in good judgement for a Victorian woman – an inexcusable dereliction of her duty to provide proper nourishment, in this case for the lamb sitting in her lap, which she allows to eat green apples. Judith Bronkhurst interprets the apples as 'an emblem of dangerous knowledge or seemingly attractive yet ultimately poisonous

88 William Holman Hunt, *The Hireling Shepherd*, 1851–2, oil on canvas.
City Art Gallery, Manchester.

doctrine'.[29] Hunt intended a critique of the religious controversies between Tractarians and Evangelicals that distracted the Church of England from its more important task of combating Romanism and saving souls. The shepherdess in scarlet (Cardinal's robes) represents Roman Catholicism (the Whore of Babylon), with whom the shepherd flirts at his peril.

In arranging this pair as a proposal composition Hunt accorded to the woman greater visibility, because her motives and goals were more important. Her spiritual wayfaring and maternal lapse were more dangerous to the social order than the man's intended sexual escapade, and the painting suggested to Victorian viewers that if women cannot resist temptation, no one can. The impending moral decision was hers to make as she reclined comfortably and turned a sceptical but aroused eye frontally toward her kneeling seducer propped up on an arm. In this presentation the man and the woman seem to be seducing one other, but the artist's interest centred on the more intriguing eyes of the woman.

In contrast to the typical proposal composition, in Hunt's *Claudio and Isabella* (illus. 89) the woman is looking at a man who looks away, and he is viewed frontally. It illustrates a scene from Shakespeare's *Measure for Measure*, some time after Claudio has seduced and impregnated his

89 William Holman Hunt, *Claudio and Isabella*, 1850–53 (retouched 1879), oil on panel. Tate Gallery, London.

fiancée, Juliet. For that he has been imprisoned and sentenced to death by the town deputy, Angelo, who agrees to free Claudio only if he can persuade his sister Isabella, shown wearing a novitiate's habit, to become Angelo's mistress. Hunt depicts the moment after Isabella has refused Claudio's request, and he turns away in despair. The painting is an exception to the usual arrangement, because the male seducer is shown frontally, while the potential female victim is in profile, but their seducer-and-victim roles are not with one another. The painting does conform, however, to the convention of giving a more frontal view to the person experiencing more stress – Claudio. Standing in the light, Isabella is a paragon of goodness, with her light-brown eyes illuminated by the sun streaming in through the window. But her expression is less intriguing than that of her brother, who twists away from her unwavering look. Unlike the numerous women who look away from the male gaze to reflect on their own difficult choices in love, he turns away from a woman's look that reveals to him the despicable nature of his request and triggers his famous meditation on the horrors of death.[30] Hunt gave Claudio the frontal pose, I suggest, because Claudio was experiencing the sort of emotional turmoil that was typically faced by women. Isabella enacts that transfer of the woman's heartbreaking

turmoil to the man by forming the shape of a heart with her hands over Claudio's own heart. As a hint of his dependency on that gesture, his left hand clutches her wrist.

While the eyes of male seducers in art are narrowed and shadowy, the eyes of full-blown seductresses are open, luminous, and dazzlingly beautiful. The woman sauntering proudly down the steps in Thomas Couture's *Jocondo* (1844; Heim Gallery, London) has large, animated eyes that are open and frontal, while the object of her gaze, her profiled lover, slouches against a wall and drowsily glances up at her from a deep shadow. The eyes of Gustave Moreau's Salomes, Sphinxes, and Sirens are aglow with potency and magic. Even his male gods have long hair, delicate faces, and large open eyes adorned with feminine cosmetics and jewelry. Toward the end of the century, dead eyes in dead men abound in portraits of Salome and Judith that express these seductresses' powerful emotions: revenge, cunning, drunkenness, mourning, contempt, triumph.

The Pre-Raphaelite painter Burne-Jones and the two neo-classical painters Frederic Leighton and John William Waterhouse created a gallery of open-eyed seductresses triumphing over weak-eyed men. Leighton was a loner with a strong aversion to aggressive female sexuality.[31] When Leighton depicted women alone, he gave them broad shoulders and radiant open eyes. The woman in *The Last Watch of Hero* (1887; City Art Gallery, Manchester) has the arms of a blacksmith and a pair of large mournful eyes. When he depicted seductive women with men, the ocular imbalance between the sexes was pronounced. In *The Fisherman and the Siren* (illus. 90), the fisherman's face is more frontal than the siren's, whose desirous open eyes are posed out of view. Her seductive powers are indicated by her encircling arms and muscular tail that snakes through the foam and envelops the fisherman's legs. In anticipation of a conquest, she gazes straight up into his eyes, while he looks down in defeat with eyes that have lost their vitality as his hands have lost their grip. From the position of his arms, we see that her seductive gaze has the power to crucify.

Unlike the bachelor Leighton, Burne-Jones was married, but both artists showed a similar fascination with the potent eyes of seductive women. In Burne-Jones, men are often androgynous and vulnerable types with delicate faces, even when matched with bodies in suits of armour. In *The Love Song* (illus. 91) the profiled knight seated in an unknightly pose with his legs tucked under himself gazes at a seductive but remote and ethereal organist, who looks frontally away from him into the distant foreground. She is assisted at the bellows by a feminized figure of (blind) Love, who has peaceful closed eyes but a wildly swirling cape. The knight's love is ardent (symbolized by tulips) but bitter (symbolized by

90 Frederic Leighton, *The Fisherman and the Siren*, 1858, oil on canvas. Bristol Art Gallery.

91 Edward Burne-Jones, *The Love Song,* 1868–77, oil on canvas. Metropolitan Museum of Art, New York.

wallflowers). Although the composition suggests that the organist is play-
ing for him, she seems to be playing for herself, if she is paying attention
to the music at all. The medieval setting creates a sense of distance from
the present and from reality, and the painting is infused with a nostalgic
atmosphere suggesting that love is remote in space as well as time. What-
ever were the reasons the knight had for coming to listen, they are fading
along with the light that illuminates the far-off glance of the organist. The
spellbound eyes of the musician and of Love are elsewhere, while the
knight attends to them. Their transcendent expressions – one with eyes
closed, the other with sad, distant eyes – transcend the male gaze.[32]

Burne-Jones's *The Beguiling of Merlin* (illus. 92) is another of the sev-
eral paintings that I discuss which include a more frontal man. Merlin was
the genius behind Arthur's reign, a personification of masculine wisdom
and magical power. He became infatuated with beautiful Nimuë, taught
her magic, and allowed himself to be seduced and go to his death in the
woods under a hawthorn tree. The painting shows a moment when Nimuë
holds the magic book and peers down on Merlin while casting a spell that
will encase him in the tree. He is losing his magical power and his will to
live. His face reveals an eerie mixture of the deep-set penetrating eyes of
a great magician and the unfocused, milky eyes of a blind man. Twenty

92 Edward Burne-Jones, *The
Beguiling of Merlin*, 1874, oil on
canvas. Lady Lever Art Gallery,
Port Sunlight, Merseyside.

years later Burne-Jones explained the personal reference: 'The head of Nimuë . . . was painted from the same poor traitor [himself, betraying his wife], and . . . her name was Mary [Zambaco]. . . . She was born at the foot of [Mount] Olympus and looked and was primeval. . . . I was being turned into a hawthorn bush in the forest of Broceliande.'[33] Of course Burne-Jones had a penetrating gaze of his own to seek out Mary, and he had a cultivated artistic eye for depicting her so powerfully, but the painting shows a literary figure known for casting spells who is rather being mesmerized by the gaze of a woman. She was born at the foot of the mountain of the gods and had a way of looking that was deadly. The painting is packed with symbols of her power to spellbind with piercing eyes: her strong upright body towers over his weakened supine body, the limbs of the blossoming tree crowd the space and entwine Merlin's limbs, and her hair is full of snakes, evoking *the* virulent female gazer, Medusa.

Burne-Jones's seductive women could be visually potent whether they were encasing a man in a tree or emerging out of one. The woman in *Phyllis and Demophoön* (illus. 93) was also modelled by Mary, this time as Queen Phyllis of Thrace, who was abandoned by her husband Demophoön. When he did not return as promised, she killed herself and was transformed into an almond tree. The painting shows a moment after his tardy return, when she surges out of the tree and into the wind, embraces his naked body with her arms, and stares forlornly into his troubled eyes. The man's eyes are more frontal, but the woman's eyes define the moment and control the action. Years later Burne-Jones described her face as being like 'hurricanes & tempests & forked lightning – & billows of the sea'.[34] In *The Tree of Forgiveness* (1882; Lady Lever Art Gallery) he disguised the already well-known identity of the model for Phyllis, but the composition was similar, with a confident and now naked seductress in profile, staring pointedly at Demophoön whose anguished eyes roll toward her like those of a prey at the mercy of its predator.

In Burne-Jones's *The Depths of the Sea* (illus. 94), another pair of enfolding woman's arms make a deadly embrace under water, where a siren has lured a sailor to his doom. He seems to have glided down easily, as though he gave up without a struggle, if not willingly.[35] The siren is secure enough in her conquest to look away from the man, with whom she has presumably had a life-and-death struggle, to face the viewer with strong, frontal eyes. A reviewer in the *Athenaeum* observed that 'She, with wicked triumph gleaming in her eyes, smiles over her victory. . . . Delight in evil gleams in her witch-like face.'[36] This response indicates how sensitive reviewers had become to potent female eyes. In fact the siren's face is hardly witch-like, and her eyes are not wicked; they are accented by white highlights that shine through the blue wash and indicate a secure sense of

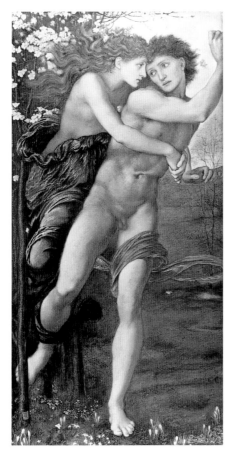

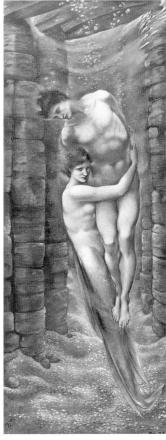

93 Edward Burne-Jones, *Phyllis and Demophoön*, 1870, watercolour. Birmingham Museums and Art Gallery.

94 Edward Burne-Jones, *The Depths of the Sea*, 1887, watercolour and gouache on paper mounted on panel. Fogg Art Museum, Cambridge, MA.

inner strength, as if this conquest was merely another day's catch. Burne-Jones was intent on showing the notoriously dangerous siren, but he did so not by depicting her in a moment of triumph with flashing diabolical eyes but with calm eyes that express satisfaction over a routine job well done.[37]

Waterhouse specialized in exceptionally young seductresses and sorceresses like the one in *Circe Offering the Cup to Ulysses* (illus. 95). Circe was the daughter of the sun god Helios, who gave light and vision to mankind. Interpretation of her magical power to transform men into animals cuts two ways, depending on whether she is seen as imprisoning men in animals or liberating the animal that has been imprisoned in them.

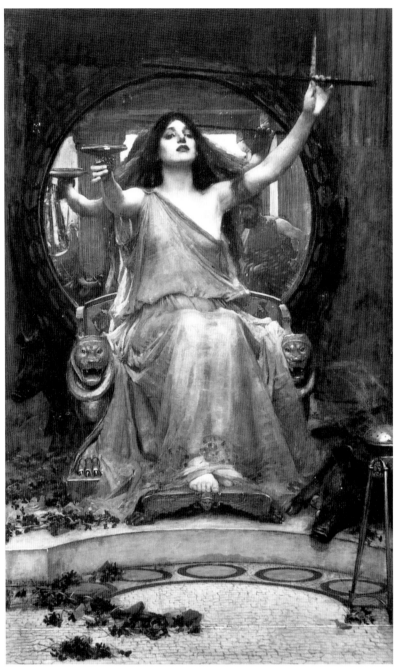

95 John William Waterhouse, *Circe Offering the Cup to Ulysses*, 1891, oil on canvas. Oldham Art Gallery.

Waterhouse shows her arrayed with symbols of her transforming power. One already transformed man/pig dozes at her feet, while another pokes a drowsy snoot out from behind her throne. In contrast to these drugged pig-eyes of easily seduceable men, the eyes of two lionesses flash warnings out of the arms of Circe's throne, which is also ornamented at the bottom with Medusa's head and deadly eyes. In Circe's hands are the tools of her magic: the wine to drug men and the rod for a final tap that turns them into animals. She is ready to so transmute Ulysses, but he has a special herb that will protect him from her magic. Waterhouse nevertheless depicts him (with a self-portrait) as a tentative and diminutive figure, reflected in a mirror and visible just behind Circe's armpit. She looks down at him and the viewer with an imperious frontal gaze. Although her sorcery comes from food and wine, she is depicted as a wide-eyed sexual seductress with her left shoulder and part of her left breast tantalizingly exposed, while Ulysses approaches cautiously from a shadowy background and eyes her warily.

Waterhouse portrayed the same mythical hero lashed to a mast, facing a flock of seductresses in *Ulysses and the Sirens* (1891; National Gallery of Victoria, Melbourne). Seven flying sirens hover about his ship and glare at him with eyes that offer more visible imagery of their terrifying powers than would be possible with an image of their deadly singing, although the sailors' bound ears remind us of their seductive song. The message is that men must close off their senses to navigate the dangers of seductive women. In *Hylas and the Nymphs* (illus. 96) a male is again surrounded by seven dangerous young seductresses, who this time are attracted to his beauty. One of them grabs his arm firmly with her two hands to draw him into the murky water, a lubricous brew of naked nymphs and budding water-lilies. Waterhouse chooses not to show Hylas's renowned beauty frontally but only in profile, shadowed in a cloudy sunlight that illuminates the nymphs, whose aroused eyes radiate modest but determined pubescent desire.

The artists and writers I have discussed were drawn to seduction as a theme that enabled them to show men and women in a pivotal moment of sexual vulnerability and moral crisis. When the women are shown as seducers their eyes command attention, often because their irresistible beauty was the source of their seductive power. When women are shown being seduced, their eyes are more prominent, because interest is directed to their victimization and downfall. They were more vulnerable than men who were seduced, because the consequences for women, unlike those for men, were social ostracism and prostitution as well as the risk of disease and death. Painters found that the eyes of women on the verge of a seduction expressed the extremes of human emotion and gave sharp

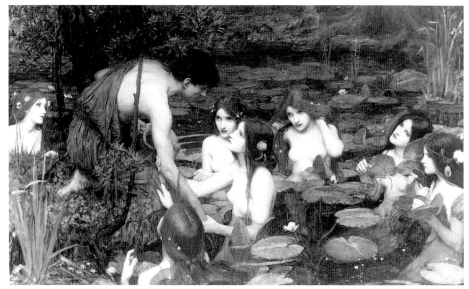

96 John William Waterhouse, *Hylas and the Nymphs*, 1896, oil on canvas.
City Art Gallery, Manchester.

focus to artworks that they hoped would bring about moral instruction and spiritual uplift. They created numerous proposal compositions with male seducers in profile working on frontally posed women who are shown contemplating the *yes* or *no* that will decide their fate.

A moral code is only meaningful as a moral code if it can be broken. Women 'on the brink' of breaking a moral code were far more interesting than male seducers who had already decided to trangress. The eyes of male seducers were consistently relegated to the shadows and the margins, directing viewer attention toward the more frontal and brightly illumin- ated women in whose eyes artists expressed the most intensely felt moral dilemmas of the age. One of the great mysteries of Victorian art is the original woman's face in *The Awakening Conscience* that Hunt was obliged to tone down from an expression of agonizing remorse mixed with a vision of Christ. Such an act of censorship indicates the potency of that woman's eyes, while those of the most seductive male gazer could scarcely have seemed as disturbing.

7 Rescue

A man fantasizes about rescuing a woman because he feels helpless to win her love. The more unattainable the love, the more extravagant the fantasy. For such men the most unattainable women – intelligent, creative, beautiful, powerful, or wealthy – are those who least need to be rescued. The male rescue fantasy is therefore based ultimately on insecurity about independent and competent women. A woman also fantasizes about rescuing a man because of her own sense of helplessness, but in the Victorian world the two sexes faced different kinds of danger that might require their being rescued, and had different motives and resources for undertaking a rescue.

Men faced dangers in the public realm that came from their commitments to war, religion, or politics – commitments that led them away from love. Because men chose such projects, they were more directly responsible for the neglect and consequent failure of love. Although some of those dangers had high moral value in the public sphere, in paintings of rescues set in the private sphere, women show a stronger commitment to the morality of love.

Women faced dangers that resulted from being appealing to a man or from venturing to love one. Abduction, seduction, out-of-wedlock pregnancy, abandonment, social ostracism, and poverty, as well as barrenness, childlessness, or spinsterhood, loomed large for women. The work for which they were raised centred on marriage and family, both of which were dependent on a mate, if not love, while men had many other kinds of work that would provide income and give life a purpose. Women shown being saved by men were threatened by physical harm as well as dangers that involved personal relationships and imperilled their capacity to love. Dangers such as premarital sex or prostitution were partly under women's control, while abduction, rape, or illness were not, but all of these perils threatened women sexually and cut them off from love, supposedly their main concern. Women were thought to be more helpless; consequently they were often depicted tied to a rock or a tree and threatened directly by a monster or an evil man, while men were shown preparing to go into a dangerous situation.

The motives for undertaking a rescue also differed. Men were motivated by a desire to win a woman's love directly, while women were motivated by the need to restrain a man from walking out on love, even when he did so to wage a battle that would supposedly make love secure. Men were depicted actually fighting for that love in a battle with another man (or a monstrous stand-in for one), while women performed rescues usually to keep men from getting into danger. It is hard to imagine two Victorian women being depicted fighting over a single man, let alone a man who is chained naked to a rock.

Men had superior resources, such as greater physical strength, protective armour, and mighty weapons, and they rode powerful horses or hippogriffs. Women's main resource was their exceptional beauty, which itself could provoke male rivalry and necessitate their own rescue. Men went on dangerous campaigns in groups with public blessing, while rescuing women ventured out alone, beyond the private sphere where proper Victorian women were supposed to be.

Rescue was an attractive theme for artists who recoiled from an unheroic present and sought models of behaviour in a heroic past. Pre-Raphaelites looked to medieval England for inspiration, while neo-classicists looked to ancient Greece and Rome. But in spite of these artists' diverse literary sources, formal objectives, and love-lives, the art of rescue by male artists reveals a pattern of fascination with the eyes of women in crisis, which reflect deeper emotional turmoil about the ways of love and deeper conflict over the moral code that governed it than did the eyes of the men who are with them at these moments of crisis.

In Victorian England, with its fantasies of a strong courtly tradition, artists enthusiastically produced images of men rescuing women. Before considering these, I must examine images of female rescuers, which reveal some clear gendered differences.

Millais repeatedly represented the rescued man's face and eyes less prominently than those of his female rescuer. In *The Black Brunswicker* (illus. 97) the soldier shown in profile attempts to leave for war, while the woman holds on to the doorknob in a gesture of restraint. His face is fixed with martial resolve; hers is delicate. Her face reveals a conflict acted out by the gestures of her back-reaching hand that counters his effort to open the door and her affectionate but restraining touch of his tunic. She confronts his resolute face along with two others: the impassioned face of Napoleon on his rearing horse, pointing the way for his men to proceed over the Alps (shown in the print on the wall), and a death's-head and cross-bones, symbolizing the Brunswicker's code of neither giving nor receiving quarter (depicted on the soldier's helmet). Her only ally, on the floor beside the man, is her faithful dog, which looks up imploringly at the

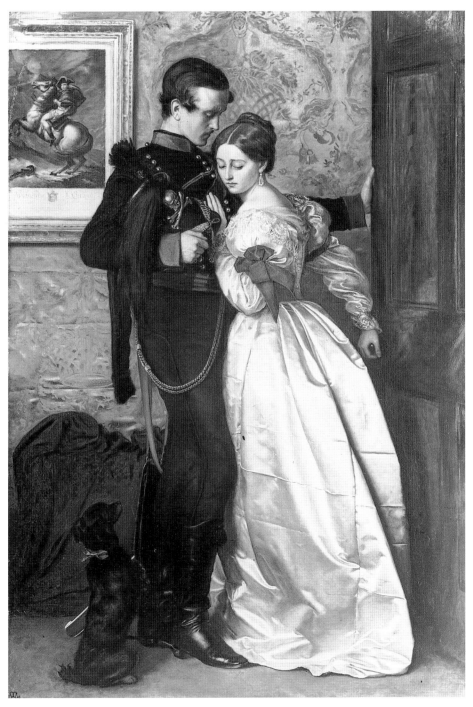

97 John Everett Millais, *The Black Brunswicker*, 1859–60, oil on canvas. Lady Lever Art Gallery, Port Sunlight, Merseyside.

soldier. The woman is trying to hold on to their commitment, while the soldier is preparing to walk out on it in order to fulfil his duty and supposedly preserve the domestic peace. He may have believed, in accord with the chivalric code, that in serving his country he was serving love, but many men enlisted in order to escape the complexities and uncertainties of love, and in any case paintings could not show such a roundabout connection between killing the enemy in the field and making love in safety at home. In this silent clash of wills, her more frontal, larger, and more delicate downcast eyes suggest greater conflict about the effect of his departure on their love. Her sensitive expression is more nuanced than his firm look of disciplined resolve, and her stronger commitment to making love succeed is more in evidence.

A similar division of male and female looks is captured in Millais's pendant to this painting, which pits a woman's love against a man's religious loyalty – *The Huguenot, Eve of St Bartholomew's Day, 1572* (illus. 98). The

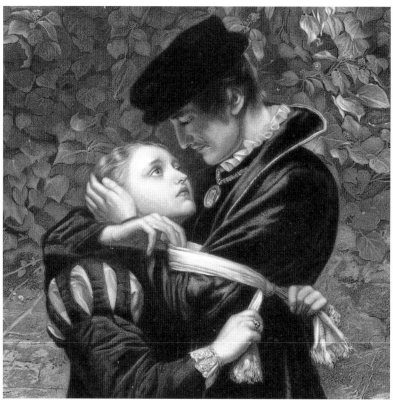

98 A detail from T. O. Barlow's engraving and mezzotint of 1857 after John Everett Millais, *The Huguenot, Eve of St Bartholomew's Day, 1572*. Yale Center for British Art, New Haven (Paul Mellon Fund).

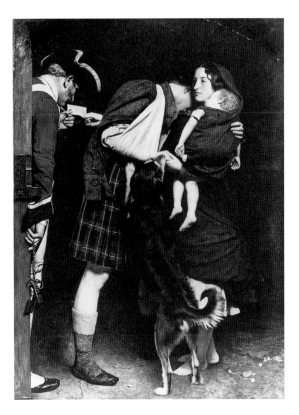

man is Protestant, the woman Catholic. She is trying to tie a white ribbon around his arm so that he will be taken for a Catholic and hence escape the massacre. He is pulling it off. Millais intended to capture a moment from Giacomo Meyerbeer's opera *Les Huguenots*, in which the woman ultimately accepts the man's decision, converts to Protestantism, and is killed with him. Although in the painting both are putting themselves at risk, the man's face is profiled and in shadow, of less pictorial interest than the woman's imploring and yet resigned face, which is uplifted and brightly illuminated. The expression of the man's courageous act of faith is partly hidden by the shadow cast over his face, while more open to view is the woman's even more courageous act of love, which, as Millais knew, and as observers of the painting who knew the opera might deduce from the full title, will involve giving up her faith as well as, ultimately, her life.

In *The Order of Release, 1746* (illus. 99) Millais shows a woman securing the release of her husband, a Jacobite rebel imprisoned by the English. She is a pillar of strength for her husband, who rests his head on her shoulder as if ashamed that she had to compromise herself to secure his release. Because she hands the jailer an order of release instead of money

(for a time Millais intended to title it *The Ransom*), perhaps she had to sac-
rifice her virtue to win the release. Whatever the price, she stands firm on
bare feet, and she shoulders her husband's head as well as his shame. Her
husband's one visible eye is in deep shadow and largely out of view, while
her strong eyes fix on the suspicious jailer.[1]

With these rescue images Millais differentiated the moral priorities of
the sexes. His men choose abstract causes that take them out of love, while
his women intercede on behalf of men and indirectly on behalf of their
causes even at risk of death. Susan Casteras has commented on the moral
value of these roles:

The idealization of women and their concomitant capacity to overshadow their
mannequin-like male companions are related traits which recur in *The Proscribed
Royalist*, *The Order of Release*, *The Black Brunswicker*, and other works by Millais.
. . . While in all these cases the choice between death and disloyalty lies mainly
with the man, the woman plays the role of an intercessor on behalf of love itself.
The overt physical heroism belongs to her companion, but the devotion and moral
bravery is all hers, because it is generally her mental battle to convince him to pre-
serve his life and her fate to accept his decision.[2]

Millais's *Peace Concluded, 1856* (illus. 100) shows an officer from the
Crimean War at home, convalescing under the care of his wife and hold-
ing a newspaper that announces the 'Conclusion of Peace'. The painting
may also reflect Millais's concern about being dependent on a woman,
which peaked in 1855 when he married Effie Ruskin, who modelled for
this painting as she had for *The Order of Release*. She had also been chosen
to model for *The Proscribed Royalist, 1651*, but was replaced. In a sketch
for *Peace Concluded, 1856*, the man's head is even more bowed and his ex-
pression more abject, while the woman's embrace is more overwhelming
and her face more troubled.[3] In the painting the woman is gently comfort-
ing him in his distress, though perhaps he is also actually wounded. His
downcast head is in profile and partly shadowed, and his eyes look toward
her hand, the instrument of her comforting and nursing. Her face ex-
presses a subtle mixture of emotions about her multiple roles that align
with the myth of the most famous rescuing nurse of Victorian England.

The social construction of Florence Nightingale, as Mary Poovey
explains, drew on contrasting female roles in the public and private sphere
to fashion the ideal of a politically alert but motherly rescuer as an altern-
ative to the passivity of the domestic ideal, while at the same time using
the passivity of that ideal to influence the public sphere. Nightingale and
her supporters used conflicting aspects of the domestic ideal to justify the
economic, political, and military expansion necessary to maintain the
British Empire. She challenged the predominance of men in medicine and
helped neutralize the spectre of aggressive female sexuality associated

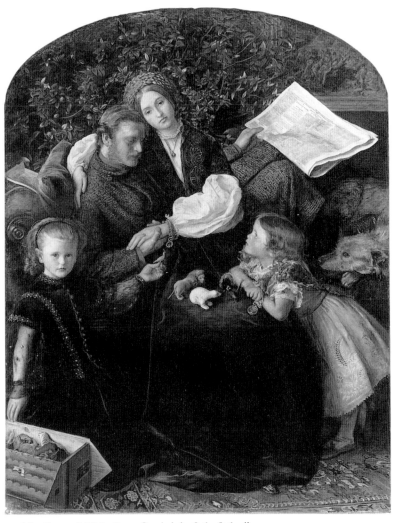

100 John Everett Millais, *Peace Concluded, 1856*, 1856, oil on canvas.
Minneapolis Institute of Arts.

with independent women. She was an angelic and motherly nurse as well
as a hard-driving, efficient administrator. She was gentle and kind, but
also fearless and strong-willed, while parlaying these characteristics into
an image that appealed to men and women struggling with the dubious
morality of both the Empire and the domestic ideal. Nightingale made it
clear, Poovey argues, 'that the militant strain implicit in the domestic ideo-
logy derived its authority from the morality that maternal instinct was
assumed to bestow on all women: because it represented all women as
middle-class and invested them with commensurate moral power, the

domestic ideology elevated every woman over every man'. In Nightingale's *Notes on Nursing* (1859), 'the patient is the first man to be dwarfed by this [moral] power'.[4]

Millais's painting captures this ideology with a resolute but angelic wife and mother nursing her husband. He has fulfilled his public moral obligation by defending the Empire, as indicated by the title of the painting, the newspaper headline, and the medal held by the daughter at the right. He has also fulfilled his personal moral obligation to protect the family, which Millais signifies with a print by James Heath after John Singleton Copley's *The Death of Major Peirson* (1783; Tate), part of which appears on the wall at the upper right. The full image reveals a young officer shot during a battle in a town, and a mother and two children fleeing to safety.[5] But this heroic end occurred far away and long ago, and its domestic implication is only roughly sketched in the Heath engraving. By contrast, the private heroism of Millais's woman is here and now, central and clearly drawn, evident in her frontal face and reflective eyes. She is a superb mother, as is indicated by the two beautiful and carefully groomed girls who appreciate their father's accomplishment: one holds his medal and looks up at him in pride, while the other looks frontally to let viewers see her wide-eyed admiration. The toy animals – bear (Russia), turkey (Turkey), lion (Britain), cock (France) – refer to the belligerent countries in the Crimean War. The mother's rich chestnut hair is wound around her head in an extraordinarily long braid to suggest her abundant female beauty as well as her controlled sexual appetite; it also forms a halo, which suggests her saintliness and self-sacrifice. She is gentle, but runs an efficient household. Her eyes express strength of will along with compassion. Behind her back, her husband absentmindedly fingers the testimony of his contribution to the public sphere, which is already about to be laid aside as yesterday's newspaper, while with her overarching arm she comforts her husband who needs nursing under the aegis of her overarching spiritual strength.

A man much more urgently in need of rescue is the central figure of Emily Osborn's *The Escape of Lord Nithsdale* (illus. 101). On 24 February 1716, the Jacobite William Maxwell, Earl of Nithsdale, was sentenced to be executed for his rebellious activities. Osborn depicts the moment when his wife carried out an ingenious plan of escape for her husband from a heavily guarded apartment in the Tower of London the night before his scheduled execution. She had arranged to get a woman's cloak and hood into Nithsdale's room, rouge his face, cover his dark brow with a wig, and leave with him disguised as a woman. She had planned to shave his full beard, but the darkness made shaving impossible, so she had him hide his chin in a muffler and feign despondency. Osborn retained only the moustache. Part of the plan was to distract the sentries with gifts, as is indicat-

101 Emily Osborn,
*The Escape of Lord
Nithsdale*, 1861.
Private collection.

ed by the package being offered to the keeper.

The Countess of Nithsdale was 'a pale and delicate girl . . . with light blue eyes . . . hardened in the fire of life'.[6] Inspired by her Catholic faith, she carried out this ingenious and daring escape with the determination evident in her watchful glance. Osborn shows Nithsdale slinking away, disguised as a pregnant woman in mourning, bowing under his wife's protective hand, in a striking reversal of the typical gender roles dictated by the chivalric code. His eyes are the more interesting, because they are so unmanly, part of his disguise as a woman. His wife had been leading him by the hand; she is shown at the moment when she lets him pass in front of her so that, when they leave, her body will shield his from behind, and the soldiers will not be able to see his 'manly stride'.[7]

The body of another woman shields a man in the thick of industrial warfare in Elizabeth Gaskell's *North and South* (1855), a novel about two regions of England and two realms of moral action that come together in the love of John Thornton, a Northern cotton manufacturer, and Margaret Hale, the daughter of a tutor from the South.

Thornton has a strong character, which, like that of Charlotte Brontë's

Rochester, is evident in his brow: 'the straight brows fell over [Thornton's] clear, deep-set earnest eyes, which, without being unpleasantly sharp, seemed intent enough to penetrate into the very heart and core of what he was looking at'.[8] Gaskell uses the language of chivalry to describe her Victorian hero with shield-like brows and sword-like eyes that penetrate to the heart of things, at least in the public sphere. The rest of his expression was softer, especially 'when the rare bright smile, coming in an instant and shining out of the eyes, changed the whole look from the severe and resolved expression of a man ready to do and dare everything, to the keen honest enjoyment of the moment' (121).

When Margaret first met Thornton he was impressed with 'her eyes, with their soft gloom . . . [and] proud indifference' (100). During another meeting he notices her 'large soft eyes that looked forth steadily at one object, as if from out [of] their light beamed some gentle influence of repose' (215). That calming influence saves his life during a strike when a crowd of workers from his cotton mill gathers outside his home. After he tells Margaret that soldiers will soon arrive to put down the strike, she challenges him to go and speak to his workers man to man. He agrees, and Margaret soon joins him 'in face of that angry sea of men, her eyes smiting them with flaming arrows of reproach' (233). Her courage quiets the crowd momentarily, but then stone-throwing starts. One stone knocks her out, and she falls against Thornton, prompting him to prove his manhood with a rescue. The sight of blood and tears pooling in her eyes subdues the workers, who quickly disperse. When she tries to walk and again collapses, he takes her in his arms and carries her to a sofa.

Inspired by her sacrifice, Thornton is emboldened to show his vulnerability and declare his love. With this gallant gesture Gaskell leads readers to expect an offer of marriage from the grateful man, but she has more important purposes. She wants to explore the presumption that leads Thornton to profess his love and the pride that leads Margaret to reject him, so the novel deepens its analysis of their love. Margaret is ashamed to have displayed so much feeling for Thornton in public and explains modestly that she did nothing more than 'a woman's work'. When Thornton responds with a declaration of love that trivializes her act, she hides her feelings and protests 'that any woman, worthy of the name of woman, would come forward to shield, with her reverenced helplessness, a man in danger from the violence of numbers' (253). Margaret is scandalized because while she acted out of a sense of what is morally right, Thornton, like most men, cannot conceive of a woman having any motive for such an act other than love. For this love to become possible both will have to compromise. The burden of change lies with Thornton, who must learn to internalize Margaret's personal moral sense and apply it in the public sphere.

Two changes bring about a reconciliation. Margaret inherits £40,000, and Thornton learns to apply Margaret's personal moral code in business. For all Margaret's goodness, her net worth must increase. Similar to Jane Eyre, Margaret uses the money to help her impoverished man, who is morally elevated by the financial loss he suffers. Facing ruin, Thornton still refuses to risk investors' money in speculation. Margaret's inheritance enables her to rescue him again, this time with an unsecured loan. In the meantime he has learned a lesson in humanity and applied it in the public sphere. 'My only wish', he explains, 'is to have the opportunity of cultivating some intercourse with the hands beyond the mere "cash nexus"' (525). With Thornton's effort to apply Margaret's personal moral code in business, the couple is ready for a humanized love.[9] They declare it and conclude the novel with a largely visual exchange:

> 'Margaret!'
> For an instant she looked up; and then sought to veil her luminous eyes by dropping her forehead on her hands. Again, stepping nearer, he besought her with another tremulous eager call upon her name.
> 'Margaret!'
> Still lower went the head: more closely hidden was the face, almost resting on the table before her. He came close to her. He knelt by her side, to bring his face to a level with her ear; and whispered – panted out the words: 'Take care. – If you do not speak – I shall claim you as my own in some strange presumptuous way. – Send me away at once, if I must go; – Margaret! – '
> At that third call she turned her face, still covered with her small white hands, towards him, and laid it on his shoulder, hiding it even there; and it was too delicious to feel her soft cheek against his, for him to wish to see either deep blushes or loving eyes. He clasped her close. But they both kept silence. At length she murmured in a broken voice:
> 'Oh, Mr Thornton, I am not good enough!'
> 'Not good enough! don't mock my own deep feeling of unworthiness'.
> After a minute or two, he gently disengaged her hands from her face, and laid her arms as they had once before been placed to protect him from the rioters.
> (529–30)

This final scene begins with the couple in a proposal composition, as Margaret looks away from Thornton's imploring gaze first by dropping her forehead on her hands, then bending her head almost down on the table, and finally laying her head on his shoulder before he at last disengages her hands from her face. The scene recapitulates the themes of female rescue and moral improvement that sustain the novel and make love possible. Margaret rescued Thornton with her body and her inheritance and by challenging him to apply her demanding personal moral code to the public world. He rescued her from the crowd after she was struck and carried her to safety, and he rescued her from the arrogance of her impossibly

high moral standards when he applied a compromised version of it in relating to workers. Their concluding dialogue is one of few words exchanged while the heroine hides her face. The eyes of the Victorian woman meet those of her lover briefly, but still tentatively, at the very end, and only after an arduous struggle to love.

Hugo's *The Man Who Laughs* (1869) also concludes with a final exchange of glances between lovers, even though one of them is blind. This novel is a moral fable about the value of true seeing over false seeming that celebrates women's superior commitment to the morality of love. As a boy, Gwynplaine was mutilated by agents of the King of England. He heals with a perpetual smile and is thus made to appear the way women were encouraged to be – perpetually smiling, with the appearance of acquiescence.[10] At the age of ten he rescues the infant Dea from a snowstorm, but the ordeal leaves her blind. They grow up together with a love triply protected from conventional sexual feelings: it is sexually innocent as a brother-sister love, his scarred face makes him incapable of engaging in conventional masculine wiles, and her blindness enables her to see only his spiritual nature.

As they come of age the rescued one becomes the rescuer. Dea saves Gwynplaine from loneliness with a love that is possible because she cannot see his face. Not motivated by visual sexual desire, she is an embodiment of feminine virtue, as Hugo rhapsodizes: she was 'wonderfully beautiful, with eyes full of brilliancy, though sightless'. Her eyes 'were mysterious torches [that] gave light, but possessed it not'. A divine goodness radiated from her 'resplendent' eyes, as 'in her gaze there was a celestial earnestness'.[11] Dea was named for God.

Hugo explains that their love was divinely conceived to exemplify spirit transcending flesh. 'Never had everything that is repulsive to woman been more hideously amalgamated in a man.' In order for a woman to love someone so repulsive, 'Providence had deprived Dea of sight' (308). The unnatural causes of their pure heavenly love highlight the impurity of natural earthly love. Their injuries dramatize how, for Hugo, sexually innocent female love is morally superior to sexually experienced male love: Gwynplaine's injury makes him appear woman-like, while Dea's makes her unresponsive to the physical sexual attraction that is inspired by normal men; his injury also makes him unable to see himself but for the derision of others, while her injury enables her to see only goodness within.

Their love is secured by her blindness, and only she remains faithful to it, because a seductress leads Gwynplaine astray. In contrast to Dea's unswerving goodness symbolized by her sightless, colourless eyes, the exquisite Duchess Josiane's multifarious corruption is symbolized by her different coloured eyes. One is blue, the other black, signifying happiness

and misery, good and evil. Her different eyes also seek different sexual thrills, and so she tries to seduce Gwynplaine, who is ultimately rescued from her by Dea. 'The blind girl, the sweet light-bearer . . . dispelled the darkness within him. . . . In a moment he became, by the mere presence of that angel, the noble and good Gywnplaine, the innocent man' (II.71).

In the end, Dea's goodness rescues Gwynplaine from corruption as well as lovelessness. He realizes that it was from 'the only gaze on earth that saw his real nature that he had strayed!' (II.341). He returns home to find Dea dying. They exchange exalted expressions of love and the hope that they will be united in death. With her last breath she exclaims what Hugo tried to show throughout the story – 'I see!' Then Gwynplaine drowns himself in the hope of being able to see once again the only eyes that saw him as beautiful and showed him the way to a morally elevated love. Although these final pages sink stylistically to a low-point of Victorian treacle, Hugo sustains the humanity of their central message with this story of a blind woman who sees more insightfully into the meaning of love than does her morally wayfaring beloved with a roving eye.

Compared with the spate of good knights saving naked maidens in Victorian art and literature, there are few female rescuers. But whatever the sex of the rescuer, artists preferred to highlight the eyes and face of the woman. When she was the rescuer, her expression attracted artistic interest because her role was so unusual; when she was herself rescued, her vulnerability offered a greater range of expressions for interpretation. Rescuing men were less interesting because they were following the chivalric code that was precisely defined and demanded universal conformity, while rescuing women pursued a moral code that was unique to each situation and demanded thoughtful cultivation.

Earlier in the century J.-A.-D. Ingres's *Roger Delivering Angelica* (illus. 102) codified the sexually dichotomous roles in the art of rescue: the man is encased in armour, while the woman is naked; he is free to move, while she is shackled to a rock; he is focused intently on his foe, while she looks about wildly. In the sixteenth-century Italian poem from which the scene is taken, Ariosto's *Orlando Furioso*, Angelica is offered as a sacrifice to the sea-monster Orc on an island off the coast of Ireland, where Roger sees her while riding his hippogriff, a beastly hybrid of horse and eagle with exceptional strength and eyesight.[12] He also carries a magical shield with a glare that can blind his foe and a magical ring that is an antidote to all enchantments. After his lance fails to pierce Orc's scales, he gives Angelica the ring to protect her eyes and then unveils his shield, which makes Orc roll over and expose his vulnerable underside. As Roger prepares to strike, Angelica urges him instead to free her from her chains, and they

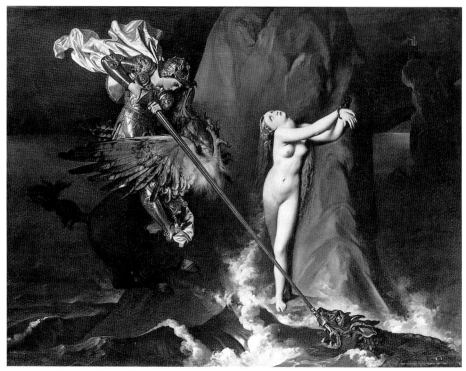

102 J.-A.-D. Ingres, *Roger Delivering Angelica*, 1819, oil on canvas.
Musée du Louvre, Paris.

ride off. Ingres shows Roger trying to rescue Angelica by thrusting his
lance at Orc, who bites its point with enormous tusks. This image of
super-heroism is not the actual rescue, however, and is so overstated that
it verges on self-parody.[13]

Typical of most rescuing men, Roger does not look at the woman he
rescues. He is peering at and sticking his spear into the mouth of a mon-
ster. Even to pre-Freudian beholders, Roger's enormous lance and the
monster's threatening jaw had obvious sexual referents, as Dante Gabriel
Rossetti indicated in a pair of sonnets written in 1849 about the painting:

> . . . The spear's lithe stem
> Thrills in the roaring of those jaws: behind,
> That evil length of body chafes at fault.
> She doth not hear nor see – she knows of them.

Angelica does not need to hear or see to anticipate why the spear's lithe
stem thrills in the roaring jaws. The 'evil length of body' refers to the spear
and the monster's body, which is also phallic. She knows them – both. By
suggesting Angelica's sexuality with the monster's mouth, Ingres attrib-
utes to her the monster's sexual appetite. While Roger's profiled face is

calm in determination, the monster's is alive with the emotions of combat. For all the power shown in Roger's thrust, the lance is caught in the monster's bite, and for all the lance's length and sharpness, according to the poem, it cannot penetrate the monster's scales. In the painting Angelica also appears impenetrable, because, like so many Victorian nudes, her pubis is a triangle of hairless, unbroken skin. Rossetti's two sonnets suggest the sexual anxiety that a knight in armour riding a hippogriff might feel in trying to rescue a naked woman with sealed loins as he peers into a monstrous tusked orifice out of which thrusts a plump red tongue.

The octet of the second sonnet addresses the threatened victim:

> Clench thine eyes now, – 'tis the last instant, girl:
> Draw in thy senses, set thy knees, and take
> One breath for all: thy life is keen awake, –
> Thou mayest not swoon. Was that the scattered whirl
> Of its foam drenched thee? – or the waves that curl
> And split, bleak spray wherein thy temples ache?
> Or was it his the champion's blood to flake
> Thy flesh? – or thine own blood's anointing, girl?

In the legend Roger gives Angelica the magical ring to protect her from the shield's glare; in this octet the voice of the poet urges her to close her eyes and draw in her senses in order to avoid being blinded when the shield is unveiled. The poet's further instructions to set her knees and take a deep breath while her 'life is keen awake' recall another knowing (and seeing), which initiated woman's primordial lapse into sin. The poet wonders whose blood (has been? will be?) shed at Angelica's anointing when, as in the last line, she passes from her climactic last instant as a girl to become a woman:

> . . . Now the dead thing doth cease
> To writhe, and drifts. He turns to her: and she,
> Cast from the jaws of Death, remains there, bound,
> Again a woman in her nakedness.[14]

The sonnets are about the awakening of a woman's sexuality as she is rescued from innocence by a knight who, in spite of his long sharp spear, cannot pierce the skin. Angelica is keenly awake and does not swoon in her bondage. From her ordeal she is drenched with foam and spray and covered with blood, only we are uncertain whether the fluid mix is the monster's, the hero's, or her own.[15] Rossetti suggests that in addition to an icon of knightly valour, Ingres created an image of masculine uneasiness. While championing a shackled innocent, Roger is mystified by a formidable *vagina dentata*. Perhaps he stares so intently into the mouth of the monster, because he does not know what he is looking for.

While his eyes are focused on his foe, Angelica's mysterious eyes roll away from the battle, exposing their whites. Their openness is accented by her frontal nakedness, their anguish is intensified by her twisting limbs, and their pain is sharpened by her manacled wrists.[16]

Another anguished look no doubt appeared in the eyes of the first version of the bound nude in Millais's *The Knight Errant*, who has been stripped of her clothing (lying scattered at her feet), and perhaps already raped. I speculate about the original nude's eyes from accounts of her frontal expression, which aroused 'howls of protest' because it seemed pornographic.[17] For the final version (illus. 103) Millais turned her face away from the viewer. As his son explained, the artist decided 'that the beautiful creature would look more modest if her head were turned away'.[18] Like Hunt, who had muted the expression of his woman with an 'awakening conscience', Millais recomposed the head of this nude in deference to Victorian viewers, who found the frontal eyes of a victim of male sexual violence too threatening to face directly. In the final version enough of her face is visible to discern that although she no longer seems afraid, she seems profoundly disappointed with everything masculine. The eyes of the knight register deep concern but also a trace of shame about being a witness to such cruelty, even though he is cutting loose her bonds. Although he has vanquished the knight lying in the right background, he approaches her from behind and glares anxiously ahead to avoid her pained look.

Millais offers an unusually candid view of the rescuing knight's tentativeness and anxiety about relating to a woman. Men with superior means to fight with evil foes typically have inferior means to deal with women. The eyes of men engaged in mortal combat are of course focused on their dangerous rivals, not the woman they are rescuing. That focus is partly a necessity of mortal combat, but it also signifies that for the men the issue at stake is which man is better, while the woman is a mere reward for victory. In such compositions men, anticipating sexual favours as a reward, will not be able to look easily at the woman after her distress has been eliminated (a moment such as Millais chose to depict), because the women are ruined. This knight's sword is blood-tipped, which recalls his recent combat but also the woman's sexual violation. Another reason for the rescuer's apparent reluctance to face the woman is that all men are implicated in the dangers to a woman that result from her beauty, especially when a man has bound her naked. This rescuing knight looks away out of consideration for her humiliation, out of shame, and because her eyes may themselves be dangerous. As Adrienne Auslander Munich suggests, the knight's position may indicate that he is hiding 'from the danger of her body, as though she threatened him like Medusa'.[19]

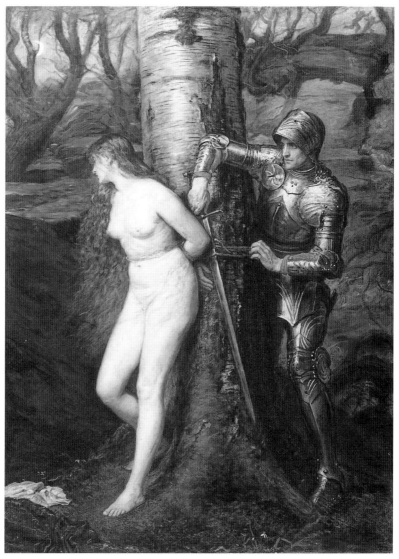

103 John Everett Millais, *The Knight Errant*, 1870, oil on canvas. Tate Gallery, London.

The myth of Perseus and Andromeda was extremely popular among male artists and writers from the Victorian period who wanted to indulge in rescue fantasies. It is about the destructiveness of female vanity and the difficulty men have seeing in a physically beautiful woman anything other than her beauty. Through no fault of her own, the renowned beauty Medusa was raped by Neptune and then punished by a jealous Minerva, goddess of culture, who turned her beautiful hair into snakes and made

her beautiful eyes capable of turning to stone anyone who looked at her. The initial cause of Medusa's misfortune – being seen by a man – becomes the occasion of her revenge, wrought by her potent eyes, which remain deadly for any being, even after her death. To kill her, Perseus must first find her, which he does by stealing the one eye shared by three sisters, the Graeae, who know the way to Medusa's home. Avoiding her eyes by looking at her reflection in his shield, Perseus cuts off Medusa's head while she sleeps and carries it away in a sack, symbolically appropriating the power of her deadly gaze. Medusa also provides Perseus with his horse, Pegasus, who arises out of the blood shed during her decapitation. Perseus thus conquers his fear of female eyes, acquires their deadly power, and becomes empowered to ride a flying steed by killing a woman who was raped and later killed because of her beauty. In this myth, a woman's vision is the conduit of power, the arbiter of life and death.

Andromeda was victimized when her vain mother, Queen Cassiopeia, boasted of her beauty to sea-nymphs, who then sent a monster to ravage the coastal town where she reigned. To appease the monster, an oracle directed Andromeda's father to offer his beautiful, innocent daughter as a sacrifice. Artists show Perseus riding to the rescue or fighting the monster in a stormy sea that surges around the rock where a tearful and naked Andromeda is chained. Although Perseus has the dominant heroic role in the myth, Andromeda dominates compositionally in the art. Her name means 'ruler of men', and in most Victorian images of her she is closer to the picture plane and hence larger than Perseus. Her face is more frontal and better illuminated and expresses a wider range of emotions than that of Perseus, who is (typically) preparing for, or is embroiled in, battle.

William Etty produced two images of the rescue in which Andromeda looks like a giantess in contrast to the tiny background figure of Perseus. In *Perseus and Andromeda* (illus. 104), she is larger than the Perseus who flies to her rescue and holds up Medusa's head in order to turn the monster to stone. Some nereids down below him signal and appear to celebrate his bravery, but not Andromeda, who looms large in the foreground, seemingly oblivious of her compromised position and dangerous circumstance. She is not frightened by the monster, impressed by Perseus's bravery, or hopeful of rescue; rather, she seems remote from the scenario of male desire, sexual rivalry, vanity, and jealousy that led to her being offered up as a monster's meal in the first place. Etty exploits male voyeurism with her nude pose but confounds it with her expression; her body is posed to titillate men, but she seems immersed in her own thoughts and impervious to their desire. Etty glorifies her body and at the same time degrades the male gaze by suggesting that what his viewers see is a visual equivalent of the monster's mouthfuls. She repudiates the dominion of natural

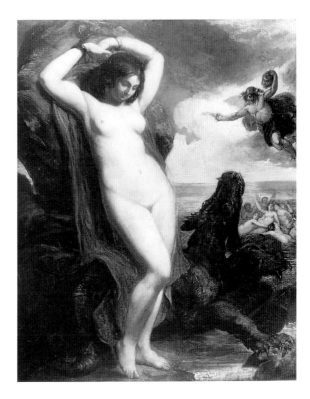

104 William Etty,
*Perseus and
Andromeda*, 1840, oil
on canvas.
City Art Gallery,
Manchester

impulse that climaxes in this fierce battle, from which she seems to rescue herself with self-composure and inner reflection.[20]

The grandeur of Etty's nudes accords with his artistic manifesto: 'Finding God's most glorious work to be WOMAN, that all human beauty had been concentrated in her, I resolved to dedicate myself to painting – not the Draper's or Milliner's work, – but God's most glorious work, more finely than ever had been done'.[21] In another portrait, simply titled *Andromeda* (*c.* 1835–40; National Museums and Galleries on Merseyside), Etty cropped Perseus from the picture and, to accent Andromeda's suffering, moved her chains up just under her breasts and directed her plaintive dark eyes to the heavens. This portrait of martyrdom condenses Etty's conception of the work of God as evident in a woman's body and suggests a vision of God in her adoring eyes.

In Frederic Leighton's *Perseus and Andromeda* (illus. 105), Perseus is lost in a sunburst and almost invisible, while Andromeda is in rich earth colours deepened by shadow. The crushing of her body and head under the weight of a hideous monster concentrates one's interest on her struggle. Perseus is remote from her danger but manages to wound the monster mortally: an arrow is shown sticking into its leathery hide. Andromeda, as symbol of woman, must nevertheless bear the weight of monstrous injus-

105 Frederic Leighton,
Perseus and Andromeda,
1891, oil on canvas. Walker
Art Gallery, Liverpool.

tice by herself. Whatever Leighton's intentions, he created an image of the futility of male rescuing. In this icon of female victimization, Andromeda appears to hold up the wounded monster, recalling Atlas who was condemned to hold up the world.[22]

Burne-Jones completed only four of an ambitious series of eight images of Perseus, culminating with the rescue of Andromeda. Most of the eight deal with Perseus's incapacity to look, reluctance to look, or fear of looking into a woman's eyes.[23] In the first, *The Calling of Perseus* (unfinished, Staatsgalerie, Stuttgart), Athene towers over Perseus while handing him the mirror to use so as not to look directly at Medusa. Even then, and for no reason, he shades his eyes in anticipation of the deadly female stare that is his greatest danger. In *Perseus and the Graeae* (1892; Staatsgalerie, Stuttgart), he reaches out to steal the one eye shared by three blind Graeae, the eye that helps him find his way. In the third image, *The Nymphs*

Arming Perseus (unfinished, Staatsgalerie, Stuttgart), he receives a helmet that makes it impossible for him to be seen and a sack for Medusa's head, so that without having to look at her eyes he can take them away and expropriate their power to petrify and kill. *The Finding of Medusa* and *The Death of Medusa* (both unfinished) show Perseus avoiding Medusa's stare, before and after she has been beheaded.

The final three images depicting the rescue of Andromeda contrast the visibility, openness, and visual adventurousness of the sexes. In *The Rock of Doom* (1888; Staatsgalerie, Stuttgart), Andromeda is naked, chained, and open to view. Perseus is triply protected from being seen by his armour, by his helmet, and by the counter-gaze of Medusa that he carries in his sack. Still, he peeks around the rock to which Andromeda is chained with the same caution he might have exercised when approaching Medusa and only tentatively removes his helmet to enable Andromeda to see him, which she does, candidly and fearlessly. In *The Doom Fulfilled* (1888; Staatsgalerie, Stuttgart) Perseus stares into the face of the monster, whose enormous body snakes up between his legs into a phallus that arches by his face and over the head of Andromeda, who stands in a graceful pose with her naked back to the viewer. Perseus does not shrink from looking into the teeth of danger, although he still stares diametrically away from the eyes of Andromeda, who glances over her shoulder at his heroics. She carries that look of secure inquiry into the last image of the series, *The Baleful Head* (illus. 106). It shows a moment after her rescue and wedding to Perseus, when he lets her look at Medusa's head by viewing it reflected in the water of a fountain. He is still reluctant to look at Medusa's head, even in reflection, and instead peers at the top of Andromeda's head while watching intently for her reaction. Andromeda alone is willing to look into eyes that signify not only the power to kill but also the power to see, to know, to love, and to be good that they also imply.[24] Her examination of Medusa is calm and direct. Perseus holds Andromeda's hand intently as he looks into her eyes, while her look ignores him, and her hand clasp is relaxed. Medusa's eyes are tranquil and seem to belong to Andromeda. Burne-Jones hints at Medusa's extensive powers by setting the trio in a garden with apples of sin that recall Eve's courageous role in assuming moral responsibility. He carefully composed the two figures as well as their crystal-clear reflection in the water to enable viewers to see from two vantage-points that Andromeda is willing to look, while Perseus is not. She wants to see, to know, and to be alive in ways that for him are blocked by fear.

Typical of other chivalrous Victorian rescuers, Perseus needs help in relating to women. He can kill monsters more easily than he can look into a woman's eyes, even the woman he saves and weds. This ambitious series

106 Edward Burne-Jones, *The Baleful Head*, 1887, oil on canvas. Staatsgalerie, Stuttgart.

was personally motivated by Burne-Jones's need to exorcize Mary Zambaco's baleful eyes, which still haunted him, and so he conflated the eyes of his dangerous mistress and his devoted wife with the eyes of Medusa and Andromeda, all inaccessible to his rescuing knight. Rossetti's poem about the rescue, 'Aspecta Medusa' (1865, 1870), includes advice that might well have come from Burne-Jones:

> Let not thine eyes know
> Any forbidden thing itself, although
> It once should save as well as kill: but be
> Its shadow upon life enough for thee.

That advice is, of course, bad advice, because human beings, and especially artists and lovers, need to know the forbidden thing itself: deadly eyes, the taste of forbidden fruit, knowledge of good and evil. While shadow knowledge of life might have been enough for Perseus, it was not enough for the woman who, as Rossetti wrote elsewhere in his poem, 'hankered each day to see the gorgon's head'. Victorian women hankered to see the world far more than they wished to be rescued from its mythological or even its real dangers.

The imagery of Victorian rescue was thus as fantastic as the emotions that inspired men to create it. Victorian women were not naked and chained to rocks or threatened by monsters. The art of rescue was highly

107 Dante Gabriel Rossetti, *Found*, 1854–81, oil on canvas. Delaware Art Museum, Wilmington.

accomplished, but the rescues it depicted were merely fantastic gestures.

Pre-Raphaelites also created failed rescues, such as *Found* (illus. 107), which Rossetti began to paint in 1853. He was interrupted and never finished because he feared viewers would think that it had been inspired by Hunt's *The Awakening Conscience* (completed in 1854), although Rossetti insisted on his independent conception. Another reason that the painting remained unfinished may be its conflicted personal meaning, because the artist identified with the fallen woman who was posed by his mistress, Fanny Cornforth.[25] He projected the greatest emotion not into the man, who looks almost impassive, but into the woman's expression, which is a mixture of frustration, despair, and opposition – all elements of artistic creation. Linda Nochlin suggests that the figure of the prostitute 'could also be an image of his despair, his sense of the self – more specifically the creative self – shut off from the possibility of help or redemption'.[26]

Rossetti's poem about the painting, also titled 'Found', concludes with the words of the fallen woman directed to the rescuing man: 'Leave me – I don't know you – go away!' The woman's one-time sweetheart also no longer knows her. He is not only unable to rescue her but is implicated in the network of circumstances that led her into prostitution, for he has himself netted and muzzled a calf that symbolizes the ensnared woman. The innocent animal is going to market (i.e., slaughter) just as the once

innocent woman with pallid skin is going to an early death (in a sketch for the painting she is by a cemetery). Rossetti compressed into her anguished expression and tattered, showy clothes as much as he could of her past experience and current thoughts about a happy childhood, rushed courtship, youthful vanity and impatience, a move from the country to the city in search of glamour and adventure, seduction and betrayal, a fall into prostitution, lonely walks on darkened streets, declining health and the likelihood of an early death, maybe by a suicide.[27] The man sees nothing of this, except perhaps an idealized memory of their brief courtship. He does not look at the suffering in her eyes and seems incapable of under-standing it. In the poem Rossetti described the man's expression as a 'gasp', but the painting does not show such a reaction. In a letter to Hunt, Rossetti explained that the man stands 'holding her hands as he seized them, half in bewilderment and half guarding her from doing herself a hurt',[28] but the pictorial message is that he is unable to address the look in her eyes and can only grab her hands with brute strength, just as he might grab the legs of the calf to hoist it into the cart.

William Windus envisioned a would-be rescuing man even less willing to look into the eyes of a former lover, although in this scenario it is he, rather then she, who walked out on love. In *Too Late* (illus. 108), the remorseful man covers his eyes from the persecutory stare of his dying beloved. Her body and face are emaciated, and her eyes are darkened by tuberculosis, an emblem of the vulnerability of Victorian women and their often unavailing patience in love. The exhibition catalogue of 1859 contains a quotation from a Tennyson poem which includes the woman's accusation about his tardy rescue attempt:

> Come not, when I am dead,
> To drop thy foolish tears upon my grave,
> To trample round my fallen head,
> And vex the unhappy dust thou wouldst not save.

From this melodramatic moment Windus created an icon of the Victorian man unwilling to look at his beloved. The dying woman struggles to sup-port herself on a cane in order to study the man whose abandonment somehow depleted her life forces. Her hollow eyes are wide open, search-ing for traces of a love that the wayfaring man was incapable of cultivat-ing. Her enlarged, judgemental dying eyes condemn the man as someone irretrievably lost, incapable of fulfilling the chivalric role and rescuing his maiden in great distress. Her sunken eyes contrast with the healthy upturned eyes of the girl at the man's side, which are also accusatory. The woman's friend in profile tries to console her, perhaps on behalf of the remorseful man, and in that role she might be viewed as a stand-in for him in what would then be a proposal composition.

Even the most morally principled man could fail to rescue a woman. In Tennyson's *Idylls of the King* (1859–85) moral high-mindedness was itself a cause of failure, as Guinevere sensed in her first sighting of King Arthur, when he appeared to her as 'cold, / High, self-contain'd, and passionless'.[29] In their final meeting Arthur explains that his goal had been to unite the kings of the realm under his inspired moral leadership in order to defend the realm and uphold the chivalric code, which included the following imperatives:

> To ride abroad redressing human wrongs . . .
> To lead sweet lives in purest chastity,
> To love one maiden only, cleave to her,
> And worship her by years of noble deeds . . .

But Arthur and his knights lost the maidens they travelled abroad to defend. His high-minded code took them on campaigns far from the women they loved and left those women near other tempted knights, such as Sir Lancelot. And so, as Guinevere explains, she gave in to temptation:

> I thought I could not breathe in that fine air,
> That pure severity of perfect light –
> I yearn'd for warmth and colour which I found
> In Lancelot . . .

205

Her adultery led not only to her moral collapse but Britain's, which Arthur drives home with a merciless condemnation of the adulterous woman, who

> . . . like a new disease, unknown to men,
> Creeps, no precaution used, among the crowd,
> Makes wicked lightnings of her eyes, and saps
> The fealty of our friends, and stirs the pulse
> With devil's leaps, and poisons half the young.

Even in betrayal, Guinevere's eyes – so full of the diseased, wicked lightnings and leaping devilish gleams that weaken feudal vows and poison the young – seem far more interesting than Arthur's eyes, which were fixed always on a remote, single goal, no doubt like his heart, 'cold,/ High, self-contain'd, and passionless'. [30]

Throughout this chapter I have emphasized how men avoided looking at the women they rescued, even avoiding the eyes of the few women who rescued them. The eyes of men in images of male and female rescuers contrast with the eyes of the typical male gaze that was directed intently at a woman with obvious erotic purposes. Rescue interrupted the typical erotic scenario, because a rescue is basically about power, not love, and so the more elaborate the male rescue fantasy, the more powerless the man who envisions it. Intentionally or not, artists avoided showing the eyes of such powerlessness and channelled their creative energies into the eyes of women being rescued.

Men who rescued faced formidable obstacles and dangerous enemies; but their challenge was in the public sphere and was external to the actuality of love, and they were ideologically secured by a chivalric code that was everywhere the same and uniformly followed. On the other hand, women who rescued had to make a code of their own that conflicted with traditional codes of womanly conduct, creating an inner turmoil that artists preferred to highlight. While men in the act of rescuing women appeared especially manly, women who rescued men appeared especially unwomanly. Artists like Millais were fascinated by the eyes of such women, because in crafting new female roles in defiance of what society deemed acceptable, those women showed even more personal courage than the knights who killed evil monsters that never existed. Artists were more interested even in the eyes of those monsters than in the eyes of the rescuing knights.

8 Marriage

Among the many images of men and women together, those of the married couple are the least candid and individual, the most formulaic in emphasizing conventional domestic roles: a protective and authoritative husband next to his protected and dutiful wife. After the wedding, the man's ardent gazing and the woman's conflicted searching were supposed to end, so that the couple might face the world side by side ready to fulfil prescribed marital goals, as they were so often posed in marital portraits. Some artists, however, portrayed the cracks in that veneer of domestic harmony through which appeared a candid glimpse of tension or alienation. Such images typically are proposal compositions, with the husband in profile, often at the margin and in shadow, and with the seductive gaze of the courting man replaced by the husband's expression of annoyance or boredom, occasionally accented by his reading a newspaper.

Manet's images hint at marital alienation with background or marginal husbands in profile beside frontal and centred wives. *In the Garden* (illus. 109) depicts a securely composed mother, whose face crowns the monumental pyramid of her white dress spread out on the grass with queenly elegance. She looks confidently and directly at the viewer with large bright eyes, accented by lashes drawn with fine black lines, while her husband's sketchy face and eyes are partly obscured by his pose and supporting hand. His location in the painting signals his marginal role as husband and father, and his expression makes him seem depressed and bored.[1]

In a persuasive reading of Manet's *At the Café* (illus. 110), Robert L. Herbert shows that the couple portrayed in it must be man and wife. The man rests his forearm on her shoulder, and his open mouth indicates that he is talking, even though the woman looks away and may not be listening. His sense of self-importance is indicated by his hand thrust into his coat, perhaps also by his cane tapping the underside of the table to accent his words. For this painting Herbert suggests a caption out of a marriage in which the wife has heard her husband's thoughts many times before, and so turns to the viewer as if to say, 'Isn't that just like a husband, prattling away and nobody listening!'[2] By highlighting her expression, Manet aligns

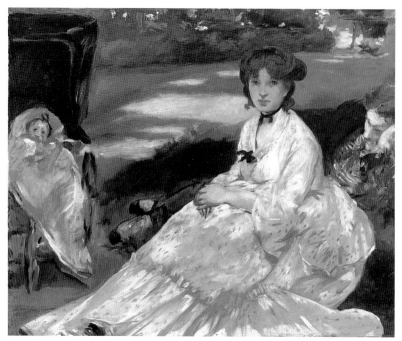

109 Edouard Manet, *In the Garden*, 1870, oil on canvas. Shelburne Museum, Shelburne, VT.

the reader with her wifely role, her need to support her husband's forearm as well as his ego. She also frames his body in this painting and mediates his relationship to the viewer. She has drunken deeper from her glass of beer than he has from his, perhaps also from the draft of experience, for she appears to know more than her husband, as suggested by her more frontal and alert eyes.

Manet's *In the Conservatory* (illus. 111) shows the Frenchman Jules Guillemet, owner of an elegant Parisian dress-shop, and his American-born wife. They are posed as husband and wife (with prominent wedding-rings) but separated by the back of the bench. Their relationship seems to be at cross-purposes, as indicated by their crossing sightlines, perhaps also accented by his cigar and her umbrella that point in cross directions.[3] Even though Guillemet does not look at his wife, the pose is similar to a proposal composition with the man looking in the direction of the woman, obviously solicitous of her attention, while she looks confidently, and a bit defiantly, away and across his line of vision.[4] Guillemet appears to be searching for the right words, while his wife appears confident that he will be unable to find them. She looks into the light, parallel to the ground, the bench, and her umbrella, which triply underscore her looking across as well as away from his glance. Her strong eyes draw viewers into the paint-

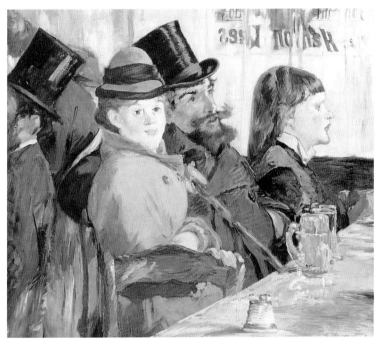

110 Edouard Manet, *At the Café*, 1878, oil on canvas. Oskar Reinhart Collection, Winterthur.

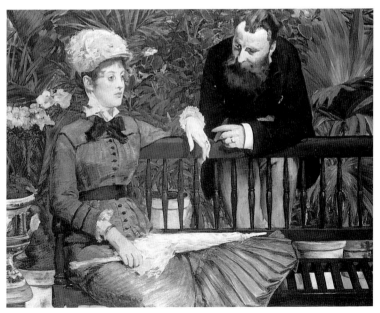

111 Edouard Manet, *In the Conservatory*, 1879, oil on canvas. Nationalgalerie, Staatliche Museen Preußischer Kulturbesitz, Berlin.

ing and then across her husband's shadowy, downcast, and almost lost expression.

Several critics have considered this Manet, along with his other images of marriage, as dividing responsibility for alienation between the husband and wife. Werner Hofmann focuses on the glance in Manet's art, where men and women live 'imprisoned in their respective inner monologues. . . . Even when people share the same spot . . . there is an invisible barrier between them.'[5] Bradley Collins finds distracted couples at every stage of Manet's career. *In the Conservatory*, specifically, omits clues about the reason for estrangement in keeping with the Impressionist objective of minimizing narrative content and creating a sense of timelessness. 'It is not so much that M. and Mme Guillemet ignore each other as that they are on different tracks.'[6] But responsibility for marital discord is not the same for men and women, as this painting reveals. It emphasizes the stable position of the woman's body and her clearer, farther, more open-eyed vision in contrast to the man who leans on the bench for support while his eyes seem to wander, as if not knowing how to focus on his wife.

In Frank Dicksee's *A Reverie* (illus. 112) the husband is having even more trouble focusing on his wife, who is seated confidently at a piano and illuminated by a lamp that reveals her eyes brimming with pleasure from the music. Her purpose is clear; her mind and body are in accord. Her husband has been distracted from reading by the music, which has recalled someone else, possibly a first wife, a former lover, a current mistress, or another woman he hopes yet to find. Depicted as a translucent wraith, she commands the scene as an embodiment of mysterious possibilities. Neither woman is objectified by the male gaze. The wife transcends it by concentrating on making music. The wraith transcends it by her immateriality and her commanding pose as she towers over the wife and husband, standing with arms raised and eyes wide open in an ecstatic vision beyond the ordinary space and time of married life, perhaps beyond the dimensions of mortal existence. The husband is slumped in an enormous over-stuffed chair, with head in hand, unable to concentrate on his book or subdue his fixation with this vision. He seems bewildered by the two queenly women, one of whom reigns by virtue of her inaccessible glance and spiritual presence, the other by virtue of her purposeful glance and artistic talent.

The vision of a more emphatically remote wife cuts across the sightline of her husband and commands the domestic space in Degas's *The Bellelli Family* (illus. 113). This portrait of the artist's aunt Laura and her Italian husband Gennaro Bellelli with their two daughters, Giovanna and Giulia, seems about to explode from marital discord. Laura's father had refused to allow her to marry another man she loved because of his lack of wealth

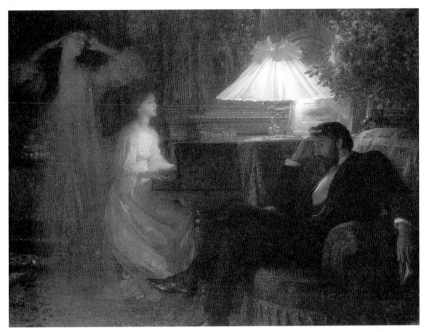

112 Frank Dicksee, *A Reverie*, 1895, oil on canvas. Walker Art Gallery, Liverpool.

113 Edgar Degas, *The Bellelli Family*, 1858–67, oil on canvas. Musée d'Orsay, Paris.

and distinction. In the portrait Laura wears black for her deceased father, whose portrait on the wall looks down on the disastrous union he forced. When she posed for Degas's portrait she was pregnant. Her dress is thus an emblem of time: it mourns what is past, conceals the unborn future, and appears to protect the present generation by pictorially framing her daughter Giovanna, whose morals and sensibilities Laura was also responsible for framing. Giovanna communicates her mother's outlook visually by engaging the viewer with the portrait's sole frontal face. She aligns with her mother's pose, while Giulia aligns with her mother's glance, augmenting the overall impression of female resistance to the male gaze.

In this disjoined composition the seated husband looks toward his standing wife, who looks away frigidly, registering her contempt under a veneer of puritanical reserve. In letters to Degas in 1859 and 1860, Laura had complained that her 'detestable' husband was 'disagreeable and dishonest'.[7] She may also have been troubled by a forced exile from her home in Naples because of Gennaro's political difficulties. While Laura's eyes are defiant and strong, Gennaro's are weak and uncertain. Degas highlighted her dissatisfaction with her more frontal stare in contrast to her husband's shadowy and marginal sidelong glance from a seated position, which, next to his standing wife is unusual, if not downright unmanly in a nineteenth-century family portrait.

In a more traditional marital portrait, *Edmondo and Thérèse Morbilli* (illus. 114) the husband and wife (Degas's sister) are shown frontally. Norma Broude finds hints of subordination, dependency, and timidity in Thérèse's position just behind her husband and with a hand resting on his shoulder: 'The startled, almost frightened expression imparted to her face by the staring, widened eyes and the defensive placement of her hand before her slightly parted lips bespeak her timidity in relation to the outside world.'[8] Jean Boggs sees Signor Morbilli as 'imposingly large and ruddy' and giving off 'a sense of his physical energy in contrast to Thérèse's nervous lassitude'.[9] Robert L. Herbert argues that the husband's shadow falling on his wife's face has the effect of 'further subordinating her by making her peer out between two shadows'.[10] Edmondo's position in front of Thérèse, however, may indicate his need for hogging the limelight and for self-promotion rather than inner strength, and her left-hand gesture may indicate her need to be steadied rather than her subordination and dependency. A comparison of their eyes suggests her greater emotional commitment to the portrait and, by implication, to the marriage it is supposed to memorialize. His eyes are pallid and glazed, almost cataractal. He looks as if he felt imposed upon by having to sit for the marriage portrait and by implication also imposed upon by being mar-

114 A detail from Edgar Degas, *Edmondo and Thérèse Morbilli*, 1865–7, oil on canvas. Museum of Fine Arts, Boston.

ried. Her eyes, on the other hand, peer forward from her slightly recessed position as if she were yearning to enter into the surrounding world and find some understanding of her relationship with the man at her side. Her vision between two shadows may indicate dawning clarity rather than subordination. She does not appear frightened but rather lucid and calm, eager to see and be seen. Whatever the distribution of power in their marriage, she has the more lively eyes, which suggest a clearer vision.

One of Degas's genre paintings, *Bouderie (Sulking)* (illus. 115), shows a not-yet resolved domestic dispute. Although the title does not indicate that the disputants are husband and wife, the everydayness of the setting suggests that they are probably married.[11] Degas posed the writer Edmond Duranty and the model Emma Dobigny to enact a moment after a flash of anger, when the man still sulks but the woman looks toward the viewer as if sharing a confidence and preparing her reconciliation. His eyes are more marginal, shadowy, evasive, and self-referential, while her frontal eyes engage the viewer directly, implying that she is willing to look away from the trivial subject of the conflict, which Degas implies is as mundane

115 Edgar Degas, *Bouderie (Sulking)*, 1869–71, oil on canvas. National Gallery of Art, Washington, DC.

as the papers on his desk. By leaning toward the man and opening her glance to the viewer at least, she appears to be the one who will swallow her pride and break the impasse. He appears to be grumbling, while she seems to be getting ready to speak. He is holding out, while she looks up as if to say, 'Do you believe he can't drop it?'

These Degas genre scenes make a composite of the Victorian paterfamilias – imperious and remote like Gennaro Bellelli, proud and self-assertive like Edmondo Morbilli, moody and uncommunicative like the man in *Bouderie*. Together with the isolated wives, these images suggest the essentials of an uncommunicative English Victorian marriage, such as John Tosh characterized it with the example of Edward and Mary Benson. Although Edward was twelve years older than Mary, better educated, condescending, authoritative, and remote, he remained emotionally dependent on her. 'In this alternation of mastery and dependence the Bensons exemplified a paradox which lay at the heart of bourgeois marriage in mid-nineteenth-century England.' He ruled the domestic scene but without comprehending it. He was 'in command but not much in evidence', and he oversaw his wife's life without actually seeing what she was about, especially her distaste for sex.[12]

In two of Tissot's images of marital disjunction with the same title (*Waiting for the Ferry*) the man is at the margin and in profile. These paintings are based on a photograph of the artist himself, who, in a role tanta-

mount to husband, was living with the divorced Kathleen Newton and her two children. Behind his interpretation of Kathleen's eyes is the story of her arranged marriage, adultery, two illegitimate children, liaison with Tissot, and tragic death from consumption in 1882. But as with the many other unique relationships between artists and models, the arrangement of this pair to privilege the eyes of the woman conforms to the typical formal pattern of a proposal composition. In both works by Tissot the man is seated next to Kathleen with his loving and perceptive eyes in relative obscurity. In one of them (illus. 116) he has downcast eyes. His head is propped by a hand, and he leans on the back of a chair, looking toward, but seemingly remote from, the smartly dressed woman in front of him. Tissot dramatizes the glamour of her eyes by means of a veil, which heightens mystery about her thoughts (she was also known as 'la mystérieuse'). Her alert frontal eyes belong with those of a host of other Tissot women who ignore the weary or wearying men nearby.

A well-known Victorian image of marital breakdown is William Orchardson's *Marriage of Convenience – Before* (illus. 117). It shows a wealthy and much older husband staring desirously but helplessly across

116 James Tissot, *Waiting for the Ferry*, c. 1878, oil on canvas. Private collection.

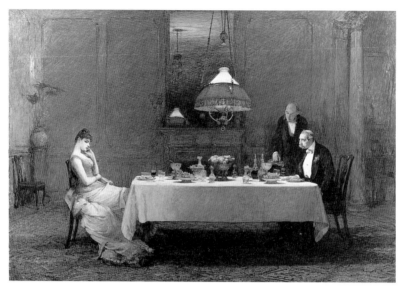

117 William Orchardson, *Marriage of Convenience - Before*, 1883, oil on canvas. Glasgow Art Gallery and Museum.

118 John Singer Sargent, *A Dinner Table at Night (The Glass of Claret)*, 1884, oil on canvas. The Fine Arts Museums of San Francisco.

an elegantly set table at his wife, who avoids his gaze to look down and away. Every material object in the image, including the butler, belongs to the husband, but he is unable to own, let alone understand or satisfy, his wife. Although both bear equal responsibility for the dubious morality of a marriage based on an exchange of money and status for youth and beauty, Orchardson calls attention to the unique pressures on women with more limited professional opportunities who were forced into such unions. To this end he aligns viewer sympathy with the troubled thoughts of the trapped wife by creating vast areas of empty, yet oppressive, domestic space to evoke how she must feel in a marriage that is devoid of love as well as emotionally oppressive.

Another image of marital alienation over a dinner table is John Singer Sargent's *A Dinner Table at Night (The Glass of Claret)* (illus. 118). But while Orchardson's husband is overly interested in his wife, Sargent's has lost interest and sits emotionally remote from her, half cut off by the frame. Sargent had moved from America to England in the early 1880s, where he remained until the end of his life. In 1884 he painted this portrait of the wealthy Sheffield industrialist Albert Vickers and his wife after a meal at a table. She holds a glass of claret and looks wearily toward the viewer. Vickers faces his wife but is decidedly not interested in looking at her, his thoughts drifting off like the smoke from his cigar. For all the proprietary hold his wealth may have given him over her, his gaze is dead. Sargent was clearly fascinated by her sad, tired eyes as they seek relief from her husband's unresponsive presence. Her nose casts a shadow from the lamplight that falls in a broad patch under her right eye and suggests her deeply depressing life. Tear-like sparkles of light on her tooth, hair-pin, brooch, and glass accent the darkness of her facial shadows, which testify to years of loneliness, insomnia, and depression.

Another wife with bags under her eyes appears in Robert Braithwaite Martineau's *The Last Day in the Old Home* (illus. 119). Husband and wife are equally frontal but occupy diametrically opposed positions in the moral hierarchy. The husband's gambling (indicated by a dice-box, a betting-book, and a painting of a racehorse) has necessitated selling the home (indicated by the labels on art objects, the man at the left receiving the house key, and the man through the doorway removing something from the wall). The husband blithely toasts champagne with his son, who also raises a glass, no doubt in line to carry on his father's irresponsibility and immorality. The father's eyes are oblivious to the misfortune he has brought on his family. Rings under his wife's eyes indicate sleeplessness over the problems that the man is able to drown in drink. Weak from grief, she fingers a rosary with her right hand and reaches out futilely in the direction of her husband and son. Her prayers will not likely be answered,

119 Robert Braithwaite Martineau, *The Last Day in the Old Home*, 1862, oil on canvas. Tate Gallery, London.

nor will those of her daughter, whose wide eyes look toward the triptych of the Crucifixion on the sideboard. Although Martineau dichotomizes male immorality and female morality in marriage more than was typical even for the Pre-Raphaelites, he nevertheless offers a visual checklist of gender roles that had a basis in reality. Victorian wives were educated to 'suffer and be still',[13] which this woman has clearly done to the limit.

Two other motifs feature the wife's eyes – those with a husband reflected in a mirror and those with his eyes buried in a newspaper.

Joseph Clark's *The Labourer's Welcome* (illus. 120) depicts a frontally posed, dutiful wife with sewing in hand. Her patience is further signalled by the calmly waiting cat that also looks in the general direction of the husband whose small and shadowy image is visible in the mirror as he enters the cottage door. Lynda Nead argues that 'it is from [the husband's] position that the scene is made intelligible'.[14] But the substance and the focus of this image is rather on the wife's wide-open eyes and her vision of the environment of the home that she has prepared for him. The husband's glance itself is weary and slightly apprehensive at the prospect of seeing his wife. He appears incapable of appreciating the rich interior

domain that is his wife's creation – an arrangement of modest furniture, artwork, household utensils, needlework, flowers, fresh baked bread, and a tea setting. The most animated part of the canvas is the wife's face that lights up with the sight of her husband and the daylight that streams in behind him through the open door, and so we understand more about her than him. As the title indicates, the painting shows the labourer's loving welcome, which is the wife's vision and artful domestic composition.

120 Joseph Clark, *The Labourer's Welcome*, undated, oil on canvas. Graves Art Gallery, Sheffield.

121 Ford Madox Brown, *Take Your Son, Sir!*, 1851 and 1856–7 (unfinished), oil on canvas. Tate Gallery, London.

122 Detail of illus. 121.

123 James Tissot, *At the Falcon Inn, Waiting for the Ferry*, c. 1874, oil on canvas. J. B. Speed Art Museum, Louisville, KY.

Ford Madox Brown's *Take Your Son, Sir!* (illus. 121) is one of the most powerful Victorian critiques of different male and female parenting roles. It also had a hidden personal meaning for the artist. In 1850 Emma Hill gave birth to Brown's illegitimate daughter. The next year he began a portrait of Emma, whom he married in 1853. He resumed the painting in 1855 after the birth of a son, Oliver, who was the original model for the baby. Another son, Arthur, was born in September 1856 and ten weeks later modelled for the final version of the baby. Brown's underlying purpose, argues Arthur S. Marks, was to legitimize his daughter's birth pictorially by representing her mother as the Madonna (who was also made pregnant when unmarried) and himself as the father in a domesticated and updated version of the Holy Family.[15] After Arthur's sudden death in 1857, Brown abandoned the painting and left it unfinished.

Although Brown's artistic role is large, his pictorial role is small. Posed as the father, he is represented in a shadowy background that is squeezed into the convex mirror partly visible behind his wife's head (illus. 122). On the other hand, her pictorial role looms large, magnified by her more central and frontal position. In offering her baby to his outstretched hands she also presents it to the world with a proud but weary expression, which suggests she may have just given birth. The model for the baby was ten weeks old, but by arranging the drapery around him to resemble the vaginal opening, Brown creates the impression that he has just been born. The baby's appealing eyes also magnify the force of the mother's pitiful frontal glance. The mirror behind her head is a multivalent symbol of halo and wedding-ring as well as the mother's eye that mirrors the husband's view of himself.

In addition to these visually remote and diminutive husbands reflected in mirrors, other Victorian husbands are shown reading newspapers that are full of information about the public world beyond the domestic realm of marriage that men were more privileged to explore, conquer, govern, own, and enjoy. Husbands shown reading newspapers flagrantly ignore their wives and thus imply the dwindling of verbal and visual communication that may occur after the wedding.

In Tissot's *At the Falcon Inn, Waiting for the Ferry* (illus. 123) the man's eyes are engaged with the news, while his wife's wander into the distance.[16] The daughter's eyes are the liveliest of all, as she looks beyond the world of her parents with a seemingly farther vision than her mother. Her animated hand gesture underscores the openness of her eyes to new adventures awaiting her in the future, in contrast to the clasped hands of her mother, which are, like her eyes, demurely composed in the deadlock of wedlock.[17]

124 Gustave
Caillebotte, *Interior
(Woman at the
Window)*, 1880, oil on
canvas. Private
collection.

125 William
MacGregor Paxton,
The Breakfast, 1911,
oil on canvas.

In Caillebotte's *Interior (Woman at the Window)* (illus. 124), the wife, being ignored by her newspaper-reading husband, is posed from behind. But still, we are more intrigued by the focus of her attention than his. This blunt-nosed cipher of a husband is squeezed prominently into the foreground corner, conspicuously in disregard of whatever his wife may think or see. Their separateness is not the result of a tiff, but of chronic alienation. She has turned her back on him, his newspaper, and her marriage. The window grille hints at imprisonment in the home, beyond which she looks for something more. Whether her eyes observe quotidian activities in the street below or search for a signal from a person barely visible in the window opposite, we cannot know.[18] Still, her vision is the mysterious subject of this painting. The husband's all-too-apparent visual focus remains, like his apparently minimal capacity for love, lost in newsprint.[19]

The Breakfast (illus. 125) by William MacGregor Paxton captures in pictorial melodrama the remote worlds of two upper-class Bostonians. Although Paxton was American, he trained at the Académie Julian in Paris in 1889–90, and the New England scene he depicted could easily have been England. The husband is preoccupied with the public world of the morning paper. Its facing side forms a barrier between him and his wife,

and one of its corners cuts his left eye from view. Also deserted by the departing maid, the wife has turned away from her husband and in the direction of the viewer, who can see her brightly lit three-quarters profile as she ponders her isolated misery. Her soft downcast eyes seem to be as confined by the waxed floor as her body is confined by the sturdy chair. The austerity of the room is slightly relieved by the flowers, vases, and bowls. Their prominence is a reminder of the care with which she decorated their home at a time when perhaps her husband took notice of her at breakfast and perhaps appreciated her decorative ceramics. Among these, the copper-coloured fruit-bowl that is almost hidden in the far corner is merely an innocuous memento of better times past.

Another decorative bowl is the central symbol of love in Henry James's novel about late Victorian marriage, *The Golden Bowl*, published in 1904. It is a fitting novel to conclude my study because it appeared just after the close of my century, concerns the subject of my final chapter, and confirms my major arguments: the husband is a *flâneur* who engages in incognito adultery; his wife's eyes have clearer vision, which is the source of her controlling knowledge; a single moral standard governs the couple's relationship; he is more driven by natural sexual desire, while she maintains a

stronger commitment to the morality of love; and the novel ends with a literary description of a proposal composition.

The story begins with an impoverished Italian prince, Amerigo, marrying for money an American heiress, Maggie Verver. Her wealthy father, Adam, marries Amerigo's old flame, Charlotte Stant, who then commits adultery with Amerigo. Maggie slowly learns about the adultery and uses her knowledge to save both marriages. The novel, like much of James's writing, is primarily about seeing and being seen, about who knows what, and about who knows who else knows.[20]

It opens with the Prince shopping in London's Bond Street while his solicitors fix his wedding date. James never describes the colour of Maggie's eyes, but he does note that her husband's are dark blue.[21] In the other novels I have surveyed, most men have dark eyes.[22] Stephen Smith (*A Pair of Blue Eyes*) and Léon Dupuy (*Madame Bovary*) have blue eyes, but they are inexperienced lovers. So James's noting the blue of Amerigo's eyes suggests that the Prince – more than Maggie – may be objectified by a gaze.[23] The Prince's objectification is further indicated when Maggie tells him that he is 'an object of beauty' (49) for her father's museum collection.[24]

The Prince cannot see the dubious morality of his dealings with women. He tells Fanny Assingham, who arranged his marriage, 'I shall always want your eyes. Through them I wish to look', and he further confesses that his morality is 'half-ruined', like some old Roman staircase (61, 62). He is aware of his archaic morality and limited respect for women, as James explains: 'The Prince's notion of a recompense to women – similar in this to his notion of an appeal – was more or less to make love to them' (55).

James concludes volume One with anticipation of upcoming disclosures, as Fanny explains to her husband how Maggie will have to learn 'to see' and doubt her husband in order to wake up to his adultery. Volume One was supposed to show Maggie through the Prince's vision of her, while volume Two was supposed to show him equally through her eyes (21). But James shows Maggie's vision with far greater acuity and consistency than he does the Prince's, and since hers comes at the end, it establishes the novel's definitive interpretations of vision and love.

Volume Two begins with the subtle stirrings of Maggie's 'recognitions and perceptions' of the Prince's deception. She scrutinizes the Prince after his return from a visit with Charlotte to Matcham, where, Maggie begins to suspect, the two may have committed adultery. She notices that he 'had followed her from the other house, *visibly* uncertain – this was written in the face he for the first minute showed her' (335). James devotes two pages to their first exchange of looks, as Maggie's suspicions begin to

mount. The Prince uses his charm to make her abandon further probing and give in to desire, but she resists and acts on behalf of her sense of what is right. Three times he takes her into his arms, and while each time she is tempted to let the embraces sweep away the tension, she feels 'terror' from the weakness they produce in her (345). A few days later he again takes her in his arms, and she allows herself to take comfort in this, but also remains determined to see and to know: 'She was making an effort that horribly hurt her, and as she couldn't cry out her eyes swam in her silence' (364).[25]

That silence is broken by the sound made when Fanny smashes the golden bowl to pieces just as the Prince enters the room. Maggie had just explained how she learned from the antiques dealer who sold her the bowl that the Prince and Charlotte had been intimate long before she had met the Prince, and that their intimacy had continued after her marriage. The bowl, cracked under its gilding, leads to the discovery of her husband's infidelity and is a symbol of the flawed marriage behind the appearance of wholeness. Fanny had been trying to destroy the incriminating evidence, but when the Prince walks in just as it crashes, Maggie reads the look which gives away his infidelity. She wishes not to see his face 'till he should have had a minute to arrange it', but her protective impulse is over-powered by her desire to know. 'Then it was that she knew how hugely expert she had been made . . . by the vision of it . . . that had flashed a light into her troubled soul the night of his late return from Matcham' (450). Maggie does not want to be convinced of his infidelity but cannot mistake what his blushing reveals. Her seeing is no untroubled discovery, but a reluctant witnessing of an ugly immorality.

James prolongs exquisitely the conflicts and ambiguities, the overt deceptions and self-deceptions, the cautious hesitations and reckless actions that follow this exchange of looks between Maggie and the Prince. She wants to say that he should take all the time he needs to compose himself – 'Only *see*, see that *I see*, and make up your mind on this new basis at your convenience. . . . Above all don't show me, till you've got it well under, the dreadful blur, the ravage of suspense and embarrassment.' But, of course, she says something else. James explores how each imagines what the other might see and say but does not, as in the following extra-ordinarily convoluted account of the couple's tortuous evasiveness: '"Yes, look, look" she seemed to see him hear her say even while her sounded words were other – "Look, look, both at the truth that still survives in that smashed evidence and at the even more remarkable appearance that I'm not such a fool as you supposed me. Look at the possibility that since I *am* different there may still be something in it for you – if you're capable of working with me".' But Maggie and the Prince are incapable of working together and can only grope toward the morally respectable love that she

vaguely perceives. Over that moral shift, which the remainder of the novel tracks, Maggie takes charge. What she sees and knows gives her the power to challenge the Prince's double standard in dealing with women. As James explains, following this exchange of revealing looks and concealing dialogue, 'there occurred between them a kind of unprecedented moral exchange over which her superior lucidity presided' (452–55). Maggie's perceptive glance diminishes the sovereign power of the Prince's seductive gaze, enabling her to impose a stronger commitment to personal morality.[26]

The power struggle that ensues hinges on who knows what. Maggie uses her knowledge to save her own morally flawed marriage.[27] She mulls over her responsibility for protecting the Prince from the devilish truth and the horror of his evil. His peace of mind and her marriage depend on her, but since she must remain silent to protect him from the truth, she cannot challenge him to assume moral responsibility. Maggie will protect him from public disgrace and soften his private humiliation, but in so doing will weaken his moral authority.

In the end she is reluctant to take charge, even though she knows she must. When the Prince pledges that things will change soon, Maggie senses the promise of 'the intimate, the immediate, the familiar as she hadn't had them for so long'. James's description of her standing in a doorway under the Prince's ardent gaze conjures up many of the conflicted faces and mixed emotions of the women in art whose images I have interpreted. She holds the doorknob but does not grasp it, she wants to leave him but also to remain, she has made innocence disappear but wants it back, she strives to control natural desire but yearns to surrender to it. She is tempted to the limit when he asks 'Ah, but I shall see you –! No?' At this moment,

He was so near now that she could touch him, taste him, smell him, kiss him, hold him; he almost pressed upon her, and the warmth of his face . . . was bent upon her with the largeness with which objects loom in dreams. She closed her eyes to it, and so the next instant, against her purpose, had put out her hand, which had met his own and which he held. Then it was that from behind her closed eyes the right word came. 'Wait!'

This literary account of a proposal composition places the urging man 'bent upon her' with large looming eyes at the side of (what I read as) a frontal woman, who tells him to 'wait' while seeming to look in the direction of the reader-as-viewer to reveal the mystery of her closed eyes as she ponders the appeal and the peril of giving in to her emotions. In this penultimate scene Maggie is unable to return his urgent gazing, although she does manage to lessen its paralyzing force as well as elevate its prospective moral worth.

Their last encounter occurs when the two are alone in order to refashion their marriage. The Prince retains the power to make her heart throb, because she needs his love. He must be able to acknowledge tacitly what has happened but without actually confessing, while she must restore truthfulness to a love that has been corrupted by deceit but without demanding a full confession of the truth. The resolution of their love is a moral one, made possible by what Maggie has seen and knows. She uses her knowledge to take control of her own marriage as well as her father's marriage to Charlotte, and she props up at least the apparent morality of everyone else. In the end Charlotte knows less than anyone else, but even her moral standing is upheld by Maggie in her last spoken words to the Prince, which insist that Charlotte is 'splendid', adding 'That's our help, you see'. James explains that that comment was intended 'to point further her moral' (579–80).

The Prince realizes that Maggie's use of 'our' is too modest, because Maggie is the only helper, as he indicates in his final words to her – 'See? I see nothing but *you*' – meaning that she alone upholds the morality of the adulterers, making possible whatever future happiness his marriage might have.[28] His eyes brighten following this admission, and Maggie closes the novel with a gesture: 'And the truth of it [Maggie's sole defining of what is right] had with this force after a moment so strangely lighted his eyes that as for pity and dread of them she buried her own in his breast' (580). This image of ambivalence suggests the consequences for a woman who ventures to take charge of the morality of love. Maggie pities the Prince because she has made it impossible for him to do what he has previously done so effectively – to 'charm her by his sovereign personal power into some collapse' (421). Without his old charm he is indeed pitiful, and she must somehow learn to love him without it. She still dreads his eyes because her triumph is ambivalent and uncertain. He may at any time reprise the sovereignty of his seductive gaze, and she may at any time lose the power to resist his seductive power that came from her discovery of his adultery. James's final image of her burying her eyes in his breast leaves the married couple with a reminder of the irrepressible potency of the male gaze, the infinite possibilities of a woman's look, and the unending tension between morality and love.

Conclusion

The argument of this book is based on a pattern of visual conventions in art supported by evidence from novels. Images that conform to this pattern I have identified as proposal compositions. In them a man looks at a woman who looks away from him and in the direction of the viewer, and her face is emphasized by its more frontal pose, brighter illumination, greater detail, and more varied expression. Such women are not objectified by the male gaze but retain a commanding subjectivity that, in comparison to the man's more erotically focused purpose and expression, conveys a wider range of thoughts and emotions. This conclusion will reconsider the evidentiary value of these compositions and what they reveal about relations between men and women in the second half of the nineteenth century.

To prepare for these final generalizations about the historical significance of this compositional pattern, I must first interpret compositions with a more frontal man beside a profiled woman. These counter-examples do not undermine my argument, however, because in most of them the man has a feminine aspect. In one such motif which I have already discussed, *The Escape of Lord Nithsdale* (illus. 101), the man is disguised as a woman. Two other motifs also give the more frontal man a feminine aspect: he may display the greater stress that was typically a woman's, as in Arthur Hughes's *The Long Engagement*, or he may have feminine features, as in Millais's *Lorenzo and Isabella*.

In *The Long Engagement* (illus. 126), a cleric appears prematurely aged by the years he spent waiting until he had enough money to marry. He and the woman have been engaged long enough for her name (Amy) carved on the tree in the foreground to be covered with ivy. His searching face is remote from her eyes, which regard him with infinite patience. Her moving expression seems almost too easily reconciled to her predicament. It conforms to the stereotype of womanly patience and unquestioning support, so it is less intriguing than the cleric's unmanly look of helplessness. Unlike the women who looked away from a man to consider how or whom to love better, this man looks away from a woman because he has failed to

126 Arthur Hughes, *The Long Engagement*, 1859, oil on canvas. Birmingham Museums and Art Gallery.

acquire the resources to satisfy the woman he loves. Although brief courtships followed by long engagements were not uncommon in the nineteenth century, the protracted waiting and postponement of sexual fulfilment created an unmanly role for the responsible man.[1] The cleric's inability to act has earned him the woman's more typical place in a proposal composition. That argument would be circular, of course, if it were not the case that nineteenth-century women *were* generally posed frontally in proposal compositions.

In *Lorenzo and Isabella* (illus. 127), the frontally posed Lorenzo seated at the right works for the family of Isabella, the woman to his left whom he intends to marry. Their story is drawn from a poem by Keats about a wealthy Florentine family in which three brothers kill their sister's impoverished beloved because they want her to marry a wealthy man.[2] Two of the brothers shown on the left have hard expressions, while the one seen cracking a nut, who actually does the murder, looks like a brute. In contrast, Lorenzo's feminized face combines the sensitive and vulnerable roles of poet and lover. Its shape also resembles that of Keats, which one

127 John Everett Millais, *Lorenzo and Isabella*, 1848–9, oil on canvas. Walker Art Gallery, Liverpool.

nineteenth-century biographer described as 'like some women's . . . wide over the forehead and so small at the chin'.[3] According to contemporary phrenology, Lorenzo's narrow eyes indicated veneration, while his broad forehead signified superior intelligence and morality. Thus, the one man devoted to love is shown frontally to reveal his exceptionally intelligent and morally superior, feminized features.

A fourth motif with a more frontal man accents the man's deficient commitment to the morality of love, as in a number of images already discussed. In *Phryne Before the Areopagus* (illus. 4), the rows of frontal men degrade naked Phryne with their judgemental gazes, while in *A Roman Slave Market* (illus. 5) the slave traders cruelly eye the naked woman as they bid for her body. In *Admiration* (illus. 76), the client displays a goofy smile while ogling a prostitute posed to display her strong and graceful back. Shelley's face in *The Lovers' Seat* (illus. 82) is more animated, but Mary Godwin's meditating profile holds the key to the future of their forbidden love, because only her moral courage can make it possible. *The Fisherman and the Siren* (illus. 90) features the defeated face of a seduced man. *The Beguiling of Merlin* (illus. 92), shows the great magician losing his magical power, while *Phyllis and Demophoön* (illus. 93) reveals a man's frontal face riddled with fear and shame stemming from his own amorous neglect. The shepherd in *Found* (illus. 107) reveals little compassion and avoids looking at the fallen woman he once loved.

The man in Degas's *Interior* (illus. 128) is an embodiment of love in ruins. He may have been suggested to Degas by a character in Zola's *Thérèse Raquin*, which includes a scene set two years after the heroine and her lover have murdered her husband, when the conspirators enter a room on the couple's wedding night only to discover that guilt has killed their desire.[4] In the painting, the couple appears to be suddenly estranged shortly after entering the room, although the reason is unclear. The woman's exposed shoulder and withdrawn position, along with her abandoned sewing and crumpled corset, make her more than a mere object of the man's look.[5] The abandoned sewing hints at her loss of virtue, while the corset raises questions about the man's morality and effectiveness as a lover. Did she throw it at him in anger, pull it off in disgust, or just remove it hurriedly to relieve some discomfort? Did he remove it and then give up? It lies on the floor half-way between the withdrawn woman and the man as a remnant of her effort to enhance her sexual appeal, which for this couple has mysteriously led to some dark tragedy.

That failure is registered conspicuously in the man's posture and expression. He stands stiffly and casts an ominous shadow; his face bears a threatening expression, with his low forehead, long nose, and eyebrows

128 Edgar Degas, *Interior*, 1868–9, oil on canvas. Philadelphia Museum of Art.

joined over deep-set beady eyes. The subdued lighting casts an eerie glow on his left eye-socket that accentuates the depth of his eyes and, along with his pointed ears, implies malevolence.[6] The dominion of the male gaze is here strewn with signs of ineptitude, alienation, and evil. Although Degas would soon abandon such didacticism, this painting records the ultimate helplessness of the overpowering male gaze, especially its incapacity to see the way to love, and it dramatizes the conflicting powers of the man's eyes and hands in relation to the woman's bare shoulder. He can see the glowing object of desire, but his hands, pressed into tiny pockets, are incapable of touching it, while her mute and objective shoulder articulates an indominable subjectivity that seems to pin him against his own menacing shadow.

The art record thus provides various examples of more frontal men who appear in atypical roles for male lovers: disguised as a woman, under greater emotional stress about love, with feminine features, or incapable of love. And such frontal men are unusual.[7] Artists typically posed women frontally to highlight their stronger commitment to the morality of love. This argument does not mean that women were more moral than men in every respect, but that in the sphere where women were supposed to be in charge – the private sphere of loving during courtship and marriage – women resisted the immediate gratification of their natural sexual desire more than did men, and they did so on behalf of their stronger commitment to a single moral standard of right and wrong with respect to their beloved, one that demanded honesty, fidelity, and a commitment to make love flourish.

My study has supported that central argument on the strength of evidence showing women in the predominant position when depicted or scripted with a man. To conclude, I will reconsider five questions about what those artistic and literary compositions might reveal about the actuality of love in the second half of the nineteenth century: Did women regulate love in the private sphere? Were they more moral than men in that sphere? Was there a single moral standard of love? Did women resist natural impulse more than men? Why did male artists create so much art that shows men in a subordinate position and with a deficient commitment to the morality of love?

No one can question the separation of male and female spheres, nor that men had the overwhelming advantages: they enjoyed superior political, military, economic, and muscular power; privileges in religion, science, education, and the arts; even greater opportunities to amuse themselves and move about in security. In courting, men enjoyed the more active role from their prerogatives regarding whom to pursue and how to proceed. But artists wanting to interpret the actuality of love were drawn not to

situations dominated by one sex but to those where love was in the balance, hence the popularity of proposal compositions in which the man is seeking some response, from a simple returned look or a friendly question to a more involved sexual solicitation or an actual proposal of marriage.

In such images the woman commanded centre stage for three reasons. First, the man also enjoyed another, wider realm of productive activity, so the woman had more time and energy to devote to love and fewer opportunities to distract her. Second, she had more to lose. Loving a man threatened to take away her innocence, health, autonomy, place of residence, maiden name, legal status, and, during childbirth, perhaps even her life. So the drama centred on her. Finally, she cared more about love and knew more about it, because she was raised primarily to prepare her for its hoped-for fulfilment in marriage. Artists highlighted the woman in images of love because she was, in fact, their primary subject.

The names *Rossetti*, *Millais*, *Burne-Jones*, *Tissot*, *Renoir*, *Degas*, *Manet*, and *Gauguin* evoke a celebration of women in art, alone or in the company of men, that is unsurpassed in any period. Impressionism itself evokes a world of dark-coated men attending to brightly attired women with alert eyes in shimmering light. In the few images *by* women that I have interpreted (illus. 16, 33, 39, 40, 46, 48, 101) the women portrayed are also more frontal and better illuminated than the men. The British neo-classicists were endlessly fascinated by 'WOMAN', whom Leighton defined as synonymous with beauty itself and as the incarnation of God's glorious work. The Pre-Raphaelites were obsessed with women. Millais's women rescue men from military, political, or religious campaigns that allow those men to flee from love, while other Pre-Raphaelites show women, whose capacity to love has been threatened by a man, being saved by men who remain preoccupied either with their male foes or a beastly stand-in for one. Thus even when in danger, women are physically and spiritually closer to the attainment of love, while men flee it, threaten it, or find ways to be distracted from it.

The second question is whether women were more moral in loving. Or did men's privileges in the public sphere erode women's moral superiority in the private sphere to which they were destined by law and custom as well as, to a certain extent, by reproductive biology? To put that question more pointedly, perhaps the celebration of woman's superior morality in personal relationships was a sop, a bit of sexist ideology (conscious or not) to conceal men's predominance even in the private realm by mystifying women with theories about their natural instinct to care for others in order to keep them in a subservient position. But the art, and especially the novels, reveal that women consistently assumed genuine moral authority in

the private sphere of love relationships, while men channelled their moral efforts into the demanding issues of the public world.

A vivid depiction of the interaction of those two moral realms is Millais's *Peace Concluded, 1856* (illus. 100), which shows the man, having fulfilled his public moral responsibility by defending national interests in the Crimean War, back in the private sphere of his home, seeking comfort under the overarching arm of his nurturing and loving wife, a gesture that also signifies her overarching moral dominion in the home. This Victorian man not only did not need to regulate the morality of love at home, he clearly did not have the energy or the will to do so. It must have been a relief to him to let his wife take charge of the moral instruction of their children, which she has done superbly as Millais narrates pictorially with the two beautiful, well-groomed, and respectful daughters. The wife's preparation for that moral task, instilled from earliest childhood, had been deeply ingrained in both sexes and was no doubt reassuring to the man as the demands of love and family increased. Her subsequent ability to use that strong moral sense in dealing with her husband was the logical extension of her upbringing, evident in this and countless other images of a domestic scene in which women are responsible for showing children how to be good, a practice that became the model for learning how to understand, care about, and love a grown spouse.

The evidence for woman's moral superiority is abundant. Victorian moralist tracts insisted on women's instinct for self-sacrifice and caring. Phrenologists identified women's more prominent faculty of 'amativeness' (sexual love) or the even more basic 'adhesiveness' (ability to form attachments). Sociologists argued that women had superior social skills and were friendlier. Psychologists concluded that women excelled in affection, sympathy, devotion, and morality. Even Darwin hypothesized that women naturally had 'greater tenderness and less selfishness'.

The affirmation of women's moral superiority is more explicit in English art and literature, but the French share the same basic attitude. Although the Impressionists were not as didactic as the Pre-Raphaelites, they nevertheless also accorded to women the more prominent position in paintings of couples. Among the French heroines I discussed, Mme Arnoux, Christine Hallegrain, and Dea evince a more faithful commitment to love than do M. Arnoux, Frédéric Moreau, Claude Lantier, or Gwynplaine. Emma Bovary breaks the morality of her marriage vow, but her loveless marriage was foisted on her by the conniving of her husband and her father and was held in place by a legal system that made a married woman a piece of property. Flaubert dramatizes her effort to hold onto what she knows to be right by having her try to hold on to icons in the cathedral during her tryst with Léon: 'Her desperate attempt to steady

her virtue made her clutch at the Virgin, at the sculptures, at the tombs, at anything that came to hand.'[8] In spite of her moral transgression, she towers over both of her morally flawed co-adulterers as the more fully realized individual, which for Flaubert was far more significant than being a morally upstanding member of the community. That role Flaubert mocks with the hypocritical Homais. When desperately in need of money, Emma still gives a blind beggar her last five francs, while the miserly Homais gives him a sou and asks for half back in change. Even Zola's Nana makes a moral statement in the end when her decaying eyes appear as a reminder of men's moral corruption and cowardice as compared with the basic humanity and moral courage of her circle of prostitutes.

In French formal thought across the political spectrum and throughout the century, moralists agreed that *la femme au foyer* should instil morality in children and therefore be the transmitter of personal morality. If that moralizing role was interpreted by patriarchs such as Jules Michelet, who assumed that women could only teach what they had learned from men, such men fooled themselves, because the living actuality of the moral sense that governed personal relationships began with the mother's very own loving guidance to her children about what is right and ended with the grown woman's very own transmission of that sense to her husband.

Victorian poetry is full of men evoking the morality of a love that was shaped by a medieval chivalric code. Arthur's decision to leave Guinevere in order to save his kingdom may have been inspired by the stringent morality of that code, but his 'cold' and 'passionless' character and his lack of Lancelot's 'warmth and colour' along with his physical absence were the triggers for her adultery and tragic downfall.

Novels offer a more explicit source for women's stronger commitment to the morality of love. It is difficult to recall a single hero of a novel who expressed his love in moralistic language about what is right and wrong with respect to others to whom he may have been already committed, or even to his current beloved. In contrast, numerous heroines, driven to the limit by their own desires and frustrations, nevertheless managed to express their love in accord with their strong moral sense. Jane Eyre loses no points to Rochester for the intensity of desire, but she checks her natural impulse even as he tries to exploit it with his early insincere reticence and his bogus courtship of Blanche, and then as he tries to control it with his vaster wealth, higher social status, and advantages in the employer–employee relationship. But love triumphs because of the strength of Jane's character, as Rochester describes it in a moment of frustration – a 'resolute, wild, free thing looking out of [her eye], defying me, with more than courage – with a stern triumph'. The courageous characters behind the strong eyes of Elfride Swancourt, Bathsheba Everdene, Tess Durbeyfield,

Maggie Tulliver, Christine Hallegrain, Hester Prynne, Maggie Verver, Margaret Hale, Dea, Trilby, and Nancy, might have been described similarly by the men in their lives.

It could be objected that by putting women on a pedestal and idolizing them as angelic, men abstracted women from their actually degraded and mundane lives and thus stripped them of any real power to act effectively in the real world. But in fact, artists posed women right next to men in a variety of morally challenging real situations and equipped them with inspiring beauty and sexual allure along with genuine intelligence and moral courage.

The answers to the first two questions make it possible to compare the moral authority of men and women in their separate spheres. Men governed the morality of the public sphere, while women governed the morality of the private sphere, the location of the those nuclear relationships from which the basic morality governing all human relations was generated. Man's moral dominion was more extensive, while woman's was more intensive and more primary.

In that morally grounding capacity women also influenced the public world. The proposal composition itself made an implicit political statement, because in it the privileged position of the woman as more frontal and expressive clashed with the political underprivilege of women. Failure to read that implied statement continues with present-day scholars, for example T. J. Clark, who does not identify the implicit feminism in a long quotation from an essay by Mallarmé that concludes his book on Manet. In 'The Impressionists and Edouard Manet', Mallarmé had argued that Impressionist art, and especially Manet's, revealed a new world with a 'hitherto ignored people in the political life of France'. That new world was more like the realm of French women than the world of those unmistakably male 'kings and gods . . . to whom was given the genius of a dominion over an ignorant multitude'. Mallarmé's labelling of that new world as 'radical and democratic' accords with feminist political goals. In that new world revealed by the Impressionists, 'the multitude demands to see with its own eyes; and if our latter-day art is less glorious, intense, and rich, it is not without the compensation of truth, simplicity and childlike charm'. Mallarmé ends by endorsing a new, unmistakably feminine, vision that requires a loosening of the restraints of education 'to let hand and eye do what they will, and thus through them reveal herself'. Clark's last words are those of Mallarmé's unintended feminist manifesto. The future of society will be governed by 'certain lovers', whom Mallarmé refers to as 'men' but then characterizes as a female. She will 'express herself, calm, naked, habitual, to those newcomers of tomorrow, of which each one will consent to be an unknown unit in the mighty numbers of a

universal suffrage, and to place in their power a newer and more succinct means of observing her'.[9] The Impressionists campaigned unwittingly for universal suffrage and women's political equality.

A third question is whether a single moral standard governed love. A double standard clearly regulated the treatment of the sexes in many areas, and Victorian men took advantage of it by indulging in sexual adventures with far less censure than was meted out to women; but whatever privileges a man may have enjoyed because of the double standard, they did not include privileged access to the love of a woman or to a conviction that what he was doing was right.

When a man faced the woman he loved, eye to eye, a single moral standard governed their respective notions of what was right and wrong. A potential confrontation of uniquely male and female moral standards provided the dramatic pivot of novels in which women evince their stronger commitment to the only genuine morality of love. And while the art was not as didactic, especially the French art, it nevertheless highlighted women's greater responsibility for love and for maintaining a single morality that demanded from both sexes an equal measure of honesty, fidelity, and commitment. The proposal composition focused on the faces of more frontal and centred women who were in control of the ways of love and more deeply committed to that single moral standard.

While a single standard governed the relationship of man to woman as they faced one another, a double standard governed their actions with respect to everyone else. To clarify this argument, I must distinguish between three kinds of reproval for moral transgression: the shame of reproval by society, the shame of reproval by a beloved, and the guilt of reproval by oneself. Men who broke the morality of love were less harshly judged by society and so were shamed less in its critical eyes. But by the evidence of novels, men felt equal shame before the eyes of their beloved and equal guilt in their own mind when no one else knew about their transgression.

Some artists, such as Augustus Egg in *Past and Present, 1* (1858; Tate), moralized about what happened to a woman who sinned against love. In that classic image a woman lies prostrate at the feet of her frontally posed husband, who sits despairingly in a chair as their two children play with a falling house of cards. While she is distraught to the point of physical collapse from shame at being found out, he wallows in self-pity and righteous indignation, without showing a hint of awareness of his partial responsibility for her transgression.[10] But most artists approached the morality of love not by its abject failures but by its hopeful moments nuanced with human deficiencies and frailties. The art of love focused on the eyes of women expressing a variety of such complex emotions: anxiety over a first

meeting, indignation during a rude flirtation, impatience before a hapless suitor, boredom during a tedious story, lonely longing in the midst of gaiety, isolation beside a courting couple, moral anguish outside a gambling den, moral awakening from out of the lap of a seducer, shame before a rescuing knight, depression beside an alienated husband, and a spectrum of expressions before various proposing suitors. In these scenes women show their deeper commitment to love and to the morality that regulated it.

The question about women's moral superiority is related to the fourth question, of whether they resisted natural impulse more than men. Art and literature testify that men were indeed more willing to gratify the natural impulses of sexual desire, while women were unquestionably more inclined to regulate the pace and define the meaning of sexual gratification. The large number of images of proposals with *yes or no?* in their titles, intended as a question for a woman to answer, indicates the predominant role that women had in denying, or at least questioning and regulating, a beloved's sexual desires. Men were less often told during their upbringing to say *no* to desire and were not counselled to do so according to courtship custom, so they are rarely shown saying *no* to desire in art.

I found no painting with that caption title intended for a man. The saints, classical heroes, and even satyrs shown resisting temptation are usually surrounded by a bevy of seductive sirens, nymphs or maenads, whose numbers indicate the man's (imagined) greater sexual capacity as well as his (actual) deficient capacity to relate to one real human female. When a man is shown being seduced by one woman, she is typically a historical or literary character, hence a real or imaginary person from a distant place or time, or a fictive morphological hybrid. Many nineteenth-century men, of course, did relate to a single real woman, but such men were nevertheless more inclined to give in to the urgings of natural instinct. In art and literature it is primarily the woman who ponders saying *no* or at least a thought-provoking *maybe* or *wait*.

The last, and most intriguing, question is why male artists packed so much emotional complexity and moral courage into the eyes of women posed with men who by comparison seem to be emotionally more predictable and morally weaker. One reason is that male artists were fascinated by the eyes of their mistresses and models, occasionally even the eyes of their wives, although when they painted their wives the result lacked the dynamic tension of a couple whose relationship was volatile. Another reason is that men were more uniformly focused on the satisfaction of natural sexual impulse, and so male artists found such men's gazes less intriguing than the more conflicted expressions of women who were obliged to restrain their own erotic gazing as well as a man's desire. But the most important reason comes from the artists' own deficiencies and dis-

appointments. Their art is therefore ultimately confessional of their own failures in love and celebratory of women's promise of success. It is a creative effort to restore balance to a world that was so imbalanced by male privilege and power.

The actual love lives of the men who founded the Pre-Raphaelite Brotherhood in 1848 were fraught with sexual failure and moral guilt. In 1849 Millais painted a manifesto for the Brotherhood, *The Girlhood of Mary Virgin* (Tate), which celebrated woman's moral superiority. As he wrote in 1852 to his fellow Pre-Raphaelite, Frederick Stephens, 'That picture of mine was a symbol of female excellence. The virgin being taken as the highest type'.[11] The painting is crowded with symbols of woman's moral purity. St. Anne (whose pregnancy with Mary was miraculously free of the taint of Original Sin), sits beside her quintessentially innocent daughter as she embroiders an image of a lily (symbol of purity). In front of Mary, in a vase resting on a pile of books inscribed on their spines with the cardinal virtues, is the subject of her inspiration, a stem of actual lilies being touched by a child-angel in white. In the background a white dove perches on a trellis. Such over-determined imagery of female sexual innocence was an inverted confession of male sexual guilt.

Failure in love plagued the Pre-Raphaelites. In 1851 Rossetti began a tortuous affair with his model Elizabeth Siddal, who committed suicide by means of laudanum in 1862, two years after she had married him.[12] He expressed his guilt and remorse as well as his love and admiration in *Beata Beatrix* (illus. 129), picturing a seated Beatrice with the face of Elizabeth, her eyes closed in prayer and in death, also suggesting an opium-induced trance and perhaps yearning for the love that Rossetti was unable to provide during her life.[13] The painting is explicitly confessional as well as celebratory.

Rossetti atones for Elizabeth's death with the symbolic red dove, a messenger of death that brings her the poppy (opium). He celebrates her life and love by projecting himself in the right background as the immortal love poet Dante glancing at a figure of Love in the left background. The painting also celebrates Elizabeth's visionary soul along with Beatrice, whom Rossetti loved through her. Rossetti was named after Dante Alighieri, whose works he translated and whose world he wrote about and painted. In *The Divine Comedy* Dante was aware of Beatrice's eyes watching him as he made his way with Virgil through Hell and Purgatory before she took over and guided him through Paradise, and so in real life Rossetti imagined Elizabeth leading him through the earthly analogues of the three realms of love. He wrote about Beatrice's eyes based on his experience with Elizabeth, 'so that all ended with her eyes, Hell, Purgatory, Paradise'.[14]

129 Dante Gabriel
Rossetti, *Beata
Beatrix*, 1864, oil on
canvas. Tate Gallery,
London.

Rossetti celebrated Elizabeth's visionary eyes after they closed on her
failed earthly love with him and turned toward the love that he believed
she would see in death, a divine love which he hoped to immortalize in art.
He explained her facial expression in a letter to the painting's owner: 'She
sees through her shut lids, is conscious of a new world, as expressed in the
last words of the *Vita nuova* "that blessed Beatrice who now gazeth con-
tinually on His Countenance who is blessed throughout all ages".'[15] The
painting's title underscored its ultimately celebratory meaning. *Beata*
means bliss, while *Beatrix* is the Latin for *Beatrice*, which means 'she who
makes happy'. The painting is an image of Rossetti's beloved, who brings
the highest bliss to all who share her beatific vision of heavenly love.

Millais was another Pre-Raphaelite who celebrated a love that was only
fulfilled after a long and morally trying search. He married Effie Ruskin
after her six frustrating years in an unconsummated marriage to his good
friend John Ruskin.[16] Although Millais's lovemaking would be more suc-
cessful than Ruskin's, on the day of his wedding to Effie in 1855 he anti-
cipated conflict and failure, as he confided to a friend: 'This is a trial
without doubt as it either proves a blessing or curse to two poor bodies
only anxious to do their best. . . .There are some startling accompani-
ments, my boy, like the glimpse of the dentist's instruments – My poor

brain and soul [are] fatigued with dwelling on unpleasant probabilities so I am aroused for the fight.'[17] On the wedding night Millais's body apparently performed better than had Ruskin's, and he presumably saw something less anxiety-provoking than a dentist's instruments. He crafted his gratitude into a suite of images of women rescuers that celebrate Effie's ultimate rescue of him from loneliness.

The most religious Pre-Raphaelite, Holman Hunt, had another sort of anxiety about women. The model for his icon of morality regained in *The Awakening Conscience* (illus. 85) was the wretchedly poor Annie Miller. Illiterate, beautiful, and sexually adventurous, she was an ideal victim for a rescuing knight. Hunt muted her pictorial degradation as a prostitute by depicting her in a moment of moral regeneration as she rises from the lap of her fancy man. His explanation that the man was 'the unconscious utterer of a divine message' alludes to his own role as the painter of a spiritually uplifting message. After finishing it, he arranged for Annie's education in letters and manners in order to elevate her for a marriage to him (which never took place) when he returned from a religious pilgrimage to the Middle East. There he painted *The Scapegoat* (1854), an image of a goat in a wasteland, symbolizing man's moral degradation through sexual desire. Hunt's description of the painting reads like a confession of Victorian man's guilty conscience as well as a morbid caricature of a guilty male gaze: it is a vision of 'men's secret deeds and thoughts . . . [and] the horrible figure of Sin – a varnished deceit – [with] earth joys at hand but Hell gaping behind, a stealthy, terrible enemy for ever'.[18]

The Awakening Conscience indicted the fancy man's immoral purpose more than the fallen woman's moral lapse. She alone sees a way out of sin when she looks up to the light emanating from Hunt's pendant to this painting, *The Light of the World* (illus. 87). The physical source of that healing light is the lamp carried by Jesus, but the spiritual source is Jesus's healing power expressed in his face, which was modelled by Rossetti's sister Christina. Hunt's pendants thus celebrate woman's superior morality in balancing the scale between men and women in so unbalanced a society; in one, a woman's eyes envision what is morally right, and in the other, the male god's eyes to which that woman looks for moral guidance were modelled by an accomplished female poet.

In 1867, the most important second generation Pre-Raphaelite, Burne-Jones, began an affair that brought guilt and frustration, because he failed to satisfy his tempestuous mistress or his neglected wife. Out of these personal failures came images from the late 1860s to the 1890s in which women pursue, evade, haunt, tempt, mesmerize, and beguile men. In his Perseus series, the knight rescuing a naked female Andromeda from danger barely conceals his own real-life incapacity to rescue anyone. In the

final and defining image of the series, *The Baleful Head* (illus. 106), Burne-Jones celebrates the courage and vision of woman with Perseus shown beside his now clothed bride, Andromeda, who alone looks Medusa in the eye.

The purpose of the PRB was, as Millais wrote, to paint pictures that 'turned the minds of men to good reflections'.[19] That goal centred on good love, which they celebrated with portraits of women as upholders of the morality of love. These mythically beautiful women with exquisite blue or green or grey or golden eyes lounge in lush canvases from which men are emphatically absent.[20] Their distant eyes yearn for a missing man or perhaps another kind of man than those they typically met, while they also finger exotic stringed instruments, symbolizing those very long-lost or longed-for lovers.[21] These images make up a gallery of women with extraordinarily large eyes perpetually glowing with frustrated desire.

Tissot painted the eyes of numerous unfulfilled women: ambitious mistresses, lonely wives, mournful widows, dying convalescents. Born and educated in France, he moved to England in 1871 for his most successful years before returning to France in 1882, and so is an in-between figure in the art of the two countries. His female subjects when depicted with men look neglected, bored, or annoyed. His art memorializes a tragic affair with the divorcée and mother of two illegitimate children, Kathleen Newton, his lover between their first meeting in 1876 and her death in 1882. During those years he watched her decline, helpless to do anything more life-affirming than paint her for posterity. The portraits of her, many with him at her side, celebrate her beauty and her moral courage to live with him in defiance of conventions. After she died he returned to France and devoted his art to religious subjects.

While the Pre-Raphaelites' difficulties with women stemmed from their youth and sexual innocence, the problems of the French artists I have considered stemmed from their increasing age and sexual recklessness.[22] French art was the less didactic, but it too was confessional as well as celebratory. French artists portrayed themselves in love scenes with less frequency and directness as they grew older, sicker, and more distant from the women who inspired them. Those widening discrepancies energized their admiration for models whom they celebrated as reverse images of their own declining health and sexual prowess.

Renoir's *Le Moulin de la Galette* (illus. 10) of 1876 is full of young artists and writers romancing young women. His *Luncheon of the Boating Party* (illus. 24) of five years later is less animated, but still crowded with pleasure-minded artists and writers romancing younger women. By 1885 Renoir was in his forties and beginning to feel the rheumatism that would make his life and art increasingly painful. In that year he painted *In the*

Garden (illus. 18), in which the young man, a stand-in for himself, urges his affections on Aline, who was at that time Renoir's mistress and pregnant with their child. Thereafter he celebrated feminine beauty and moral purity in images of bathing women who were remote from sexually desiring men. In some images he included a number of wide-eyed girls beside protective mothers. Although in private he insulted his models, in art he ennobled them. In his earlier work they promenade, read, eat, bathe, dance, flirt, and attend the theatre with men in images of carefree recreation and happy romancing. In his later work he celebrated their nurturing capacities and motherly goodness.

Degas had difficulty loving women personally. As Berthe Morisot wrote to her sister in 1869: 'As for your friend Degas, I certainly do not find him personality attractive; he has wit, but nothing more. Manet said to me very comically yesterday, "He lacks spontaneity, he isn't capable of loving a woman, much less of telling her that he does or of doing anything about it".'[23] His art celebrated the love that he was incapable of talking about or 'doing anything about'. It also challenged sexual harrassment and the marital abuse of women. In the 1870s, his top-hatted *abonnés* with strong libidos and weak morals cruise ballet studios and theatres. He located these predators in shadows and at the margins (sometimes cut off by the picture frame) to signify their shady morality and emotional incompleteness. His brothel scenes are some of the most pointed indictments of illicit masculine sexuality and of the male gaze in the history of art. In his marital portraits and genre scenes the men appear incapable of love, either deeply troubled by women or threatening to them. By contrast, his ballet dancers embody discipline in the service of beauty, even as they are being ogled by men on the prowl, and his solitary bathers are visions of gentle self-stimulation and implied self-reflection.[24]

Renoir and Degas suffered progressive infirmities that compromised their art. For the ageing Renoir, rheumatism made holding a brush difficult. Degas's poor eyes deteriorated from his late teens, and by his forties he was afraid that he was going blind.[25] Blindness was a common symptom of gonorrhoea, and although his eye-trouble appears not to have been caused by a venereal disease, he must have suspected it was.

With Manet and Gauguin there was little doubt. They both believed that they had syphilis, which was a consequence of their promiscuity and viewed by contemporaries as the wages of sin. Manet was already in great pain from it when he began *A Bar at the Folies-Bergère*. Suzon's melancholic look projects Manet's vision of the end of life through her longing for it to begin. Her eyes view what was slipping away but also what might lie ahead, a mixture that Manet tried to capture in the painting. One of many art historians to be fascinated with this final masterpiece has specu-

lated that perhaps Suzon is there 'to heal us, the socially and spiritually disoriented urban bourgeois spectators and Manet, the physically failing artist. Perhaps, too, he has *passed into* her (which is why we don't see him or ourselves in the mirror), so that he and she are both healers possessed of different potions or lotions but with equivalent powers and promises.'[26] In the painting, Suzon's centrality and frontality, and the positioning of her hands, are similar to those of Christ in Manet's *Dead Christ with Angels* (1864), and she is posed to display her own healing powers signified by her flowers, bosom, hands, fruit, potions, and luminous eyes.[27]

Gauguin looked to the women of Tahiti to discover how love went wrong and perhaps find a way to revitalize it. Certainly even he, a colonial syphilitic, knew that his way of loving Tehamana had dubious moral worth. So to celebrate his love for her in art, he drained his talent and plumbed the depths of his imagination. Common sense no doubt told him that his ageing, drugged, sick eyes did not belong in his art, gazing at her nude body even if they were in profile, near the margin, or in shadow. In an early version of *Parau na te Varua ino*, the standing Tehamana posing as Eve had two sets of eyes, and the seated Spirit of the Dead had been Gauguin himself holding a mask to the side. In the final painting (illus. 58) he condensed her vision into a single pair of strong, frontally posed eyes, and he replaced the seated figure by a female spirit with her own glowing eyes directed protectively toward threatening male viewers.

Gauguin's disguising and marginalizing himself followed the pattern of his contemporaries. Renoir created stand-ins for himself in early portraits of couples, and later painted female bathers remote from the presence of men. Degas located men at the margins in dance studios and brothels and then banished them from his pastels of solitary bathers. In earlier scenes of crowded merrymaking Manet portrayed himself near the edge of the canvas, while in *A Bar at the Folies-Bergère* he further effaced his artistic persona with the man at the side, modelled by a fellow artist, who from the front appears to be invisible.[28] In the final version of *Parau*, Gauguin removed his own face and eyes altogether and moved the mask, now a substitute for his own face, to the upper-right corner, where it is barely visible (illus. 130). There, incognito, he could look down at the naked Tahitian Eve, who with a single pair of searching eyes now stands in a monumental pose, covering her pubis with a protective cloth. The painting disguises his shameful eyes and confesses his infectious lust, while it celebrates the impenetrable eyes of this primitive woman who embodied the primordial love that he ventured so far to find. Standing in her Tahitian Eden, she looks away from Gauguin's mask-eyes with an intriguing mixture of pristine innocence and worldly wisdom nuanced with a trace of melancholy over her own fall at the hands of Gauguin himself. Just as a

morally adventurous Eve had offered to a morally paralyzed Adam the forbidden fruit that was a delight to his eyes, so does Tehamana offer to the eyes of the world the possibility of a dangerous but transforming love that was the inspiration for the artist's painting, a driving spirit of Western art and literature, and a solace to human loneliness everywhere.

130 Detail of illus. 58.

References

Introduction

1 These images are from the 91 listed in Susan Casteras, 'Down the Garden Path: Courtship Culture and Its Imagery in Victorian Painting', PhD diss., Yale University, 1977, Appendix IX, 'The Proposal'. The sources for these images are Millais (Mappin Art Gallery, Sheffield), Stone (Witt Library, London), Waite (ex-Sotheby's Belgravia sale, 1972), Stephens (Tate Gallery), Blair-Leighton (Royal Academy exh. cat.), Frith (Royal Adademy exh. cat).

2 *The Engaged Couple* is the title used in the early twentieth century. It is also known as *Albert Sisley and his Wife* or *The Sisley Family*. Despite the titles, the female model Lise Tréhot was not Sisley's fiancée or wife. On her identity and the titles see John House's commentary in *Renoir*, exh. cat., Hayward Gallery (London, 1985), pp. 188–9.

3 Thomas B. Hess and Linda Nochlin, eds, *Woman as Sex Object: Studies in Erotic Art, 1730–1970* (New York, 1972).

4 John Berger, *Ways of Seeing* (New York, 1972), p. 47.

5 *Discipline and Punish: The Birth of the Prison*, trans. Alan Sheridan (New York, 1979), pp. 170, 187, 200–08. The plan first outlined by Jeremy Bentham in 1791 called for a periphery of cells with two windows enabling light from the outside to illuminate the interior for surveillance by someone in a central tower. This panoptic mechanism makes it possible for the authorities to see, but not be seen, thereby creating the effect of a God-like observer. The surveillance is supposed to become internalized in the prisoner, who ultimately imposes upon himself the discipline, punishment, and morality of the political authority.

6 On the feminist use of Foucault see Irene Diamond and Lee Quinby, eds, *Feminism and Foucault: Reflections on Resistance* (Boston, 1988), especially Biddy Martin, 'Foucault, Femininity, and the Modernization of Patriarchal Power', pp. 3–19; for an application of Foucault to prostitution see Jann Matlock, *Scenes of Seduction: Prostitution, Hysteria, and Reading Difference in Nineteenth-century France* (New York, 1994), pp. 19–120.

7 'Visual Pleasure and Narrative Cinema, *Screen*, 16, no. 3, (1975), reprinted in Laura Mulvey, *Visual and Other Pleasures* (Bloomington, IN, 1989), p. 19.

8 Mary Ann Doane, 'Film and the Masquerade: Theorizing the Female Spectator', *Screen*, XVI/3 (Sept/Oct 1982), pp. 74–87.

9 Mary Ann Doane, *The Desire to Desire: The Woman's Film of the 1940s* (Bloomington, IN, 1987), pp. 23, 98–100. Her title itself shuts down the intentional and outgoing nature of female subjectivity even before it can get out of the gate of consciousness. Deprived of the outgoing desire for an object, women are limited merely to the self-referential desire to desire (12–13).

10 E. Ann Kaplan, *Women and Film: Both Sides of the Camera* (New York, 1983), p. 30.

11 Teresa de Lauretis, *Alice Doesn't: Feminism, Semiotics, Cinema* (Bloomington, IN, 1984), pp. vii, 15, 8, 108.

12 Kaja Silverman, *Male Subjectivity at the Margins* (London, 1992), pp. 15, 42, 152. Judith Mayne argues that 'there is a divergence in feminist film theory between woman as object –

to which considerable theoretical attention has been paid – and woman as subject, which has received much less attention'. In the late 1980s Maria LaPlace's focus on the subjectivity of Bette Davis in *Now, Voyager* (1942) remained unusual in feminist cinema scholarship. 'Discussions of female spectatorship in mainstream film have been so influenced by Laura Mulvey's model of the woman as object and the man as subject that readings like LaPlace's, in which women are defined as subjects as well as objects, challenge the always-already dichotomous model of the classical cinema'. *Cinema and Spectatorship* (London, 1993), pp. 75, 130. Maria LaPlace, 'Producing and Consuming the Woman's Film: Discursive Struggle in *Now, Voyager*', in Christine Gledhill, ed., *Home Is Where the Heart Is: Studies in Melodrama and the Woman's Film* (London, 1987), pp. 138–66.

13 'How Do Women Look? The Female Nude in the Work of Suzanne Valadon', *Feminist Review*, XIX (March 1985); shorter version reprinted in Rosemary Betterton, ed., *Looking On: Images of Femininity in the Visual Arts and Media* (London, 1987), pp. 217–34.

14 Nochlin concedes that 'as Mulvey has later pointed out, this is perhaps too simple a conception of the possibilities involved. Nevertheless, it still seems to offer a good working conception for beginning to think about the position of the female spectator of the visual arts'. 'Women, Art, and Power' (1988) reprinted in Norman Bryson, Michael Ann Holly and Keith Moxey, eds, *Visual Theory: Painting and Interpretation* (Cambridge, 1991), p. 40.

15 Griselda Pollock, 'Modernity and the Spaces of Femininity', in *Vision and Difference: Femininity, Feminism and Histories of Art* (London, 1988), p. 85.

16 'The Female Body and the Male Gaze', in Norma Broude and Mary D. Garrard, eds, *The Expanding Discourse: Feminism and Art History* (New York, 1992), p. 7. That same year Eunice Lipton published an account of her twenty-year search for the person behind the most famous nineteenth-century model, Manet's Victorine Meurent. Drawing on extensive research and imaginative reconstruction, Lipton projected thoughts back into the mind of Victorine, 'whose naked body said: "See this? It's mine. I will not be the object of your gaze, invisible to my own".' Lipton turns her own indignation at such objectification into speculation about what might have been behind the eyes, in the mind of her subject. *Alias Olympia: A Woman's Search for Manet's Notorious Model and Her Own Desire* (New York, 1992), p. 15.

17 *Masculinities in Victorian Painting* (Aldershot, 1995), pp. 24–5. In applying that argument, he reveals the sort of contradictions to which such sexually dichotomous theorizing can lead. He argues that knights in armour are 'the supreme signifier of masculinity, the permanent erection', but adds that male nudes are 'the quintessential constructions of masculinity in nineteenth-century British culture'. Thus both the dramatically exposed male body as well as the emphatically concealed male body are ultimate signifiers of male superiority (pp. 97, 269).

18 William Tait, *Magdalenism: An Inquiry into the Extent, Causes and Consequences of Prostitution* (Edinburgh, 1840), p. 58. Quoted in Lynda Nead, *Myths of Sexuality: Representations of Women in Victorian Britain* (Oxford, 1988) which also documents further the connection between prostitution and the returned look in England (pp. 174–5).

19 Antony Copley, *Sexual Moralities in France, 1780–1980: New Ideas on the Family, Divorce, and Homosexuality* (London, 1989), p. 88.

20 Thomas Hardy, *A Pair of Blue Eyes* (Penguin: Harmondsworth, 1986), p. 107.

21 Susan Casteras, 'Down the Garden Path', In Appendix IX, pp. 582–4, she lists thirteen images titled 'He Loves Me, He Loves Me Not', indicating the woman's analogous conflict prior to receiving a proposal of marriage.

22 Elizabeth Gaskell, *North and South* (Penguin: Harmondsworth, 1983), p. 48.

23 Private Collection, Wantage, cited in Casteras, 'Down the Garden Path', p. 217.

24 Anthony Trollope, *He Knew He Was Right* (Oxford University Press: Oxford, 1985), pp. 124–5.

25 In England there was considerable effort to control men's transgressions of the moral code governing sexual relations. As Philippa Levine concludes, 'a plethora of organizations sought to encourage state legislation on moral issues; the Social Purity Alliance, the Moral

Reform Union, the National Vigilance Association and the Association for the Improvement of Public Morals were amongst those groups who, in the 1870s and 1880s, began to articulate a moral rearmament which challenged the rights of unrestrained male carnality'. *Feminist Lives in Victorian England: Private Roles and Public Commitment* (Oxford, 1990), p. 87.

26 Keith Thomas, 'The Double Standard', *Journal of the History of Ideas*, xx (April 1959), pp. 197, 195, 207.

27 James F. McMillan, *Housewife or Harlot: The Place of Women in French Society, 1870–1940* (New York, 1981), p. 18. Lieselotte Steinbrügge documents the attribution of a superior moral sense to women in the French Enlightenment. 'The exclusion of women from public life and its complement, their relegation to private life, appeared to qualify women particularly for the realm of morality, conceived of in bourgeois society as a genuinely private morality'. Although Steinbrügge critiques women's reputation for moral superiority because it betokened their exclusion from the public sphere, she abundantly documents evidence for that reputation and for woman's genuine moral authority in the private sphere. *The Moral Sex: Woman's Nature in the French Enlightenment*, trans. Pamela E. Selwyn (New York, 1995), p. 6.

28 Copley, *Sexual Moralities*, p. 85.

29 Thomas Hardy, *Tess of the d'Urbervilles* (Penguin: Harmondsworth, 1985), p. 292.

30 Charlotte Brontë, *Jane Eyre* (Penguin: Harmondsworth, 1966), pp. 172, 167.

31 Gustave Flaubert, *Madame Bovary*, trans. Francis Steegmuller (Vintage: New York, 1957, reprinted 1992), p. 223. Flaubert continues to contrast Emma's emotional depth with Rodolphe's shallowness. Because Rodolphe had heard such words uttered by loose women and prostitutes 'he had little belief in their sincerity when he heard them now'. He exploited Emma's jealousy and 'made her into something compliant, something corrupt' (224).

32 Recent historical studies of manliness replicate that isolation, because in them 'women are almost entirely absent', as Michael Roper and John Tosh argue. They call for new studies of men relating to women in education, work, and politics as well as the domestic scene. But even their studies of men in the domestic setting focus on the way the Victorian paterfamilias attempted to wield authority over women, not love them. See *Manful Assertions: Masculinities in Britain Since 1800* (London, 1991), pp. 2–4. To document how men are 'empowered through contemplation of heroic imagery', Kestner reproduces relatively few images of men loving women. Out of his 123 images of knights, soldiers, husbands, fathers, and male nudes, only about fifteen are of a man with a female beloved, and in most of these at least one of the pair is being seduced or abducted or else exhausted, starving, drunk, wounded, or dead. See *Masculinities in Victorian Painting*, p. 25.

33 This historical contrast comes from J. A. Mangan and James Walvin, eds, 'Introduction' to *Manliness and Morality: Middle-Class Masculinity in Britain and America, 1800–1940* (Manchester, 1987), pp. 1,3. For a discussion of 'manly Christianity' in Thomas Arnold, Charles Kingsley, and Thomas Hughes see Norman Vance, *The Sinews of the Spirit: The Ideal of Christian Manliness in Victorian Literature and Religious Thought* (Cambridge, 1985).

34 For Americans' definition of masculine morality in the 'exclusively male site' of the boxing-ring see Michael Hatt, 'Muscles, Morals, Mind: The Male Body in Thomas Eakins' *Salutat*', in Kathleen Adler and Marcia Pointon, *The Body Imaged: The Human Form and Visual Culture Since the Renaissance* (Cambridge, 1993), pp. 57–69.

35 As Robert A. Nye writes, 'in all these variations of the "gallant" duel, it is the *amour-propre* of the male and his susceptibility to the judgment of others that seems to trigger his action, not . . . some transcendent chivalric ideal'. *Masculinities and Codes of Honor in Modern France* (New York, 1993), pp. 201, 96.

36 Ibid., 115.

37 Brontë, *Jane Eyre*, p. 344.

38 Sherry Ortner, 'Is Female to Male as Nature Is to Culture?' in Michelle Zimbalist Rosaldo and Louise Lamphere, eds, *Woman, Culture, and Society* (Stanford, 1974), pp. 67–87. For a

critique of Ortner see my p. 67. Joseph A. Kestner assumes the correctness of Ortner's formula and applies it to nineteenth-century culture. 'The fact that men were conceived of as spiritual, women as natural, had important cultural consequences'. *Mythology and Misogyny: The Social Discourse of Nineteenth-century British Classical Subject Painting* (Madison, WI, 1989), p. 31. Kestner quotes Jean Pierrot, *The Decadent Imagination: 1880–1900* (Chicago, 1981), who, drawing on Baudelaire, claimed that 'Antinaturalism leads quite naturally to antifeminism, since woman symbolizes nature. . . . For Baudelaire, woman is necessarily contemptible because she is much closer to nature than man is' (p. 124). Baudelaire wrote, 'When woman is hungry she wants to eat, when she is thirsty she wants to drink, and when she is in heat, she wants to be fucked. Woman is *natural*, that is, abominable'. Charles Baudelaire, 'Mon cœur mis à nu', *Oeuvres complètes* (Paris, 1961), p. 1272. Baudelaire's view of women, however, is far more suited to men than women, and the arguments of Pierrot and Kestner are weakened accordingly.

39 Novelists throughout the eighteenth and nineteenth centuries, as Ruth Bernard Yeazell shows, took for granted the heroine's 'temporary resistance to the body and its desires' and devoted 'greater attention to the story of [woman's] consciousness', her penchant for 'observation and questioning'. See *Fictions of Modesty: Women and Courtship in the English Novel* (Chicago, 1991), pp. x–xi.

40 Some of these conventions are temporarily reversed in a short story, 'L'Aveugle', by Charles Aubert (1883), which Tamar Garb interprets against the atmosphere of heated debate over the admission of women to the Ecole des Beaux-Arts, a movement spearheaded by the Union des Femmes et Sculpteurs, founded in 1881. In the story, the woman's atypical opportunity to see a male nude is compromised by numerous conventions: She is pious and innocent and afraid of being able to contain her desires while looking at him. He has magnificent eyes and pretends to be blind so he can pose for her and not offend her modesty. By the end they switch roles. As she paints, her dress slips down to expose her nipple, while he gets an erection under his drapery and turns into an irresistible seducer. He also emerges as an accomplished artist with seeing eyes, who also touches up the finished work. As Garb notes, these extravagant measures necessary to reassure the male gaze are evidence of its deficiency and fragility, not its unchallenged dominion. 'The Forbidden Gaze: Women Artists and the Male Nude in Late Nineteenth-century France', in Adler and Pointon, *The Body Imaged*, pp. 33–42.

41 Hardy, *Tess*, p. 146.

42 As Frances B. Cogan's survey of American literature concludes, 'novel after novel suggests, in concert with the more strident advice books, that heroines inevitably find to their dismay that they are morally superior to their suitors'. *All American Girl: The Ideal of Real Womanhood in Mid-Nineteenth-century America* (Athens, GA, 1989), p. 104. Nancy Armstrong argues that women's stronger moral commitment as dramatized in the novel was a 'major event in political history'. During the nineteenth century, women defined what is right as feminine and middle-class against the aristocratic and male hegemony of earlier times. Rochester's loss of aristocratic bearing in preparation for his moral transformation before succeeding in love with Jane is symptomatic of many 'narratives in which a woman's virtue alone overcomes sexual aggression and transforms male desire into middle-class love'. Armstrong, *Desire and Domestic Fiction: A Political History of the Novel* (New York, 1987), pp. 3, 6. My argument about women's superior morality is more restricted than Cogan's or Armstrong's, because I apply my argument to the morality of love, not a general morality.

43 'I cannot evade the notion (though I hesitate to give it expression) that for women the level of what is ethically normal is different from what it is in men. Their super-ego is never so inexorable, so impersonal, so independent of its emotional origins as we require it to be in men'. 'Some Psychical Consequences of the Anatomical Distinction Between the Sexes', *The Standard Edition of the Complete Psychological Works of Sigmund Freud*, XIX (London, 1961), p. 257.

44 Catherine Hall, 'The Early Formation of Victorian Domestic Ideology', in Sandra

Burman, ed., *Fit Work for Women* (London, 1979), p. 25ff.

45 J. G. Spurzheim, *Phrenology, or the Doctrine of Mental Phenomena* (Boston, 1833), I, p. 97. Quoted in Cynthia Eagle Russett, *Sexual Science: The Victorian Construction of Womanhood* (Cambridge, MA, 1989), pp. 18–19. In *Jane Eyre*, Rochester, disguised as a gypsy fortune-teller, tells Jane that she has 'an eye for natural beauties and a good deal of the organ of Adhesiveness' (p. 278).

46 Sarah Ellis, *The Women of England: Their Social Duties and Domestic Habits*, 11th edn (London, n.d.), 53, quoted in Catherine Gallagher, *The Industrial Reformation of English Fiction, 1832–1867* (Chicago, 1985), p. 118.

47 O. S. Fowler, *Creative and Sexual Science* (Washington, DC, 1857), p. 160.

48 Charles Darwin, the opening pages of Part II of *The Descent of Man and Selection in Relation to Sex* (London, 1871).

49 Quoted by Yaezell, *Fictions of Modesty*, p. 220.

50 John Ruskin, 'Of Queens' Gardens', *Sesame and Lilies* (New York, 1886), pp. 101, 105.

51 John Stuart Mill, *Autobiography* [1873] (Penguin: Harmondsworth, 1989), pp. 187–8, nn. 185–6. Although this assessment was no doubt embellished after her death, the autobiography remains a valuable record of his thinking at that time and a document that itself had considerable influence thereafter.

52 John Stuart Mill, *The Subjection of Women*, ed. Susan M. Okin (Hackett: Indianapolis, 1988), p. 92.

53 Russett, *Sexual Science*, p. 43.

54 August Comte, *Système de politique positive* (Paris, 1852), II, p. 466.

55 McMillan, *Housewife or Harlot*, p. 10.

56 Abbé de Gibergues, *Les Devoirs des hommes envers les femmes, instructions aux hommes du monde prêchées à St Philippe-du-Roule et à St Augustin* (Paris, 1903), quoted by McMillan, ibid., p. 9.

57 John Kucich, *The Power of Lies: Transgression in Victorian Fiction* (Ithaca, NY, 1994), pp. 128, 60.

58 Mary Poovey, *Uneven Developments: The Ideological Work of Gender in Mid-Victorian England* (Chicago, 1988).

59 I discuss this novel in chapter Seven.

60 From *The Germ*, 2 (February 1850), p. 61, quoted in Stephanie Grilli, 'Pre-Raphaelitism and Phrenology', in Leslie Parris, ed., *Pre-Raphaelite Papers* (London, 1984), p. 45.

61 Sir Charles Bell, *The Anatomy and Philosophy of Expression as Connected with the Fine Arts* (London, 1842).

62 Johann Kasper Lavater, *Essays on Physiognomy* [1789–98] (reprinted London, 1848), cited in Julie F. Codell, 'Expression over Beauty: Facial Expression, Body Language, and Circumstantiality in the Paintings of the Pre-Raphaelite Brotherhood', *Victorian Studies*, XXIX (Winter 1986), pp. 255–90. She adds: 'Since facial expression and individuality were so vital to PRB content, it seems likely that such attention to physiognomy was in an attempt to convey the moral life just as facial expression and morality are intertwined in Lavater's view and in the use of physiognomy by Victorian novelists' (p. 275).

63 Thomas Hardy, *Far From the Madding Crowd* (Penguin: Harmondsworth, 1986), p. 67. Linda M. Shires challenges the 'reverse sexism' of some 'feminist criticism' that collapses all the scenes when men look at Bathsheba into 'a monolithic patriarchal male gaze'. She identifies rather a variety of male looks and finds abundant evidence for 'the female as gazer' in a novel that questions conventional constructions of masculinity as well as femininity. See 'Narrative, Gender, and Power in *Far From the Madding Crowd*', in Margaret R. Higonnet, ed., *The Sense of Sex: Feminist Perspectives on Hardy* (Urbana, IL, 1993), pp. 49–65.

64 Charles Baudelaire, 'The Painter of Modern Life', in *The Painter of Modern Life and Other Essays*, trans. Jonathan Mayne (London, 1964), pp. 29–30.

65 Adelyn Dohme Breeskin, *Mary Cassatt: A Catalog Raisonné of the Oils, Pastels, Watercolors, and Drawings* (Washington, DC, 1970), figs 18, 22, 73, 230.

66 Deborah Cherry, *Painting Women: Victorian Women Artists* (London, 1993), figs 10, 21, 22, 23, 28, 39. The exception is fig. 34 by Alice Havers, *The Belle of the Village* (1885; Royal Academy). This pattern was no mere oversight. Just why women avoided such motifs I have been unable to determine, although several explanations may have come into play: because they knew that a male-dominated artistic academy and community of reviewers would not accept their interpretations, because they were by upbringing persuaded that it was not 'ladylike' to comment on or even think about such matters, because they were less interested than men in sexual love, because they were afraid to admit that interest to themselves, or because they were inspired to depict other human relationships such as friendship between women or a mother and child.

67 *Victorian Women Artists* (London, 1987). Those few exceptions are figs 5, 8, 23, 28.

68 Dorothy Mermin documents the fear of self-exposure among the most prominent female English novelists of the Victorian period in *Godiva's Ride: Women of Letters in England, 1830–1880* (Bloomington, IN, 1993), pp. xvi–xvii and *passim*.

69 Degas's *The Print Collector* (1866; Metropolitan Museum of Art) and *Edmond Duranty* (1879; Glasgow) and Caillebotte's *In a Café* (1880; Musée des Beaux-Arts, Rouen) and *Self-portrait* (1892; Musée d'Orsay), along with Manet's portraits of artists and writers are as revealing of character as any individual portraits of women.

70 On the connections between English and Continental art in the nineteenth century see Susan P. Casteras and Alicia Craig Faxon, eds, *Pre-Raphaelite Art in its European Context* (Cranbury, NJ, 1995). In the Introduction Faxon surveys numerous formal similarities between the PRB and Impressionism as well as common thematic interests, especially prostitution. See also the essay by Alice H.R.H. Beckwith, 'Pre-Raphaelites, French Impressionism, and John Ruskin: Intersections at the Eragny Press, 1894–1914' (pp. 175–90).

1. Meeting

1 Gustave Flaubert, *Madame Bovary*, trans. Francis Steegmuller (Vintage: New York, 1957, reprinted 1992), pp. 3, 39.

2 Victor Hugo, *Les Misérables*, trans. Norman Denny (Penguin: Harmondsworth, 1982), p. 604. All further references are to this edition.

3 In 1884 Renoir announced the creation of a 'Society of Irregularists', a group of artists who would agree that 'the two eyes of the most beautiful face will always be slightly unlike'. He went on to insist that the entire face must be slightly irregular. He concluded that 'every truly artistic production has been conceived and executed according to the principle of Irregularity'. Quoted by Barbara Ehrlich White, *Renoir: His Life, Art, and Letters* (New York, 1984), pp. 145–6. Similar thinking inspired novelists. An article from *Once a Week* (26 December 1868) argued that 'Men no longer sigh for the perfectly beautiful woman . . . the handsomest women are also the dullest. . . . [Men] choose out her whose irregularities of feature are lost in the movement and light of the face, in the glow and colour of the eyes, in preference to the woman of cold and formal accuracy of outline'. Quoted by Jeanne Fahnestock, 'The Heroine of Irregular Features: Physiognomy and Conventions of Heroine Description', *Victorian Studies*, XXIV (Spring 1981), p. 333.

4 Robert L. Herbert argues that 'the Parisian *flâneur* was the role in which Baudelaire, Manet, Degas, Caillebotte, Duret, Duranty, Halévy, and Edmond de Goncourt cast themselves as did so many of the artists and writers of their era. That it was a role, a pose, was already evident in the 1830s, when the *flâneur* was first clearly defined'. See *Impressionism: Art, Leisure, and Parisian Society* (New Haven, 1988), pp. 33–4. Although I analyse artists' formal concerns and historical precedents even less than does Herbert, my approach to art history is modelled after his interpretation of the Impressionists in an historical context and focuses on the way they tried to capture the actuality of contemporary life.

5 My commentary emphasizes a first encounter between the couple, even though two sketches for it suggest a different narrative. In one the *flâneur* is beside the woman, while in the other he is farther ahead, clearly preoccupied with the worker. My reading is of the final image that Caillebotte chose to depict an encounter on a Parisian street.

6 Charles Baudelaire, 'The Painter of Modern Life', in *The Painter of Modern Life and Other Essays*, trans. Jonathan Mayne (London, 1964), pp. 7–9.

7 Walter Benjamin, *Charles Baudelaire: A Lyric Poet in the Era of High Capitalism* [1969] (reprinted London, 1973).

8 Griselda Pollock, 'Modernity and the Spaces of Femininity', *Vision and Difference: Femininity, Feminism and Histories of Art* (London, 1988), p. 67.

9 Ibid., p. 66. Janet Wolff, 'The Invisible Flâneuse; Women and the Literature of Modernity', *Theory, Culture, and Society*, II/3 (1985), p. 43. By 'literature' Wolff means the sociological literature of Georg Simmel, Walter Benjamin, Talcott Parsons, and Marshall Berman. In novels, which she does not cite, although women remain far less visible than men in the public sphere, they are equally if not more visible in the private sphere.

10 Wolff, ibid., p. 40.

11 Pollock, 'Modernity', p. 69.

12 Jean-Paul Sartre, *Being and Nothingness* [1943], trans. Hazel Barnes (New York, 1956), p. 257.

13 Pollock, 'Modernity', p. 71.

14 Martin Jay lists eight French feminists who subscribed to this argument, including Julia Kristeva, Hélène Cixious, and Monique Wittig. See *Downcast Eyes: The Denigration of Vision in Twentieth-century French Thought* (Berkeley, 1993), p. 526.

15 Interview in *Les Femmes, la pornographie et l'érotisme*, ed. Marie-Françoise Hans and Gilles Lapouge (Paris, 1978), p. 50.

16 Luce Irigaray, 'This Sex Which Is Not One' [1977], trans. Catherine Porter in *This Sex Which Is Not One* (Ithaca, NY, 1985), pp. 25–6.

17 Ibid., p. 26.

18 Anthea Callen, *The Spectacular Body: Science, Method and Meaning in the Work of Degas* (New Haven, 1995), p. 71.

19 Walkowitz offers evidence that by the 1880s 'middle-class men were not the sole explorers and interpreters of the city. . . . Thanks to the material changes and cultural contests of the late-Victorian city . . . female philanthropists and "platform women", Salvation Army lasses and match girls, as well as glamorized "girls in business", made their public appearances and established places and viewpoints in relation to the urban panorama'. *City of Dreadful Delight: Narratives of Sexual Danger in Late-Victorian London* (Chicago, 1992), p. 18. That widening of the 'spaces of femininity' was registered in art and literature where women showed greater insight into the ways of love.

20 George Eliot, *The Mill on the Floss* (Penguin: Harmondsworth, 1979), p. 647.

21 The original meaning of spinster was a woman who spins or whose profession was to spin; later it became associated with an unmarried woman or 'old maid'.

22 Georges Rivière, 'L'Exposition des impressionistes', *L'Impressioniste* (6 April 1877), quoted in White, *Renoir*, p. 73. The article accompanied its first exhibition, and White speculates that it probably had Renoir's approval.

23 Robert Rosenblum, *Paintings in the Musée d'Orsay* (New York, 1989), p. 288.

24 The comment is from *Punch*, quoted in Jeremy Maas, *Victorian Painters* (New York, 1969), p. 232.

25 White, *Renoir*, p. 150. This painting from a private German collection was lost or destroyed during World War II (personal communication from Barbara White).

26 Jean Renoir, *Renoir, My Father*, trans. Randolph and Dorothy Weaver (New York, 1958), p. 373.

27 Quoted in Barbara Ehrlich White, 'Renoir's Sensuous Women', in Thomas B. Hess and Linda Nochlin, eds, *Woman as Sex Object: Studies in Erotic Art, 1730–1970* (New York, 1972), p. 171.

28 Thomas Hardy, *A Pair of Blue Eyes* (Penguin: Harmondsworth, 1986), p. 51. All further references are to this edition. J. B. Bullen interprets this introduction of Elfride as someone who 'has no existence in her own right: she is the reflection of the image already in the eye of the beholder'. See *The Expressive Eye: Fiction and Perception in the Work of Thomas Hardy* (New York, 1986), pp. 55–6. But in the following passage from the novel (p. 52), which compares Elfride to the subjects of several paintings, we learn that she expresses 'the *thoughtfulness* which appears in the face of the Madonna della Sedia . . . the *warmth* and *spirit* of the type of woman's feature most common to the beauties . . . of Rubens, [and the] *yearning human thoughts* that lie *too deep for tears*' in the 'female faces of Correggio' (my emphases). Elfride and most other Hardy heroines are more thoughtful than their gazing male admirers.

29 Dante Alighieri, *La vita nuova*, trans. Barbara Reynolds (Penguin: Harmondsworth, 1969), pp. 29, 31.

30 Graham Reynolds argues that it shows a later meeting, after a misunderstanding had arisen, when Beatrice sees Dante but 'denies him her most sweet salutation'. See *Victorian Painting* (revd edn, New York, 1987), p. 93. Clearly this Beatrice is not denying Dante, because she has not yet seen him. Moreover, Holiday's painting illustrates exactly the moment described in the earlier episode.

2. Recreation

1 Anne Coffin Hanson emphasises 'the shock – and shock it was – of direct confrontation with Manet's nude, a recognized model, looking at you, the spectator, unashamed, her fertile freshness reflected in the cornucopian picnic basket, her modernity clearly declared by the fashionable clothes she has left on the ground'. *Manet and the Modern Tradition* (New Haven, 1977), p. 95.

2 Harry Rand sees this painting as a 'moral inquiry of the spectator', coming out of a visual 'conversation' between model and viewer. 'The fixed attention that she directs at the spectator, at our presence and our returned gaze, takes the form of a conversation between two parties whose relationship, however brief or prolonged, began when the model's absorption in her book was plucked from the page, by the spectator's act of appearing in her view'. *Manet's Contemplation at the Gare Saint-Lazare* (Berkeley, 1987), p. 82.

3 Beatrice Farwell, 'A Manet Masterpiece Reconsidered', *Apollo*, LXXVIII (July 1963), p. 51.

4 The two women were based on figures in works that Manet drew on as precedents – Titian's *Concert* (formerly attributed to Giorgione, *c.* 1508; Musée du Louvre) and an engraving by Marcantonio Raimondi after Raphael's *Judgment of Paris* (1510–11; Yale University Art Gallery). George Mauner has argued presuasively that the women signify sacred and profane love. The bather has a precedent in Christian art (Susanna), is clothed (modesty), is near water (purity), is standing (higher), and has a bullfinch above her head (symbol of freedom and closer to heaven). As an embodiment of profane love, Victorine has a precedent in profane art (river nymph), is naked (immodesty), is near food and men (materiality and sensuality), is seated (lower), and has a frog near her in the lower-left corner (symbol of the material and closer to earth). The pure bather does not engage the eye of the viewer, while the sensuous nude does. *Manet Peintre-Philosophe: A Study of the Painter's Themes* (University Park, PA, 1975), pp. 7–45.

5 This gesture has invited over-interpretation. Mauner argues that Manet intended to have the man's thumb point to sacred love (the bather) and the man's finger point to profane love (the nude); ibid., pp. 18–21. Wayne Anderson argues that the man is offering his forefinger as a perch for the bullfinch, a symbol of sexual promiscuity and hence of his own sexual solicitation. 'Manet and the Judgment of Paris', *Art News*, 72 (February 1973), pp. 63–9. It is hard to take Anderson seriously here, because wild birds do not fly down to perch on fingers.

6 For a summary of that view see Tamar Garb, 'Renoir and the Natural Woman', in Norma Broude and Mary D. Garrard, *The Expanding Discourse: Feminism and Art History* (New

York, 1992), pp. 295–311. This essay, written for an exhibition on Renoir's women, discusses only a few of Renoir's minor works. In none is there a man relating to a woman, aside from a portrait of a collector holding a statuette of a female nude. Garb quotes 'Renoir's own ironic assertion that he painted "with his prick"' (p. 296), although she goes on to discount its irony. Renoir's use of sexual slang indicated his passion for art, not his designs on models.

7 The identifications of these figures are based on *Renoir*, exh. cat., Hayward Gallery (London, 1985), p. 223, and Robert L. Herbert, *Impressionism: Art, Leisure, and Parisian Society* (New Haven, 1988), p. 248.

8 In Renoir's *The Luncheon* (*c.* 1879; The Barnes Foundation), the same man, also posed frontally, returns the glance of a female companion, this time posed in a one-quarter profile. His pleasant wide-open eyes express relaxation perhaps brought about by the wine already consumed from their almost empty glasses. He looks passive as he fingers his glass and sits inertly opposite the woman.

9 A few of Arnold Böcklin's sea nymphs swim in it. His *Playing in the Waves* (1883; Neue Pinakothek, Munich) shows a woman with large worried eyes, swimming for her life, as she turns away from a squint-eyed lecherous centaur.

10 In Mary Cassatt's *The Boating Party* (1893–4; National Gallery of Art, Washington, DC) the frontally posed young mother and her infant daughter look away from the dutifully rowing man in profile who is intent on them. Manet's *Boating* (1874; Metropolitan Museum of Art) is a notable exception, although the man's frontal expression is flat, and his relationship to the profiled female passenger is ambiguous.

11 David Brooke, 'An Interesting Story by James Tissot', *Art Bulletin of Victoria* (1969–70), pp. 22–9 provides information about the clothing, maps, and architecture in this painting and its original title, *Tracing the Northwest Passage.*

12 On 'the dominant fiction' see Introduction, n. 12.

13 John Guille Millais, *The Life and Letters of Sir John Everett Millais* (New York, 1909), pp. 48–50. Joseph A. Kestner links this image to the thinking behind John Ruskin's lecture of 1870 that called on men to fulfil England's imperial destiny. 'It *is* with us, now, "Reign or Die". . . . [England] must found colonies as fast and as far as she is able, formed of her most energetic and worthiest of men.' He also links the painting's theme of 'aspiring masculinity' to that of *The Boyhood of Raleigh* by noting that the original composition included a male child looking at a globe. Intent on using this image to document how 'the dominant fiction of masculinity could be sustained by collective male belief . . . [and] empowered through the voyeuristic component of the male gaze', Kestner does not mention the woman in the foreground, who provides the erotic dimension to the dominant fiction. *Masculinities in Victorian Painting* (Aldershot, 1995), pp. 26–9.

14 For contemporary critics who judged her to be a 'trollop', see Herbert, *Impressionism*, p. 236, and T. J. Clark, *The Painting of Modern Life: Paris in the Art of Manet and His Followers* (New York, 1985), p. 168.

15 The poem is 'Circumstance' from Alfred, Lord Tennyson, *Poems* (Edward Moxon: London), p. 62. On this identification see Susan Casteras, 'Down the Garden Path: Courtship Culture and its Imagery in Victorian Painting', PhD diss., Yale University, 1977, p. 248.

16 George Eliot, *The Mill on the Floss* (Penguin: Harmondsworth, 1979), p. 470. All further references are to this edition.

17 In Michelle Zimbalist Rosaldo and Louise Lamphere, eds, *Woman, Culture, and Society* (Stanford, 1974), p. 72.

18 Linda Nochlin also argues for the pivotal role of the women. 'The women, in their provocative anonymity, are the point of the picture – or rather, the point is in some sense the nascent act of physical intimacy growing up everywhere among the hidden but patently attractive women and the (theoretically) identifiable men of the world who surround them.' See 'Manet's *Masked Ball at the Opera*' (1983), reprinted in *The Politics of Vision: Essays on Nineteenth-century Art and Society* (New York, 1989), p. 86.

19 Herbert, *Impressionism*, p. 76.

20 In *Painted Love: Prostitution in French Art of the Impressionist Era* (New Haven, 1991), pp. 134–53, Hollis Clayson argues that these waitresses were 'clandestine prostitutes'. *Clandestine* in this context meant unregistered by the police. A main objective of Impressionism, however, was to paint what was present to the eye more or less as it appears, not underlying meanings or clandestine identities.

21 The model for him was Renoir's brother Edmond. No doubt Renoir did not intend to critique Edmond's way of relating to women, but as I have argued, his art repeatedly contradicted his ideology.

22 *Renoir*, exh. cat., Hayward Gallery, p. 203.

23 For Renoir's commitment to 'Irregularity', see chapter 1, n. 3. Tamar Garb describes the woman's eyes as 'unfocused' in emphasizing the woman's objectification. Garb's essay presents several hypotheses for critique and then interrogates those critiques, so it is difficult to be certain about her own position. She argues, for example, that the 'man is enshrined as powerful possessor of the gaze, woman as its object' but then adds that 'we cannot possibly read the painting as an unproblematic reflection of the power of the male gaze' (p. 224). I concur with this latter claim. See 'Gender and Representation', in Francis Frascina et al., eds, *Modernity and Modernism: French Painting in the Nineteenth Century* (New Haven, 1993), pp. 219–90.

24 'Woman and the Spaces of Femininity', in *Vision and Difference* (London, 1988), p. 75.

25 David S. Brooke, 'James Tissot's Amateur Circus', *Boston Museum Bulletin*, LXVII (1969), pp. 4–17.

3. Working

1 For an out-of-work man shown facing away from an exhausted and despairing wife see Hubert von Herkomer's *Hard Times* (1885; City Art Gallery, Manchester), in which the worn-out labourer looks down a winding road, while his wife sits at the roadside in front of him, her eyes closed with exhaustion and despair, supporting a hungry-looking boy against her left knee and holding a nursling to her breast. In his *On Strike* (1891; Royal Academy), the frontally posed man with grim eyes appears resolved to stay on strike although deeply worried about its success. With fixed jaw and brow, he looks away from his wife, while she leans against him, with one arm draped over his shoulder and her eyes cast down in resignation.

2 He also included a self-portrait in *Fishing, Saint-Ouen* (1861–3; Metropolitan Museum of Art), possibly commemorating his upcoming marriage to Suzanne Leenhoff, who is posed at his side. In 1878–9 he completed *Self-portrait with a Palette* (Metropolitan Museum of Art), and *Self-portrait with a Skullcap* (Bridgestone Museum of Art, Tokyo).

3 Novelene Ross, *Manet's Bar at the Folies-Bergère* (Ann Arbor, 1982), pp. 85, 67–8, 6–7. She notes that Manet may have been influenced by Cassatt's work in the Impressionists' exhibition of 1879, where he saw her *Lydia in a Loge* (1879; Collection of Mrs William Coxe Wright, Pennsylvania).

4 This identification is based on the discussion of Callias in ibid., pp. 68–9.

5 In *The Balcony* (1869; Musée d'Orsay) Morisot leans on the railing of a balcony, looking out through mysterious dark eyes, while behind her stands a man who views another angle of the same vista but whose eyes are sketchier and less focused. In *Berthe Morisot with a Fan* (1872; Musée d'Orsay) she holds a fan in front of her face and peeks through the supporting ribs. In *Le Repos* (1870–71; Museum of Art, Rhode Island School of Design), she holds the fan while looking out from penetrating dark eyes. Finally, there is *Berthe Morisot with a Fan* (1874; Art Institute of Chicago).

6 Jack Flam concurs with the argument that 'at least some of what we see in the mirror can be taken to be a visualization of what the woman is actually thinking'. His emphasis is on the painting as 'a projection of desire in the abstract, as a kind of longing to grasp that which is fragile and fleeting, very much present yet constantly elusive'. 'Looking into the Abyss: The Poetics of Manet's *A Bar at the Folies-Bergère*', in Bradford R. Collins, ed.,

12 Views of Manet's Bar (Princeton, forthcoming).

7 Based on descriptions of Manet's gait and his history of remissions, Mary Mathews Gedo argues that he may have had multiple sclerosis and not neurosyphilis, although she concedes that he nevertheless 'believed that his condition was the unfortunate legacy of a youthful sexual indiscretion in which he had contracted syphilis'. See 'Final Reflections: *A Bar at the Folies-Bergère* as Manet's Adieu to Art and Life', in *Looking at Art From the Inside Out: The Psychoiconographic Approach to Modern Art* (New York, 1994), pp. 6–9.

8 Antonin Proust, *Édouard Manet: souvenirs* (Paris, 1913), p. 112.

9 Quoted in T. A. Gronberg, *Manet: A Retrospective* (New York, 1988), p. 174.

10 George Heard Hamilton, *Manet and His Critics* (New Haven, 1954), pp. 248–9; Ross, *Manet's Bar*, pp. 2–4; Adolphe Tabarant, *Manet et ses oeuvres* (Paris, 1947), pp. 371, 376, 423.

11 Quoted in Juliet Wilson-Bareau, ed., *Manet By Himself* (London, 1991), p. 259.

12 'The masterpiece in which Manet celebrated his own delight in the world of the Folies-Bergère grew from the observed realities of his own experience'. Juliet Wilson-Bareau, *The Hidden Face of Manet: An Investigation of the Artist's Working Processes*, exh. cat., Courtauld Institute Galleries, London (London, 1986), p. 77.

13 Reviews quoted in T. J. Clark, *The Painting of Modern Life: Paris in the Art of Manet and his Followers* (New York, 1985), pp. 239–43.

14 As he remarked about his portrait of George Moore from 1879, 'Is it my fault if Moore looks like a squashed egg yolk and if his face is all lopsided? Anyway, the same applies to everybody's face, and this passion for symmetry is the plague of our time. There's no symmetry in nature. One eye is never exactly the same as the other, there's always a difference.' Recorded by Antonin Proust, 1897, quoted in Wilson-Bareau, *Manet By Himself*, p. 184. Cf. Renoir's comment on 'Irregularism', chapter 1, n. 3.

15 Clark, *Modern Life*, pp. 252–4.

16 Peter Bailey's study of the Victorian barmaid emphasizes her moral qualities as a ministering angel who symbolized visibility, openness, glamour, and the promise of excitement, while still maintaining her 'fundamental purity' (p. 155). To counter the immorality of the English pub, the English barmaid of the 1890s had to wear a black dress and apron, white collars and cuffs (p. 162). Bailey argues that 'the Victorian barmaid was not, like Clark's reading of Manet's subject, an alienated whore, but an assertive and competent modernist: there may in fact have been more alienation on the other side of the bar' (p. 165). 'Parasexuality and Glamour: The Victorian Barmaid as Cultural Prototype', *Gender & History*, II (Summer 1990), pp. 148–72.

17 Hollis Clayson, *Painted Love: Prostitution in French Art of the Impressionist Era* (New Haven, 1991), p. 151.

18 Hans Jantzen argued that the man may be a shadowy after-image (*Nachbild*) of a past conversation. 'Edouard Manet's "Bar aux Folies-Bergère"', in *Essays in Honor of Georg Swarzenski* (Chicago and Berlin, 1951), pp. 228–32, quoted by Albert Boime in 'Manet's *Un bar aux Folies-Bergère* as an Allegory of Nostalgia', reprinted in Collins, *12 Views*. Boime interprets the spatial irregularities of the painting as a way to capture the passage of time as Suzon sees the man at the bar, sizes him up, then dismisses him from her mind as she reflects on other matters suggested by the crowd in the mirror. 'Here it is a case of the *flâneuse* mastering the *flâneur*. . . . This is not a demonstration of the *flâneur* in a moment of masculine power, but in a moment of the attenuation of that power as he yields up his subjectivity to the female.'

19 Werner Hoffman, 'Glances', lecture at 'Manet: A Symposium', the Metropolitan Museum of Art, New York, 22 October 1983.

20 Flam, 'Looking into the Abyss', in Collins, *12 Views*.

21 'The Dialectics of Desire, the Narcissism of Authorship: A Male Interpretation of the the Psychological Origins of Manet's *Bar*', in Collins, *12 Views*. In a freewheeling psychoanalytic interpretation of the painting, Steven Z. Levine sees Suzon as embodying not only Manet's vision of the world, but also that of his wife and his mother. 'Now

married to Suzanne but since 1867 living at his mother's home, it is through his wife that his mother's gaze makes its circuit to his eyes; later it will be through Suzon that Suzanne will look at him.' See 'Manet's Man Meets the Gleam of her Gaze: A Psychoanalytic Novel', in ibid.

22 The last sentence reads, 'Cela formait un ensemble d'une harmonie tendre et blonde'. George Jeanniot, 'En Souvenir de Manet', *La Grande Revue* (10 August 1907), p. 853. I modified Gronberg's translation in *Manet*, p. 173.

23 *Manet's Silence and the Poetics of Bouquets* (London and Cambridge, MA, 1994), p. 197.

24 In *Manet at the Races* (n.d.; Metropolitan Museum of Art) and in sixteen other drawings and paintings that finally resulted in *At the Racetrack, Jockeys* (c. 1868), Degas portrayed Manet, himself part of a proposal composition, in some way trying to identify with a woman's superior (or at least more magnified) view of the world. Manet is in profile looking at a frontal woman who is looking through binoculars. Two penetrating, although over-interpreted, essays on this painting are Deborah Bershad, 'Looking, Power and Sexuality: Degas' *Woman with a Lorgnette*', and Griselda Pollock, 'The Gaze and the Look: Women with Binoculars – A Question of Difference', in Richard Kendall and Griselda Pollock, eds, *Dealing With Degas: Representations of Women and the Politics of Vision* (New York, 1991), pp. 95–105, 106–30.

25 Arthur Tooth Gallery exh. cat., quoted in Russell Ash, *James Tissot* (New York, n.d.), plate 40.

26 For a psychoanalytic interpretation of the novel as a study of 'spectatorship' in love see Michelle A. Massé, 'Looking Out for Yourself: The Spectator and *Jane Eyre*', *In the Name of Love: Women, Masochism, and the Gothic* (Ithaca, NY, 1992), pp. 192–238. She focuses on Jane's childhood, which separated love from cruelty and authority, thereby protecting her from falling into the typical Gothic scenario that combined the two and allocated authority in love to the stronger male. She interprets Jane's spectatorship as a means of distancing herself from cruelty and authority to achieve a more nearly equal love, and she interprets Jane's 'scopophilia' and 'epistemophilia' as defensive strategies against an oppressive patriarchal society. She concludes that Jane's story may be historically representative. 'What Jane sees for herself she also sees for other women: she will not be an accomplice in the reproduction of unjust authority' (p. 238). Many novels and paintings of this period show the superior 'spectatorship' of women over men who had other sources of authority.

27 Charlotte Brontë, *Jane Eyre* (Penguin: Harmondsworth, 1966), p. 145. All further references are to this edition.

28 Brontë believed that character was evident in the face, and she included several physiognomical readings in the novel. Ian Jack, 'Physiognomy, Phrenology and Characterization in the Novels of Charlotte Brontë', *Brontë Society Transactions*, XV/5 (1970), pp. 377–91.

29 Janet Gezari speculates that '*Eyre* is a name that Brontë may have pronounced and certainly would have seen in some relation to the "eye" it includes'. As evidence she mentions 'a square in Edinburgh that bears the name Eyre and is pronounced "Ire".' There were also strong personal reasons for Brontë's concern with blindness, because when she began writing the novel, her father was being treated for cataracts and she herself suffered from acute near-sightedness. Gezari views the novel as a story of Jane's triumph over the social forces that punish her for looking and a defense of her 'right to look'. See 'In Defence of Vision: The Eye in *Jane Eyre*', *Charlotte Brontë and Defensive Conduct* (Philadelphia, 1992), pp. 59–62.

30 Rochester's outburst anticipates Sartre's philosophy of the look (*le regard*) as an essential feature of human relations. In *Being and Nothingness* [1943], trans. Hazel Barnes (New York, 1956), Sartre elaborated the threatening aspects of *the look*, that is, the experience of looking at and being looked at by another person. Although we need others, the gaze of the Other is full of potential danger, paralysis, enslavement. Sartre's account of the sadistic response to the frustrations of love reads like a gloss on Rochester. The sadist 'wants to knead with his hands and bend under his wrists . . . the Other's freedom'. But such efforts

are bound to fail, because 'no matter what pressure is exerted on the victim, the abjuration remains *free*'. 'The sadist discovers his error when his victim *looks* at him; that is, when the sadist experiences the absolute alienation of his being in the Other's freedom' (pp. 403–05). Rochester discovers the alienation of his hope to love someone who is good when his own conscience is still full of shame. Brontë crafts a way out of his dilemma with some typical Victorian narrative devices including an inheritance and divine intervention, but for atheistic Sartre such narrative devices are unacceptable, because the confrontation of *the look* is inherent in human relations and inescapable.

31 For discussion of a blind heroine who takes charge of love in Hugo's *The Man Who Laughs* see chapter Seven.

32 Clayson, *Painted Love*, p. 118. Although I disagree with her interpretation of this painting, her survey of the historical circumstances of women in such 'suspicious professions' is most informative, pp. 113–31.

33 Opinion differs whether she is in mourning for her parents, which would make her an orphan (Susan Casteras, *Images of Victorian Womanhood in English Art*, Rutherford, NJ, 1987, pp. 104–05), or for her husband, which would make her a widow. Christopher Wood suggests another possibility, that since the widow is not wearing a wedding-ring, she is in mourning for her lover rather than her husband and for that reason both nameless and friendless. *Victorian Panorama: Paintings of Victorian Life* (London, 1976), p. 110. Whatever the cause of her mourning, her lack of a name and a friend only increases the intrigue of her expression.

34 Deborah Cherry, *Painting Women: Victorian Women Artists* (London, 1993), p. 81.

35 Written about 1890, quoted and translated by Robert L. Herbert, *Impressionism: Art, Leisure, and Parisian Society* (New Haven, 1988), 130. The crucial lines are:

> Nymphes, Grâces, venez des cimes d'autrefois;
> Taglioni, venez, princesse d'Arcadie,
> Ennoblir et former, souriant de mon choix,
> Ce petit être neuf, à la mine hardie.

36 Eunice Lipton, *Looking into Degas: Uneasy Images of Women and Modern Life* (Berkeley, 1986), pp. 73–115.

37 George Du Maurier, *Trilby* (New York, 1978), p. 8. All further references are to this edition. The novel is crudely anti–Semitic and refers to Svengali as 'the Jew' with as much routine contempt as Dickens refers to Fagin in *Oliver Twist*, another stereotypal Jew with evil dark eyes.

38 In *Woman and the Demon: The Life of a Victorian Myth* (Cambridge, MA, 1982), Nina Auerbach offer a persuasive interpretation of the Victorian woman 'who was strong enough to bear the hopes and fears of a century's worship' (p. 10). Her study alerted me to the historical value of *Trilby* as evidence of the transforming, creative power of women as angels and demons, along with a host of other roles in a society that accorded an imbalance of privileges and powers to men. Even in the medical and artistic academies ruled by men, women emerged with unexpected resources of their own.

4. The Nude

1 Carol Ockman's study of Ingres's nudes 'calls into question the assumptions that erotic imagery always has been the sole province of men and that pleasure in looking has been an exclusively male prerogative'. A chapter titled 'Two Large Eyebrows *À l'orientale*: The Baronne de Rothchild' quotes from a review of 1848 that mentioned the Baroness's 'eyes that sparkle with life and wit'. Ockman follows with examples from nineteenth-century literature that associate the beautiful, dark eyes of Jewish women with sensuousness, intelligence, and forbidden pleasures. Ockman's main purpose, however, is to explain and justify her own (and woman's) pleasure in looking at Ingres's figures, not to interpret the eyes or vision of his models. *Ingres's Eroticized Bodies: Retracing the Serpentine Line* (New

Haven, 1995), p. 68.

2 Thomas B. Hess and Linda Nochlin, eds, *Woman as Sex Object: Studies in Erotic Art, 1730–1970* (New York, 1972).

3 Rozsika Parker and Griselda Pollock, *Old Mistresses: Women, Art and Ideology* (New York, 1981), p. 116.

4 Robert Rosenblum, *Paintings in the Musée d'Orsay* (New York, 1989), p. 38.

5 The eyes of Eustacia Vie in Thomas Hardy's *The Return of the Native* (1878) are especially bewitching because of this characteristic: 'She had Pagan eyes, full of nocturnal mysteries. Their light, as it came, and went, and came again, was partially hampered by their oppressive lids and lashes; and of these the under lid was much fuller than it usually is with English women. This enabled her to indulge in reverie without seeming to do so: she might have been believed capable of sleeping without closing them up. Assuming that the souls of men and women were visible essences, you could fancy the colour of Eustacia's soul to be flame-like' (Bk I, ch. VII, 'Queen of Night').

6 Peter Brooks, *Body Work: Objects of Desire in Modern Narrative* (Cambridge, MA, 1993), p. 18.

7 Charles Bernheimer, *Figures of Ill-Repute: Representing Prostitution in Nineteenth-century France* (Cambridge, MA, 1989), p. 104.

8 Anthea Callen, *The Spectacular Body: Science, Method and Meaning in the Work of Degas* (New Haven, 1995), p. 88. 'In most images of the female nude in Western art', she begins, 'the woman is "aware" of being looked at'. The internal quotation marks indicate the dubious status of female consciousness throughout Callen's study. The remainder of her discussion of the nude neglects even the model's awareness of being looked at and concentrates on the male spectator, female genitalia, woman's 'animality', and Degas's 'sado-masochistic position' with respect to his models (pp. 84–8).

9 Norma Broude and Mary D. Garrard, eds, *The Expanding Discourse: Feminism and Art History* (New York, 1992), p. 7. Martin Jay mentions twenty-two film critics who followed Laura Mulvey's 'path-breaking' critique of the 'male gaze'. *Downcast Eyes: The Denigration of Vision in Twentieth-century French Thought* (Berkeley, 1993), p. 490.

10 The term 'bogus dichotomy' is from Calvin Schrag's analysis in *Experience and Being: Prolegomena to a Future Ontology* (Evanston, IL, 1969), pp. 4–9 and *passim*. He argues that 'a deeply ingrained tendency to move in the direction either of absolute objectivity or of absolute subjectivity has characterized much of the development of modern and contemporary philosophy'. 'Subject and object' may be an illuminating distinction, but when it is transformed into a bogus dichotomy, 'the interlacing and connectedness of that which is distinguished within experience is concealed, and the stage is set for half-truths and reductivisms' (p. 5).

11 G.W.F. Hegel, *Phenomenology of Spirit*, trans. A. V. Miller (New York, 1977), p. 112.

12 Simone de Beauvoir, *Force of Circumstance* [1963], trans. Richard Howard (New York, 1965), p. 185; idem, *The Second Sex* [1949], trans H. M. Parshley (New York, 1989), p. xxxv.

13 France Borel, *The Seduction of Venus: Artists and Models,* trans. Jean-Marie Clark (New York, 1990), pp. 91–105.

14 Henrik Ibsen, *When We Dead Awaken and Three Other Plays*, trans. Michael Meyer (Anchor: New York, 1960), pp. 336, 336. All further references are to this edition.

15 Emile Zola, *The Masterpiece*, trans. Thomas Walton (Ann Arbor, 1968). All further references are to this edition.

16 For these referents see Robert J. Niess, *Zola, Cézanne, and Manet: A Study of L'Oeuvre* (Ann Arbor, 1968).

17 'Eroticism and Female Imagery in Nineteenth-century Art', in Hess and Nochlin, *Woman as Sex Object*, p. 15.

18 Ovid, *The Metamorphoses*, trans. Mary M. Innes (Harmondsworth, 1955), pp. 231–2.

19 In *Artist's Model* (1895; Haggin Museum, Stockton, CA), Gérôme shows Pygmalion with downcast eyes, intent on sculpting Galatea's marble thigh, while he emphatically avoids the inviting look of the sensuous model seated next to his statue. In three different paintings of

Pygmalion kissing Galatea, Gérôme shows the artist with eyes closed, straining up on tiptoes to reach Galatea's lips. In *The End of the Seance for Omphale* (1886; untraced) Gérôme shows the artist twisting up to sneak a peek at his model as she turns away from him and begins to wrap the unfinished sculpture.

20 Groom aptly characterizes the mood of the painting as 'one of equanimity between the model and the artist, who may well be the absent lover' and documents that the model might have been Caillebotte's teen-age companion, Charlotte Berthier. Commentary in Anne Distel et al., *Gustave Caillebotte: Urban Impressionist*, exh. cat., Art Institute of Chicago (New York, 1995), p. 214.

21 After arriving in Tahiti in 1891 he had 'a violent haemorrhage and his heart began to give him trouble', possibly a sign of cardiovascular syphilis. In 1895 he had an eruption of syphilitic sores all over his body. See Bengt Danielsson, *Gauguin in the South Seas* (New York, 1966), pp. 89, 181.

22 Letter to his wife of July 1891, in Maurice Malingue, ed., *Lettres de Gauguin à sa femme et à ses amis* (Paris, 1946), p. 218.

23 Paul Gauguin, *Noa Noa*, trans. O. F. Thies (New York, 1985), p. 31.

24 Ibid., p. 33.

25 Interview in *L'Echo de Paris* (13 May 1895), quoted in Daniel Guérin, ed., *The Writings of a Savage* (New York, 1978), p. 112.

26 Tertullian's early third-century commentary was most influential and typical of later readings of Eve's role in the moral corruption of Christendom. In *De Cultu Feminarum*, I, 12, he wrote: 'You are the devil's gateway . . . you are she who persuaded him whom the devil did not dare attack. . . . Do you not know that every one of you is an Eve? The sentence of God on your sex lives on in this age; the guilt, of necessity, lives on too.' Quoted by Elaine Pagels, *Adam, Eve, and the Serpent* (New York, 1988), p. 63.

27 These interpretations are from Wayne Anderson, *Gauguin's Paradise Lost* (New York, 1971), pp. 176–80.

28 For the earlier version of his mother as Eve and subsequent changes see Henri Dorra, 'The First Eves in Gauguin's Eden', *Gazette des Beaux-Arts*, n.s. 6, XLI (1953), pp. 89–202; Henri Dorra, 'More on Gauguin's Eves', *Gazette des Beaux-Arts* n.s. 6, LXIX (1967), pp. 109–12.

29 As Peter Brooks concluded, Gauguin's nudes 'call into question traditional kinds of looking. His construction of the natural, in *Te nave nave fenua* for instance, is a matter of the utmost artifice, aimed at disarming our traditional view of the nude, and of the primitive, revising the space of our observation and the context of our looking.' 'Gauguin's Tahitian Body', in *Body Work*, p. 180.

30 *Gauguin's Paradise Lost*, p. 181.

31 On these substitutions see Ziva Amishai-Maisels in 'Gauguin's "Philosophical Eve"', *The Burlington Magazine* (June 1973), pp. 373–82.

32 See, for example, the ironically titled self-portrait *Be in Love, You Will Be Happy* (1889; wood relief, Museum of Fine Arts, Boston), which shows Gauguin also in the upper-right corner, with thumb in mouth, profoundly *un*happy about being in love. This source and my commentary on *Parau* is indebted to Charles F. Stuckey's discussion in Richard Brettell et al., *The Art of Paul Gauguin* (New York, 1988), pp. 266–8.

33 Henri Dorra views them as gossips who begin to appear in the late 1880s and continue in later works, including the two 'sinister' observers in the background of *Where Are We Going?* 'Gauguin's Unsympathetic Observers', *Gazette des Beaux-Arts*, n.s. 6, LXXVI (December 1970), pp. 367–72.

34 Anderson, *Gauguin's Paradise Lost*, p. 107.

35 These two half-nudes recall those in *Two Tahitian Women* (1899; Metropolitan Museum of Art), whom Linda Nochlin invokes as an example of women offering their breasts (symbolized by the fruits or flowers in the bowl) for male visual pleasure. 'Eroticism and Female Imagery' in *Woman as Sex Object*, p. 11. Peter Brooks's forthright reply to that interpretation (without mentioning any specific scholar) also applies to the nudes in *Primitive Tales*: 'We can, to be sure, simply stigmatize the painting as one more example of

a male gaze taking a depersonalized woman as its sexual object. But we may also find it moving and persuasive as a painting *about* looking: about the positive, guilt-free, invitation to take pleasure in the gaze directed at the body.' *Body Work*, p. 194.

36 Daniel Halévy, *My Friend Degas* [1960], trans. Mina Curtiss (Middletown, CT, 1964), p. 119.

37 G. Jeanniot, 'Souvenirs sur Degas', *La Revue universelle*, LV (1933), p. 172. Quoted in Richard Thomson, *Degas: The Nudes* (London, 1988), p. 47.

38 According to Thomson, only six were shown at the eighth Independent exhibition in Paris. Ibid., p. 130.

39 George Moore, *Impressions and Opinions* (New York, 1891), p. 318.

40 His fascination with every part of a woman's body is attested to by a later model, Alice Michel. 'Often he went into raptures before the body of his model, praising her beautiful legs, her arms with their charming roundness, her delicate shoulder/groin, wrists and ankles'. See 'Degas et son modèle', *Mercure de France*, 131 (16 February 1919), p. 627, quoted by Heather Dawkins, 'Frogs, Monkeys and Women: A History of Identifications Across a Phantastic Body', in Richard Kendall and Griselda Pollock, eds, *Dealing with Degas* (New York, 1992), p. 213. Dawkins emphasizes the model's visual assertiveness as indicated by her title, 'Alice Michel Returning the Look: Reading as a Model'.

41 Respectable women went to extreme measures to avoid being seen while bathing, even to avoid seeing themselves. Some of the especially prudish used powders to cloud bath water and make it impossible to see their own immersed bodies. Anne Martin-Fugier, 'Bourgeois Rituals' in Michelle Perrot, ed., *A History of Private Life: From the Fires of Revolution to the Great War* (Cambridge, MA, 1990), p. 460.

42 For these reviews see the concise summaries by Martha Ward, 'The Rhetoric of Independence and Innovation', in Charles S. Moffett, *The New Painting: Impressionism 1874–1886* (Geneva, 1986), pp. 430–34, and Thomson, *Degas: The Nudes*, pp. 135–9.

43 Maurice Hermel wrote: 'Degas has given the most spiritual commentary on the current metaphors which rank women, according to their natural affinities, in the orders of bovines or frogs, squirrels or cranes.' Quoted by Ward, who argues that '[Octave] Maus assumed that they behaved not just unself-consciously but, moreover, unthinkingly. Their actions revealed the innate instinct of the female animal'. Ibid., p. 432.

44 For an appreciation of how the nudes invite 'our lingering, caressing look', see Wendy Lesser, 'Degas's Nudes', in *His Other Half: Men Looking at Women Through Art* (Cambridge, MA, 1991), pp. 53–80. She challenges the misogynist argument with her conclusion that 'for Degas, women were the heroes of modern life, the figures whose actions mattered'. For a further critique of the misogyny argument see Norma Broude, 'Degas's "Misogyny"', in Norma Broude and Mary D. Garrard, *Feminism and Art History: Questioning the Litany* (New York, 1982), pp. 247–69. Carol M. Armstrong rejects the notion that Degas was a misogynist but argues that his earlier *Bather* (1885; priv. col., New York) interprets the look 'as a kind of pressure, a violence inflicted on the body like a rape or a subtle torture' (p. 234). She concludes that Degas so radically disjoined the male viewer from the female model that his nudes have 'the structure of celibacy'. 'Degas and the Female Body', in Susan Rubin Suleiman, *The Female Body in Western Culture* (Cambridge, MA, 1986), pp. 223–42. The man may have been celibate, but his art was a highly successful union of artist and model.

45 Henry Fèvre, quoted in Thomson, *Degas: The Nudes*, p. 139.

46 Eunice Lipton argues that the use of a tub in a furnished room indicates a servant, so they were not labourers. Middle-class women would not allow themselves to be viewed naked in their bedrooms. Especially compelling are her comparisons of the poses and settings of women in bather and brothel scenes. See 'Degas' Bathers: The Case for Realism', *Arts Magazine*, LIV (May 1980), pp. 94–7.

47 Lipton argues that 'insofar as a spectator is watching a woman in the bather paintings who is not returning the glance, the spectator's very point of view subjugates her: he knows he is watching, she does not; he takes her by surprise, she can only acquiesce. Furthermore, that

the woman is naked makes her additionally vulnerable'. Lipton's own evidence that these models are prostitutes, however, undercuts her argument about their subjection, surprise, and vulnerability. More convincing is her further conclusion: 'Degas' bathers are monumental images of self-absorbed women. In this sense, whether by intention or not, Degas subverted contemporary ideology concerning the female nude.' Ibid., pp. 96–7.

48 From a review by Gustave Geoffroy in 1886, quoted by Ward, 'Rhetoric of Independence', p. 432.

49 Edward Snow, 'Painterly Inhibitions', *A Study of Vermeer* (Berkeley, 1979, revd edn, 1994), pp. 28–32.

50 See my discussion of the monotypes in chapter Five.

51 H. Rostrup, 'Degas og Réjane', *Meddelelser fra Ny Carlsberg Glyptotek*, XXXIV (1977), pp. 7–13. Cited in Thomson, *Degas*, p. 207, n. 52.

52 Paul Valéry, 'Degas Dance Drawing', *The Collected Works of Paul Valéry*, XII, trans. David Paul (New York, 1960), p. 49.

53 Octave Uzanne, *La Femme à Paris* (Paris, 1894), pp. 27–8. He adds: 'Women have been described and painted an infinite number of times, but *woman* has never been accurately captured. The model who distills the passion of the surrounding air has always been able to blind her contemporaries' (p. 24).

5. Prostitution

1 Terms for the prostitute in France include *grisette, cocotte, pirreuse, femme de maison, insoumise, femme à parties, femme galante, femme entretenue, femme de spectacles et de théâtres.* Charles Bernheimer, *Figures of Ill Repute: Representing Prostitution in Nineteenth-century France* (Cambridge, MA, 1989), p. 6. Terms for courtesans include *courtisane, joueuse, lionne, impure, amazone, fille de marbre, mangeuse d'hommes, demi-mondaine, horizontale.* T. J. Clark, *The Painting of Modern Life: Paris in the Art of Manet and His Followers* (New York, 1985), p. 109. In English there is harlot, whore, cat, bat, tart, drab, stew, scarlet woman, painted woman, fallen woman, white slave. According to Michel Foucault, such a 'discursive explosion' expanded the realm and the significance of sexual experience in the nineteenth century even among professions conceived to control and inhibit it. See Foucault, *The History of Sexuality: Volume 1, An Introduction,* trans. Robert Hurley (New York, 1978), p. 17.

2 Philippa Levine writes, 'For the champions of idealized womanhood and Victorian moral puritanism, the prostitute woman was a concrete manifestation of moral disintegration and degradation, signifying a canker on the body politic whose presence was necessarily contaminating.' *Feminist Lives in Victorian England: Private Roles and Public Commitment* (Oxford, 1990), p. 81.

3 Clark, *Modern Life*, pp. 79–80, 107–09. James F. McMillan underscores the basic moral dichotomy of French society as invested in the two dichotomous roles for women that are named in his main title, *Housewife or Harlot: The Place of Women in French Society* (New York, 1981).

4 On this riot of voyeurism and exhibitionism see Emily Apter, 'Cabinet Secrets: Peep Shows, Prostitution, and Bric-a-bracomania in the Fin-de-siècle Interior', *Feminizing the Fetish: Psychoanalysis and Narrative Obsession in Turn-of-the-Century France* (Ithaca, NY, 1991), pp. 39–64.

5 'The prostitute is ubiquitous in the novels and the paintings of this period not only because of her prominence as a social phenomenon but, more important, because of her function in stimulating artistic strategies to control and dispel her fantasmatic threat to male mastery'. Bernheimer, *Figures of Ill Repute*, p. 2.

6 Charles Baudelaire, 'Les promesses d'un visage', from *Les fleurs du mal* (1857) in *Oeuvres complètes* (Paris, 1961), pp. 146–7.

7 For this quotation and evidence of his syphilis see Bernheimer, *Figures of Ill Repute*, pp. 130, 134ff.

8 Gustave Flaubert, *Sentimental Education*, trans. Robert Baldick (Penguin: Harmondsworth, 1964), p. 419.

9 Bernheimer surveys the most important French novels in *Figures of Ill Repute*. For England see George Watt, *The Fallen Woman in the Nineteenth-century English Novel* (London, 1984).

10 Emile Zola, *Nana*, trans. and introduced by George Holden (Penguin: Harmondsworth, 1972), pp. 44–6. All further references are to this edition. The card that Zola drew up on Nana before writing the novel includes: 'As early as Chapter One I show the whole audience captivated and worshipping . . . in front of that supreme apparition of the cunt'. Quoted in Holden's Introduction, p. 13.

11 Christopher Rivers maintains that Nana reinforces 'the idea of female sexuality as the origin of all evil', but he weakens his argument by adding that 'the danger Nana represents to men is a product not of her will, nor of any perverse penchant for cruelty; indeed, she seems almost unaware of the destruction she brings about'. *Face Value: Physiognomical Thought and the Legible Body in Marivaux, Lavater, Balzac, Gautier, and Zola* (Madison, WI, 1994), pp. 199, 203–04.

12 Bernheimer suggests this verbal connection and adds that 'many readers remember her as dying from the pox, syphilis'. *Figures of Ill Repute*, p. 224.

13 In the end, as Naomi Schor argues, 'women are morally superior to men'. *Zola's Crowds* (Baltimore, 1978), p. 102. Based on a survey of the positive value accorded to lesbian love among the prostitutes, Schor shows how Zola consistently contrasts 'male selfishness vs. female compassion' (p. 91).

14 For a detailed commentary on the painting and its impact see Albert Boime, *Thomas Couture and the Eclectic Vision* (New Haven, 1980), pp. 131–88. Boime notes: 'The *leitmotif* of the composition is the provocative woman in the centre whom all the critics describe as a "courtesan": her eyes droop with weariness, and her limp hands reflect the total lassitude of her body Her deep fatigue, the fixedness of her eyes, her languorously swinging arm emphasize that we are witness to the waning hours of a bacchanale' (p. 140).

15 Sharon Flescher argues that the name 'Olympia' (not the more common French name 'Olympe'), suggests the heroines of a widely acclaimed contemporary opera and an unpublished play by Manet's friend Zacharie Astruc, whose poem he selected to be used in the Salon catalogue. Both heroines are 'defiant' women who use their seductive powers to control men. In the opera, *Herculanum*, she is a pagan queen. In the play she is a vain and foolish virgin who expresses independent views, as when she proclaims, 'Free, sovereign, that must be our fate'. See 'More on a Name: Manet's "Olympia" and the Defiant Heroine in Mid-Nineteenth-century France', *Art Journal*, XLV (Spring 1985), pp. 27–35.

16 In French and English 'cat' and 'pussy' suggest female sexuality, but although there is no visual evidence of its sex in the painting, this black cat with a raised tail is masculine. In a subsequent Manet lithograph, *The Cat's Rendezvous* (1868), the black cat is masculine, aligned with an erect chimney pipe, while a white cat is feminine, aligned with a moon. As Manet explained, 'the chimney pipes correspond to the black cat, and the mottled white moon, [seen] through the clouds, forms a kind of complement to the white cat'. Quoted in Theodore Reff, *Manet: Olympia* (New York, 1976), p. 100.

17 George Moore thought that her look had 'the same calm certitude of her sovereignty as the eternal Venus for whose prey is the flesh of all men born'. George Moore, *Modern Painting* (London, 1893), p. 41. In an attempt 'to deprive the colonizing, patriarchal gaze of its authority', Mieke Bal suggests that Olympia's look might be 'a response to an intrusive interruption in her engagement with her visiting [black female] friend'. Bal interprets the servant's look as erotic and interprets her fingers on the bouquet as symbolically masturbating Olympia's clitoris, 'the top corner of that huge vagina – the place where female pleasure is engendered'. One can interpret this nude more plausibly as an image of a heterosexual courtesan, which she obviously is, one who 'decolonizes' the patriarchal gaze. See 'His Master's Eye', in David Michael Levin, ed., *Modernity and the Hegemony of Vision* (Berkeley, 1993), pp. 401, 399, 397.

18 Baudelaire, *Oeuvres complètes*, p. 1034.

19 The quotation from Baudelaire and the evidence about pornography are from Gerald Needham, 'Manet's "Olympia" and Pornographic Photography', in Thomas B. Hess and Linda Nochlin, eds, *Woman as Sex Object: Studies in Erotic Art, 1730–1970* (New York, 1972), pp. 81–9.

20 Marthiel and Jackson Mathews, eds, *The Flowers of Evil*, trans. David Paul (New York, 1955), p. 23.

21 Translated by Barbara Gibbs, ibid., p. 31.

22 Charles Baudelaire, 'The Painter of Modern Life', in *The Painter of Modern Life and Other Essays* trans. Jonathan Mayne (London, 1964), p. 30.

23 Quoted in Flescher, 'More on a Name', p. 29, translation modified.

24 Clark, *Painting of Modern Life*, pp. 88–96.

25 George Heard Hamilton, *Manet and his Critics* (New Haven, 1954), p. 73.

26 'The true reason for . . . indignation was that for almost the first time since the Renaissance a painting of the nude represented a real woman in probable surroundings. . . . To place on a naked body a head with so much individual character is to jeopardize the whole premise of the nude.' *The Nude: A Study in Ideal Form* (New York, 1959), pp. 224–5.

27 Eunice Lipton, *Alias Olympia: A Woman's Search for Manet's Notorious Model and Her Own Desire* (New York, 1992), pp. 2, 56, 85.

28 According to Alain Corbin, police knew more about prostitutes than about any other professional group. *Women for Hire: Prostitution and Sexuality in France after 1850* (Cambridge, MA, 1990), p. 375, n. 48.

29 *History of Sexuality*, p. 45.

30 On the historical significance of the new 'panoptic mechanism' see my Introduction, n. 5.

31 'The processes through which the prostitute was investigated and marginalized were even more discreet and thus more effective than the penitentiary mechanisms Foucault described, but, strangely, they were also capable of generating resistance in ways that threatened to topple the entire panoptic system.' Jann Matlock, *Scenes of Seduction: Prostitution, Hysteria, and Reading Difference in Nineteenth-century France* (New York, 1994), p. 13.

32 Quoted in Elaine Showalter, *Sexual Anarchy: Gender and Culture at the Fin de Siècle* (New York, 1990), p. 129.

33 Judith Walkowitz, *Prostitution and Victorian Society: Women, Class, and the State* (Cambridge, 1980), pp. 56–7.

34 Thomas Laqueur, *Making Sex: Body and Gender from the Greeks to Freud* (Cambridge, MA, 1990), p. 206.

35 *Speculum of the Other Woman*, trans. Gillian C. Gill (Ithaca, NY, 1985), p. 145.

36 This painting is reproduced in Charles S. Moffett, ed., *The New Painting: Impressionism 1874–1886* (Geneva, 1986), plate 108.

37 Victorian art is full of sleeping women. Bram Dijkstra sees them as a comfort to male artists trying to come to terms with women's new independence and sexual aggressiveness. 'By placing woman in nature in a state of utter exhaustion, the painters were trying to indicate that although she was no longer an ideal creature, and instead very much a part of nature, she was still not an active threat to man, who was, after all, in may ways far superior to brute nature.' *Idols of Perversity: Fantasies of Feminine Evil in Fin-de-Siècle Culture* (New York, 1986), p. 82. I interpret sleeping women as at peace with themselves and the world, absorbed in their own dreams, not in fulfilling men's fantasies. The attitude of male artists is envy rather than the projection of patriarchal anxiety. I concur with Kenneth Bendiner who interprets Victorian sleepers as images of 'aesthetic completeness' and 'fulfilment'. *An Introduction to Victorian Painting* (New Haven, 1985), p. 125.

38 My commentary on *Rolla* is based on the richly documented discussion of it by Hollis Clayson in *Painted Love: Prostitution in French Art of the Impressionist Era* (New Haven, 1991), pp. 79–88.

39 In addition to those discussed in this paragraph, Degas cuts men off at the margins in

sixteen other brothel monotypes and drawings. See Jean Adhémar and Françoise Cachin, *Degas. Radierungen, Lithographien, Monotypien* (Munich, 1973), plates 17–19, 31, 33, 56–7, 60, 61, 63, 65–67, 69, 74–5.

40 For Bernheimer, the monotypes 'destabilize the male viewer's gaze and confront him with the ideological assumptions underlying his voyeuristic position'. 'Degas's Brothels: Voyeurism and Ideology', in *Figures of Ill Repute*, p. 166.

41 Charles Dickens, *Oliver Twist* (Penguin: Harmondsworth, 1985), p. 423. All further references are to this edition.

42 Steven Marcus views this episode as supplying 'the master theme of Dickens's novels'. He argues psychoanalytically that it screened an earlier trauma when Charles witnessed his parents having sex and interpreted what he saw as 'a form of violence, specifically of murder, inflicted by the male upon the female'. Marcus presents compelling evidence from the novel and Dickens's autobiography to explain Nancy's murder as a re-enactment of a child's view of the 'primal scene'. His argument provides further evidence for my emphasis on Nancy's maternal significance, although its interpretation of childhood witnessing of the primal scene goes beyond the evidentiary basis and interpretive range of my own. Steven Marcus, 'Who is Fagin?' in *Dickens from Pickwick to Dombey* (New York, 1965), pp. 358–78.

43 George Dolby, *Dickens As I Knew Him* (1885), 1912 edn, quoted in Philip Collins, *Dickens and Crime* (Bloomington, IN, 1968), p. 268.

44 Philip Collins, ed., *Charles Dickens: Sikes and Nancy and Other Public Readings* (Oxford, 1983), pp. x–xx, 229–31.

6. Seduction

1 My interpretation of this work is drawn from Susan Casteras, *Images of Victorian Womanhood in English Art* (Cranbury, NJ, 1987), pp. 139–40.

2 For other examples see William Etty, *A Pirate Carrying off a Captive (The Corsair)* (1846); Edward Matthew Ward, *Charles II and Nell Gwynne* (1854; Victoria and Albert Museum); James Tissot, *The Meeting of Faust and Marguerite* (1860; Musée du Luxembourg); John Atkinson Grimshaw, *Two Thousand Years Ago* (1878) and *An Ode to Summer* (1879); Maxwell Armfield, *Faustine* (1904; Musée d'Orsay); John William Waterhouse, *Apollo and Daphne* (1908; see the *Art Journal* for 1909). The seductive young son of a squire in John Millais's *The Woodman's Daughter* (1850–51; Guildhall Art Gallery, London) is posed in profile as he offers strawberries to the young girl, whom he will eventually seduce and lead to ruin.

3 After Mary agreed to an unmarried liaison, Shelley celebrated his respect for her bold commitment in his dedication to *The Revolt of Islam*:

> How beautiful and calm and free thou wert
> In thy young wisdom, when the mortal chain
> Of custom thou didst burst . . .

4 She presents numerous sources for the widespread thinking about that scenario as is evident from the implied sequence in her article's title, 'Seduction, Prostitution, Suicide: *On the Brink* by Alfred Elmore', *Art History*, v (September 1982), pp. 308–22.

5 George Eliot, *Daniel Deronda* (Penguin: Harmondsworth, 1984), p. 882. All further references are to this edition. Jacqueline Rose omits such crucial passages in interpreting the novel. The title of her article, 'George Eliot and the Spectacle of the Woman', de-emphasizes what Gwendolen sees or thinks in order to emphasize her objectification under the male gaze. Thus the novel documents 'the link between male truth and a woman's failing' and between 'the sexual morality of the woman and social decay'. Rose omits positive expressions of female sexual morality that sustain love. She views the widespread

Victorian belief in 'the supremacy of the woman's moral nature' as the twin pole of woman's 'potential degeneracy', and she concentrates on woman's degeneracy. Therefore Gwendolen's witnessing of the death of Grandcourt is symptomatic of the dangerous potential of the 'crazed woman' whose 'glance of desire' may lead to stabbing or drowning. She also views Dorothea in *Middlemarch* as an hysteric who reveals how the 'the controlling knowledge of science is threatened, but also guaranteed – upheld even – by the image of a female sexuality gone wild'. Surely this is feminist criticism gone wild. *Sexuality in the Field of Vision* (1986), pp. 105–22.

6 George Eliot, *Adam Bede* (Penguin: Harmondsworth, 1985), p. 199.

7 Gustave Flaubert, *Madame Bovary*, trans. Francis Steegmuller (Vintage: New York, 1957, reprinted 1992), p. 154. The French reads 'elle a des yeux qui vous entrent au cœur comme des vrilles'.

8 Mary Elizabeth Braddon, *Lady Audley's Secret* (OUP: Oxford, 1987), pp. 6, 297.

9 Giovanni Verga, *The She-Wolf and Other Stories*, trans. Giovanni Cecchetti (University of California Press: Berkeley, 1973), pp. 3–9.

10 Victor Hugo, *Les Misérables* trans. Norman Denny (Penguin: Harmondsworth, 1982), p. 707.

11 Thomas Hardy, *Far From the Madding Crowd* (Penguin: Harmondsworth, 1986), p. 149. On the inability of all the male characters (except Gabriel Oak) to look directly and perceptively at Bathsheba, see J. B. Bullen, *The Expressive Eye: Fiction and Perception in the Work of Thomas Hardy* (New York, 1986), pp. 73–5. But even Gabriel's gaze can be demeaning. As Rosemarie Morgan notes, his first incognito observation of Bathsheba transforms her 'natural ease of self-perception' into 'self-consciousness'. This first spying portends the morally degrading effect of his gaze throughout the novel. 'From behind hedges, through the crevices of sheds and field-huts, and less clandestinely but just as penetratingly, from behind the bland, unassuming countenance of his own moon face, he pruriently stares, probes and exposes. From these concealed vantage points he prises Bathsheba from her privacy to draw her out into the open where her exploratory activity will, of necessity, become restricted and censored.' *Women and Sexuality in the Novels of Thomas Hardy* (New York, 1988), pp. 36, 44.

12 Nathaniel Hawthorne, *The Scarlet Letter* (Penguin: Harmondsworth, 1986), pp. 80–81. Further references are to this edition.

13 Thomas Hardy, *Tess of the d'Urbervilles* (Penguin: Harmondsworth, 1985), p. 51.

14 Whether she was seduced or raped is an open question. Kristan Brady surveys the arguments in 'Tess and Alec: Rape or Seduction?', *Thomas Hardy Annual*, IV (1986), pp. 124–47. She notes that earlier drafts of the novel had Tess showing greater familiarity with Alec but later ones emphasized her victimization. Still, the final version retains evidence of Tess's partial attraction to Alec when she confesses to her mother that even after her pregnancy she 'had been stirred to confused surrender' (p. 130).

15 On vision in *Tess* see Kaja Silverman, 'History, Figuration, and Female Subjectivity in *Tess of the d'Urbervilles*', *Novel*, XVIII (Fall 1984), pp. 5–28, which views Tess as 'dominated by the awareness of a structuring [male] gaze' but also traces her effort 'to place herself beyond the mastery of the male gaze' (pp. 23, 25).

16 For Emma's eyes see chapter One, p. 31; for Elfride's see chapter One, p. 48. On the colour of men's eyes see chapter Eight, n. 22.

17 More evidence for this interpretation and the source for the moralist quoted are in Stephen Kern, *The Culture of Love: Victorians to Moderns* (Cambridge, MA, 1992), pp. 155–7.

18 Stephanie Grilli points out further that in accord with current phrenological theory, the man's Mephistophelean appearance and libidinous nature are suggested by his low forehead, broad skull, coarse red hair, menacing teeth, and ruddy complexion. 'Pre-Raphaelitism and Phrenology', in Leslie Parris, ed., *Pre-Raphaelite Papers* (London, 1984), p. 59ff.

19 William Holman Hunt, *Pre-Raphaelitism and the Pre-Raphaelite Brotherhood* (London, 1905), II, p. 430. Quoted by Susan Casteras in 'Down the Garden Path: Courtship Culture

and Its Imagery in Victorian Painting', PhD diss., Yale University, 1977, p. 425, to which I am indebted for my commentary on this painting and *The Light of the World* as well as the sources cited in the following six notes (pp. 421–71, 669).

20 *The Athenaeum*, XXVII, pt. 1 (6 May 1854), p. 561.

21 Letter to *The Times* (25 May 1854).

22 Hunt, *Pre-Raphaelitism*, II, p. 430.

23 Review in *The Art Journal*, XVI (1854), p. 165,

24 Hunt, *Pre-Raphaelitism*, II, p. 429.

25 Ibid., p. 430.

26 Casteras, 'Down the Garden Path', p. 447.

27 Jeremy Maas surveys the various male models who might have sat for Hunt but emphasises the importance of Lizzie Siddall for Christ's hair and Christina Rossetti for his face and eyes. Hunt wrote: 'Appreciating the gravity and sweetness of expression possessed by Miss Christina Rossetti, I felt she might make a valuable sitter for the painting of the head'. Quoted in *Holman Hunt and The Light of the World* (London, 1884), p. 38. Maas also quotes from a letter Hunt sent to Edward Clodd in 1898: 'As I had to have some living being for the colour of the flesh with growth of eyebrows and eyelashes, the solemn expression, when the face was quiescent, of Miss [Christina] Rossetti promised to help me with some shade of earnestness I aimed at getting, and so I felt grateful to Mrs. R[ossetti] and herself when they promised to come to Chelsea one morning' (p. 41).

28 Helene Roberts, 'Marriage, Redundancy or Sin: The Painter's View of Women in the First Twenty-Five Years of Victoria's Reign', in Martha Vicinus ed., *Suffer and Be Still: Women in the Victorian Age* (Bloomington, IN, 1972), p. 67.

29 *The Pre-Raphaelites*, exh. cat., Tate (London, 1984), p. 96.

30 The exhibition catalogue of the Royal Academy in 1853 included the lines from Shakespeare's *Measure for Measure*, III, i, that express Claudio's thoughts:

> Ay, but to die, and go we know not where:
> 'Tis too horrible!
> The weariest, and most loathed worldly life,
> That age, ache, penury, and imprisonment
> Can lay on nature, is a paradise
> To what we fear of death.

31 Joseph A. Kestner provides compelling evidence that Leighton was sexually suppressed and homoerotic with a strong fear of sexually aroused women. *Mythology and Misogyny: The Social Discourse of Nineteenth-century British Classical Subject Painting* (Madison, WI, 1989).

32 Burne-Jones revealed the personal meaning for this image by reproducing it as an illumination on the open page of a medieval manuscript held by his mistress in *Portrait of Maria Zambaco* (1870; Clemens-Sels-Museum, Neuss). His wife Georgiana was the model for the musician, reproduced in miniature, but his bitter love was for the full-sized subject of the portrait, his wide-eyed Maria Zambaco.

33 Burne-Jones to Helen Mary Gaskell, February 1893, quoted in Kestner, *Mythology and Misogyny*, p. 85.

34 The same letter to Helen Gaskell quoted in ibid.

35 Whether or not it is relevant to a painting executed almost fifteen years later, an unconfirmed story circulated that when the affair with Mary ended in 1869, they made a suicide pact to drown themselves in the Serpentine. The couple actually waded in, but found it too cold and came out. David Cecil, *Visionary and Dreamer. Two Poetic Painters: Samuel Palmer and Edward Burne-Jones* (Princeton, 1966), p. 128.

36 Quoted in Kestner, *Mythology and Misogyny*, p. 98.

37 Burne-Jones modelled the siren after Laura Tennant, whom he referred to as 'The Siren'. In 1897 he told his studio assistant Thomas Rooke: 'There are two kinds of women I like; the very good, the goldenhaired; and the exceedingly mischievous, the sirens with oat-coloured hair'. Quoted in ibid., p. 97.

1 There may be a personal referent in her expression, because Millais had a growing dependency on the actual model who was the pillar of strength in her own shaky marriage. She was Effie Ruskin, unhappy wife of the famous English aesthetician John Ruskin, who taught Victorians how to appreciate beauty, but whose unconsummated marriage to Effie was annulled after six years, shortly before she married Millais.

2 Susan Casteras, 'Down the Garden Path: Courtship Culture and Its Imagery in Victorian Painting', PhD diss., Yale University, 1977, p. 241. Millais's *The Proscribed Royalist, 1651* (1852–3; priv. col.) is set during the English Civil War and shows a female Roundhead rescuing a Royalist. He kneels in the shadow of a hollowed tree-trunk and looks up out of a partial profile with plaintive eyes at his protector and rescuer, who is posed frontally and looks away from him, into the sunlight, alert to any danger.

3 For a reproduction of the sketch and an interpretation of these personal referents see Michael Hancher, '"Urgent Private Affairs": Millais's *Peace Concluded, 1856*', *The Burlington Magazine*, CXXXIII (August 1991), pp. 499–506, which finds ironic truth in the quoted phrase and suggests that in all three paintings with Effie as the intended or final model, Millais worked through his own urgent private affairs involving 'the anxious theme of male dependency'.

4 Mary Poovey, *Uneven Developments: The Ideological Work of Gender in Mid-Victorian England* (Chicago, 1988), pp. 166–9, 187.

5 Hancher, 'Urgent Private Affairs', p. 505.

6 William Hepworth Dixon, *Her Majesty's Tower*, 2 vols. 7th edn (London, 1885), p. 392. On the reasons behind Nithsdale's capture and trial and the details of the escape plan see pp. 385–403.

7 'Too dark to shave, he thrust his chin into a muffler; and his cheeks being painted red, his ringlets twisted round his brow, his petticoats and hood put on, she raised the latch and led him by the hand'; ibid., p. 402.

8 Elizabeth Gaskell, *North and South* (Penguin: Harmondsworth, 1970), p. 121. All further references are to this edition.

9 Catherine Gallagher focuses on how Margaret's moral influence on Thornton affects his public morality in running a factory. 'In *North and South*, as in [Sarah Ellis's] *Mothers of England*, the moral influence women indirectly exert on men is said to be the force connecting public and private life. The moral influence of an ethically scrupulous woman is at the centre of Gaskell's novel.' *The Industrial Reformation of English Fiction: Social Discourse and Narrative Form 1832–1867* (Berkeley, 1985), p. 168. Margaret's influence is part of the 'widening sphere' of women's moral influence in the 1860s, when, as Martha Vicinus maintained, 'a small band of activists hoped to widen the definition of women's "proper sphere". They argued that just as women had an obligation to educate their children in morality, so too did they have the wider responsibility to educate society on moral issues.' *A Widening Sphere: Changing Roles of Victorian Women* (Bloomington, IN, 1977), p. x.

10 Nancy Henley reported on a study of 300 men and women, which concluded that 'females returned smiles more often than males did'. The figures for opposite sex returned smiles were 93 per cent for women and 67 per cent for men. *Body Politics: Power, Sex, and Nonverbal Communication* (Englewood Cliffs, NJ, 1977), p. 176.

11 Victor Hugo, *The Man Who Laughs* [2 vols], anonymous translation (H. M. Caldwell: New York, n.d.), I, pp. 301–02. Further references are to this translation of *L'homme qui rit*.

12 In Ovid's *Metamorphoses*, Perseus slays Orc with his sword. Ingres draws from the later poem.

13 As Richard Wollheim noted, Roger on his hippogriff looks 'like a boy on his rocking-horse'. 'Painting, Omnipotence, and the Gaze: Ingres, the Wolf Man, Picasso', in *Painting as an Art* (Princeton, 1987), p. 259.

14 The sonnets appear under the title, 'For "Ruggiero and Angelica" by Ingres', in William M. Rossetti, *The Complete Poetical Works of Dante Gabriel Rossetti* (Boston, 1898), pp. 278–9.

15 Adrienne Auslander Munich uses the sonnet to interpret the painting as a depiction of woman's sexual initiation. 'Couching mysterious knowledge in her body, Angelica is a type of Eve at the moment of sexual initiation. Slaying or calming "the [dead] thing" gives her carnal knowledge'. *Andromeda's Chains: Gender and Interpretation in Victorian Literature and Art* (New York, 1989), p. 106.

16 Henri Rousseau schematized this composition in *Unpleasant Surprise* (1901; The Barnes Foundation), which shows a heavily clothed hunter with a barely visible, profiled eye aiming a long rifle while shooting a bear with long sharp teeth and claws, who looms in the foreground. The hunter is presumably rescuing a standing nude woman from the danger of the bear, but Rousseau subverts the traditional iconology of rescue. The bear is smiling and looking past the nude woman, and she appears unconcerned about the rescue. She is nevertheless fully frontal, with large wide open eyes that centre the viewer's focus and seem to interrogate what all the (unpleasant? surprising?) heroism is about.

17 Mark Girouard, *The Return to Camelot: Chivalry and the English Gentleman* (New Haven, 1981), p. 159.

18 John Guille Millais, *The Life and Letters of Sir John Everett Millais* (London, 1899), I, pp. 31–33, quoted in ibid.

19 Munich, *Andromeda's Chains*, p. 18.

20 In Etty's *Andromeda – Perseus Coming to Her Rescue* (1840; Royal Albert Memorial Museum, Exeter), Andromeda is brightly lit and looms huge in the foreground with a pose that is imitated by the other figures. The monster faces away from Perseus as well as from her and imitates the heavenward direction of her glance. Pegasus gallops not toward her but parallel to the direction she faces. He carries Perseus, who does not look toward Andromeda or the monster but struggles in chivalrous confusion, juggling two lances and a shield while twisting away from the direction in which Pegasus is racing. Andromeda's garment is more energized than Perseus's swirling cape or the sea-monster's churning sea, and her upward glance recalls Etty's ideal of the nude as an image of God's glory.

21 From his notebook of 1843, quoted in ibid., p. 42.

22 In William Gale's *Perseus and Andromeda* (*c.* 1856; Yale Center for British Art, New Haven), a sword-wielding Perseus is in shadow and profile, while Andromeda twists in a seductive frontal nude pose, with sunlit downcast eyes that centre the painting.

23 'Burne-Jones and his Victorian associates force us to look into the serpent-woman's face and to feel the mystery of a power, endlessly mutilated and restored, of a woman with a demon's gifts.' Nina Auerbach, *Woman and the Demon: The Life of a Victorian Myth* (Cambridge, MA, 1982), p. 9.

24 In Shelley's poem, 'On the Medusa of Leonardo Da Vinci in the Florentine Gallery', Medusa 'seeks to terrorize whatever in the observer is still committed to evil and to invigorate in him everything that strives for life'. Jerome J. McGann explores this moral influence of Medusa in subsequent romantic writers, culminating in William Morris's poem *The Earthly Paradise*, in which Medusa leads Perseus to cultivate the noblest human achievements – love, integrity, and civilization. 'The Beauty of the Medusa: A Study in Romantic Literary Iconology', *Studies in Romanticism*, II (Winter 1972), pp. 3–25.

25 Throughout his life he worked on this painting that was completed by friends posthumously. My commentary is indebted to Linda Nochlin's, 'Lost and *Found*: Once More the Fallen Woman', *The Art Bulletin* (1978), reprinted in *Woman, Art, and Power and Other Essays* (New York, 1988), pp. 57–85; and Susan Casteras, 'Rossetti's *Found* and the Country Girl Gone Astray', in 'Down the Garden Path', pp. 363–81.

26 Ibid., p. 80.

27 This reading is suggested by some of the detail that Rossetti included in drawings but left out of the painting – a churchyard with tombstones, a rose in the gutter, and two birds building a nest.

28 Letter of 30 January 1855, quoted in Nochlin, 'Lost and Found', p. 58.

29 Quotations are from the 'Guinevere' section of Tennyson's *Idylls of the King* (1859–85).

30 William Morris's poem 'The Defence of Guenevere' (1858) dramatizes the Queen's

response to the charge of adultery that men brought against her by exposing the limits of their monocular vision. The poem is an implied celebration of her fuller vision, as she appeals to her male accusers to rethink (and re-view) their narrow-minded judgement of her. Lindsay Smith argues that although in the poem the Queen offers herself as a spectacle for men's viewing, she does so to interrogate the limits of their vision. Smith concludes that the Queen is, far from being a mere object of the male gaze, rather 'a sexually differentiated perceiving subject'. *Victorian Photography, Painting and Poetry: The Enigma of Visibility in Ruskin, Morris and the Pre-Raphaelites* (Cambridge, 1995), p. 195.

8. Marriage

1 Manet's *The Monet Family in the Garden* (1874; Metropolitan Museum of Art) shows Monet's wife and child frontally in a similarly well-lit composition, while Monet, in profile and in shadow, putters with his flowers behind and to the side.

2 *Impressionism: Art, Leisure, and Parisian Society* (New Haven, 1988), p. 71.

3 Herbert argues that 'we should recognize in Mme Guillemet the reappearance of the independent, unsubmissive woman whom Manet had favored in so many of his paintings. . . . [She] not only has the favored Anglo-Saxon features, she also has the self-confidence and independence that were leading characteristics of the American woman. Manet knew her well, and chose her for this picture [because] she fits perfectly the pictorial role he envisioned. Her husband is there principally to exhibit his wife.' Ibid., p. 182.

4 No doubt Eunice Lipton, who in 1975 was already searching for the spirit behind the eyes of Manet's more famous model Victorine Meurent, saw a similar spirit in the eyes of Mme Guillemet whom she found to be 'extraordinarily self-confident and self-engrossed'. Lipton presses a broader claim that Manet's women are seen as 'strong, autonomous beings, firmly saying no to centuries of conventional behavior'. 'Manet: A Radicalized Female Imagery', *Artforum*, XIII (March 1975), p. 53.

5 'Glances', unpublished lecture at 'Manet: A Symposium', The Metropolitan Museum of Art, New York, 22 October 1983, quoted by Bradley Collins, see following reference. John Richardson maintains that 'examples of Manet's detachment and the isolation of his subjects are easily turned up' in 'Estrangement as a Motif in Modern Painting', *British Journal of Aesthetics*, XXII (Summer 1982), p. 197.

6 Bradley Collins, 'Manet's "In the Conservatory" and "Chez le Père Lathuille"', *The Art Journal*, XLV (Spring 1985), pp. 60–61. Joel Isaacson presses the conflict interpretation too far in arguing that their momentary disjuncture is a 'a tense, almost brutally strained moment in an enduring relationship (the kernel of the situation offered in the stalled eroticism of the two juxtaposed hands, centred in the canvas)'. 'Impressionism and Journalistic Illustration', *The Arts Magazine*, LVI (June 1982), p. 110.

7 Quoted in Linda Nochlin, 'A House is Not a Home: Degas and the Subversion of the Family', in Richard Kendall and Griselda Pollock, eds, *Dealing with Degas: Representations of Women and the Politics of Vision* (New York, 1992), p. 45.

8 In concluding, however, she counters critics who saw Degas as a misogynist and insists on the uniquely individualized subjectivity of his women in art: 'In portraiture, then, Degas did not paint women as stereotyped feminine objects but as distinct human beings, emphasizing neither charm nor grace nor prettiness, but, rather, individual character'. 'Degas's "Misogyny"', in Norma Broude and Mary D. Garrard, eds, *Feminism and Art History: Questioning the Litany* (New York, 1982), pp. 253, 261.

9 *Portraits by Degas* (Berkeley, 1962), p. 18.

10 Herbert, *Impressionism*, p. 50.

11 In 1923 Julius Meier-Graefe identified the couple as married. He argued that it showed 'the fierce and sinister husband seated at the writing table, arms crossed, refusing even to bestow a glance on his young wife'. *Degas*, trans. J. Holroyd Reece (New York, 1988), p. 18. More recently Henri Loyrette has speculated that 'we do not really know what has happened or

what is about to happen between the couple (undoubtedly lovers or husband and wife)'. *Degas*, exh. cat., Metropolitan Museum of Art (New York, 1988), p. 148. *Bouderie* has also been translated as *Pouting, Distraction*, and *The Banker*.

12 'Domesticity and Manliness in the Victorian Middle Class: The Family of Edward White Benson', in Michael Roper and John Tosh, eds, *Manful Assertions: Masculinities in Britain Since 1800* (London, 1991), pp. 56, 49.

13 Sarah Stickney Ellis, *The Daughters of England* (New York, 1842), p. 73.

14 Lynda Nead, *Myths of Sexuality: Representations of Women in Victorian Britain* (London, 1988), p. 38.

15 'Ford Madox Brown's "Take Your Son, Sir!"', *Arts Magazine*, LIV (January 1980), pp. 135–41. Helene S. Roberts argues that the painting shows a mother gazing 'accusingly' at a married man to make him accept responsibility for fathering her child: 'Marriage, Redundancy or Sin: The Painter's View of Women in the First Twenty-Five Years of Victoria's Reign', in Martha Vicinus, ed., *Suffer and Be Still* (Bloomington, IN, 1973), pp. 73–5. J. H. Plumb argues that Emma's look is an aggressive challenge from a mistress to take a bastard son off her hands: 'The Victorians Unbuttoned', *Horizon* (Autumn 1969). Those interpretations are implausible, because they cannot explain the father's smiling face and outstretched hands nor why Brown would depict his own wife as an adulteress and impugn the legitimacy of his own child.

16 Tissot was intrigued by men with visually evasive women near water. In addition to the several reproduced in my study see *The Three Crows Inn, Gravesend*, (*c*. 1873; National Gallery of Ireland, Dublin); *The Last Evening* (1873; Guildhall Art Gallery, London); *The Captain and the Mate* (1873; priv. col., England); *The Gallery of H.M.S. Calcutta (Portsmouth)* (*c*. 1877; Tate); *Portsmouth Dockyard (How Happy I Could Be With Either)* (1877; Tate); *The Terrace of the Trafalgar Tavern, Greenwich* (*c*. 1878; H. Shickman Gallery, New York); *A Passing Storm* (*c*. 1878; Beaverbrook Art Gallery, NB, Canada).

17 In Tissot's *Reading the News* (*c*. 1874) a young woman stands next to a much older man who is reading the newspaper. Their contrasting ages imply not marital isolation but a more general isolation between young and old as well as between men and women. In *Room Overlooking the Harbour* (*c*. 1876–8; priv. col.) Tissot posed Kathleen Newton immersed in a book while seated at the opposite end of a table from a grey-haired man reading a newspaper.

18 Robert Rosenblum speculates that someone might be returning her look in the window opposite: 'Gustave Caillebotte: The 1970s and the 1870s', *Artforum* (March 1977), p. 50.

19 Gloria Groom argues that the artist's 'genre scenes painted between 1879 and 1882, show an extraordinary parity between the sexes, and sometimes empower the female through the artist's treatment of the space, scale, and viewpoint typically reserved for the male gaze'. 'Interiors and Portraits', in Anne Distel et al., *Gustave Caillebotte: Urban Impressionist*, exh. cat., Art Institute of Chicago (New York, 1995), p. 184.

20 'Seeing, in *The Golden Bowl*', writes Mark Seltzer, 'constitutes the central narrative action, and the process of vision everywhere entails a power of supervision'. *Henry James and the Art of Power* (Ithaca, NY, 1984), p. 63. Other books on James that focus on seeing include Sallie Sears, *The Negative Imagination: Form and Perspective in the Novels of Henry James* (Ithaca, NY, 1968); Ora Segal, *The Lucid Reflector: The Observer in Henry James' Fiction*, (New Haven, 1969); Carolyn Porter, *Seeing and Believing: The Plight of the Participant Observer in Emerson, James, Adams, and Faulkner* (Middletown, CT, 1981); Paul B. Armstrong, *The Phenomenology of Henry James* (Chapel Hill, NC, 1983); Darshan Singh Maini, *Henry James: The Indirect Vision*, revd 2nd edn (Ann Arbor, 1988); Susan M. Griffin, *The Historical Eye: The Texture of the Visual in Late James* (Boston, 1991); Adeline R. Tintner, *Henry James and the Lust of the Eyes: Thirteen Artists in his Work* (Baton Rouge, LA, 1993).

21 Henry James, *The Golden Bowl* (Penguin: Harmondsworth, 1987), p. 49. All further references are to this edition.

22 Edward Rochester, Rodolphe Boulanger, Svengali, Claude Lantier, Alec d'Urberville, Bill

Sikes, Gwynplaine, John Thornton, and Arthur Dimmesdale have dark eyes. I found no mention of the eye-colour of Marius Pontmercy, Harry Knight, Stephen Guest, Angel Clare, Count de Muffat, or Malinger Grandcourt.

23 In *The Historical Eye* Griffin argues that 'Maggie's visual power demonstrates that the gaze is not exclusively male in James', and that by portraying the 'female as perceiver' James 'further deconstructs the gendered opposition between seer and seen' (pp. 20, 60).

24 Even the Prince's seductive technique becomes objectified for Maggie as she observes it working on other women and learns to resist its pulverizing effect. 'She never admired him so much, or so found him heart-breakingly handsome, clever, irresistible, in the very degree in which he had originally and fatally dawned upon her, as [when] she saw other women reduced to the same passive pulp that had then begun, once for all, to constitute *her* substance' (pp. 156–7).

25 Dorothea Krook argues that the Prince's efforts to sap Maggie's resolution are 'heart-rendering' scenes that show 'Maggie's heroic struggle against her own susceptibilities' and the 'terrifying . . . power of the sexual element' which the Prince uses to 'dominate and subdue'. *The Ordeal of Consciousness in Henry James* (Cambridge, 1962), p. 257.

26 In 'Henry James and the Battle of the Sexes', Wendy Lesser argues that 'Women suffered more because, in [James's] view, they were capable of suffering more: their sympathy, their intelligence, their knowledge made them suffer, whereas men were generally, like the Prince, protected by a layer of self-serving obtuseness. In all of James's work, there is no marriage in which the man understands more than the woman. . . . James's novels are, in part, about mutuality in love; but there is a limit to how mutual love can be if one member of the pair is invariably morally, emotionally, and intellectually superior.' See *His Other Half: Men Looking at Women Through Art* (Cambridge, MA, 1991), pp. 106–07.

27 Krook views the novel as a 'great fable . . . of the redemption of man by the transforming power of human love' personified by Maggie, who ultimately achieves 'a restoration of the universal moral order which has been disordered by the immorality of an ugly betrayal'. *Ordeal of Consciousness*, pp. 240–41.

28 I question Krook's argument that the Prince's final line means that he sees (i.e. loves) only Maggie and no longer Charlotte, but I concur with her interpretation that James intended this final scene to offer 'the supreme expression of the moral beauty of his heroine'. *Ordeal of Consciousness*, p. 319.

Conclusion

1 Roland Barthes argues that a man who suffers in waiting, or even a man who simply loves, is 'feminized'. *A Lover's Discourse* trans. by Richard Howard (New York, 1978), p. 14.

2 Keats's poem is titled *Isabella*. Millais drew on phrenology to express these dynamics with the facial structures of family members seated at a table. In 'The Dilemma of the Artist in Millais's *Lorenzo and Isabella*: Phrenology, the Gaze, and the Social Discourse', *Art History*, XIV (March 1991), pp. 51–66, Julie F. Codell analyses the influence of phrenology on Millais in this painting.

3 Quoted in ibid., p. 55.

4 Theodore Reff elaborated the possible influence of Zola's novel in 'Degas's "Tableau de Genre"'(1972), revised in *Degas: The Artist's Mind* (New York, 1976), pp. 200–38. Most likely the painting was also influenced by physiognomical theory. When Degas was working on *Interior* he recorded in his notebook: 'Make of the *expressive head* (in the style of the Académie) a study of modern feelings – a sort of Lavater. . . . Study Delsarte's observations on the emotional movements of the eye'. Notebook 23, p. 44. Quoted by Roy McMullen, *Degas: His Life, Times, and Work* (Boston, 1984), p. 157. François Delsarte was a professor of music and rhetoric, who wrote lectures on the expressive meanings of posture, gesture, and eye-movement.

5 Carol Armstrong argues that *Interior* associates the male with the look and the female with the object, continuing an art historical tradition (exemplified in David's *Oath of the Horatii*)

of separating the significant male part from the female part that is 'opposed to the main drive of the story and to its message'. 'Edgar Degas and the Representation of the Female Body', in Susan Rubin Suleiman, ed., *The Female Body in Western Culture* (Cambridge, MA, 1986), pp. 29–30. But the narratives of both paintings would be unintelligible without the women, who clearly 'drive' the men in both paintings. Moreover, it was Degas's express intention not to divide subjective and objective roles between the sexes but to distribute these roles between the them, as Susan Sidlauskas has argued convincingly in 'Resisting Narrative: The Problem of Edgar Degas's *Interior*', *Art Bulletin*, LXXV (December 1993), pp. 671–96.

6 One early reviewer commented, 'A lewd fire burns in his gaze – oh, that white point on his pupil!'. George Grappe, *Degas (L'art et le beau)*, III/1 (Paris, 1908), p. 52. But Degas captured not so much the fire of the male gaze but, as Sidlauskas notes, 'the anxiety associated with looking'. Sidlauskas concludes that 'Degas's vision of masculinity is empty of heroism and constrained by ambivalence'. Sidlauskas, op. cit., p. 691, and for Grappe quotation, p. 694.

7 For a few more examples see also Renoir, *The Luncheon* (*c.* 1879; The Barnes Foundation), Manet, *Boating* (1874; Metropolitan Museum of Art) and *Chez le Père Lathuille* (1879; Musée des Beaux-Arts, Tournai), Degas, *Manet Listening to his Wife Play the Piano* (*c.* 1865; unlocated), Gustave Moreau, *Young Man and Death* (1856–65; Fogg Art Museum, Cambridge, MA), Charles Wynne Nicholls, *On the Beach: A Family on Margate Sands* (1867; Scarborough Art Gallery), Frank Dicksee, *Harmony* (1877; Tate), Tissot, *The Captain and the Mate* (1873; priv. col.).

8 Gustave Flaubert, *Madame Bovary*, trans. Francis Steegmuller (Vintage: New York, 1957, reprinted 1992), p. 285.

9 Stéphane Mallarmé, 'The Impressionists and Edouard Manet', *Art Monthly Review*, XXX (September 1876), pp. 121–2, quoted in T. J. Clark, *The Painting of Modern Life: Paris in the Art of Manet and His Followers* (New York, 1984), p. 268. This essay was written in English, so Mallarmé's female pronouns are intentional, perhaps a consequence of thinking in French but not merely the result of an awkward translation from the French. Eva Cherniavsky makes an analogous argument for the essentially social and democratic function of motherhood and the maternal body in nineteenth-century American discourse and society. See *That Pale Mother Rising: Sentimental Discourses and the Imitation of Motherhood in 19th-century America* (Bloomington, IN, 1995), pp. ix, 4, 12–13 and *passim*.

10 Men were also shown in abject shame. The man with the bowed head in Millais's *Retribution* (1854; British Museum) has been sought out by his wife, who has entered his den of sin, displayed her wedding-ring to his mistress, and accused him with a fiercely indignant stare as she kneels and supports her son who also directs an accusing glance at his perfidious father.

11 Alastair I. Grieve, *The Art of Dante Gabriel Rossetti: The Pre-Raphaelite Period 1848–50* (Hingham, Norfolk, 1973), p. 8.

12 The confessional and celebratory aspect of Rossetti's relationship with models is captured in a sonnet of 1856 by his sister Christina, which interpreted her brother's need for models and his conviction of their needing him, a mixture that was especially evident in his relationship with Elizabeth.

> He feeds upon her face by day and night,
> And she with true, kind eyes looks back on him . . .
> Not wan with waiting, nor with sorrow dim
> Not as she is, but was when hope shone bright;
> Not as she is, but as he fills his dream.

Christina Rossetti, 'In an Artist's Studio', quoted (p. 18) by Susan P. Casteras, 'The Double Vision in Portraiture', Maryan Wynn Ainsworth, ed., *Dante Gabriel Rossetti and the Double Work of Art*, Yale University Art Gallery (New Haven, 1976), pp. 9–35. Casteras interprets Rossetti as haunted by images that conflate images of his model and himself (p. 14).

13 He began a portrait of Elizabeth before her death and completed it afterwards as *Beata*

Beatrix. For this and much valuable information on this painting see Ronald W. Johnson, 'Dante Rossetti's *Beata Beatrix* and the *New Life*', *Art Bulletin*, LVII (December, 1975), pp. 548–58.

14 'Dante at Verona', *The Collected Works of Dante Gabriel Rossetti* (London, 1890), I, p. 14. Quoted in ibid., p. 551.

15 Letter of 26 March 1871, quoted in ibid., p. 552.

16 For a discussion of the this episode see Stephen Kern, *The Culture of Love: Victorians to Moderns* (Cambridge, MA, 1992), pp. 145–6.

17 Quoted in Mary Luytens, *Millais and the Ruskins* (New York, 1967), p. 261.

18 William Holman Hunt Journal, 1854, John Rylands University Library of Manchester, quoted in Judith Bronkhurst, '"An interesting series of adventures to look back upon": William Holman Hunt's Visit to the Dead Sea in November 1854', in Leslie Parris, ed., *Pre-Raphaelite Papers* (London, 1984), p. 120.

19 Quoted by Christopher Wood, *The Pre-Raphaelites* (New York, 1981), p. 10.

20 Griselda Pollock and Deborah Cherry document conflicting accounts of the eye-colour of Elizabeth Siddall: 'If W. M. Rossetti wrote of her eyes as "greenish-blue", Swinburne deemed them a "luminous grey green", and Georgiana Burne-Jones recalled eyes of "golden brown, agate color, and wonderfully luminous.".' 'Woman as Sign in Pre-Raphaelite Literature: The Representation of Elizabeth Siddall', in Griselda Pollock, *Vision and Difference: Femininity, Feminism and Histories of Art* (London, 1988), p. 102.

21 In *The Blue Bower* (1865; Barber Institute of Fine Arts, Birmingham) a woman plucks a dulcimer; in *Veronica Veronese* (1872; Delaware Art Museum), a woman fingers a violin; in *La Ghirlandata* (1873; Guildhall Art Gallery), a woman fingers a harp; in *The Bower Meadow* (c. 1872; Fitzwilliam, Cambridge), one woman strokes a lute, the other a psaltery.

22 In 1848 when the Brotherhood was founded, Millais was 19, Rossetti was 20, and Hunt was 21 years old. Not all English artists, of course, were young and naïve, nor were all French artists ageing and sick. I contrast the groups this way because they happen to align along national lines and so emphasize two kinds of problems with women. These accidental national differences among the artists do not hold for novelists.

23 Quoted by Wendy Slatkin, ed., *The Voices of Women Artists* (Englewood Cliffs, NJ, 1993), p. 59.

24 His suite of bathers, as Edward Snow has written, was an attempt 'to redeem sexual desire by transforming it, through art, into a reparative impulse'. 'Painterly Inhibitions', *A Study of Vermeer* (Berkeley, 1979, revd edn, 1994), p. 28.

25 Degas's deteriorating eyesight and fear of blindness show up in letters from the early 1870s. On 26 October 1890, he wrote to his friend Evariste de Valernes, 'I envy you your eyes which will enable you to see everything until the last day. Mine will not give me this joy; I can scarcely read the papers a little, and in the morning, when I reach my studio, if I have been stupid enough to linger somewhat over the deciphering, I can no longer get down to work.' On 6 December 1891 he wrote, 'I see worse this winter, I do not even read the newspapers a little. It is Zöe, my maid, who reads to me during lunch. . . . Ah! Sight! Sight! Sight!' See Marcel Guerin, ed., *Edgar Germain Hilaire Degas Letters* (Oxford, 1947), pp. 172, 174. The photograph *Self-portrait with Zöe Closier* shows her in the background, looking straight at the viewer with the piercing brightly lit eyes that she used to read to Degas, while he is in the foreground, looking to the side with a sick, seemingly blind right eye. Reproduced and discussed in Carol Armstrong, *Odd Man Out: Readings of the Work and Reputation of Edgar Degas* (Chicago, 1991), p. 236ff.

26 Kermit Swiler Champa recounts his 'fixation' with *A Bar at the Folies-Bergère* since 1963 and his conviction that it was the painting that obsessed Claude Lantier in *L'Oeuvre*, even though, by Zola's account, Suzon was not its literal subject. See 'Chef d'Oeuvre (bien connu)' in *'Masterpiece' Studies: Manet, Zola, Van Gogh and Monet* (University Park, PA, 1994), pp. 34, 49.

27 For a sensitive reading of the bouquet see James H. Rubin, *Manet's Silence and the Poetics of Bouquets* (London and Cambridge, MA, 1994), pp. 157–99, which shows how especially

toward the end, when Manet knew he was dying, he gave away paintings of flowers as 'forms of compensation', as little acts of 'love returned' for the models' effort in posing. In *A Bar at the Folies-Bèrgere* 'the delicate petals at the barmaid's bosom are like the signature of his poetics of bouquets' (p. 196). Mary Mathews Gedo sees the painting as 'a monument to the psychic healing and reintegration that [Manet] effected through the regenerative power of art'. 'Final Reflections: *A Bar at the Folies-Bergère* as Manet's Adieu to Art and Life', in *Looking at Art From the Inside Out: The Psychoiconograpic Approach to Modern Art* (New York, 1994), p. 24. To support her argument that the painting was Manet's 'last will and testament' (p. 4) she cites Christopher Lloyd, 'Manet and Fra Angelico', *Source*, VII/ 2 (Winter 1988), pp. 20–24, who argues that Manet was influenced by Fra Angelico's *Christ Rising from the Tomb* (*c.* 1440; San Marco, Florence).

27 He was modelled by the painter Gaston Latouche. Werner Hoffman speculates that 'The customer of the barmaid is an unknown *flâneur*, but we can well imagine Manet in his place'. From 'Glances', a lecture delivered at 'Manet: A Symposium', Metropolitan Museum of Art, New York, 22 October 1983.

Photographic Acknowledgements

The author and publishers wish to express their thanks to the following sources of illustrative material and/or permission to reproduce it (excluding those sources credited in the picture captions):

Jörg P. Anders: 111; Walters Art Gallery, Baltimore: 5; Juliana Cheney Edwards Collection, Museum of Fine Arts, Boston: 41; The Hayden Collection, Museum of Fine Arts, Boston: 39; Gift of Robert Treat Paine II, Museum of Fine Arts, Boston: 114; Gift of Mr William M. Chase, Albright-Knox Art Gallery, Buffalo, NY: 72; A. Conger Goodyear collection, Albright-Knox Art Gallery, Buffalo, NY: 56; Ken Burris: 109; The Harvard University Art Museums, Cambridge, MA: 94; Mr & Mrs Potter Palmer Collection, Art Institute of Chicago: 25; Christie's Images: 116; Museum Folkwang, Essen: 59; Musée du Petit Palais, Geneva: 8; Glasgow Museums and Art Galleries: 117; Julian Hartnoll: 79; Kenneth Hayden: 123; Ole Haupt: 63; Frédéric Jaulmes: 23; Rheinisches Bildarchiv, Cologne: 3; National Museums and Galleries on Merseyside/John Mills: 21, 92, 97, 105, 112; Bridgeman Art Library, London: 95, 120; British Museum, London: 80, 81; Courtauld Institute of Art, London (Samuel Courtauld Trust): 13, 14, 48, 82; National Gallery, London: 6, 7; Sotheby's, London: 1, 9; Manchester City Art Galleries: 88, 96, 104; The Barnes Foundation, Merion Station, PA: 17; John R. van Derlip Fund, The Minneapolis Institute of Arts: 55; Tate Gallery, London/Art Resource, New York: 61; Otto Nelson: 16; Yale Center for British Art, New Haven (from the collection of Edmund J. and Suzanne McCormick): 46; Alinari/Art Resource, New York: 102; Art Resource, New York: 28, 29, 75, 85, 86, 89, 99, 103, 108, 119, 121, 122, 129; Berry-Hill Galleries, New York/Helga Photos: 125; Frick Art Reference Library, New York: 27; Giraudon/Art Resource, New York: 11, 22, 30, 40, 42, 52, 62, 65, 66; Scala/Art Resource, New York: 10, 34; Sotheby's, New York: 47, 71; The Warden and Fellows at Keble College, Oxford: 87; Agence Photographique de la Réunion des Musées Nationaux, Paris: 68, 113; Archives Durand Ruel, Paris: 18, 19; Henry P. McIlhenny Collection in memory of Frances P. McIlhenny, Philadelphia Museum of Art: 128; W. P. Wilstach Collection, Philadelphia Museum of Art: 33; Gift of the Atholl McBean Foundation, The Fine Arts Museums of San Francisco: 118; Elke Walford: 4, 67; Gift of the Avalon Foundation, National Gallery of Art, Washington, DC: 73; Ailsa Mellon Bruce collection, National Gallery of Art, Washington, DC: 49; Chester Dale Collection, National Gallery of Art, Washington, DC: 36, 70; Gift of the W. Averell Harriman Foundation in memory of Marie N. Harriman, National Gallery of Art, Washington, DC: 58; H.O. Havemeyer collection, Bequest of Mrs H.O. Havemeyer, National Gallery of Art, Washington, DC: 60, 115; Gift of Mrs Horace Havemeyer in memory of her mother-in-law, Louisine W. Havemeyer, National Gallery of Art, Washington, DC: 35; Samuel and Mary R. Bancroft Memorial, Delaware Art Museum, Wilmington, DE: 107; Graydon Wood: 33.

Index

italic numerals refer to illustrations

adultery 18-19, 20, 89-91, 170, 205-6, 224-7, 234-5, 237
 see also marriage
Alighieri, Dante 51-3, 239-40
Alma-Tadema, Lawrence
 Pleading 2, 9
Anderson, Wayne 253 n.5, 260 nn. 27, 34
Andromeda *see under* Perseus
Apter, Emily 262 n. 4
Ariosto, Lodovico
 Orlando Furioso 193
Armstrong, Carol 272 n. 5
Armstrong, Nancy 249 n. 42
artists/writers, male, love lives of: 27, 238-43; specifically:
 Burne-Jones 27, 109, 241-2
 Degas 243
 Flaubert 129
 Gauguin 27, 112, 143-5
 Hunt 27, 241
 Leighton 173
 Manet 27, 243-4
 Millais 27, 240-1
 Renoir 27, 47, 242-3
 Rossetti 27, 239-40
 Tissot 27, 215, 242
 Toulouse-Lautrec 27
artists' models 28, 47-8, 71, 74-6, 81-7, 95, 104-8, 123, 127
 and female artists 28
 and male artists 15, 27, 28, 46-8, 54, 60, 74, 75-6, 81-7, 95-8, 104-7, 109, 112, 127-8, 136-7, 168, 170, 176, 215, 238, 243
Astruc, Zacharie 136
Auerbach, Nina 258 n. 38, 269 n. 23

Bailey, Peter 256 n. 16
Bal, Mieke 263 n. 17
Barnes, E.C.
 The Seducer 79, 154-5
Bastien-Lepage, Jules

The Hay-Makers 42, 81
Baudelaire, Charles 27, 35, 129, 135
Beauvoir, Simone de 103
Beckwith, Alice 251 n. 70
Bell, Charles 25
Benjamin, Walter 25
Berger, John 11
Bernheimer, Charles 102, 262 nn.1, 5, 7; 263 nn. 9, 12; 265 n. 40
Blair-Leighton, Edmund 9
Boggs, Jean 212
Boime, Albert 256 n. 18, 263 n. 14
Borel, France 104
Braddon, Mary Elizabeth 161
Brady, Kristin 266 n. 14
Bronkhurst, Judith 170
Brontë, Charlotte 30
 Jane Eyre 18-19, 20, 24, 88-91, 98, 235
Brontë, Emily
 Wuthering Heights 91
Brooks, Peter 102, 260 nn.29, 35
Broude, Norma 102, 212, 261 n. 4
Brown, Ford Madox 25
 The Last of England 25
 Take Your Son, Sir! 121, 122, 221
Bullen, J. B. 253 n. 28, 266 n. 11
Burne-Jones, Edward 27, 173, 175
 The Baleful Head 106, 201-2, 242
 The Beguiling of Merlin 92, 175-6, 230
 The Depths of the Sea 94, 176-7
 The Calling of Perseus 200
 The Death of Medusa 201
 The Doom Fulfilled 201
 King Cophetua and the Beggar Maid 20, 50-1
 The Love Song 91, 173-5
 The Nymphs Arming Perseus 200-1
 Perseus and the Graeae 200
 Phyllis and Demophoön 93, 176, 230
 Pygmalion and the Image (series) 109-10
 Pygmalion and the Image: The Soul Attains 54, 109-10

The Rock of Doom 201
The Tree of Forgiveness 176

Cabanel, Alexandre
 The Birth of Venus 53, 101
Caillebotte, Gustave 58
 Interior (Woman at the Window) 124, 222
 Nude on a Couch 55, 110-11
 Pont de l'Europe 8, 34
Callen, Anthea 37, 102
Callias, Nina de (Manet's model) 84
Carnforth, Fanny (Rossetti's model) 203
Cassatt, Mary 28
 Woman and Child Driving 33, 70
 Woman in Black at the Opéra 39, 76, 84
Casteras, Susan 170, 186, 254 n. 15, 265 n. 1,
 266 n. 19, 267 n. 26, 269 n. 25, 273 n. 12
Cézanne, Paul 139
 The Eternal Feminine 69, 139-40
 A Modern Olympia 68, 138-9
Champa, K. S. 274 n. 26
Charigot, Aline (Renoir's model) 47-8, 58, 60,
 243
Cherniavsky, Eva 273 n. 9
Cherry, Deborah 94
cinema *see under* film
Clark, Joseph
 The Labourer's Welcome 120, 218-19
Clark, T. J. 85, 128, 236
Clayson, Hollis 255 n. 20, 256 n. 17, 258 n.
 32, 264 n. 38
Codell, Julie 250 n. 62, 272 nn. 2, 3
Cogan, Frances 249 n. 42
Collins, Bradley 210
Corinth, Lovis
 Salome 64, 127
courtship 31
 conventions 15
 imagery 15, 37-8
 see also marriage proposals, proposal compo-
 sition
Couture, Thomas
 Jocondo 173
 Romans of the Decadence 65, 132-3
culture *v.* nature argument
 see under nature

Dagnan-Bouveret, Pascal-Adolphe-Jean
 A Rest by the Seine 47, 93
Darwin, Charles 234
 The Descent of Man 22
Dawkins, Heather 261 n. 40
Degas, Edgar 27, 37, 94, 102, 120-5, 145, 152,
 212, 243
 Admiration 76, 147, 230f

The Bellelli Family 113, 210-12
Bouderie (Sulking) 115, 213-14
The Customer 147
Dancers Backstage 49, 94-5
Edmondo and Thérèse Morbilli 114, 212-13
Interior 120, *128*, 231-2
Repose 147
The Serious Client 75, 147-8
The Toilette after the Bath 63, 124-5
The Tub 62, 121
Waiting for the Client 147
Woman Bathing in a Shallow Tub 60, 121
Woman In a Tub 61, 121
Dickens, Charles 151-2
 Oliver Twist 149-52
Dicksee, Frank
 A Reverie 112, 210
Dijkstra, Bram 264 n. 37
Doane, Mary Ann 11-12
Dobigny, Emma (Degas's model) 213
double standards, moral
 see under morality
Du Maurier, George
 Trilby 51, 95-8, 104, 105

Egg, Augustus
 Past and Present 237
Eliot, George 69
 Adam Bede 161
 Daniel Deronda 160-1
 Middlemarch 19
 The Mill on the Floss 37, 66-7
Ellis, Sarah 22
Elmore, Alfred
 On the Brink 83, 84, 158-60
Etty, William 199
 Andromeda 199
 Perseus and Andromeda 104, 198-9
Eve and Adam in art 113-18, 133, 201, 244-5
 see also Gauguin
eyes
 beautiful 24, 48-50, 75-6, 161-3, 173, 192,
 242
 closed 145
 dangerous 95-8, 101, 117-18, 149, 161, 166,
 176-7, 179, 227, 232
 of the dead 127, 149-51
 female, and aggression 101, 161, 176, 179
 and frontality 133, 156, 160, 171, 173, 176,
 179, 207-8, 215
 male *v.* female 7, 9, 10, 31, 48-9, 67, 68, 80,
 89-90, 98, 133, 134, 153, 157, 160, 173,
 176, 179-80, 204, 205, 208, 212-13, 217,
 221, 227

and masks 244-5
vari-coloured 31, 53, 163-4, 192-3
see also gaze, look

Fahnestock, Jeanne 251 n. 3
Farwell, Beatrice 55
Faxon, Alicia Craig 251 n. 70
femininity 22, 23
feminist art history 10-14, 15, 36, 93, 102
film theory 10, 11-13
Flam, Jack 255 n. 6, 256 n. 20
flâneur, the 34, 35, 36
flâneuse, the 35
Flaubert, Gustave 129
 Madame Bovary 19, 31, 129, 161, 224, 234-5
 A Sentimental Education 129
Flescher, Sharon 263 n. 15, 264 n. 23
Forain, Jean-Louis
 The Actress's Dressing-room 144-5
Foucault, Michel 140-1, 262 n. 1
Fowler, O. S. 22
Freud, Sigmund 21-2
Frith, William 9, 158
 The Lovers' Seat 82, 157-8, 230
frontality, female 34, 38, 41, 45, 46, 50, 53, 54, 56, 65, 93, 99, 138, 145, 167, 179, 188, 198, 212, 215, 221, 226, 232, 233
frontality, male 7, 9, 29, 157, 171, 175, 179, 228
 see also proposal composition

Gallagher, Catherine 268 n. 9
Garb, Tamar 249 n. 40, 253 n. 6, 255 n. 23
Garrard, Mary 102
Gaskell, Elizabeth
 North and South 15, 24, 189-92
 Ruth 21, 153
Gauguin, Paul 27, 30, 112-20, 243-5
 images of Eve in the work of 113-18, 244-5
 Manao tupapau (The Spirit of the Dead Watching) 56, 112-13
 Parau na te Varua ino (Words of the Devil) 58, 117-18, 130, 244-5
 Primitive Tales 59, 118-120
 Te nave nave fenua (The Delightful Land) 57, 114-17
 Where Do We Come From? What Are We? Where Are We Going? 119
gaze, the
 in animals 22
 female 7, 9, 13, 14, 22, 32, 36, 52-3, 54, 75-8, 79, 85, 95, 136, 138, 143-4, 148, 162, 229
 inward 88, 173-5
 male 7, 9, 10-14, 25, 36, 37-8, 39-40, 41, 52-3, 58, 76, 78, 81, 88, 93, 94, 95, 98, 101-2, 104, 123-5, 134, 136, 137-40, 142, 143-4, 145, 147-8, 156, 210, 226, 227, 228-32
 masked 118
 medical 140-3
 and objectification 224, 228
 reciprocal 29, 52-3, 104
 spectatorial 94, 102
 ungendered 103
 see also eyes, look, voyeur
Gedo, Mary Mathews 256 n. 7, 275 n. 26
gender theory 10, 24
Gérome, Jean-Léon 25, 120
 Phryne Before the Areopagus 4, 25, 120, 230
 A Roman Slave Market 5, 25, 230
Gervex, Henri *Rolla 74*, 145
Gezari, Janet 257 n. 29
Glaize, Auguste-Barthélemy
 The Picnic 23, 56-8
Godwin, Mary 157-8, 230
Gonzalès, Eva
 A Loge at the Théâtre des Italiens 40, 78
Griffin, Susan 271 n. 20, 272 n. 23
Grilli, Stephanie 266 n. 18
Groom, Gloria 111, 271 n.19
Guillemet, M. and Mme Jules 208, 210

Hall, Catherine 22, 249 n. 44
Hancher, Michael 268 nn. 3, 5
Hanson, Ann Coffin 253 n. 1
Hardy, Thomas
 Far From the Madding Crowd 25, 162
 A Pair of Blue Eyes 15, 48-50, 224
 Tess of the d'Urbervilles 18, 21, 163-6
Hatt, Michael 248 n. 34
Hauser, Henriette (Manet's model) 138
Hawthorne, Nathaniel
 The Scarlet Letter 17-18, 162-3
Hayllar, Edith
 A Summer Shower 16, 45
Hegel, G. W. F. 103
Herbert, Robert 207, 212, 251 n. 4, 254 nn. 7, 19; 270 n. 3
Hill, Emma (Ford Madox Brown's model) 221
Hofmann, Werner 210
Holiday, Henry
 Dante and Beatrice 21, 51-3
Horsley, John
 Blossom Time 31, 65-6
 Showing a Preference 13, 14, 41-2
Hughes, Arthur

The Long Engagement 126, 228-9
Hugo, Victor
 The Man Who Laughs 192-3
 Les Misérables 162
Hunt, William Holman 25, 241
 The Awakening Conscience 24, *85*, *86*, 167-
 70, 180, 203, 241
 Claudio and Isabella 89, 171-3
 The Hireling Shepherd 88, 170-1
 The Light of the World 87, 169-70, 241
 The Scapegoat 241
Huysmans, J.-K.
 Marthe 128

Ibsen, Henrik
 When We Dead Awaken 104-5
Ingres, J.-A.-D.
 Roger Delivering Angelica 102, 193-6
 The Turkish Bath 52, 99-100, 101
Irigaray, Luce 36, 37, 142
Isaacson, Joel 270 n. 6

James, Henry
 The Golden Bowl, 223-6
Jay, Martin 252 n. 14, 259 n. 9
Johnson, Ronald 274 n. 13

Kaplan, E. Ann 12
Keats, John 229-30
Kestner, Joseph 13-14, 248 n. 32, 249 n. 38,
 254 n. 13, 267 nn. 31, 33, 34, 36, 37
Kucich, John 23, 24

Laurent, Méry (Manet's model) 82
Lauretis, Teresa de 12
Lavater, Johann Kaspar 25
Leighton, Frederic 27, 173, 233
 The Fisherman and the Siren, *90*, 173, 230
 The Last Watch of Hero 173
 Perseus and Andromeda 105, 199-200
Leslie, George 15
Lesser, Wendy 261 n. 44, 272 n. 26
Levine, Philippa 262 n. 2
Lipton, Eunice 136-7, 261 nn. 46, 47; 270
 n. 4
Long, Edwin
 The Proposal 1, 7
look, philosophy of, the 13-14, 36-7, 103
 see also eyes, gaze

Maas, Jeremy 267 n. 27
McGann, Jerome 269 n. 24
McMillan, James 262 n. 3
Magnan, J. A. 248 n. 33

Mallarmé, Stéphane 236-7
Manet, Edouard 27, 29, 82-7, 243-4
 Argenteuil 30, 64-5
 At the Café 110, 207-8
 A Bar at the Folies-Bergère 43, *44*, 81-7,
 243-4
 Café-Concert 37, 74
 Corner in a Café-Concert 74
 Dead Christ with Angels 244
 Le Déjeuner sur l'herbe 22, 54-6
 In the Conservatory 111, 208-10
 In the Garden 109, 207
 La Gare Saint-Lazare 54
 A Masked Ball at the Opéra 35, 72, 82
 Mme Victorine as an Espada 54
 Music at the Tuileries 82
 Nana 67, 137-8
 Olympia 66, 134-6, 152
Marks, Arthur 221
marriage, as a theme 129-30, 153, 207 ff.
 proposals of 7-9, 15-16, 49, 90, 164
 see also proposal composition
Martineau, Robert Braithwaite
 The Last Day in the Old Home 119, 217-18
Massé, Michelle 257 n. 26
Mauner, George 253 n. 4
meeting, as a theme 31 ff.
Mermin, Dorothy, 251 n. 68
Meurent, Victorine (Manet's model) 54-6,
 134
Meyerbeer, Giacomo
 Les Huguenots, 185
Midwood, William
 At the Crafter's Wheel 9, 38
Mill, John Stuart 22-3
 The Subjugation of Women 22-3
Millais, John Everett 9, 29, 233
 The Black Brunswicker 97, 182-4, 186
 The Boyhood of Raleigh 28, 62
 Effie Deans 80, *81*, 156-7
 The Girlhood of Mary Virgin 239
 *The Huguenot, Eve of St Bartholomew's
 Day 98*, 184-5
 The Knight Errant 103, 196
 Lorenzo and Isabella 127, 228-30
 The North-West Passage 29, 64
 The Order of Release, 1746 99, 185-6
 Peace Concluded, 1856 100, 186, 234
Miller, Annie (Holman Hunt's model) 168,
 241
mirrors 138, 218-21
models, *see under* artists' models
Moore, George 121
morality

double standards in 16-19, 21, 26, 165, 166, 237-8
English 16-19, 23, 149, 151, 157-8
Eve's role in 201
feminine 17-18, 20, 22, 24, 25-7, 30, 49-50, 68, 91, 123, 131, 132, 151, 158, 160, 162-6, 170, 171, 179-80, 190-1, 223-4, 226-7, 233-6, 239, 241
French 18, 23
gendered 15, 19, 22, 24, 25, 68, 131, 162-3, 190, 218, 233-6, 238
of love 16, 30, 68, 181, 190, 226-7, 232-6
masculine 18-19, 20, 25-7, 114, 131, 162-3, 236
and physiology 24, 25, 165
and religion 23, 67, 113, 114-18, 172, 184-5
Roman 133
Moreau, Gustave 173
Morisot, Berthe 28, 84, 243
Mulvey, Laura 11, 13-14
Munich, Adrienne Auslander 196, 269 n. 15
Muschamp, F. Sydney
Scarborough Spa at Night 12, 41-2
Musset, Alfred Rolla 145

nakedness 113-14, 117
and nudity 107-10
Nana see under Manet and under Zola
nature v. culture argument 20, 67-8
Nead, Lynda 160, 218
Needham, Gerald 135
newspapers 207, 221-3
Newton, Kathleen (Tissot's model) 215, 242
Nightingale, Florence 186-8
Nini, or 'Guele-de-Raie' (Renoir's model) 75-6
Nochlin, Linda 13, 203, 254 n. 18, 260 n. 35, 269 nn. 25, 28
nude, the, as a theme 56, 99ff.
and nakedness 107-10
see also artists' models
Nye, Robert 248 n. 35

Ockman, Carol 258 n. 1
Orchardson, William Marriage of Convenience - Before 117, 215-17
Ortner, Sherry 248 n. 38
Osborn, Emily
The Escape of Lord Nithsdale 101, 188-9, 228
Nameless and Friendless 48, 93-4
Ovid
Metamorphoses, 108-9

Parker, Rozsika 101
Paxton, William MacGregor
The Breakfast 125, 222-3
Perseus and Andromeda myth 104, 105, 197-202, 241-2
phrenology 22, 24, 29, 234
placental barrier 165
Pollock, Griselda 13, 35, 36, 76, 101, 274 n. 20
Poovey, Mary 24, 186-7
Pre-Raphaelite Brotherhood 24-5, 27, 29, 233, 239-42
see also under individual artists
private v. public sphere 24
proposal composition 7-10, 37-8, 65, 135, 164, 167, 191, 207, 208, 226, 228, 233
and seduction 155-6
see also frontality
prostitution, as a theme 14, 64, 99-100, 128ff., 160, 170
surveillance and 128, 140-3
public see private v. public sphere
Pygmalion, myth of 28, 108-10

Rand, Harry 253 n. 2
recreation, as a theme 54 ff.; specifically:
bathing 55, 56, 120-4
boating 56, 60-4, 68-9
circus-going 78-80
concert-going 74-78
dancing 70-4
drinking 74
driving 70
eating 53, 56-60
gambling 158-60
Reff, Theodore 263 n. 16, 272 n. 4
Réjane (Degas's model) 124-5
Renoir, Pierre 243
and Aline Charigot 47-8, 71, 243
and Suzanne Valadon 71
Dance at Bougival 71
Dance in the City 71
Dance in the Country 34, 71
The Engaged Couple 3, 10
In the Garden 18, 19, 46, 47-8, 242-3
Leaving the Conservatoire 17, 45-6
The Loge 38, 75-6
Luncheon of the Boating Party 24, 58-60, 242
Le Moulin de la Galette 10, 39, 70-1, 242
Reading the Role 50, 95
The Rowers' Lunch 25, 60
The Swing 11, 40
The Umbrellas 6, 7, 31-2, 38, 40

rescue, as a theme 181 ff.
 failed rescuers 182-5
 female rescuers 82-91, 192-3, 205
 male rescuers 181 ff.
Reynolds, Graham 253 n. 30
Rivers, Christopher 263 n. 11
Roberts, Helene 170, 271 n. 15
Romanes, George 23
Roper, Michael 248 n. 32
Rose, Jacqueline 265 n. 5
Rosenblum, Robert 101, 271 n. 18
Ross, Novelene 255 n. 3
Rossetti, Christina (Holman Hunt's model)
 170, 241
Rossetti, Dante Gabriel 1, 239-40
 Beata Beatrix 129, 239
 Ecce Ancilla Domini 77, 78, 53
 Found 107, 203-4, 230
 poetry 194, 195, 202, 203-4
Rubin, James 86, 274 n. 27
Ruskin, Effie (Millais's model) 186, 240-1
Ruskin, John 22, 168, 240-1
Russett, Cynthia 250 nn. 45, 53

Sargent, John Singer
 A Dinner Table at Night (The Glass of
 Claret) 118, 217
 Street in Venice 73, 145
Sartre, Jean-Paul 36
Schor, Naomi 263 n. 13
Scott, Walter
 The Heart of Midlothian 156
seduction, as a theme 104, 153 ff.
Seltzer, Mark 271 n. 20
sex-objects, women as 99, 101, 103
Shakespeare, William
 Measure for Measure 171-2
Shelley, Percy Bysshe 157, 158, 230
Shires, Linda 250 n. 63
Siddal, Elizabeth (Holman Hunt's and Ros-
 setti's model) 170, 239-40
Sidlauskas, Susan 273 n. 5
Silverman, Kaja 12-13, 64, 266 n. 15
Sisley, Alfred 9
sleeping, women 145
Smith, Lindsay 270 n. 30
Snow, Edward 124
Solomon, Rebecca *The Governess* 46, 88, 98
spectatorship *see under* gaze, male
Spurzheim, J. G. 22
Stephens, Frederick 9, 24
Stone, Frank 9
subject-object distinction 103
 in Beauvoir 103

 in Hegel 103
 in Sartre 103
subjectivity, female 99, 103, 108, 125, 126
subjectivity, male 12
 in Foucault 11
 see also voyeur
surveillance of prostitutes 128, 140-3
Suzon (Manet's model) 81-7, 98, 243-4

Taylor, Harriet 22-3
Tehamana (Gauguin's model) 112-13
Tennyson, Alfred 50, 65, 204
 Idylls of the King 204-5, 235
Thomas, Keith 17
Tissot, James 27, 242
 At the Falcon Inn, Waiting for the Ferry 123,
 221
 The Captain's Daughter 15, 44-5
 An Interesting Story 26, 62
 London Visitors 32, 69-70
 The Reception 72, 143-4
 The Return from the Boating Trip 62
 The Sales Assistant 45, 87-8
 The Tedious Story 27, 62
 Waiting for the Ferry 116, 214-15
 The Woman of Fashion 71, 142
 Women of Paris: The Circus-Lover 41, 78-9
Tosh, John 214, 248 n. 32
Toulouse-Lautrec, Henri de
 A Corner of the Moulin de la Galette 36, 74,
 145
 Rue des Moulins, 1894 70, 140, 142
Trollope, Anthony
 Framley Parsonage 23-4
 He Knew He Was Right 16

Uzanne, Octave 128

Valadon, Suzanne 71
Vance, Norman 248 n. 33
Verga, Giovanni 161
Vicinus, Martha 268 n. 9
vision
 as masculine *per se* 36, 37
 monocular *v.* binocular 7, 9, 44, 75-8
 as moral quality 91, 94, 223, 224-6
voyeurism, 56, 101, 120-1, 123-4, 127, 128,
 130-2, 148
 see also surveillance

Waite, James 9
Walvin, James 248 n. 33
Ward, Martha 261 nn. 42, 43

Waterhouse, John William
 Circe Offering the Cup to Ulysses 95, 177-8
 Hylas and the Nymphs 96, 179
 Ulysses and the Sirens 179
White, Barbara Ehrlich 251 n. 3, 252 n. 25
Wilson-Bareau, Juliet 256 nn. 11, 12
Windus, William
 Too Late 108, 204
Wolff, Janet 35
Wood, Christopher 258 n. 33
working, as a theme 81 ff.
 actresses 95
 agricultural labourers 81, 170-1, 218
 barmaids 74, 81-7
 clerics 228-9
 dancers 94
 governesses 88-9
 housewives 218-19, 222-3
 laundresses 93

models, *see under* artists' models
nurses 186-8
prostitutes 123, 99-100, 128 ff., 170, 203
sailors 41, 42, 44, 60-2, 64, 65-6
sales clerks 87-8
soldiers 182-4

Yeazell, Ruth Bernard 249 n. 39, 250 n. 49

Zambaco, Maria/Mary (Burne-Jones's
 model) 109, 110, 176, 202
Zola, Emile
 L'Assommoir 137
 La Bête humaine 19, 161
 Les Misérables 31-2
 Nana 130-2, 137
 L'Œuvre 105-8
 Thérèse Raquin 231